PAUL BOOTH

DIGITAL FANDOM

New Media Studies

PETER LANG
New York • Washington, D.C./Baltimore • Bern
Frankfurt • Berlin • Brussels • Vienna • Oxford

Library of Congress Cataloging-in-Publication Data

Booth, Paul.
Digital fandom: new media studies / Paul Booth.
p. cm. — (Digital formations; v. 68)
Includes bibliographical references and index.
1. Digital media—Social aspects. 2. Fans (Persons)—Psychology.
3. Online social networks—Social aspects.
4. Technological innovations—Social aspects. I. Title.
HM851.B675 303.48'33—dc22 2010014256
ISBN 978-1-4331-1071-9 (hardcover)
ISBN 978-1-4331-1070-2 (paperback)
ISSN 1526-3169

Bibliographic information published by **Die Deutsche Nationalbibliothek**.
Die Deutsche Nationalbibliothek lists this publication in the "Deutsche
Nationalbibliografie"; detailed bibliographic data is available
on the Internet at http://dnb.d-nb.de/.

Cover design by Sarah McNabb / FamousAfterIDie.com

The paper in this book meets the guidelines for permanence and durability
of the Committee on Production Guidelines for Book Longevity
of the Council of Library Resources.

Printed in the United States of America

TO KATE

TABLE OF CONTENTS

LIST OF TABLES

ACKNOWLEDGMENTS

Just as fans do their work within communities of their own making, I have had the pleasure of writing this book surrounded by a community of peers, friends, and scholars who have been influential on my thinking and scholarship. I owe a debt of gratitude to everyone who has been involved in discussions, conversations, presentations, critiques, or general chats about the ideas that have been developed over the past few years and which find their present form in the pages of this book.

The Department of Communication at Northern Illinois University housed some of the most caring, dedicated and consummate professionals with whom I have worked—my mentors and, now, my friends. I am indebted beyond words to Robert Brookey, Gary Burns, and Jeffrey Chown. Additionally, David Gunkel has been a true inspiration throughout my time working on this project, and I owe him a debt of gratitude (and at least two beers).

This book found life in the discussions I had in the Department of Language, Literature and Communication at Rensselaer Polytechnic Institute with my advisor, June Deery, whose clear guidance, dependable critiques, and bottomless cups of tea helped all manner of ideas develop. I am forever grateful to June not only for the help she provided during my schooling, but also for the lessons she taught me about being a scholar. I am also grateful to the help of Michael Century, Ekaterina Haskins, and James P. Zappen.

My home at DePaul has been more wonderful than I can possibly acknowledge. Thanks to my colleagues in Media/Cinema Studies at DePaul, including Luisela Alvarez, Jay Beck, Kelly Kessler, and Meheli Sen. Thanks also to Jacqueline Taylor for the helpful advice and chats. And thanks to Sarah McNabb for the superb book design advice.

Further thanks are due to the anonymous readers, listeners and editors who have helped shape some of these ideas as they germinated in earlier versions: I presented portions of the Introduction at the 2008 meeting of the National Communication Association in San Diego, CA, and at Columbia College Chicago's Cultural Studies Department colloquium series (01 Oct

2009), and am grateful to Ann Hertzel Gunkel and Jaafar Aksikas for feedback. I presented portions of Chapters Two and Three at the 2009 Midwest Popular Culture Association (MPCA) conference in Detroit, MI. A good portion of Chapters Four and Five were published in Winter 2009 in *Narrative Inquiry* 19.2 as "Narractivity and the Narrative Database: Media-Based Wikis as Interactive Fan Fiction," pp. 373-393 and were presented at the 2008 MPCA meeting in Cincinnati, OH, but this present volume contains a deeper analysis than both (used with kind permission by John Benjamins Publishing Company, Amsterdam/Philadelphia, www.benjamins.com). Portions of Chapter Six and Seven were published in Dec 2008 in *Critical Studies in Media Communication* 25.5 as "Re-Reading Fandom: MySpace Character Personas and Narrative Identification," pp. 514-536 (used with kind permission by Taylor & Francis, New York, www.informaworld.com), and were presented at the 2007 meeting of the Narrative Society in Washington, DC. Finally, portions of the conclusion were presented at the 2008 MPCA meeting in Cincinnati, OH.

Further thanks to Kathy Colman, Jan Darling, Penny Darling, Pat Marra, and Tracy Paul, for advice, chats, candy, and help. Thanks to Brendan Riley and Brian Ekdale for all the thoughtful comments throughout the years. Thanks to my co-conspirators at RPI and in Troy, David Bello, Shira Chess, Amber Davisson, Elia Nelson, Eric Newsom, Karen Newsom, Hillary Savoie, Wes Unruh, and Jason Zalinger.

I'd also like to acknowledge the fan authors and commenters on whose works I based this book. Thank you for doing what you do.

Thanks to Steve Jones, Sophie Appel, and Mary Savigar at Peter Lang for their help and support throughout the writing and revision of this book.

Thanks to my parents, Colin and Deb, and to my sister, Anna, for their support and encouragement.

This book could not have been written without the necessary mental breaks provided by Slinky, whose affection is more valuable than my constant furnishing of tasty treats, tennis balls, and belly rubs could ever hope to match. Gizmo, Dusty, and Black Kitty also provided helpful, if often disastrous, distractions.

But my deepest thanks always remain for Kate, for seeing this through, and for being there. Kate, I am your biggest fan.

Introduction

New Media Studies

This is a book about fans, fan fiction (of a sort), and the fan communities that center on that fiction. But it is more than that, too: It's also a book about digital media and necessary changes in our contemporary study of media. Fans are a microcosm of this change, and the study of fans can become emblematic of studies in contemporary media.

I do not take this grandiose claim lightly, for I believe that the second decade of the 21st century brings with it new forms of media beyond traditional models of broadcasting, beyond mass media, and beyond convergence. I believe that the contemporary media environment is more than the sum of its parts. This book is also about these changes to the media environment. And I believe that the best way of examining this sum is with the new tools and methodologies that take into account these changes.

There has been a paradigm shift in our media, a shift that I believe can best be seen and analyzed through studies of Alternate Reality Games (ARGs). The ARG represents one type of integration of converged media, one possible future of entertainment. In this book, I will demonstrate, through an examination of fandom, how the characteristics of the ARG become allegorical for characteristics of New Media. In other words, studying fans tells us something about studying ARGs; and studying ARGs tells us something about New Media. This book, therefore, is also about the future of media as it is lived, experienced and loved.

What is it about media fans that continues to fascinate media scholars? For over twenty years, fan studies have been a way to explore audience participation with a media text. From the pioneering studies of John Fiske, through the germinal ethnographic research of Henry Jenkins, to more recent explorations of fans and technology by Matt Hills, Karen Hellekson, Jona-

than Gray, and Cornel Sandvoss (among others), the productive work of media consumers has been at the forefront of audience analysis. The evolution of fan studies, however, has reached a critical moment: Traditional studies of media fandom in the digital age seem inadequately equipped to describe and analyze what I call the "philosophy of playfulness" we can observe in fans' use of today's digital technology.

What is a "philosophy of playfulness"? The contemporary media scene is complex, and rapidly becoming dependent on a culture of ludism: today's media field is fun, playful, and exuberant. More so than at any other time, the media we use in our everyday lives has been personalized, individualized, and made pleasurable to use. The field of media studies needs to take into account this philosophy of playfulness in order to represent the media texts created by fans not just as fan fiction, fan videos, fan songs, or fan research, but rather as pieces of what fans use as a larger media "game," one allegorized by the Alternate Reality Game.

An ARG is a game played in the physical world that utilizes digital technology to help players solve and decipher clues and puzzles. Although much of the game takes place online, some real world excursions blur contemporary distinctions of media and technology. Why do I link fans to ARGs in this manner? I do not mean to suggest that only "fans" participate in ARGs, nor do I intend to imply that ARGs are created solely for fans' uses. However, I believe there is an important linkage between the two on the theoretical level. Fans are actively engaged in their media texts, participating in some way with the creation of meanings from extant media events. Players of ARGs, similarly, participate in the active reconstruction of the game environment, and create new meanings from the intersection and convergence of media texts. Further, active fans who create fan fiction regularly transgress the boundaries of the original text, by adding new material, creating new readings, or providing alternate takes of the plot of the original. Similarly, ARGs utilize ubiquitous web and digital technology to help players participate in a game that is both constructed through and effaced by mediation, transgressing and destabilizing traditional media theories. In short, the types of participation in which fans engage mirrors the type of participation in which players of ARGs engage; and this type of participation is reflected by many contemporary media audiences in general.

But is it not enough just to declare that the ARG is a metaphor for the future state of mediation. What the ARG also offers us is a glimpse into a

new realm of media scholarship. By representing these changes, ARGs demonstrate what I'm calling in this book "New Media Studies." New Media Studies is not a new type of scholarship, but rather a new way of looking at the practice of contemporary media studies that takes into account, and uses, the technologies that audiences are using to engage with media. In an age where digital media is becoming convergent and ubiquitous, it becomes important to analyze not just that media, but also the very discipline of media studies. This book is, therefore, a response to William Merrin, who writes, "ongoing changes in digital media needed to be placed at the core of the discipline; backward-looking perspectives needed to be left behind; and the historical basis of the discipline needed to be opened up to critical scrutiny."[1] The language we speak and the terminology with which we define our technology, will always delimit and define the ways in which we can understand our theoretical conceptions.[2] ARGs offer a chance not only to explore the destabilization of concepts in mediation, but also to emphasize and paradoxically underplay New Media mediation at the same time.

But what do I mean by "New Media?" Quite plainly, I define New Media as those media forms that are digital, interactive, updatable, and ubiquitous: in this book represented by blogs, wikis, and Social Network Sites.[3] Digital media are, at their most basic, media defined by their constituent parts: the 1's and 0's of binary code. This has the effect of making all New Media texts boundless—or, rather, bound in the same infinite mediation as all other New Media texts. Whereas once the technological device determined which media entertainment one might experience (TV programs were on TV, newspapers were in print, films were in the cinema), now the digitization of media means that the mediated entertainment does not depend on the technology of its viewership. Interactive media means not only that the media product can influence its viewership's identities, but also that viewers themselves can influence their interpretation of the media product.[4] The wiki I edit today, for example, may not be the wiki you view tomorrow, thanks to the interactive actions of a multitude of amateur editors. Specific online interactive New Media "texts" include blogs, wikis, online comments, Social Network Sites, and all interactions between them.

New Media, additionally, are updatable, which follows naturally from the interactivity of the mediation. Users of New Media can easily update the media "texts" as they use them. New Media are not static products, but instead are akin to what Raymond Williams describes as cultural processes.[5]

A scholar cannot cite a wiki, for example, without acknowledging the date she downloaded that wiki, because the wiki exists just as much in time as it does in space. Indeed, looked at differently, wiki texts are ultimately timeless because they are also, ultimately, formless. Finally, New Media are ubiquitous, meaning not only that New Media surround us and greet us on a daily basis, but also that they do it without our even noticing. The iPod revolution reveals a great reliance on our New Media as technological showcases: I have an iPod not only to listen to music/watch videos/check my email but also so that others will see me with an iPod.

New Media and fandom are closely tied academic subjects; and indeed, it is important to look at fans in New Media because of the close ties between fandom and extant media objects.[6] The show *Babylon 5* is a good example of this, as creator J. Michael Straczynski made major changes to the show after fan's offered input online about the pilot episode.[7] Deery has demonstrated how producers of the *X-Files*

> did read fan sites and did take on some suggestions occasionally. Writers used online fan names for bit parts and even dedicated one episode to a prominent online fan who had recently died. Viewer feedback also determined the prominence of character roles. The character of Skinner, for instance, was apparently expanded due to positive viewer reactions.[8]

Although, as Deery suggests, this interactivity between fans and producers is still nascent, it does exist. More recently, producers of the show *Battlestar Galactica* announced a new show to feature a Second-Life-like virtual environment "tied directly to [the] TV show, letting fans influence [and] affect the broadcast storyline and vice versa."[9] The virtual world would be populated by fans, who would meet there to write new content, read the show, and participate in the production of the television program. Footage of the virtual world will, according to the Sci-Fi network, be featured on a television show, and the fan-presence itself will be a factor in the show's television text. Other fan-created content has made it into shows, albeit usually through officially sponsored channels. For example, the cult show *Heroes* featured a "Create Your Own Hero" fan-based promotion in which fans could go online and vote on various characteristics for two new heroes. The results of the voting determined the personality, appearance and abilities of the heroes, among other attributes. After producers tallied the votes, the new heroes premiered in an online series.[10] Although the producers of *He-*

roes maintained rights over the fan-created content, the fact they sought out and utilized this content speaks to the ubiquity of fan culture in television production.

By enacting these changes, fans perform New Media Studies; academics, therefore, need to keep pace in order to keep current. In this book, I refer to this type of scholarship into fan performance specifically as Digital Fandom, a way of searching for new paradigms and new ways of seeing the media technology we use on a daily basis. Fans are one way of looking at New Media, and fans' use of online, interactive technologies demonstrates an important step to an augmentation of scholarship in media studies. It is "digital" fandom not because it assumes that there is some inherent deterministic difference in the way digital technology affects fans, but rather because many creative fan practices rely on the characteristics of the digital. By integrating digital scholarship into fan studies, I hope to provide a text that offers a unique view of contemporary audiences.

The trajectory of *Digital Fandom* thus follows two parallel paths. First, I augment traditional studies of media fandom with descriptions of the contemporary fan in an online media environment. Second, I use this analysis of digital fandom to discuss media studies as a contemporary field of study. I undertake both a critical and a historical analysis of contemporary media by looking at contemporary uses of New Media. Importantly, I should note here that to make large generalizations of New Media based on a relatively small sample of texts, as I do, can be problematic: one is faced with offering the work of a few to represent larger trends. However, I use this form of textual analysis for a specific effect: namely, I show under-examined and under-theorized aspects of New Media through an analysis of specific ways audiences are using New Media. I do not mean to indicate that this is the only way fans use New Media, nor do I argue that the fan texts at which I look in this book are universal. I simply highlight particular uses of New Media to indicate changes in our scholarly perception of this new, exciting, digital environment. The very fact they are happening is indicative of larger shifts in our use of media in general.

SUMMARY

In this book I use an escalating analysis—by which I mean I examine individual online texts in order to analyze some of the ways people communicate

online. These individual texts lead me to ideas about ARGs, and the way they function in a super-mediated environment. The ideas about ARGs then point the way to a better understanding of our contemporary media environment. Indeed, the way contemporary fans interact complicates traditional media theory; however, I intend this book not to replace but to augment traditional media theories. To misquote Shakespeare, I come to praise traditional media studies, not to bury it. In order to examine this new toolbox and the contents within, I undertake a form of cultural criticism of fan-created, online interactive media texts. In this book I deal specifically with fans of cult television programs, because the interaction with this serial, on-going, extant media object offers unique insights into the fan community and its use of online media. Cult texts have "vast, elaborate and densely populated fictional world[s] that [are] constructed episode-by-episode, extended and embellished by official secondary-level texts (episode guides, novelizations, comics, magazines) and fan-produced tertiary texts (fan fiction, cultural criticism essays, art, scratch videos)."[11] Fans "fill in the gaps" between episodic narratives: for example, a cult text asks the audience to answer questions like, will the survivors get off the island in *Lost*? Who is *Doctor Who*? In what ways will the future be different in *Star Trek*? Who are the hidden Cylons in *Battlestar Galactica*? Cult television's meaning exists not in any one place, but rather in the ethereal location in-between answer and question, in-between desire and the fulfillment of desire.[12] Jason Mittell argues that this form of "narrative complexity" complicates the cult world so much that we watch in order to "crack each program's central enigmas."[13]

As I demonstrate, part of "cracking" these "enigmas" involves much the same process as players and participants of Alternate Reality Games enact to solve the puzzles of those games. This applicability to contemporary media is what makes the ARG such a useful guide for New Media Studies, as I demonstrate in the first chapter. My exploration of the ARG as a metaphor for Digital Fandom and New Media Studies begins in Chapters Two and Three, with an examination of the blog as an intra-textual document. In Chapter Two I show that Roland Barthes's conceptualization of intertextuality is no longer adequate to describe works or texts of New Media. The blog represents a new form neither wholly intertextual nor individual. Specifically, a blog is made up of both the posting and the comments about that posting, and the "author" of a blog fan fiction is not a fan, per se, but rather a fandom. Chapter Three uses Bakhtinian theories of the carnivalesque to begin an intra-textual discussion of blogs. In contrast to intertextuality, which sees the ways texts work together and where meaning is uncovered between texts, intra-textuality examines the meaning that occurs inside the document text

itself. Through an examination of blog fan fiction written about the television show *Battlestar Galactica* (2003), I posit six factors that construct and determine intra-textuality.

The next two chapters reveal the interactive potential of wikis as archives of narrative information by looking at the wikis for the cult TV shows *Lost* (2004) and *Heroes* (2006). In Chapter Four, I examine the implications of this narrative reconceptualization as an interactive narrative database. The narrative database forces a reappraisal of traditional narrative form, where narrative is split between what is told (the "story") and the telling of that tale (the "discourse"). Chapter Five explores the interactive narrative construction of narractivity, the process by which communal interactive action constructs and develops a narrative structure. Through an analysis of spoilers on these wikis, I describe three different ways fans can construe the story.

In the next two chapters, I show the blurring of boundaries between the real and the virtual in Social Network Sites. In Chapter Six I detail how fans create a new form of textual "space" on MySpace which is open to user interpretation and play, and normalizes the virtual and the real-world identities of their users. Taking off from the work of de Certeau, I reconceptualize the role of strategies and tactics in reading a cult television text, and demonstrate that MySpace offers an interreality, a third space of fan creation. Chapter Seven describes three ways this identity roleplay allows fans to rewrite a media text's characters on MySpace. Specifically, I show how other fans reread this roleplay as a narrativized sense of identity in online character personas, and then reproduce their fan community in this interreal space. For users of MySpace, creating a profile of a character is more than fan fiction, and more than textual poaching: it is a space where identities mingle.

In the conclusion I interrogate the very methodology I have used in the book, by re-examining the concept of the Alternate Reality Game refracted through the lens of New Media Studies. I show that the ARG is the result of the outcome of the heavy mediation in a contemporary mediated society. Through an articulation of concepts described in Jay David Bolter and Richard Grusin's *Remediation*, I show how ARGs actually *demediate* real life by reversing and surpassing the polarity of hypermediacy and immediacy.[14] Hypermediacy represents the way media are made obvious: When we admire the special effects in a film, we are in awe of its obviousness. Immediacy, alternately, is the way a media can seem to disappear, and we can seem to forget that we are using or experiencing it. When we emerge bleary-eyed

from a film, forgetting that we were even watching, we have been experiencing immediacy. I argue that ARGs represent a future of media entertainment that reverses these two conceptions through a demediated, playful hyper-immersion, and assert that just as useful a metaphor as the ARG makes, so too must it fall under the very re-examination it portends.

I conclude the book by showing the connection between fans' use of online, interactive technologies and New Media in general. I discuss the ways that Digital Fandom provides a lens through which we can focus on changes in our contemporary media landscape. We must examine the unquestioned assumptions that gird contemporary analysis of media. For example, as Benkler indicates, the traditional theories of media and cultural studies cannot account for the potential and the actualization of online practices.[15] We must rethink traditional ways of dealing with issues such as ownership, originality, authorship, commercialization, and copyright in the online world.

This book is about media. It is media. It relies on and examines media. But more so, it offers a glimpse of a mediated future as seen through contemporary media practices. It should not be the end of the conversation, though; this should not the last Tweet in our dialogue. Media, like fans, are continually evolving, and it is only through a constant and vigilant observation of these changes that scholars, students, and practitioners of media can hope to stay current. If anything, therefore, this book is about a particular time and a particular mediated state. It is about making claims about the future, only a few of which may actually come to truth.

This book is an attempt, therefore, to describe fandom in a digital culture, and to introduce, problematize, and explain new conceptions in media studies as demonstrated by fans. It is my hope that readers will come away not only with some new ideas about the contemporary media landscape, but also with new questions to ask, and new avenues of research to explore. To that end, I do not intend this book to be a conclusion; rather, it is what I hope to be the first line of dialogue in a conversation—the first IM, perhaps—about media, about fandom, and about the place of both in contemporary scholarship.

NOTES

[1] William Merrin, "Media Studies 2.0: Upgrading and Open-Sourcing the Discipline," *Interactions: Studies in Communication and Culture* 1, no. 1 (2009): 19.

[2] See, David Gunkel, *Hacking Cyberspace* (Boulder, CO: Westview Press, 2001), 1.

3 I do not mean to imply that these are the only types of New Media out there, but for the sake of brevity it is on these three I focus.

4 See, Cornel Sandvoss, *Fans: The Mirror of Consumption* (Malden, MA: Polity Press, 2005), 101.

5 Raymond Williams, *Culture and Materialism* (London: Verso, 1980), 48.

6 I use the term "extant media object" in this book as a shorthand of the text for which a fan shows appreciation, or the object of the fan's attention.

7 "What Effect Have Fans Had?" *The Lurkers Guide to Babylon 5*, 19 Mar 2006, http://www.midwinter.com/lurk/resources/fans.html#effect (accessed 10 Mar 2009).

8 June Deery, "TV.com: Participatory Viewing on the Web," *The Journal of Popular Culture* 37, no. 2 (2003): 177.

9 "Sci Fi Channel Partners with Trion for Interwoven TV Show and Virtual World," *Virtual Worlds News,* 02 June 2008, http://www.virtualworldsnews.com/2008/06/sci-fi-channel.html (accessed 10 Mar 2009), ¶1.

10 "Create Your Own Hero" (See, Appendix B).

11 Sara Gwenllian-Jones, "Virtual Reality and Cult Television," in *Cult Television*, ed. Sara Gwenllian-Jones and Roberta E. Pearson (Minneapolis: University of Minnesota Press, 2004), 84.

12 Matt Hills, "Defining Cult TV: Texts, Inter-texts, and Fan Audiences," in *The Television Studies Reader*, ed. Robert C. Allen and Annette Hill (London: Routledge, 2004), 509–10: Hills shows how the definition of "cult" relies on the intersection of production, intertextuality and fan appreciation; see also, Matt Hills, *Fan Cultures* (London: Routledge, 2002), 131–5.

13 Jason Mittell, "Narrative Complexity in Contemporary American Television," *The Velvet Light Trap* 58 (2006): 38.

14 Jay David Bolter and Richard Grusin, *Remediation* (Cambridge, MA: The MIT Press, 1999).

15 Yochai Benkler, "Coase's Penguin, or, Linux and the Nature of the Firm," in *CODE: Collaborative Ownership and the Digital Economy*, ed. Rishab Aiyer Ghosh (Cambridge, MA: The MIT Press, 2005), 169.

Chapter One

The ARG Metaphor

[Texts] are mirrors in the image of those who wrote them. They reflect their concerns, questions, desires, life, death. ...They're living beings: you have to know how to feed them, protect them...
—*Pérez-Reverte, The Club Dumas, p. 60*

[I]n literature there are never any clear boundaries. Everything is dependent on everything else, and one thing is superimposed on top of another. It all ends up as a complicated intertextual game...
—*Pérez-Reverte, The Club Dumas, p. 95*

In traditional parlance, a fan is a person who invests time and energy into thinking about, or interacting with, a media text: in other words, one who is enraptured by a particular extant media object. As the quotations from Arturo Pérez-Reverte's novel *The Club Dumas* indicate, fandom can even extend towards antiquarian books. Corso, the hero of Pérez-Reverte's novel, deals in centuries-old occult manuscripts that their collectors religiously revere and for whom these texts lead to new worlds: worlds inhabited by demons and devils, angels and authors. Indeed, in their quasi-religious devotion to these ancient texts, the book collectors are also, in a sense, fans. *The Club Dumas*, while ostensibly a novel about book collecting and the occult, also provides us with a traditional popular cultural reading of fandom, and through it we can glean a number of salient details about popular conceptions of the fan. As something no "respectable" book collector would consider himself, fans are "vulgar," are "miserable wretch[s]," cannot distinguish "the line between fantasy and reality," and are akin to "innocents and children."[1]

However, the study of fans over the past two and a half decades has found that more complex associations can be made about fans than these crude generalizations indicate. The very interaction with the text that these

antiquarian bibliophiles crave mirrors, in many ways, the interactions of fans with cult television texts. For Corso texts are more than just the words on a page. Corso discovers that texts can also grow and change with every reader and every reading, and can adopt new meanings as new readers can read and reread them throughout time. At first, the connection between the text and its reader is tactile and sensual: a collector/fan holds a book, strokes the crisp leather binding, and smells the ink and printing. Further in the story, however, Corso learns that the connections between texts and their readers can be more intimate than the five senses allow. Texts enter a reader's soul, and become part of that reader: readers imagine themselves to be in the story, a part of the literature.

For fan scholars, fans are representative of audiences like those book collectors: They do more than passively view media. Fans make explicit what we all do implicitly: That is, we actively read and engage with media texts on a daily basis. In this book, I add to this body of fan scholarship by positing that, in the digital age, fans are an exemplar of a change in media studies itself. This is a change William Merrin refers to as "Media Studies 2.0," a form of scholarship that uses the digital technology of today's audiences to examine media as it is currently being consumed and produced. Merrin argues that "today, only a post-broadcasting, digital paradigm can explain our contemporary media experience," and this is available to us only by exploring not just new types of media, but also new users of and practices in that media environment.[2] I show that Media Studies 2.0 can be tangibly witnessed and enacted in the study of fans, what I refer to as a "Digital Fandom."

One key characteristic we can witness in Digital Fandom is how fans' use of technologies brings a sense of playfulness to the work of active reading. The work that fans put into creating fan fiction, fan blogs, fan videos, fan wikis or other fan works can all be boiled down to the fact that they are fun to share. What these examples illustrate is an approaching trend in contemporary media to ludicize texts, or for audiences to create a philosophy of playfulness in their writing to each other. This is not to indicate that fans don't take themselves—or their work—seriously. Far from it. Rather, I mean to show that there would be no fan fiction, no fan work, if fans did not derive some playful pleasure from the act or existence of their fandom. This philosophy of playfulness can perhaps best be witnessed through the metaphor of the Alternate Reality Game. The mechanics of the ARG represent a shift in our understanding of key media studies concepts, as participants in ARGs

often work long hours doing repetitive and often tedious tasks to play these games. By looking at these shifts through the lens of fan studies, we not only see an explicit version of New MediaStudies but also an implicit idea of how the mechanics of an ARG structure and affirm new concepts while destabilizing traditional ones.

An ARG is a game-like narrative played both off- and online, which uses multiple modes of mediation to immerse the player in the game's narrative. Players often participate in these narratives by roleplaying and acting with non-players in the "real world." The form of the ARG "defined by intense player involvement with a story that takes place in real-time and evolves according to participants' responses, and characters that are actively controlled by the game's designers."[3] These designers are called "Puppetmasters," as they metaphorically represent people "pulling the strings" of the players' actions. It is near impossible to collate the complete "text" of an ARG, because so much of it depends on user involvement, unlike a film or a website, which can often be studied in and of itself as a text. When playing an ARG, players receive clues disguised as phone calls, e-mails, text messages or other modes of mediated communication.[4] Developed by the Puppetmasters, these communiqués mediate the game.[5] Not only do the communications mediate, but the mediation also communicates, for the ARG can only be seen through this mediation. Because of this constant mediation, ARGs offer us a mirror with which we can view the digital inebriation of our contemporary mediated culture, and Digital Fandom offers a new method of analysis.

However, just as Digital Fandom offers a new way of analyzing cult media fans, so too does it provide us with a new way of analyzing larger cultural changes related to the media. How do we analyze what happens when the playing stops and the game become real, when the game itself is happening in "real" life? The ARG found its way into popular media before it became realized in ludic form: for example, in the 1980 Disney film *Midnight Madness*, a technologically savvy college kid invites a number of students to a clandestine meeting where he informs them that they have each been picked to participate in a "real-world" game. Each team scrambles across Los Angeles at night to solve puzzles and complete tasks. As they traverse the city, the participants of the game interact with real-world environments, in order to fulfill this ludic goal. Importantly, the film *Midnight Madness* portends a conceptual blend of the ludic with the non-ludic, as

characters encounter "real-world" people not part of the game that become embroiled within the "game-world." Further, David Fincher's 1997 aptly titled *The Game* depicts the protagonist thrown into a series of events that seem to be random, but are in fact different tasks he must perform in order to proceed to the "next level" of the reality-game. For the heroes of *Midnight Madness* and of *The Game*, much like for Corso in *The Club Dumas*, part of the challenge of the narrative is not just to navigate the events, but also to determine the ontological significance of those events: are they part of their non-ludic world or part of the ludic world? Is life just, as Pérez-Reverte states, a giant intertextual game?

Using the ARG as a metaphor for our contemporary media landscape, I critically examine five dialectics at play within media studies. By looking at how fans, as explicitly pro-active media audiences, use and utilize key digital environments, I show that New Media destabilizes these traditional dialectics, and that destabilization symbolically functions to represent larger issues at stake in media studies. The dialectics I examine in this book are:

- Work/Play (Leisure)
- Text/Intertext
- Narrative/Interactivity
- Real/Virtual
- Immediate/Hypermediate

The focus of the rest of this chapter will be on the work/play interaction. Chapters Two and Three focus on the interplay between text/intertext as seen and enacted on blogs. Chapters Four and Five highlight the confluence of narrative and interactivity on narrative-based wikis. Chapters Six and Seven provide an analysis of the interaction between the real and the virtual on fictional MySpace profiles. Finally, the conclusion deals with issues of immediacy and hypermediacy in contemporary, postmodern media culture.

ALTERNATE (?) REALITY (?) GAMES (?): REWRITING MEDIA STUDIES

The ARG is a manifestation of the "technologization" of our society, a massive representation of a mediated population, and thus can act as a microcosm of the intersection between work and play in contemporary fandom.[6] It

is difficult to determine the popularity or the exact numbers of players that play ARGs, for games can take place over months and players are often dispersed around the globe. New media scholar Christy Dena has made an admirable attempt at compiling statistics about the most widely played ARGs, and her statistics come from a variety of sources, both academic and popular.[7] Still, true numbers are hard to come by, as the way ARGs are played limits the ability to tell who might be involved at any minor level. As Dena also suggests, play can take many forms, and players can come and go from the game without consequence. She describes different levels of commitment to the game, and defines two types of players: the casual players, who simply follow the game's unfolding on webpages and wikis, and the hard-core players, who are involved with actually solving the puzzles.[8] Thus, while Dave Szulborski estimates that 10,000 people worked collectively to solve the first ARG, *The Beast*, Elan Lee, one creator of *The Beast*, estimates the total number of users of that game as "somewhere in the neighborhood of 2.5 million," with 100,000 people playing in the first three hours.[9] For hundreds of thousands of people, playing an ARG is an important, and time-consuming, passion.

Just as it is difficult to pin down the exact numbers of players, however, it is equally difficult to pin down one definition of what exactly an ARG *is*. The first difficulty comes in the name itself: for example, Jenkins calls these "*Alternative* Reality Games."[10] Although there seems to be a certain amount of sloppiness in the conflation of the terms "alternative" and "alternate" in the popular lexicon, there are important lingual differences between the terms that become significant in this context. "Alternate" means taking turns, or occurring in succession; "alternative" simply means different. Think of the difference between "they worked on alternate days," which means they worked every other day, or "they worked on an alternative day," would means they worked a different day, but for an indefinite amount of time. The key difference here is ontological. Does an "ARG" switch between two different states of being, going back-and-forth between them ("alternate") or does it shift between a series of different states of being, occupying one for an indefinite period of time ("alternative"). In other words, is the ARG positioned in a binary situation, or is it an open and assorted set of states of being?

In truth, the ARG is a mediated reality that mashes up, but does not blur, the line between the non-ludic and the ludic. While there is no clear distinc-

tion between the two, it is not that a player of an ARG exists either in or not in the non-ludic or the ludic, but rather is perpetually in-between them. An "*Alternate* Reality Game," would indicate instead that, first, players are either in one reality (the physical, non-ludic world) or in an alternate reality (the ludic "game world"), and, second, players do not choose when to transgress the boundary between realities. Because the ARG itself mashes up this distinction between the non-ludic and ludic, a more appropriate term may be "*Vague* Reality Games," "*Confused* Reality Games," or even the most ontologically sound name, "*Mashed-Up* Reality Games." However, having noted this more correct appellation, I do and will continue to use the moniker "*Alternate* Reality Game" throughout this book, merely because this is the preferred term by the community of people that play them (as evidenced by the website, ARGnet.com—"Alternate Reality Game Network").

Another distinction of ARGs is how they mash up the concepts of a ludic world, where the rules of play are discrete and unique, with the world as non-ludic, where gameplay does not affect a player's mental construct of the world.[11] Players work at play in an ARG. For players, this mash-up occurs as they take seriously the game itself. McGonigal believes that part of the reason people want to play an ARG is to lose their sense of reality, to surrender control to the Puppetmasters who determine the in-game missions.[12] The ludic regulations of ARGs, the rules and policies set down by the Puppetmasters that control what the players can and cannot know, become virtual codes and mores enacted by the players in the game. These virtual codes mirror the "magic circle" hypothesized by Johan Huizinga, the "temporary worlds within the ordinary world, dedicated to the performance of an act apart," or the representation of the play-spacer where game rules supersede rules by which society is organized.[13] As Marcus Montola persuasively illustrates, an ARG "is a game that has one or more salient features that expand the contractual magic circle of play socially, spatially or temporally."[14] The magic circle of the ARG, in other words, expands its virtual codes to include the entire "real" world. For players of ARGs, the phenomenological experience of the game can subsume their experiences outside the game.

Specifically, Alternate Reality Games utilize ubiquitous web technology to help players participate in a game that is both constructed through and effaced by mediation. On the one hand, these games are constructed though what Jay David Bolter and Richard Grusin would describe as hypermediated media content: ARG "texts" can only be experienced through mediation.[15]

Because elements of the ARG are spread out across different spatial environments and temporal locations, they literally exist in many locations at different times. They are ubiquitous, multitudinous and global.

On the other hand, despite the overtness of their mediation, ARGs elements are also effaced by the very mediation they construct, and attempt to immerse the player in an immediate environment by appearing to be non-mediated. As McGonigal has shown, the Puppetmasters attempt to make the players forget that they are playing a game: the ARG exists between "what [players] know to be feigned with what they feel to be real."[16] The mediation used in ARGs—the e-mail, instant messages, phone calls, websites—are ubiquitous technologies, and create what Bolter and Grusin would describe as an immediate experience. They disappear, fade into the background of the game, and exist in order that players, who are used to such media technology, can easily forget the mediated nature of these in-game missives. In effect, the media mechanisms of the game allow players to forget that it is mediated, by mashing up the *ludic* into a *non-ludic* environment.

Why Fans?

Similarly to the way ARGs function in a mediated society, fans represent the same kind of activity seen in active ARG players. But while information is hard to come by for players of ARGs, fans leave clues to their existence scattered online: fan fiction at fanfiction.net; fan blogs on LiveJournal; fan wikis at various wikias. Fandom is, of course, already heavily researched and this aids one basic supposition to this argument: that we cannot learn about what we must change in our scholarship without first knowing what our scholarship is. Fandom has also become a ubiquitous frame of reference for media professionals. As more and more television shows develop serialized plots that extend beyond the boundaries of the television set, it's the fan sensibility that is being courted. Fans engage in television shows in a way that makes explicit the activity that many contemporary viewers perform implicitly. Further, fans offer us something we can all relate to. Whether cult television, sports, food, opera or books—we are all fans of something out there, and we all become emotionally involved over something. Studying fans, in effect, is a way of not only studying ARG players, but also a way of studying ourselves.

Fans Are Well-Researched

First, fandom is a heavily researched area of scholarship. The start of popular media fandom in the early 1930s coincides with an important point in the history of popular media technology.[17] Within approximately a decade of each other, *The Jazz Singer*, the first motion picture with sound, debuted (1927), Philo Taylor Farnsworth invented the first electric television (1927), FM radio was invented (1933), and regular electronic television service began in the United States (1939). The tumultuous decade of the Great Depression may have seen the economic downfall of many of the world community, but it also saw the invention and spread of some of its most technologically innovative media devices. Moreover, as these devices became popular, so too did the media entertainment displayed on them. From the 1930s onward, groups of people who all enjoyed the same media entertainment were referred to as "fans," from the pejorative meaning of the term "fanatic."[18]

The importance of fans and fan studies cannot be overestimated. Fan studies invokes and participates in an ongoing discussion with, among others, popular culture studies, audience analysis, communication studies, psychology, media studies, and technology studies. Fandom can be experienced individually or in a community, and as such, fan studies has recently been situated next to, and contributes to, ongoing academic dialogues about the nature of identity, the concept of the text, and issues of community. Different types of fan studies examine different types of fans: some, like Henry Jenkins's *Textual Poachers*, and John Tulloch and Henry Jenkins's *Science Fiction Audiences*, have specifically examined fans' experiences with individual media texts. Nicholas Abercrombie and Brian Longhurst examine fans as one important component on a spectrum of audience types. Matt Hills examines the theory behind analyses of fans. Three important fan authors, Camile Bacon-Smith, Constance Penley, and Rhiannon Bury all look specifically at the writing of fan-fiction. Recent collections examine fans in online discourses.[19] All of these studies treat the fan—in whatever respect they determine—as an active reader, one participating in a de Certeauan view of *productive consumption.*[20]

Fans Are Well-Integrated

Fans are also well-integrated into the media landscape. As Jenkins shows, television media consumers can be broken into three (generalized) categories: Zappers, Casuals and Loyals.[21] Zappers flit around the television channels, flipping between shows but watching no program in particular. Casuals enjoy watching different television shows when they are on the air, but rarely schedule time to watch. Loyals, as fans,

> actually watch fewer hours of television each week than the general population: they cherry pick those shows that best satisfy their interesting, they give themselves over fully to them, they tape them and may watch them more than one time; they spend more of their social time talking about them; and they are more likely to pursue content across media channels.[22]

Although broadcast-era advertising tended to target Zappers, recent media advertisers have started to target Loyals. In fact, according to Lawrence Lessig, media corporations are even creating new types of content to appeal directly to these fans.[23] Loyals are fans, and although they may be in the minority of viewers, "advertisers are increasingly realizing that they may be better advised investing their dollars behind show that have a high favorability rather than shows that have high ratings."[24] Indeed, Loyals tend to purchase more products, percentage-wise, than do other types of media audiences. When these producers court fans and fan communities, the resulting increase in critical praise and profits can also help the media company. For example, according to Shefrin, one of the main factors behind the success of Peter Jackson's *The Lord of the Rings* film trilogy was the fact that the producers actively sought the advice and support of the *The Lord of the Rings* fan community.[25] Fans seek out shows, interact with them, and this interaction influences the type of shows that are made and the ways these shows are advertised and created. As advertisers target fans, media corporations create new types of content that appeals to fans. We can see this in recent advertising campaigns for films such as *District 9*, which tended to blanket internet sites with what Jenkins et al. call, "spreadable media content."[26]

Thus, it becomes important to look at fans as a target audience for advertisers; for, to have a critical understanding of public relations and modern media political economy means we must not only understand fandom, but we must also examine the extant media objects of fandom with full scholarly

attention. The study of fandom is becoming a crucial analytic tool in our changing, digital culture. Fans typically utilize their technological capacities, their communal intelligence, their individual knowledge base, and their social interaction skills to investigate and explore media. Fans lie at the forefront of our rapidly changing media environment. As Jenkins has recently written, the future of media entertainment belongs to the fan.[27]

Everyone Is a Fan

Finally, whether or not we are fans of cult television, of the type I describe in this book, chances are good that everyone is a fan of *something*. We may not be the fans of *Doctor Who* or *Star Trek* that Tulloch and Jenkins describe, but we might be fans of music, of sports, or even food. An analysis of cult media fans reveals as much about the analysis as it does about the fan: and this analysis can be used in other contexts, in terms of other types of fans or audiences. Whatever we are fans of, we base part of our identity on our appreciation of that fandom. As Sandvoss shows, a media object "is part of the fan's (sense of) self," as some fans use their identity *as* fans as a way to differentiate themselves from other media audiences.[28] Being a fan means identifying with a media text, and studying fans allows us to "explore some of the key mechanisms through which we interact with the mediated world at the heart of our social, political, and cultural realities and identities."[29]

As I explore throughout *Digital Fandom*, the more fans become of interest to those that produce and provide media, the more the study of fans becomes integral to understanding mass media. Media scholar Hector Postigo demonstrates that "practices of one community (fandom) are bleeding into the other (mass culture);…changes in technologies that mediate cultural products have made more porous the boundaries to practicing the mores of fan culture."[30] In an era when the mass media saturate our lives, and the boundaries between cult and mass cultures have blurred, fandom becomes one way to understand contemporary digital culture. For, as Sandvoss goes on to show, "it has become impossible to discuss popular consumption without reference to fandom and fan theory, just as it has become next to impossible to find realms of public life which are unaffected by fandom."[31] Fans are becoming ubiquitous audience members, and fans' interactions with and within online technologies, akin to the relationship of players to ARG texts, provides an interesting and rich area of media scholarship.

Thus, throughout this book, I follow two seemingly contradictory claims. The first is determinist in nature and argues that *new technology means New Media, which calls for new scholarship*. The second is constructivist in nature and mirrors Robin Williams and David Edge's assertion that "technology does not develop according to an inner technical logic but is instead a social product, pattered by the conditions of its creation and use": in other words, *new technology cannot be understood without a reading of the cultural theory that has come before*.[32] Both claims, by themselves, are limiting and self-contained. But the contradiction between determinism and constructivism is itself a useful device for the examination and analysis of the media, which are, after all, both constructed and determined. In reality, both arguments are, by themselves, reductive: to assert that cultural effect or change has only one cause is to discount the multitudinous forces at work in society.

I believe that neither determinism nor constructivism is uniquely enough to explain the complicated relationship between media, technology and society. Neither factor can be entirely responsible for the other. I agree with Potts, who calls for a more sophisticated form of analysis that integrates both theories: a bridge between determinism and constructivism.[33]

Thus, by seeing *beyond* the paradox—by using the contradiction as a way to break out of a determinist dialectic—we can effectively witness the inherent tensions at the heart of media studies; not to resolve them, but to embrace them.[34] In this way, and as I describe in detail later, I do not attempt either a purely determinist argument, nor an entirely constructivist one, but rather merely acknowledge that there must be some relation between technological development and the society in which this development happens.

DIGITAL FANDOM: NEW MEDIA STUDIES

As Raymond Williams cautions us, however, any new discussion of scholarship must be sure to start at the level of language: in intellectual discourse, scholars must be careful to use the same vocabulary with the same meanings, and to articulate exactly what they mean in their discourse.[35] My investigation of Digital Fandom is no exception. I present three concepts in this chapter to lay the groundwork for the rest of my argument, as they relate to Alternate Reality Games and to New Media Studies. However, each is discussed in greater depth throughout the book.

Digital Fandom

At the heart of my argument, *Digital Fandom* implies an augmentation to scholarly research about fans, a further stepping-stone in scholarship about fandom, which takes into account tenets in the study of Alternate Reality Games. Digital Fandom examines fandom as the work of a collective community, and not fans as individual audience members. By "community," I refer to the social grouping of individuals with shared interests, joined together through some form of mechanism of membership; the self-selected organization of a group of fans who both enjoy an extant media object, and who create additional content about that extant media object.[36] Studies of fandom have concentrated on the communalization of fans, as *New York Times* columnist Rob Walker points out in his description of *Star Trek* fandom.[37] Fan communities have always been the object of study in fan studies, but usually from the point of view of the individual fan's contribution to the whole. I ask, instead, what of the contribution of *the community* to the whole? How does, as in an ARG, a community contribute collectively to a common goal?

A fan's work tends to be described on a production/consumption dialectic. For example, the work first undertaken by Jenkins places fandom on a continuum between producer and consumer—a metaphor based in market or commodity economics.[38] The fan "consumes" the text that media conglomerates "produce" in order to sell advertising time. These fan studies use the metaphor of the market economy to describe the work of fans.[39] Academic studies of fandom have described fans as a combination of both producer and consumer—with such neologisms as "produser," "prosumer" and "prosumption," for example—but still remain tethered to a binary which views fan productivity in relation to the fan's consumptive attitudes.[40]

However, this commodity metaphor has limitations. In order for the production/consumption metaphor to function, we must assume that *consumption also implies destruction*—the destruction of possession, or the destruction of demand. This market economy model assumes a limited text, and a limited market for the text. Digital Fandom provides a balance to this "productive" dichotomy metaphor of Internet communication by revealing non-market economic antecedents to fan's use of media.

Web Commons

Digital Fandom thus requires a re-evaluation of how we view the web, as fans form a type of Web Commons. The term *Web Commons* describes not a change in technology, but a shift in the way we discuss the usage of the web; as for example we discuss the Alternate Reality Game as existent through the use of the web. Fans make use of the communal, social, and communicative properties of the web to form a social grouping that relies on camaraderie and sharing. In this way, it is akin to the traditional conception of the feudal commons area. The Web Commons contrasts with the web as a resource for information, or what I'm calling the "Information Web."

The Web Commons is thus not a "new web," but rather a new way of *conceptualizing* how people use the Internet. Like recent technological developments in the web the Web Commons indicates an evolution in our understanding of the web.[41] Specifically, two different types of non-mutually exclusive practices exist on the web, both exemplified here by the ARG. Like the research undertaken by participants to solve ARG puzzles, the Information Web focuses on ways the web remediates print. In this conception, the web is like a vast library of books, hypertextually linked to one another.[42] Although it has a global reach and a ubiquitous nature, the "Information Web" is ultimately static and non-interactive. In contrast, the Web Commons is exemplified by the communalization of ARG players, the group-think that helps see larger issues. In this way, it embraces an online version of what James Carey calls "ritual communication"; that is, communication not for "the extension of messages in space but...the maintenance of society in time; not the act of imparting information but the representation of shared beliefs."[43]

The Web Commons is a *mind-set*, not a specific form of technology. Although it exists online, it extends beyond the Internet and represents a substantive alteration in how we conceive of the socialization of information. Lawrence Lessig suggests that the interactions and precedents we set online spill over into our offline culture: it matters what happens online, because it influences our offline lives.[44] Just as there is a change in the interconnected nature of contemporary media, so too is there a revolution in the way media technologies are used. We can see it in the collective, communal nature of the web, in the self-conscious nature of the use of the web, and in the assertiveness of fans. According to Birdsall, these changes "are congruent with and central to those articulated as constituting a human right to communicate.

Thus, recent developments in Web development are a significant phase in ... a component in a larger social movement."[45]

In sum, we "are seeing a shift from individuals who depend on social relations that are dominated by locally embedded, thick, unmediated, given, and stable relations, into networked individuals—who ... weave their own web of more or less instrumental relatively fluid relationships."[46] What helps to illustrate this shift from an online to an offline world is an economic bridge, a new form of economy posited in the Web Commons by the fan: the Digi-Gratis economy.

Digi-Gratis Economy

The collaborative potential of the Web Commons can be seen through a mash-up of two different economic structures as exemplified by ARGs. By "mash-up," I refer to a bastard art form for which artists would illegally appropriate and fuse together two different copyrighted audio recordings; however, I use the term in a more general sense, to refer to the combination of two (or more) disparate elements which forms a unique object or concept that retains characteristics of its constituent components while simultaneously presenting something new.[47] For my purposes, I argue that the existence of a "Digi-Gratis" economy is based upon a mash-up of the market economy and the gift economy. The Digi-Gratis, being a mash-up, retains key elements of both economies, but exists as unique unto itself. Importantly, it is *not* a convergence or a hybrid of the two. It is the simultaneous existence of both economies as both separated and conjoined.

The term *Digi-Gratis* indicates an economic structure where money is not exchanged, but which retains elements of a market structure. In a "gratis" economy, people create and share content without charge or recompense, or, at least, by charging a variable, user-determined fee.[48] In many ways, this exchange is related to the gift economy described by Mauss as one where "exchanges and contracts take place in the form of presents..."[49] The gift economy builds social bonds. This economic structure, in many respects, differs from our contemporary idea of a market economy, in which goods and services are exchanged for monetary recompense, and in which the purpose is to build wealth.

However, as Mauss's quotation goes on to say, "...in reality [exchanges and contracts] are given and reciprocated *obligatorily*."[50] To give a gift necessarily implies reciprocity, a return of a gift in kind. This gift reciprocity

falls under certain social rules: if you recently brought a bottle of wine to the last dinner party, and this time it's your turn to host and no one brings anything, you feel insulted, cheated, deprived even. The reason for this giving/receiving/reciprocation triumvirate has to do with the loss of the tangible object: Derrida shows us that "in general, it is thought that one can give only what one has, what one possesses as one's own, and give it to the other who, in his or her turn, can thus have it, come into possession."[51] To give thus implies a loss, a consumption. Yet, in the digital, there *is* no loss of the tangible, no deficit of object during transfer. There is, instead, a *reproduction* of the object, a copy/exchange. The "gift" of digital objects comes with infinite reproducibility — my giving an MP3 file to one friend does not limit me from giving it to a second, a third, a fourth, as well as then keeping it for myself.

The Digi-Gratis, therefore, is not quite a gift economy, and not quite a market economy. Linguistically, the term also resonates with another portmanteau, "digirati," as coined by John Brockman, for whom the digirati are the "digital elite," the people at the forefront of the computer and Internet industries.[52] Fans become these elites not through sociological means, but through specialized knowledge.

We can see this allegorized in ARGs, which integrate both market and gift economies to function. Namely, ARGs use the participation of the audience as a form of *viral marketing*. Örnebring notices this as an absence in critical scholarship of ARGs: "there is relatively little academic concern with how ARGs function as *marketing tools*, and critical acknowledgement of the fact that most high-profile ARGs are produced for marketing purposes is limited at best."[53] Viral marketing describes a form of advertising that emerges as the participation of the audience distributes content through word-of-mouth, viral videos, e-mail forwards, or other online user-generated content. Also called "immersive marketing," this form of advertisement relies on the activity of consumers for the promotion of a product. Gosney, the author of the first textbook about ARGs, interprets this strategy as one of informed consent: "I don't think it belittles or otherwise reduces your enjoyment of the ARG experience by keeping in mind that what you are playing ... has been developed, in many cases, to market a product."[54] As Andrejevic notes, "the promise of virtual participation in the production process... facilitates the conversion of viewer feedback into potentially productive marketing and demographic information."[55] For example, *The Art of the*

Heist was designed as promotional material for the car company Audi. As players progressed through the game, they had to explore websites devoted to the car maker, discuss Audi products with other players, and travel to an actual (non-ludic) Audi showroom. Further, the ARG *ilovebees* was designed to promote the release of the Xbox game *Halo 2*, while *The Beast* began life as a large marketing campaign for the Steven Spielberg film *A.I.* Other ARGs, however, are designed as both promotions and supplements to other products. *The Lost Experience* both promotes the television show *Lost*, through commercials and word-of-mouth advertising, and also supplements the backstory of the *Lost* narrative. As media scholar Brian Ekdale describes, *The Lost Experience* found players not only scouring webpages for information, but making phone calls, writing e-mails, putting together physical jigsaw puzzles, and even reading a 200-page novel, in order to uncover clues related to the larger mysteries in the show.[56] Dena shows that this form of narrative marketing is designed specifically for an active audience, one supposed to fill in the gaps left both intentionally and unintentionally by the producers.[57] For example, Christopher Nolan, director of *Batman Begins* and *The Dark Knight,* designed an ARG called *Why So Serious* that asked audiences to fill in the gaps between the two Batman films. By filling in these gaps, the players of the ARG function in a shared network, where the discussion of the narrative of the game operates as a dialogue about the brand the ARG advertises; and also act as fans do through the creation of fan fiction and other forms of hyperdiegesis.

Conversely, ARGs also utilize characteristics of the gift economy, which include sharing, reciprocation and communalization. Players must communicate with each other and share information in order to continue. Most saliently, this is visible in *ilovebees,* where players from around the county were given different pieces of information which they then combined into a workable whole. By working together and contributing unique information, players successfully combined interactivity with play. They contributed information freely, as gifts to benefit the whole of the community; but they use market economics to buy the components of the game—the individual texts that make up the ARG.

The Digi-Gratis economy applies to fandom as well. The way that media and fandom co-exist in market economy is obvious. Fans routinely purchase merchandise based around the object of their fandom. When producers release DVDs for a fan's favorite TV show, many fans buy them even if they have already seen them when the show aired, and sales can be staggering.[58]

Fandom, however, can also be perceived in a non-monetary environment online: highlighting instead the social standing of the individual. As Benkler states,

> For any given culture, there will be some acts that a person would prefer to perform not for money, but for social standing, recognition, and probably, ultimately, instrumental value obtainable only if that person has performed the action through a social rather than a market, transaction.[59]

Fandom in the digital, thus, cannot be seen either as a market or as a gift economy, but rather as a mash-up of the two.

DIGITAL FANDOM, THE WEB COMMONS, AND THE DIGI-GRATIS ECONOMY IN PRACTICE

We can see how these three concepts function through an extended example of contemporary fandom at work. The BBC documentary *Love Off-Air* describes a community of fans of the cult science-fiction show *Doctor Who* and how their fandom supported and completed a re-release of a missing title from the series.[60] Through the practice of Digital Fandom, these *Doctor Who* fans helped produce—and reproduce—a key *Doctor Who* text, using the Web Commons in a Digi-Gratis style economy.

During the early years of the series (before the advent of the VCR), a large fan culture would record *Doctor Who* episodes on audio cassette by holding the microphone of the recorder up to the speaker on the television set. According to the documentary, fans often played these fan "off-air" recordings as they effectively re-played the series with action figures, re-enacting the visuals of the episodes while using recovered audio. Off-Air recording fans would often also meet with other fans to play back the recording, and this group of fans would then perform the television show together in a communal atmosphere. As documentary subject and *Doctor Who* fan Justin Richards put it, the "sound archiving of *Doctor Who* was a very serious business" for the community of young fans.

This form of *Doctor Who* fandom came to a head in the early 2000s, when fans and media producers worked together to reconstruct a missing serial from the long run of the show. Tragically, many of the early *Doctor Who* episodes are missing. The show has been on the air (with a few hiatuses) since 1963. From the start of the series in 1963 to the current run beginning in 2005, the British Broadcasting Corporation has broadcast over

750 episodes of the series. During that 45 year-run, the BBC has lost or destroyed 108 episodes, due to policy or to negligence.[61] One such serial was the now-classic 1968 "The Invasion." Representing a pivotal moment in the program's history, "The Invasion" only existed in fragments: of the original eight parts, two were completely missing.

Thanks to digital recording technology, however, the BBC used the off-air recordings of those missing episodes made by fans in 1968 in a re-play of the serial. By digitally combining and cleaning up the recordings of a number of fans, audio engineer Mark Ayres was able to reproduce the broadcast audio from the missing two episodes. In other words, it's not that the BBC cleaned up one recording to make the new soundtrack; rather, they used the collaborate unity of *many* to create a master-track. Using this new master soundtrack, BBC then commissioned film studio Cosgrove Hall to animate the missing episodes in order to produce the entire serial. In many ways, the fandom of *Doctor Who* saved the audio—and the episode—from complete destruction. More episodes are being saved, as fan Michael Stevens puts it: "That hobby I used to have, when I was eight or nine years old, of recording *Doctor Who* off the telly, we now use people's similar recordings and polish them up and put them on CDs."

In one view, then, it appears that the BBC used the work of fans to produce another product for those self-same fans to purchase: a DVD. This market view is undoubted, and the BBC profited off of the work of the fan community. Yet, looked at differently, the fans that worked on this project helped to shape and to contribute to the continued success and promotion of the object of their fandom. Their work—both as audio recorders in 1968 and as a fandom in the 21st century—could be interpreted as gifts to *Doctor Who*. By saving and contributing their work, these fans became active participants in the creation and preservation of the object of their fan affection. Only through the Digi-Gratis economy, an economy based on a mash-up of market economics and gift giving, could such a transaction have happened.

Throughout the rest of this book, I use examples from online fan creations to augment the theories of New Media I propose. However, this warrants a caveat: obviously, no scientific conclusions can be drawn from small samples like the ones I investigate in this book. This is not intended to be a definitive account of all fan practices in the digital, nor is it intended to elucidate every use of the web. Instead, I examine specific instances of Digital Fandom and describe how they illustrate the necessity for a change in scholarship of New Media. Although the samples are small, the work these

fans create is immense, both in terms of its meaning for the individual fan (and the fan community), and in terms of its larger cultural context. It is significant in the most important way: to those that create it.

NOTES

1 Arturo Pérez-Reverte, *The Club Dumas*, trans. Sonia Soto (New York: Vintage, 1996), 246, 156, 260, 322.

2 William Merrin, "Media Studies 2.0: Upgrading and Open-Sourcing the Discipline," *Interactions: Studies in Communication and Culture* 1, no. 1 (2009): 32.

3 "Alternate Reality Game," *Wikipedia*, 2008, http://en.wikipedia.org/wiki/Alternate_ reality_game (accessed 01 Oct 2008). Wikipedia is one of the better sources for definitional work on ARGs, because the players of ARGs utilize online Web Commons tools like Wikipedia and Google, to interactively work in a Digi-Gratis economy to solve the puzzles in the games for Alternate Reality Games. See, Henry Jenkins, *Convergence Culture* (New York: New York University Press, 2006), 127.

4 Jane McGonigal, "I Love Bees: A Buzz Story" (paper presented at AD:TECH, San Francisco, 25–27 April 2005), http://avantgame.com/McGonigal_42%20Entertainment_ |ADTECH|_April|%202005|.pdf (accessed 01 Sept 2007); Brian Ekdale, "The Small Screen Getting Smaller: Network Television on the Web" (paper presented at the annual meeting of the Midwest Popular Culture Association, Indianapolis, IN, 2006).

5 Dave Szulborski, *This Is Not A Game: A Guide to Alternate Reality Gaming* (New York: New Fiction Publishing, 2005), 266.

6 Walter Ong, *Orality and Literacy* (London: Routledge, 2002), 80–2. His description of "technologization" describes the way technology shapes consciousness and culture.

7 Christy Dena, "ARG Stats," *Universe Creation 101,* 08 Dec 2008, http://www.christydena.com/online-essays/arg-stats/ (accessed 10 Dec 2008).

8 Christy Dena, "Emerging Participatory Culture Practices: Player-Created Tiers in Alternate Reality Games," *Convergence: The International Journal of Research into New Media Technologies* 14, no. 1 (2008), 43.

9 Szulborski, 98; Mark Stephen Meadows, *Pause and Effect* (Indianapolis, IN: New Riders, 2003), 136. Additionally, according to McGonigal, over 600,000 people participated in the "real world" excursions promoted by the ARG *ilovebees*, but Szulborski doubts this number, and attributes a minor rise in popularity due to gamers' excitement over the release of *Halo 2*, which *ilovebees* was created to promote (McGonigal, I Love Bees, ¶18; Szulborski, 166).

10 Jenkins, *Convergence*, 123–8, my emphasis.

11 Markku Eskelinen, "The Gaming Situation," *Game Studies* 0101 1, no. 1 (2001), http://gamestudies.org/0101/eskelinen/ (accessed 15 Oct 2008), ¶2

12 Jane McGonigal, "The Puppetmaster Problem: Design for Real-World, Mission-Based Gaming," in *Second Person: Role-Playing and Story in Games and Playable Media*, ed. Pat Harrigan and Noah Wardrip-Fruin (Cambridge, MA: The MIT Press, 2007), 262.

13 Johan Huizinga, *Homo Ludens: A Study of Play Element in Culture* (Boston: Beacon Press, 1955), 10.

14 Marcus Montola, "Exploring the Edge of the Magic Circle: Defining Pervasive Games" (proceedings of DAC, Copenhagen, Denmark, 2005), http://www.iki.fi/montola/ exploringtheedge.pdf (accessed 01 Aug 2007), sec. 3.

[15] Jay David Bolter and Richard Grusin, *Remediation* (Cambridge, MA: The MIT Press, 1999), 53–4.
[16] Jane McGonigal, "A Real Little Game: The Performance of Belief in Pervasive Play" (Level Up: Proceedings of DiGRA conference, Utrecht, Netherlands, Nov 2003), ¶44.
[17] Francesca Coppa, "A Brief History of Media Fandom," in *Fan Fiction and Fan Communities in the Age of the Internet*, ed. Karen Hellekson and Kristina Busse (Jefferson, NC: McFarland & Co., 2006), 42.
[18] See, Henry Jenkins, *Textual Poachers: Television Fans and Participatory Culture* (New York: Routledge, 1992), 12.
[19] See, about fans: Jenkins, *Textual*; John Tulloch and Henry Jenkins, *Science Fiction Audiences* (London: Routledge, 1995). About types of fans: Nicholas Abercrombie and Brian Longhurst, *Audiences: A Sociological Theory of Performance and Imagination* (London: Sage Publications, 1997), 138–42. Theory of fans: Matt Hills, *Fan Cultures* (London: Routledge, 2002). About fan fiction: Camile Bacon-Smith, *Enterprising Women: Television, Fandom and the Creation of Popular Myth* (Philadelphia: University of Pennsylvania Press, 1992); Constance Penley, *Nasa/Trek: Popular Science and Sex in America* (London: Verso, 1997); Rhiannon Bury, *Cyberspaces of Their Own: Female Fandoms Online* (New York: Peter Lang, 2005). Recent edited collections: Karen Hellekson and Kristina Busse, ed., *Fan Fiction and Fan Communities in the Age of the Internet* (Jefferson, NC: McFarland and Co., 2006); Jonathan Gray, Cornel Sandvoss, and C. Lee Harrington, ed., *Fandom: Identities and Communities in a Mediated World* (New York: New York University Press, 2007).
[20] Michel de Certeau, *The Practice of Everyday Life*, trans. Steven Randall (Berkeley: University of California Press, 1984), 29–42. See, also, for a reconception of this metaphor, Cornel Sandvoss, *Fans: The Mirror of Consumption,* (Malden, MA: Polity, 2005).
[21] Jenkins, *Convergence,* 74–9, echoing Abercrombie and Longhurst.
[22] Ibid., 74.
[23] Lawrence Lessig, *Remix: Making Art and Commerce Thrive in the Hybrid Economy* (New York: Penguin, 2008), 221.
[24] Jenkins, *Convergence,* 76.
[25] Elana Shefrin, *"Lord of the Rings, Star Wars,* and Participatory Fandom: Mapping New Congruencies between the Internet and Media Entertainment Culture," *Critical Studies in Media Communication* 21, no. 3 (2004): 262.
[26] Henry Jenkins, Xiaochang Li, Ana Domb Krauskopf, with Joshua Green, "If It Doesn't Spread, It's Dead," *Confessions of an Aca-Fen,* 11 Feb 2009, http://henryjenkins.org/2009/02/if_it_doesnt_spread_its_dead_p.html (accessed 16 Feb 2009), ¶1.
[27] Henry Jenkins, "Afterward: The Future of Fandom," in *Fandom: Identities and Communities in a Mediated World*, ed. Jonathan Gray, Cornel Sandvoss, and C. Lee Harrington (New York: New York University Press, 2007), 361. He describes how some media commentators avoid using the term "fan," both to avoid the same tired stereotypes, and also because the practices of the fan have become so common that to differentiate fans from consumers is futile.
[28] Sandvoss, *Fans*, 101.
[29] Jonathan Gray, Cornel Sandvoss, and C. Lee Harrington, "Introduction: Why Study Fans?" in *Fandom: Identities and Communities in a Mediated World*, ed. Jonathan Gray, Cornel Sandvoss and C. Lee Harrington (New York: New York University Press, 2007), 10.
[30] Hector Postigo, "Video Game Appropriation through Modifications," *Convergence: The International Journal of Research into New Media Technologies* 14, no. 1 (2008): 71.
[31] Sandvoss, *Fans*, 3.

[32] Robin Williams and David Edge, "The Social Shaping of Technology," http://www.comunicazione.uniroma1.it/materiali/16.47.15_WilliamsEdge_1996_TheSocialShapingOfTechnology.pdf (accessed 25 Aug 2008), 2.

[33] John Potts, "Who's Afraid of Technological Determinism?: Another Look at Medium Theory," *Fibreculture* 12 (2008), http://journal.fibreculture.org/issue12/ (accessed 01 Sept 2008), ¶3. My argument in this book tends to fall more on the deterministic side, if only because fans generally cannot change the technology and must work with the tools they are given: thus, the technology does affect the practice of creating fan fiction in the guises I discuss in this book. However, in the larger realm of New Media Studies, I do believe that society has an effect in the development of technology.

[34] See, David Gunkel, *Thinking Otherwise* (West Lafayette, IN: Purdue University Press, 2007).

[35] Raymond Williams, *Keywords: A Vocabulary of Culture and Society* (Oxford: Oxford University Press, 1976), 9.

[36] Peter Kollock and Marc A. Smith, Introduction to *Communities in Cyberspace*, ed. Marc A. Smith and Peter Kollock (London: Routledge, 1999), 16; Thomas Erickson, "Social Interaction on the Net: Virtual Community as Participatory Genre" (proceedings of The Thirtieth Annual Hawaii International Conference on System Sciences, IEEE, 1997): Sec 2.1; Williams, "Kewords," 66. I refer to the conception of the community as written by Kollock and Smith, who describe communities as "groups of people who meet to share information, discuss mutual interest, play games, and carry out business." Erickson brings up the topic of membership. Williams asserts that term "community" is problematic because "unlike all other terms of social organization (state, nation, society, etc.) it seems never to be used unfavourably, and never to be given any positive opposing or distinguishing term."

[37] Rob Walker, "Enterprising: Her *Star Trek* Conventions Harnessed the Power of Media Fandom Long before the Barons of Content Did," *New York Times Magazine*, 23 Dec 2008.

[38] Jenkins, *Textual*.

[39] As we will see, recent studies of fans use the metaphor of the gift to explain fan transactions. However, I show that both gift and market are limited in themselves, and only through a mash-up of the two do we understand contemporary fan consumptive practices.

[40] Axel Bruns, *Blogs, Wikipedia, Second Life, and Beyond* (New York: Peter Lang, 2008) coined the term "produser"; Alvin Toffler, *The Third Wave* (New York: Bantam Books, 1980) coined "prosumer"; Don Tapscott and Anthony Williams, *Wikinomics: How Mass Collaboration Changes Everything* (New York: Penguin, 2006) use "prosumption."

[41] The term "commons" has been used to describe the web before, notably in Benkler's "commons-based peer production" and Lessig's "creative commons." New web spaces use the term commons as well: many amateur photographers use a Creative Commons license for the pictures on the web, while Wikipedia houses a Commons-based encyclopedia. Yochai Benkler, "Coase's Penguin, or, Linux and the Nature of the Firm," in *CODE: Collaborative Ownership and the Digital Economy*, ed. Rishab Aiyer Ghosh, (Cambridge, MA: The MIT Press, 2005), 169; see, also, Yochai Benkler, *The Wealth of Networks* (New Haven, CT: Yale University Press, 2006); Lawrence Lessig, "The Creative Commons," *Florida Law Review* 55 (1994).

[42] See, Jay David Bolter, *Writing Space: Computers, Hypertext, and the Remediation of Print*, 2nd ed. (Mahwah, NJ: Lawrence Erlbaum Associates, 2001), 27–46.

[43] James Carey, "A Cultural Approach to Communication," in *Communication and Culture: Essays on Media and Society* (New York: Routledge, 1992), 18.

[44] Lawrence Lessig, *Free Culture: The Nature and Future of Creativity* (New York: Penguin, 2004), xiii–xvi.

[45] W. Birdsall, "Web 2.0 as Social Movement," *Webology* 4, no. 2 (2007), http://www.webology.ir/2007/v4n2/a40.html (accessed 24 Mar 2008), ¶34.

[46] Benkler, *Wealth*, 362.

[47] See, Kenneth E. Kendall and Allen Schmidt, "Mash-ups: The Art of Creating New Applications by Combining Two or More Web Sites," *Decision Line* 38, no. 2 (2008), http://www.decisionsciences.org/DecisionLine/Vol38/38_2/dsi-dl38_2ecom.pdf (accessed 02 Dec 2008), 15; John Shiga, "Copy-and-Persist: The Logic of Mash-Up Culture," *Critical Studies in Media Communication* 24, no. 2 (2007); David Gunkel, "Rethinking the Digital Remix: Mash-ups and the Metaphysics of Sound Recording," *Popular Music and Society* 31, no. 4 (2008).

[48] See, Nancy Baym, "The Lost Librarians of National Defense," *Online Fandom: News and Perspectives on Fan Communication and Online Life*, 30 Apr 2008, http://www.onlinefandom.com/archives/the-lost-librarians-of-national-defense (accessed 01 May 2008).

[49] Marcel Mauss, *The Gift: The Form and Reason for Exchange in Archaic Societies*, trans. W. D. Halls (New York: Norton, 1990), 3.

[50] Ibid., emphasis mine.

[51] Jacques Derrida, *Given Time: I. Counterfeit Money*, trans. Peggy Kamuf (Chicago: University of Chicago Press, 1992), 48.

[52] See, John Brockman, *Digerati: Encounters with the Cyber Elite* (San Francisco, CA: Hardwired, 1996).

[53] Henrik Örnebring, "Alternate Reality Gaming and Convergence Culture: The Case of *Alias*," *International Journal of Cultural Studies* 10, no. 4 (2007): 449.

[54] John Gosney, *Beyond Reality: A Guide to Alternate Reality Gaming* (Boston, MA: Thompson, 2005), 22.

[55] Mark Andrejevic, "Watching Television Without Pity: The Productivity of Online Fans," *Television and New Media* 9, no. 1 (2008): 27.

[56] Ekdale.

[57] Dena, "Player-Created," 41.

[58] See, Thomas K. Arnold, "'Lost 2' Finds Way to Top of DVD Sales," *Hollywood Reporter*, http://www.hollywoodreporter.com/hr/search/article_display.jsp?vnu_content_id=1003121876 (accessed 01 Nov 2008), ¶1–2.

[59] Benkler, *Wealth*, 96.

[60] James Goss and Rob Francis, producers, *Love Off-Air*, documentary feature on DVD, *Doctor Who: The Invasion* (London: British Broadcasting Corporation, 2006).

[61] See, Richard Molesworth, "BBC Archive Holdings," *Doctor Who Restoration Team*, 1997, http://www.purpleville.pwp.blueyonder.co.uk/rtwebsite/archive.htm (accessed 15 Oct 2008).

Chapter Two:
Digital Fandom Between Work and Text

Place some [books] over others? ...I simply couldn't do it. They all have the same immortal soul.
—Pérez-Reverte, The Club Dumas, p. 150

Wow, it was really brilliant! I have totally enjoyed it, the whole story, the whole interactions between the characters and the plot! You fabulously mixed all the little things from the canon and made your own story ...Your characters are very canon.
—pellamerethiel, comment on "Hubris"

It is near impossible to define the "text" of an ARG. Participants in the game must glean clues from scores—perhaps hundreds—of separate and seemingly unrelated areas. For example, in *The Lost Experience,* an ARG for the television program *Lost,* clues came in a variety of guises, including web pages, wikis, tangible books, and jigsaw puzzles. Only by connecting the proverbial dots could players create the whole of the game. In a traditional way of analyzing media, each of these "texts" would be considered whole and absolute: separate, yes; but linked by an imaginary network of connections.

In a converged culture, as Jenkins has shown, this form of transmediation is central to analyses of contemporary cult media, as it asserts new ways of examining traditionally conceived texts. His example of *The Matrix* functions as an exemplar for "the age of media convergence, [by] integrating multiple texts within a single medium."[1] *The Matrix* franchise consists of three blockbuster motion pictures, a straight-to-DVD animated volume, a number of Manga tomes, comics, a video game, a phenomenally large web presence, and a MMORPG (Massively Multiplayer Online Role Playing Game). The connections between these separate texts become a transmedi-

ated story, which "unfolds across multiple media platforms, with each new text making a distinctive and valuable contribution to the whole."[2]

For fans, of the type described by Pérez-Reverte in the above quotation, the extant media objects enjoyed can hold deep and meaningful truths. Yet, it's not just individual texts that hold meaning, but also vast intertextual networks of connected texts—some of which can be fan created in themselves. For example, as representative of a new form of interaction with texts, the second quotation inscribed at the head of this chapter comes from a comment on a piece of blog fan fiction. For readers of pellamerethiel's blog comment, many of these transmediated connections already do exist, thanks to the relationship between the blog fan fiction and the extant media object on which it is based. Traditional fan fiction is intertextual by its very nature: it exists as part of a larger corpus of works. Blog fan fiction, alternatively, offers a unique space to comment on, interpret, and acknowledge the object of their devotion. Blogs exist as ontologically whole but characteristically divided: They are constructed not just of the post but of the comments as well. Pellamerethiel's blog comment is situated in a singular location: both *part of* the fan fiction on the blog and *apart from* the fiction, it is both distinctive and elemental to the whole.

Furthermore, blogs are an integral part of ARGs: players of ARGs often post their findings on blogs, and blogs can also function as summaries of the game so far. Additionally, ARG Puppetmasters often hide or disguise clues in blog entries. Some blogs are ostensibly written by characters from ARG narratives, like in *The Lost Experience* or in U-Media's *Trope* (2006).[3] Thus, blogs also function as one component of the increasingly complex contemporary media environment.

In this chapter, I examine the nature of rewriting not as a revision, but as communal reimagining. I use a new reading of cultural critic Roland Barthes' essay "From Work to Text" to chart this rewriting as intra-textuality. In this piece, Barthes describes two different conceptions of textuality. On the one hand, he calls a "work" that which is "a fragment of substance, occupying a part of the space" of physical objects. The work is tangible, is able to be seen, and is complete and whole in and of itself. On the other hand, he describes the "text" as a "methodological field," an "activity of production" which "cannot stop...cutting across" works.[4] Put more concretely, the "work" is a tangible object, a physical entity, while a "text" is a series of

relationships, an intertextual web of meanings and connections *between* works.

A piece of blog fan fiction, as an example of an online "text" and as representative of larger issues in media studies, problematizes both of Barthes' delineations. Tellingly, Barthes himself indicates as such in "From Work to Text": on one page he alternately describes the text as "a new object," and yet also declares, "The Text is *not to be thought of as an object that can be computed*."[5] In this contradiction, Barthes calls the "text" both something that is tangible and specific, as well as something that cannot be pinned down or defined, something that cannot be "computed," or figured out. In fact, the blog most specifically represents a new form, one not described as either a "work" or a "text." It is not enough go "From Work to Text," but rather we must now look "between work and text." For media fans, blog fan fiction represents a new style of communication; for media studies scholars, a new type of digital document.

REWRITING THE MEDIA TEXT: DIGITAL FANDOM

But to begin, I should describe the ways I'm using the notion of fans and fan fiction in this book. In the past, fan fiction has been described as the writing of stories using characters and/or plot lines that have been created either by professional media producers or by other fans. In this conception of fan fiction, the fan, as a consumer of a media product, produces a new strand of a story that usually fits into the canon of the source text. A story "canon" is the complete fictional universe deemed (either by the fans or by the media creators) "authentic," or an accurate history of that story world. Cult television shows, which have an extensive back-story, often complicate issues of canonicity, because specific units of knowledge about a show might contradict other units of information (e.g., Spock is an only child in the original *Star Trek* series, but has a half-brother in the fifth film, *The Final Frontier*: the "canonicity" of Spock's sibling is thus in doubt for many fans). Fan fiction writers produce strands of the story that are not officially considered "canon," but that other fans can read as adjacent to canon; as "a work in progress," to use Busse and Hellekson's phrase.[6]

Fans are exemplars of a New Media Studies, as they rewrite versions of extant media objects not to revise them, but to reimagine them. I posit the

term "Digital Fandom" to examine fans through a new critical, cultural investigation of their online creations. Fans move and shape source extant media objects, appropriating and re-appropriating material in what Lev Manovich refers to as a remix culture.[7] Fans take advantage of what Jenkins notes about media characters: "once television characters enter into a broader circulation, intrude into our living rooms, pervade the fabric of our society, they belong to their audience and not simply to the artists who originated them."[8] But fans do not write in a vacuum. As Bacon-Smith has noted, fans write in order to be *read*, to be interpreted by a community.[9] By examining fan-created texts as key aspects in the formulation of active communities, Digital Fandom articulates a new way of conceiving of textual creation.

Digital Fandom builds on and contributes to the historical development of fan studies.[10] By studying fans, scholars found a way to discuss active reading and textual appreciation in a concrete way. Early fan scholars based their work on de Certeau's conception of tactical reading, which led to a scholarly understanding of fandom as an aspect of a popular consumption in a mediated society. By showing the communalization and activity of fans, early scholars dispelled the negative stereotypes of fans in popular culture, the portrayal of fandom as a pathological condition.[11] Another conception of active fandom came from Fiske's concept of the "producerly" text. For Fiske, the "producerly" text is one that opens itself up for audience engagement. With producerly texts, viewers can "construct narratives," produce their own meanings, and find their own values, but can still appreciate the construction of the text, the artificially created narrative.[12]

Fan studies, crucially, looks also at the socio-political dynamics of fandom, how fans create and re-create "social and cultural hierarchies…as a reflection and further manifestation of our social, cultural, and economic capital."[13] Taking off from work like Bourdieu's *Distinction*, fan studies looks at the fan community's hierarchical societies. Indeed, for this type of fan studies, scholars analyze the fan not merely as a "viewer," but also as an active participant in a complicated social structure. Hierarchy in fan communities, however, is not always clear-cut. Often, those at the "top" of the fan hierarchy are there because they either have "an active and knowledgeable" comprehension of the extant media object, or because they have a radically different view of the extant media object, one so distinctive and individual it reveals itself as an equal companion to the original.[14] Key here is the fan's reproduction, or representation, of the source text's canon. To know the most

arcane details from the extant media object, even if one changes those details in the fan fiction, is to be intimately tied with the object of devotion. Fans that can "quote whole sections" of a narrative are thus positioned higher on that hierarchy.[15]

Fan studies has recently charted and mapped fandom onto other realms of study. Using both empirical and theoretical research methodologies, fandom becomes a means to an end: "fandom is no longer only an object of study in and for itself…[it] aims to capture fundamental insights into modern life."[16] In other words, fan studies examines the relationship of fandom to areas of scholarly pursuit other than media studies, and the relation of fans to aspects of culture other than the popular.

My "Digital Fandom" approach to fan studies uses a critical analysis of fan texts via the mechanisms of their own textual production. In other words, I look at fan texts as unique exemplars of contemporary media theory. Antecedents to Digital Fandom are apparent in the literature already: for example, Kurt Lancaster's *Interacting with Babylon 5* is a close and critical read of the television show *Babylon 5* via its ancillary products. He makes it clear that *Interacting with Babylon 5* "is not an analysis of…subculture" but rather of a "generic process" by which "imaginary entertainment[s] can be perceived as sites of performance." Performance here is key: the fan texts perform a function for fans and fans perform their fandom for each other. Instead of analyzing the fans, however, Lancaster examines the text(s) of *Babylon 5*'s fandom for how the immerse experiences of "playing" with *Babylon 5* envelops fans in a media environment.[17]

Digital Fandom is perhaps most closely aligned with the fan studies that examine the relationship between fan communities and the Internet. For example, Baym focused on the interaction between technologies and practices of fan communities.[18] Jenkins and Hills, among others, have also taken this stance, and both illustrate how fans use the Internet and the World Wide Web to create texts. For example, in *Convergence Culture*, Jenkins illustrates how message boards and forums become knowledge communities that structure and organize the fans' knowledge about a particular text.[19] Hills describes how *X-Files* fans "have become increasingly enmeshed within the rhythms and temporalities of broadcasting, so that fans now go online to discuss new episodes immediately after the episode's transmission time—or even during ad-breaks."[20] Dialogue through forums and listservs create meaning for the members of the community separated from the meaning

contained (or read) within the extant media object. Deery examines the religiously themed shrines set up to "praise" (ironically) *The X-Files*.[21] Further, Boese's doctoral thesis about the Xenaverse (universe created about the television show *Xena: The Warrior Princess*) discovered that fan "texts construct a particular social culture" online.[22]

Furthermore, by looking at how fans cooperate with each other, Digital Fandom helps us examine a particular philosophy of playfulness that fans have in their interactions. This philosophy of playfulness lies at the heart of any fan interaction: examining fan-created texts as "imaginary entertainment" online is not enough. Digital Fandom not only looks at how fans produce new texts, but also how, in that process, they playfully reproduce old ones. This production-through-reproduction is perhaps best demonstrated by *Star Wars Uncut*, a remarkable online recreation of the first (chronologically) *Star Wars* film (*A New Hope*). Users of the site choose a fifteen-second clip from George Lucas's film, and then remake that fifteen-second clip in whichever style they would like. Some animate their clip using Lego toys. Others re-create the scene as closely as possible. At least one user has subtitled his one-year-old's babbling with dialogue from the Han Solo/Greedo Mos Eisley Cantina scene (and yes, Han shoots first). As the collection of user-generated clips grows, the creator of the site, Casey Pugh, reassembles them in their original filmic order, inserts the traditional *Star Wars* music, and creates anew a fan-made version of their favorite film.[23]

What is remarkable about the *Star Wars Uncut* project is not that individual fans are creating their own versions of *Star Wars*, but that a group of fans is. The fannish rewriting of *Star Wars* here takes on a completely different tenor from that described elsewhere by Jenkins. As Jenkins has described, individual fans have been rewriting filmic texts for well over half a century, in the forms of fanzines originally, and then in more and more complexity as the technology has improved and aided the fan work. *Star Wars* has been a perennial fan favorite, and fans embrace the web to take their fan productions public.[24] The fan process with *Star Wars Uncut*, however, is different. It's not an individual fan re-making a scene or a film for others to watch, but rather the entire community remaking the complete film for each other to watch.

What the existence and popularity of *Star Wars Uncut* means is that a re-evaluation of the way fan studies functions is necessary in order to fully understand the dramatic and dynamic process of fannish (re)production. This

process is also complicated in this case by the fact that, as Pugh states, the entire film will be available in multiple versions because different people can all remake different scenes:

> Multiple people are allowed to have a scene so that everyone can be a part of Star Wars: Uncut! A rating system is in the works to choose everyone's favorite version of each scene. Don't worry though- All scenes will be kept forever so that we can watch Star Wars a completely different way every time!

Rereading the text is never a singular event, but a continual process or rearticulation and reevaluation.

But Digital Fandom becomes a useful tool for examining *Star Wars Uncut* not because the fan community is creating something new, but rather because they're reproducing something they've already known: *Star Wars*. The ultimate goal with *Star Wars Uncut* is not to produce a new take on *Star Wars*, or to showcase individual talents at digital filmmaking (although both of those are appreciated within the individual fifteen-second clips). Rather, the ultimate goal is something Pugh intimates on his "rules" page: "Make sure the beginning and end of your scene matches up closely to the original." Pugh's ultimate goal, therefore, seems to be matching as "closely to the original" as possible, through matching action on the cuts and through the use of the original soundtrack. What Pugh wants is not a typical, traditional fan-created, unique vision of the *Star Wars* universe, the type described by Jenkins.[25] Rather, Pugh wants *Star Wars* as filtered through the fan community; a film seen through the eyes of its fans.

As I show throughout this book, Digital Fandom does not look at these fans as doing something entirely new, but rather looks at these fans in new ways. Fans both influence and are influenced by technology not just as tools but also as necessary and catalytic mechanisms to alter their subjective experiences of cultural life. Fans are techno-literate, liberating the experience of viewership through self-conscious knowledge about the technology of mediation. Fans use digital technology not only to create, to change, to appropriate, to poach, or to write, but also to share, to experience together, to become alive with community. Fans rewrite not just the extant media object, but also the state of media studies itself.

A Fan's "Work" Is Never Done

At the heart of New Media Studies lies the study of the relationship between audiences, texts, and productive/creative work. In this book, I am using the term "fan community" or "fandom" as a loose knit, but allied, group of people who all produce or create original documents based on extant media objects. Fan "work," the creation of fan fiction and fan texts, occupies a nebulous legal space, as many have noted.[26] In many ways, then, this conception of the fan community's productive ability resembles what de Certeau terms "perruque": labor undertaken and disguised as work for an employer. For example, a "perruque" worker might sneak into his employer's carpentry shop after hours with his own tools and materials to make his own chair. This worker steals nothing tangible (for nothing leaves the place of work), but instead uses the tools of others to complete work for him-/herself. He steals only from his own leisure time. This deliberately "non-productive" worker

> diverts time (not goods, since he uses only scraps) from the factory for work that is free, creative, and precisely not directed towards profit. In the very place where the machine he must serve reigns supreme, he cunningly takes pleasure in finding a way to create gratuitous products whose sole purpose is to signify his own capabilities through his *work* and to confirm his solidarity with other workers or his family through *spending* his time in this way....[They] use the tools and products taken from a language of social operations to set off a display of technical gadgets and thus arrange them, inert, on the margins of a system that itself remains intact.[27]

This economic system does little to stop the "perruque," for the simple reason that, as de Certeau shows, the system itself remains intact: the workers participating in "perruque"—just like the fan—have not, in and of themselves, damaged the economic system in which they find themselves. The key difference between the "perruque" and the fan, however, lies in the manner of construction: the "perruque" uses another's tools to construct a tangible good; the fan uses her own tools to construct what is often an intangible, digital work of creativity, a playful work deemed fun by the fan.

More recently, Axel Bruns extended the idea of this digital creativity to examine the nature of production in the digital age. Bruns developed the idea of the "produser," who

> highlights that within the communities which engage in the collaborative creation and extension of information and knowledge...the role of 'consumer' and even that

of 'end user' have long disappeared, and the distinctions between producers and users of content have faded into comparative insignificance.[28]

In other words, the produser is a digital perruque, producing digital goods with a near-professional quality. Defined as both a producer and a user of content, the produser has several characteristics similar to those that fans posses: the produser exists in a community of other produsers, is part of a participatory culture, and collaborates through "intercreativity."[29]

In many ways, then, produsage is integral to Digital Fandom. Key to both Bruns' and my argument is the shift in the nature of the digital product. Whereas once works of fan fiction, fan art, or any fan-created imaginative work inspired by an extant media object would have been *discrete* and *whole* works of original production akin to the materials used by de Certeau's perruque, the ubiquity of a digital-based creation and reception of media products has led to more fluid and distributed works of creative enterprise. Indeed, as I go on to argue throughout the book, this one key shift—from finished product to unfinished process—affects all aspects of the way scholars study fans, audiences, and the media.

The key aspects of this shift lies in the role of the consumptive object. Traditional media studies are based in broadcast-era concepts which use a market economy metaphor to analyze consumptive practices. They rely on the notion that there is a practical demand for an object: that at some point, the consumer will not have something he/she needs or wants and will be forced to buy it from a supplier. Underlying this notion is the assumption that there is a limited supply of media goods: once they are sold/gone, there are no more. In an age without VCRs, DVDs, TiVos, DVRs, BitTorrents or iPods, this metaphor makes sense. In a very real sense, if you missed an episode of *Gunsmoke*, or even the original *Star Trek*, it was gone—at least, in terms of quality, or until it was repeated, at the discretion of the TV distributor or network.

Thus, the consumption of the goods implies the destruction of the goods, as the term "consumption" implies the ultimate utilization of perishable commodities. In the digital environment, however, commodities/gifts are no longer tangible, but instead are infinitely reproducible. "Consumption" as a concept no longer applies. We can copy documents, email and transfer them, with no appreciable loss of quality or value. This shift in the ontological status of "objects" forces a renewed attention on scholarship of the media in

the digital age. Even when media goods became infinitely reproducible, when DVDs, VCRs and the like were invented and widespread, media producers worked from this assumption. For example, every television commercial that airs that urges you to "tune in at 9 pm" for the next episode of *Lost* is operating under the assumption that you can't or won't just go to your computer to download the episode immediately afterwards. The advertisement attempts to create a demand, to pretend that the media object of *Lost* will only be available at 9 pm. Because the television rating system still operates under the top-down measurement of *how many eyes are watching when a show airs*, media producers hope to create a desire—a need—for audiences to tune in.

This desire is related to the nature of the mediated text, one (mirrored in the ARG) which spans outlets and extends narratives across boundaries. The open-ended enigmas of shows like *Lost* (2004), *Battlestar Galactica* (2003), and *Doctor Who* (1963/2005) encourage returning viewers. The meaning of that show for the audience exists between what is revealed and what is eternally hidden, and exists not in any one place, but rather in the ethereal location in-between answer and question, in-between desire and the fulfillment of desire. This cultish desire, in a Lacanian sense, can never be entirely fulfilled in a cult narrative, for the cult show rarely resolves.[30] Fans attempt to fill in this ethereal space through the fulfillment of what Hills calls a "hyperdiegesis," an immense and immersive narrative structure.[31] Fan fiction becomes a way to complete a narrative, through a rewriting of the boundaries of the cult text canon.

To be sure, creators of the cult media television world structure the television show deliberately to garner these fan viewers.[32] Producers of cult media can construct and market these texts in a commodity economy: through the use of textual cues, the show can garner viewers, who then see advertisements on the show, and then (hopefully, to the media advertisers) buy those products. Yet, traditional studies of fandom "implicitly constitute 'resistance' as a condition inherent to fandom itself."[33] Scholars tend to perceive fans in a utopist "us vs. them" stance against media conglomerates. The consequence of this scholarly attention is to embody and implicitly condone the production/consumption metaphor. However, while media producers in the market economy function by selling products, fans often bypass this economy by sharing texts. As Benkler points out, users in contemporary digital culture tend to help others find a text of their own, often

acting outside of the mass-media environment to enact this commons-based communication.[34]

To rethink the production/consumption dialectic is to reposition existent scholarly conceptions, and to redefine old ways of thinking. It is not enough to look at fans anew, but we must also reexamine how we are looking at contemporary texts. While fan studies has evolved to follow the fan's producerly progress, it needs new concepts to explore the effect of interactive technology on fandom online, one in which fans aren't perceived on a production/consumption continuum, or even a production/usage continuum, but rather as members of a community that don't just produce content, but share, give, and develop content, and embrace the work of other fans.

BLOG INTRA-TEXT

As an integral component of ARGs and other interactive online content, blogs offer one type of text open to new scholarship. In popular discussion of blogs, the blog post itself is valued more highly than the comments. References to blogs tend to refer to the post by default (i.e., if I talk about a particular "blog," what goes unstated is the fact I'm referring to the post of that blog, not the blog as a whole). Yet, such determination slights the important function of the comments on the blog "text" itself.[35] In fact, even describing the blog using the word "text" here could be considered erroneous. In digital environments, "texts" can be made up of many different elements, each one wholly discrete and complete unto itself. The blog is not just a post, but is rather the combination of the post plus the comments (plus the multitudinous blog entries written over time). The "writer" of the blog is ultimately a group, not an individual. Importantly, for every digital document that the creator imbues with their own personal, unique stamp, there will always be contributions over which the owner has little to no control. Blogs, consequently, are never finished. They are in a constant state of revision and rewriting, as more and more comments contribute more and more information to the blog.

Using this concept of the blog as an exemplar, New Media Studies provides us with an understanding of new methods of analysis. I posit "intra-textuality" as one such method. In contrast to the traditional intertextuality, where meaning is uncovered *between* texts and "any text is the absorption and transformation of another," intra-textuality examines the meaning that occurs *inside* the transmediated text itself.[36] For Digital Fandom, this has

enormous consequences for the construction of blog fan fiction, as the fan fiction author writes on the blog not just to reference an original text, but also to playfully build a fan-community, a fandom, of other blog writers through agreeable, non-critical comments about a mutually shared media text.

The Blog: A Critical Understanding

The blog functions as a repository for continually updated writing.[37] Importantly, the physical proximity between the blog post and the blog comment allow us to see how both exist on the same page, spatially connected to each other. Lessig shows how "comments [are] an integral part of blogging," and thus by adding a way to talk back, blogs "changed how they were read."[38] Comments become a way for the blog to elicit feedback and participation by members of a community. One can imagine a blog post and comment connection: for example, a comment might correct a misspelling or suggest a change in phrasing, uniquely tying the comment to the post. In effect, the "blog," as an amalgam of post and comment, is therefore ultimately authored by both poster and commenter.

In traditional media studies, however, the blog would primarily be seen through the text and images in the post. The comments are generally considered extra-text at best, or superfluous at worst. There are a number of consequences if scholars refer to the blog post as the main aspect of the blog. The post, like a book or tract, is written by a particular author with a particular mental schema and in a particular context. As described by rhetorical scholars Carolyn Miller and Dawn Shepherd the blog genre is "a contemporary contribution to the art of the self," as the blog post contributes to an understanding of how conceptions of identity and of self are created and maintained.[39] In this view of blogs, blogs are essentially ego-driven diaries, or spaces for individual expression. Blogs are merely publicly visible documents that depict the personal and intimate writings of a subject. In this way, the blog post makes tangible (or, more precisely, digital) the "self-writing" as described by Foucault, who says that "to write is thus to 'show oneself', to project oneself into view, to make one's own face appear."[40] By externalizing thoughts into writing, blog post authors can literally write themselves into existence. For Internet critic Andrew Keen, this intimacy creates a problem with blogs: "everyone…is too busy ego casting [writing about themselves]…to listen to anyone else."[41]

Blogs have been examined from this standpoint since their inception. As spaces for a writer to promote his/her own agenda, as a publicly visible text for ego casting, blogs have traditionally been seen as a space for one person to voice an opinion. In this traditional view, the blog is like a diary, like a filtering service, a commonplace book, or a media monitoring service.[42] To describe the blog in this way, however, is to limit it: yet, other uses of blogs exist. For example, few scholars have discussed fiction writing on blogs, and even fewer blog researchers have discussed fan fiction writing.[43] Yet, to integrate the comments into our notion of the blog is to allow a new reading of ritual communication as it establishes a community.

The Blog in Theory

Equally, one could easily argue that a blog is simply a specific and personal type of web page, a fact most astute political candidates have embraced. For example, in his run up to the 2008 Presidential election, and later as President, Barack Obama and his campaign staff included blogs on his primary web page to detail Obama's "up-to-the-minute" results, and opinions from the mind of the candidate himself.[44] By positioning the blog prominently on his webpage, Obama indicated that readers of the site could get more details about his policies, about the electoral process, and perhaps most importantly, about the candidate himself. As John Killoran describes, while the web page is considered a site for personal development, the blog tends to gravitate towards civic engagement.[45] Thus, because Obama included a blog on his homepage, the entire site seems to become more community-based, more in turn with a civically-minded culture.

For fans, writing on blogs might be aligned with writing on forums, especially when it comes to fan fiction.[46] Forums are online bulletin-board-type systems that allow users to post an item to which other users can then comment. The key difference between the blog and the forum, however, is that any comments on a forum exist separate from the post itself (i.e., a reader must hyperlink between the post and the comment), while comments on a blog post are part of the same document.

Such a difference may seem to be small, but ultimately has major consequences. The blog creates a document that continually expands with each additional comment; a fan fiction forum, however, remains static, and only the comments' webpage changes. On the forum website, the posts and the comments remain separated, and thus, the "text" of a forum is always the

product of one particular author. A URL of a forum will point to that particular fiction post itself. For example, fanfiction.net/storyX directs solely to the fiction post. The post is static and thus, as long as that URL remains active, it will always point to that fiction, and only that fiction. For example, on www.fanfiction.net, 240 static fiction texts about *Battlestar Galactica* (the original series) have been posted by hundreds of individuals. One such story, "Battlestar Galactica 1980/1985 Finding Earth," details the exploration and eventual location of the mythic Planet Earth. However, in contrast to the blog, where the comments lay directly beneath the post, on this forum post there is only a hyperlink to the comment: it reads "Submit a Review" as part of a drop-down menu, to direct readers to post comments on a separate page.[47] Forums, by virtue of the different format, are not constructed in the same way as blogs. On a blog, although only one author may write the post, many additional voices can comment on the same webpage, creating a multi-layered, multi-authored document. For example, livejournal.com/storyY might direct to a document with both fiction and comment. While the fiction post itself may remain static, the comments may increase in number continually. Because blogs are one document, any change to the comments necessarily changes the blog.

The unique features of blog technology aid and guide the writing of fiction: namely, the fact that the blog encourages immediate communal responses encourages fiction writers to use it as source for feedback or revision.[48] Fan fiction scholar Rachel Shave also shows how fan fiction authors can revise their works based on the comments of the fan community online: "Occasionally inconsistencies are noticed, which the author has often chosen to incorporate into the story by rewriting earlier chapters."[49] Comments in any medium help fan fiction authors revise.

Thus, by juxtaposing a blog post with comments about that post, blogs spatially unite two disparate elements: the text and the discussion/criticism of that text. Blogs, in this view, are thus dependent upon the community of readers that form in and around them.[50] Crucially, then, blogging also functions as a community: as blog scholar Lovink states, "Bloggers need each other."[51] To post a blog online is to be aware that others might read your writing—and is to join in a community of other blog readers. To write fan fiction is also to write *fandom* fiction. In fact, by

seductively opening up their lives for scrutiny, one of the expectations of [blog] dia-
rists is not only meeting other people, but enlisting their active cooperation in the
creation of an inner circle, a small group of people gathered around certain charac-
teristics…a rivalry-free, ideal community of equals.[52]

Note here Serfaty's use of the metaphor of the "diary" for blog writing:
despite promoting the communal aspect of the blog as the most salient,
Serfaty still grants a priority to the post as the central aspect of the blog
document.

Roland Barthes' "From Work to Text"

In short, I believe the blog is a Barthesian multi-worked text: a mash-up, an
object with more than one component that retains the unique character of
each. There are, of course, antecedents to this form of textuality: footnotes
become similarly spatially connected to their requisite text.[53] However, there
is a fundamental change in the organization of blog elements as a feature of
the medium. Although the ontological distinction between *fiction* and *cri-
tique* remains, the timeliness/rapidity of the critique, along with the spatial
connection between the two, effectively produces a document that is funda-
mentally different in nature from a footnoted work. In the past, critiques
would have been diegetically separated from the object of that critique: the
author/critic relationship existed in time as well as space.[54] For example,
Barthes' own avant-garde *S/Z* includes footnotes which function like blog
comments, explaining the text for readers or elucidating the denser moments.
Now, however, critiques are part of, not apart from, the blog post itself.
Although traditional criticism interacts with the text in a manner similar to
modern blogs, a blog is qualitatively different in two respects: first, the
temporal rapidity of the comment and second, the function of the comment.

 First, the temporal swiftness of the comment on the post allows the blog
writer almost instantaneous feedback and critique on her work, and the blog
readers a view of a rapidly and visibly growing connection between many
fans. In the story "Seelix/Cally, Lubing the Viper," commenters
life_on_queen and lyssie leave three comments back and forth on the space
of the blog: the rapid pace of the commenting occurs within an hour of one
another on the blog fan fiction document as Life_on_queen first posts at 4:14
am, lyssie responds at 4:47 am, and life_on_queen writes back at 5:08 am.[55]
This interaction is telling: it's not just that life_on_queen debates the merits

of the fiction, but also that she seems to assert a communalization with her fellow blogger. "Dude," she writes, of the slash fiction, "I'm torn between applauding and tearing my frickin' eyes out." She enacts a certain playfulness with this comment, reaching out across the Internet to assert a value of connection: but this assertion is phrased playfully, as if to indicate a more lighthearted sentiment.

To comment on a blog is to assert not only that you have read the post, but also that you care enough about the post to *act* in some manner. The commenters cannot alter the text of the fiction post, nor can the writers of the fiction change a comment once it has been posted (unless it is their comment).[56] The rapidity of the comments indicates the fact that both commenters cared enough about each other and the blog itself to contribute to it. Both commenters and writers of fiction can change that blog document as a whole. The rewriting that occurs on a blog happens not because the fiction post is revised, but because the blog itself changes, is rewritten with each comment posting.

Second, the function of the blog comment qualitatively differs from the function of the annotated footnote. Footnotes, especially in works of literary criticism, tend to elucidate or explain the text to a reader.[57] Authors might read those critical footnotes later, and even respond in a future edition or reprint, but the conversation would be slow and ultimately the interaction stilted. Comments on a blog, however, are tangible links between the author of the blog post and the author of the blog comment: regardless of what is written, the mere act of comment asserts a connective relationship. The aforementioned conversation between life_on_queen and lyssie is indicative of this: we can see how their comments take the form of a conversation, rather than a textual critique, as life_on_queen and lyssie engage in a playful conversation about the blog post. Although it would not be difficult to imagine a comment which critiqued a work of blog fiction, can you imagine Barthes engaging in a communal discussion of *Sarrasine*, "Dude, I'm torn between applauding and tearing my frickin' eyes out. LOL"?

If annotations and critiques could originally have been analyzed as intertextually connected to the object of that critique, blog fan fiction thus invites a rereading of the theory of intertextuality because of its incongruous existence as both fictional and meta-critical work. The confluence of fiction and critique on one document indicates a reevaluation of the way we examine traditional textuality and intertextuality. The "meaning" of the blog

post—of any media text—is traditionally seen between it and the comments that are separated from it. Kristeva illustrates this separation through her language: "*inter*textuality and *trans*position" indicate "the text's constitutive state [as] one of motion."[58] Through a rewriting of how media scholars examine textuality, a revision in media studies can be undertaken.

THEORETICAL SHIFTS

Throughout literary theory, the term "text" has been used to describe different things. The most commonly used definition of text, at least in popular parlance, is that of something *read*, that is, a written document utilizing language and symbolic understanding with the intent of transmitting information from one place or source ("the author") to another ("the reader"). We can see this in a quotation from Russian literary scholar Sergei Gindin: "A text is a 'quantum' of communicative activity possessing relative autonomy (distinctness) and unity (integrity)."[59] For years, literary studies have had "a long history of fetishizing the text as a solitary, pristinely autonomous object."[60] Texts are commonly conceived of as printed or written documents. However, not all "texts" are written, and in the sense that a viewer watches a television show for symbols and the meaning that emerges from them, that show can also be considered a "text." Further, not all "texts" are unified or wholly autonomous. We have already seen how Barthes "creates a radically new [conception of] text," one made up of a "potential, indeterminate and loose" network of associations.[61] Thus, traditional media theory, which examines the blog post and the blog comments as separate components, uses the language of intertextuality.

Intertextuality, as a theoretical concept, emerges from the post-structuralist semiotic analyses of both Kristeva and Barthes in the late 1960s and early 1970s.[62] Julia Kristeva coined the term "intertextual" to describe the process of subconscious textual relationships: every text that is written is written with the knowledge and covert textuality of every other text written before. As she describes, "any text is constructed as a mosaic of quotations; any text is the absorption and transformation of another."[63] Further, Barthes's description of intertextuality examines texts not as discrete unites, "not [as] a line of words releasing a single 'theological' meaning," but rather as links in a chain of interrelated and interconnected meanings, "a multi-dimensional space in which a variety of writings," a "tissue of quotations drawn from the

innumerable centers of culture."[64] In sum, intertextuality is a thread inter-woven into the tapestry of all "texts," all other references and works, part of an intertextual web spanning the eons.

Thus, instead of focusing on the *author* as the consistent voice through-out textual analysis, intertextuality has

> revealed [that] a text is made of multiple writings, drawn from many cultures and entering into mutual relations of dialogue, parody, contestation, but there is one place where this multiplicity is focused and that place is the reader, not, as was hith-erto said, the author. The reader is the space on which all the quotations that make up a writing are inscribed without any of them being lost; a text's unity lies not in its origin but in its destination.[65]

Thus, a new intertextual theory of authorship emerges, one where "the logic regulating the [t]ext is not comprehensive…but metonymic; the activity of associations, contiguities, carryings-over coincides with a liberation of symbolic energy."[66] Any "truth" contained within a text comes not from the author, who is merely a name, an organizing principle behind a work, but from the plurality of voices of the readers, who establish a plurality of mean-ing.[67] Media critic Jonathan Gray in his intertextual analysis of the television show *The Simpsons* echoes Barthes when he says, "even a simple sentence requires a reading history to understand."[68] Any text is constructed not through any particular writing down or authorship, but rather in the space *between* the reader and the written. As Steven Johnson, Mittell, and Gray have all indicated, contemporary television media texts are becoming more akin to Barthesian intertexts, as cult television shows have started to spread out the "text" of the show across different media platforms.[69] The viewer moves across media to construct the narrative intertextually. In fact, we must look at a transmediated environment not just as a way of presenting narrative story, but also as a way of perceiving it as well. The reader moves between discursive texts, actively constructing the story.

The Blog Needs New Scholarship

Fan scholars use the theory of intertextuality to define the process of fans' moving between texts. However, an intra-textual redefinition of the media text changes the way we can look at how media entertainment is made. If we start to think of digital objects not as works or as texts, but rather as between them, then we can see how we need a redefinition of the theories we use to

analyze media—we need what William Merrin calls a "revision and updating" to media studies.[70] Just as for broadcast-era media we needed to look at entertainment through intertextuality rather than mere textuality, for digital era media we need to look at entertainment through an intra-textual analysis. Once it may have been possible to read a fictional work and never encounter a critique of that work. Now, however, blog fiction not only includes but also actively seeks critique and input. It is now nearly impossible not to encounter critiques on blogs as comments. As fan fiction writers write on a blog, they not only intertextually contribute to the ongoing discussion about the extant media object, but they also intra-textually construct that text itself through their own playful contributions.

NOTES

[1] Henry Jenkins, *Convergence Culture* (New York: New York University Press, 2006), 97.
[2] Ibid., 97–8.
[3] http://www.argn.com/2006/12/the_trouble_with_tropes/.
[4] Roland Barthes, "From Work to Text," in *Image-Music-Text*, trans. Stephen Heath (New York: Hill and Wang, 1977), 156–7.
[5] Ibid., 156, emphasis mine.
[6] Kristina Busse and Karen Hellekson, "Introduction: Work in Progress," in *Fan Fiction and Fan Communities in the Age of the Internet,* ed. Karen Hellekson and Kristina Busse (Jefferson, NC: McFarland and Co., 2006), 6.
[7] Lev Manovich, "What Comes After Remix?" 2007, http://www.manovich.net/DOCS/remix_2007_2.doc (accessed 03 Jan 2008), ¶1.
[8] Henry Jenkins, *Textual Poachers: Television Fans and Participatory Culture* (New York: Routledge, 1992), 279.
[9] Camile Bacon-Smith, *Enterprising Women: Television, Fandom and the Creation of Popular Myth* (Philadelphia: University of Pennsylvania Press, 1992), 57.
[10] Jonathan Gray, Cornel Sandvoss, and C. Lee Harrington, "Introduction: Why Study Fans?" in *Fandom: Identities and Communities in a Mediated World*, ed. Jonathan Gray, Cornel Sandvoss and C. Lee Harrington (New York: New York University Press, 2007), 3–9. The authors describe three "waves" of fan studies as three epistemological breaks in the discipline.
[11] Joli Jenson, "Fandom as Pathology: The Consequences of Characterization," in *The Adoring Audience*, ed. Lisa A. Lewis (London: Routledge, 1992), 27.
[12] John Fiske, *Reading the Popular* (New York: Routledge, 1989), 121. See, also, John Fiske, *Understanding Popular Culture* (New York: Routledge, 1989), 99; John Fiske, "The Cultural Economy of Fandom," in *The Adoring Audience*, ed. Lisa A. Lewis (London: Routledge, 1992); Cassandra Amesley, "How to Watch *Star Trek*," *Cultural Studies* 3, no. 3 (1989): 335, calls this "double-viewing."
[13] Gray, Sandvoss, and Harrington, 6.
[14] Charles Soukup, "Hitching a Ride on a Star: Celebrity, Fandom, and Identification on The World Wide Web," *Southern Communication Journal* 71, no. 4 (2006): 323, 327.

[15] Umberto Eco, "*Casablanca*: Cult Movies and Intertextual Collage," *SubStance* 47 (1984): 3.

[16] Gray, Sandvoss, and Harrington, 9.

[17] Kurt Lancaster, *Interacting with Babylon 5* (Austin: University of Texas Press, 2001), xxvii–xxviii.

[18] Nancy Baym, *Tune In, Log On: Soaps, Fandom, and Online Community* (London: Sage, 2000), 21.

[19] Jenkins, *Convergence*, 32–4.

[20] Hills, *Fan Cultures*, 178.

[21] June Deery, "TV.Com: Participatory Viewing on the Web," *The Journal of Popular Culture* 37, no. 2 (2003): 176.

[22] Christine Boese, "The Ballad of an Internet Nutball: Chaining Rhetorical Visions from the Margins of the Margins to the Mainstream in the Xenaverse," (PhD dissertation, Rensselaer Polytechnic Institute, 1997), http://www.nutball.com/dissertation/ (accessed 28 Aug 2008), ¶5.

[23] http://www.starwarsuncut.com; as of this writing, 814 of 1251 15-second clips have been completed.

[24] Jenkins, *Convergence,* 135–6.

[25] Ibid., 135–73.

[26] See, Rebecca Tushnet, "Copyright Law, Fan Practices, and the Rights of the Author," in *Fandom: Identities and Communities in a Mediated World*, ed. Jonathan Gray, Cornel Sandvoss and C. Lee Harrington (New York: New York University Press, 2007). See, also, Lawrence Lessig, *Free Culture: The Nature and Future of Creativity* (New York: Penguin, 2004); Lawrence Lessig, *Code: Version 2.0* (New York: Basic Books, 2006); Lawrence Lessig, *Remix: Making Art and Commerce Thrive in the Hybrid Economy* (New York: Penguin, 2008).

[27] Michel de Certeau, *The Practice of Everyday Life*, trans. Steven Randall (Berkeley: University of California Press, 1984), 25–6.

[28] Axel Bruns, *Blogs, Wikipedia, Second Life, and Beyond* (New York: Peter Lang, 2008), 2.

[29] Ibid., 16. "Intercreativity" is a term coined by Tim Berners-Lee the inventor of the World Wide Web, which means networked creativity: the way information communities collaborate to construct creative projects, like wikis (see http://intercreativity.com/?p=1).

[30] See, Slavoj Žižek, *Looking Awry: An Introduction to Jacques Lacan through Popular Culture* (Cambridge, MA: The MIT Press, 1991).

[31] Hills, *Fan Cultures,* 137.

[32] Sara Gwenllian-Jones, "Web Wars: Resistance, Online Fandom and Studio Censorship," in *Quality Popular Television*, ed. Mark Jancovich and James Lyons (London: BFI publishing, 2003), 166.

[33] Ibid., 163.

[34] Yochai Benkler, *The Wealth of Networks: How Social Production Transforms Markets and Freedom* (New Haven, CT: Yale University Press, 2006), 13.

[35] Andrew Sullivan, "Comments," *The Daily Dish*, 03 Mar 2008 http://andrewsullivan.theatlantic.com/the_daily_dish/2008/03/comments.html (accessed 05 Mar 2008), ¶2–3 writes about comments: "Most other blogs have them; they give readers a place to write and vent and discuss. No one has to read them." Sullivan notably does not allow comments on his blog, which forces a rhetorical question, is it a blog if there are no comments? In common parlance, the "blog" is a space for writing, not the way that space functions. However, for this chapter, I am defining the "blog" as a way of writing: the blog is text written for an online community to read. In this, even without allowing his readers to comment, Sullivan understands the fact the blog must deal with communities: "This

blog has become as much about you as me over the years." Even without comments, Sullivan intertextually (and passively) references the community of readers he has.

36 Julia Kristeva, "Word, Dialogue, Novel," in *Desire in Language: A Semiotic Approach to Literature and Art*, ed. Leon S. Roudiez, trans. Thomas Gora, Alice Jardine, and Leon S. Roudiez (New York: Columbia University Press, 1980), 66.

37 Rebecca Blood, "Weblogs: A History and Perspective," *Rebecca's Pocket*, 07 Sept 2000, http://www.rebeccablood.net/essays/weblog_history.html (accessed 23 Jan 2008).

38 Lessig, *Remix*, 59.

39 Carolyn Miller and Dawn Shepherd, "Blogging as Social Action: A Genre Analysis of the Weblog," in *Into the Blogosphere: Rhetoric, Community, and Culture of Weblogs*, ed. Laura Gurak, Smiljana Antonijevic, Laurie Johnson, Clancy Ratliff, and Jessica Reyman (Minneapolis: University of Minnesota Press, 2004), http://blog.lib.umn.edu/blogosphere/ (accessed 20 Jan 2008), ¶42; For more on blogs as texts, see Vincent W. Hevern, "Threaded Identity in Cyberspace: Weblogs & Positioning in the Dialogical Self," *Identity: An International Journal of Theory and Research* 4, no. 4 (2004): 324–31; David A. Huffaker and Sandra L. Calvert, "Gender, Identity, and Language Use in Teenage Blogs," *Journal of Computer-Mediated Communication* 10, no. 2 (2005), http://jcmc.indiana.edu/ vol10/issue2/huffaker.html (accessed 12 Dec 2007); and David Huffaker, "Teen Blogs Exposed: The Private Lives of Teens Made Public," (American Association for Advancement of Science, St. Louis, MO, 2006), http://www.soc.northwestern.edu/gradstudents/huffaker/papers/Huffaker-2006-AAAS-Teen_Blogs.pdf (accessed 20 June 2007).

40 Michel Foucault, "Self-Writing," in *Ethics: Subjectivity and Truth Vol 1*, ed. Paul Rabinow trans. Robert Hurley and Others (New York: The New Press, 1997), 216.

41 Andrew Keen, *The Cult of the Amateur* (New York: Random House, 2007), 34.

42 See, Miller and Shepherd; Viviane Serfaty, *The Mirror and the Veil: An Overview of American Online Diaries and Blogs* (Amsterdam: Rodopi, 2004).

43 With the notable exception of Angela Thomas, "Fictional Blogs," in *Use of Blogs (Digital Formations)*, ed. Axel Bruns and Joanne Jacobs (New York: Peter Lang, 2006).

44 Although many of the blog posts were written by staffers; see http://www.barakobama.com and http://my.barackobama.com/page/content/hqblog.

45 John B. Killoran, "Homepages, Blogs, and the Chronotopic Dimensions of Personal Civic (Dis)Engagement," in *Rhetorical Democracy: Discursive Practices of Civic Engagement*, ed. Gerard A. Hauser, Amy Grim, and the Rhetoric Society of America Conference (Mahwah, NJ: Lawrence Erlbaum Associates, 2003), 213.

46 See, for a definitive account, Rhiannon Bury, *Cyberspaces of Their Own: Female Fandoms Online* (New York: Peter Lang, 2005).

47 Firewolfe, "Battlestar Galactica 1980/1985 Finding Earth," *Fanfiction.net*, 20 Nov 2007, http://www.fanfiction.net/s/3777645/1/Battle_Star_Galactica_1980_1985 Finding Earth (accessed 30 Dec 2007); WHCnelson, Review of "Battlestar Galactica 1980/1985 Finding Earth," *Fanfiction.net*, 20 Nov 2007, http://www.fanfiction.net/r/3777645/ (accessed 30 Dec 2007).

48 Dennis Cooper, "This Is Not an Isolated Incident: An Introduction," in *Userlands: New Fiction from the Blogging Underground*, ed. Dennis Cooper (New York: Akashic Books, 2007), 12.

49 Rachel Shave, "Slash Fandom on the Internet, or Is the Carnival Over?" *Refractory* 6 http://blogs.arts.unimelb.edu.au/refractory/2004/06/17/slash-fandom-on-the-internet-or-is-the-carnival-over-rachel-shave/ (accessed 07 Oct 2008), ¶2.

50 See, Jill Walker Rettberg, *Blogging* (Cambridge, UK: Polity Press, 2008), 57.

51 Geert Lovink, *Zero Comments: Blogging and Critical Internet Culture* (New York: Routledge, 2008), 38.

52 Serfaty, 58.

53 See, for a fascinating study, Anthony Grafton, *The Footnote: A Curious History* (Cambridge, MA: Harvard University Press, 1999).

54 See, Shaun Moores, *Media/Theory* (London: Routledge, 2005), part I.

55 life_on_queen, comment on "Seelix/Cally, Lubing the Viper" (See, Appendix A).

56 Authors of posts can delete comments, although they rarely do.

57 Grafton, 6.

58 Kristeva, "Word," 66; quoted in Jonathan Gray, *Watching with The Simpsons: Television, Parody, and Intertextuality* (New York: Routledge, 2006), 27.

59 Sergei I. Gindin, "Contributions to Textlinguistics in the Soviet Union," in *Current Trends in Textlinguistics,* ed. Wolfgan U. Dressler (Berlin: de Gruyter, 1978), 261.

60 Gray, *Simpsons*, 19.

61 E. R. Harty, "Text, Context, Intertext," *Journal of Literary Studies* 1, no. 2 (1985): 4.

62 For texts that introduce intertextuality, see Julia Kristeva, "The Bounded Text," in *Desire in Language: A Semiotic Approach to Literature and Art,* ed. Leon S. Roudiez, trans. Thomas Gora, Alice Jardine and Leon S. Roudiez (New York: Columbia University Press, 1980); Kristeva, "Word"; Roland Barthes, "The Death of the Author," in *Image-Music-Text,* trans. by Stephen Heath (New York: Hill and Wang, 1977); Roland Barthes, "From Work"; Roland Barthes, "Theory of the Text," in *Untying the Text: A Post-Structuralist Reader,* ed. Robert Young, trans. Ian McLeod (London: Routledge, 1981). For texts that describe intertextuality, see Thaïs Morgan, "Is There an Intertext in This Text?: Literary and Interdisciplinary Approaches to Intertextuality," *American Journal of Semiotics* 3, no. 1 (1985); Graham Allen, *Intertextuality* (London: Routledge, 2000); Brian L. Ott and Cameron Walter, "Intertextuality: Interpretive Practice and Textual Strategy," *Critical Studies in Media Communication* 17, no. 4 (2000); Mary Orr, *Intertextuality* (London: Polity, 2003).

63 Kristeva, "Word," 66.

64 Barthes, "Death," 146.

65 Ibid., 148.

66 Barthes, "From Work," 158.

67 See, also, Michel Foucault, "What Is an Author?," in *Language, Counter-memory, Practice,* ed. and trans. Donald Bouchard and Sherry Simon (Ithaca, NY: Cornell University Press, 1977).

68 Gray, *Simpsons*, 21.

69 Steven Johnson, *Everything Bad Is Good For You* (New York: Riverside, 2005); Jason Mittell, "Narrative Complexity in Contemporary American Television," *The Velvet Light Trap* 58 (2006); Jonathan Gray, *Television Entertainment* (New York: Routledge, 2008); Jenkins, *Convergence*; see also Paul Booth, "Intermediality in Film and Internet: *Donnie Darko* and Issues of Narrative Substantiality," *Journal of Narrative Theory* 38, no. 3 (2008), and what I call "intermedia" narratives.

70 William Merrin, "Media Studies 2.0: Upgrading and Open-Sourcing the Discipline," *Interactions: Studies in Communication and Culture* 1, no. 1 (2009): 28.

Chapter Three

Intra-textuality and Battlestar Blogs

A reader is the total of all he's read, in addition to all the films and television he's seen. To the information supplied by the author he'll always add his own.

—Pérez-Reverte, The Club Dumas, p. 335

I also really enjoyed the way you transformed Sharon in this fic from passive to much more active. Even from a jail cell, you [sic] find a way to make her be more part of the action.

—millari, comment on "Hubris"

Pérez-Reverte discusses here the strange, dual nature of readers: both existent at the nexus of an intertextual web of the already-read and also shaping the stories as they are read. Media studies posit that such interactions occur every time someone picks up a book or turns on the television. To create or inscribe meaning is a major component of how we decode texts. Alternate Reality Games are no exception, but they offer a unique view of a more complicated media environment. Players of ARGs must always read between the texts offering clues, and must create the game from their own experiences of individual components linked together.

Much as Roland Barthes describe texts, each time we read an ARG—every time we sit down to experience some form of mediated entertainment or engage with media in some way—we bring to that experience the "already-read," the experience of a "text-between of another text."[1] Every text has a plurality of voices within it, interacting and speaking to each other. For example, I read *The Club Dumas* with all the knowledge given to me by other stories I've read, seen, experienced, or used. These are personal, indi-

vidual intertextual connections, and may be very different from yours, my wife's, or even Pérez-Reverte's connections to the story. In this way, no two readings of any work can *ever* be the same, for each reader automatically brings to the reading his/her own background and experiences.

Fans are no different from any other reader in the respect that they bring to the extant media object ideas, notions, thoughts, and experiences that shape their understanding of the narrative. However, fans also participate viscerally in this intertextuality through the writing of fan fiction. Fan fiction is, by definition, peripheral and ancillary to the primary extant media object. It functions as a text outside and apart from the extant text. Writing fan fiction not only gives fans a way to participate in the creation of new aspects of extant media objects, but also, as pointed out by Kaplan, helps fans interpret the extant media object itself.[2] We can see this most saliently represented in the second quotation that inscribes this chapter: millari leaves a comment on a blog fan fiction story that both references the blog post itself—"in this fic"—as well as intertextually connects to the extant media object of *Battlestar Galactica*, through a reference to Sharon's transformation from passive to active. The references that millari make create intertextual links between three different "texts": they help establish a connection between *Battlestar Galactica* the media product, *Battlestar Galactica* blog fan fiction, and her own comment about both.

Similarly, the ARG represents intertextuality writ large: there is no ARG without the intertextual functioning of the individual media texts. Players may experience each text as a whole, but the ARG itself can only be formed from the interpretation of the meaning that emerges from the combinatory power of all constituent texts. Thus, like the blogs in this chapter, the texts that make up the ARG are arenas of complex theoretical work. Intertextuality, by itself, is not adequate enough to describe the internal construction of individual ARG texts, nor enough to describe the blog. Simply put, I argue a new theoretical construction helps us to explain this complicated interaction: intra-textuality is a Barthesian tissue of connections that propels the reader deeper into a media object, as it connects aspects of the text to other aspects of that text.[3] Further, intra-textuality describes the relationship between aspects in any transmediated nararative, like ARGs or other distributed narratives. Whereas intertextuality exists *in-between* texts, intra-textuality implies *movement within a whole*. The US highway system is a good exam-

ple of this linguistic linkage: the interstates travel between states, while an intrastate highway connects towns within a single state.[4]

On the one hand, intertextuality is central to the web, as it emerges from the connections between fragments of narratives.[5] A fragmented narrative, like a distributed narrative, is a conception of serialized narrative form experienced in discrete units separated by time and space.[6] What holds a distributed narrative "together," what unites the disparate elements, is the desire for narrative unity or completeness. For example, fans of *The Matrix* narrative must piece together different narrative elements—a DVD, a film, a video game, a manga book—in order to understand the entire story, an experience from which active readers may derive pleasure.[7] On the other hand, an intra-textual sensibility comes from the interplay of elements within a larger document, self-referentiality instead of *exter*-referentiality.

In this chapter, I examine blog fan fiction based around the 2003 television remake of the show *Battlestar Galactica* to demonstrate intra-textuality. I use the concept of the carnivalesque to explore how intra-textuality permeates web interactions. While cultural scholars have used the concept of the carnivalesque before as a theoretical methodology, only rarely have they done so to describe digital technology.[8] One notable exception is fan scholar Rachel Shave, who uses Bakhtin's work with carnival to describe slash fan fiction.[9] Although Shave's article was the first to directly connect fan fiction and carnival, she does not examine fandom as a larger concept, nor does she examine the way that other New Media texts like ARGs have significantly altered theoretical conceptions in media studies. Thus, taking off from her work, I describe blog writing in relation to the carnivalesque, and aim in this chapter not only to articulate a new methodology for examining New Media texts, but also to re-examine the carnivalesque as a useful tool for media research.

BETWEEN INTERTEXTUALITY AND INTRA-TEXTUALITY

Intertextuality and intra-textuality both hinge on reconceptualizations of the definition of text. Intertextuality sees texts as spread out, open, and defined by the connections between discrete units. Intra-textuality, alternately, sees documents as complete, whole, and unified entities, defined by the connections within internal elements. Intertextuality is a useful tool for investigating

narratives that cross technologies of distribution channels. For example, Bennett and Woollacott's famous analysis of the James Bond meta-narrative considers the intertextual relationship between components within the Bond textual corpus. For Bennett and Woollacott, any reading of a James Bond work—be it movie, book, comic, toy or review—is a process by which the "inter-textually organized reader meets the inter-textually organized text…" as the work becomes "not the place where the business of culture is conducted," but rather the site "around which the pre-eminently social affair of the struggle for the production of meaning" occurs.[10] This study of James Bond, like the study *Batman* conducted fifteen years later by Brooker, cannot, by definition, be a textual analysis of any one source, but must exist as an intertextual analysis that spans multiple works, readerships and cultures.[11]

But this definition of intertextuality necessarily sees a fragmented narrative. Why is this the case? Why is a gap across technologies necessarily a fragmentation? If narratives are whole and complete, then can't we say that they are all intra-textually connected? Ultimately, these questions depend largely on how one defines "text." In the previous chapter, I showed how a "text" can be considered both whole and concrete, and itself a minute component of a larger intertextual system. Such definitions are not consistent across media studies. For example, Tulloch and Jenkins' analysis of science-fiction audiences also betrays a loose definition of both text and intertext. On the one hand, Tulloch interviews fans of *Doctor Who*, and uses the term "intertextuality" to refer to times when they comment not on the particular episode they are watching, but on other episodes in the series.[12] For example, he discusses the episode "The Monster of Peladon" in detail with the fans, but in reference to it, they often cite other episodes in the *Doctor Who* canon as comparison. If one considers each episode of *Doctor Who* a separate text, then Tulloch would be correct in calling this intertextual. On the other hand, if one looks at the *Doctor Who* corpus as a whole as a single complete narrative—as, indeed, many fans do—then this becomes not an intertextual cite, but rather an intra-textual one.[13] In this conception of the larger "text," each *Doctor Who* episode is one in a serial narrative, contributing pieces to a complete, existent cult story.[14] As Fairclough states, "The interpretation of inter-textual context is a matter of deciding which series a text belongs to."[15] *Doctor Who* "texts," therefore, can be seen as enacting both intertextuality and intra-textuality, depending on the way the viewer interprets the media content and the term "text." Therefore, if a body of media work can have

both inter- and intra-textuality, then the two terms are not mutually exclusive, are not dialectically defined, but are instead linked by a common approach to textuality as a fluid concept.

Indeed, both inter- and intra-textuality are based on conceptions that originated with the writings of Russian literary scholar Mikhail Bakhtin. As we saw in the last chapter, intertextuality came to English-speaking scholars through the works of Julia Kristeva and Roland Barthes. By incorporating Bakhtin's work with languages and Saussure's work with structuralism to her studies of textuality, Kristeva formulated the concept of "intertextuality," as we saw in the last chapter, as "a mosaic of quotations." Kristeva's definition first reads off of Saussure's scientific view of language as a system that can be analyzed distinct from the regional and cultural differences that make up language systems. Language is rational and systematic.[16] Kristeva contrasted Saussure with Bakhtin, who examined the way language grows organically. Specifically, Bakhtin re-evaluated communication to be inherently dialogic, or always created and spoken within culturally specific moments. Language doesn't exist in a vacuum, but must be studied within its cultural practices: no language exists apart from its speakers. Bakhtin himself wrote about Saussure: "one cannot say that [his] diagrams are false or that they do not correspond to certain aspects of reality. But when they are put forth as the actual whole of speech communication, they become a scientific fiction."[17] Language, for Bakhtin, is completely inseparable from the culture in which it is created, spoken, meant, and uttered.

As we've seen, there is both an inward (intra-) and an outward (inter-) movement when reading between texts. Similarly, Bakhtinian thought sees an outward force to language, the centrifugal, which describes the social and historical forces at play within each individual speech act; and an inward force, the centripetal, which unify the way we speak.[18] On the one hand, a language references, consciously or not, any and all languages that have come before, as speakers interpret from the range of their experiences. On the other hand, the forces that bind a language together, that cohere it, work through self-referentiality, through the internal construction of that language itself. And as it is for language, so too is it for media: the web is rife with both inter- and intra-textual media. For example, one common feature on blogs is the "trackback" function, which allows one post to refer, intertextually, to another post of which it makes reference. By clicking on the "trackback" link (also called the "linkback" or "pingback"), users can follow a

network of referencing links outward and beyond the confines of the blogosphere. But many blogs also feature links to other entries by the same author on the same blog: such "internal links" reference inward, towards more of the same blog. The "permalink" link on many blogs is a tangible representation of this: clicking on that link will take you the original page of the blog which featured that self-same permalink.

For fan studies, knowing inter- and intra-textuality can bolster analyses of fan fiction, whether on blogs, forums, or in print. Every piece of fan fiction on a blog exists between these two pulls—one connecting it to a larger corpus of work and the other building a more cohesive document. If Bakhtin's concept of heteroglossia may be a theoretical antecedent to intertextuality, then, a different Bakhtinian concept—that of the carnivalesque—leads to a productive discussion of intra-textuality. If we think of heteroglossia as one voice revealed as many, then the notion of the carnivalesque becomes many voices spoken as one.

THE NEW CARNIVAL

The carnivalesque most saliently deals with issues of collectivity and unification. A "carnival," in the sense that Bakhtin uses it, is a rambunctious festival, a Mardi Gras, in which the individuality of each participant becomes subsumed by the festival itself: for "Carnival is not a spectacle seen by the people; they live in it, and everyone participates because its very idea embraces all of the people."[19]

The theory of the carnivalesque becomes a useful tool for New Media scholars to analyze the blog. Individuals in a carnivalesque atmosphere subsume their identities, join a collectivity, and participate in a textual freedom. The carnivalesque represents a state of consciousness—a theoretical state problematically and ultimately unachievable by humankind—where the underprivileged and repressed subvert and overturn the socio-economic (and religious) hierarchies at the core of human society.[20] In this way, the carnivalesque encourages collectivity, although that collectivity must always be tempered by the concept of anonymity. In fact, as Kristeva says, any subject in a carnival is reduced to "nothingness," as the concept of hiding the self, of shrouding the face in a mask and embracing anonymity amongst the crowd, is enacted by all participants of carnival.[21] The mask is deliberately ambigu-

ous, and represents "the variety and flux of identities that otherwise, unmasked, are conceived as single and fixed."[22]

Although this is not the only reason carnival becomes a useful tool for examining blog fan fiction, it is an easy way to understand the underlying relationship between the two. For a blog, participants are often shrouded in anonymity, hidden by the mask of their screen name and their personal icon.[23] Each commenter can pick a unique name and a unique icon to represent themselves in the online community. Each icon, however, acts also as a mask, a "peculiar interrelation of reality and image," as each icon both masks a "real" fan and also displays an "image" of the fan to others. One consequence of this anonymity is that no one person dominates the carnivalesque, as "everybody makes carnival, everyone is carnival."[24] This collectivity implies an equal and non-hierarchical structure to the carnivalesque. Clark and Holquist thus describe the carnivalesque as "fundamentally opposed to all hierarchies in epistemology, all canons and dogmas."[25] Bakhtin scholars Morson and Emerson describe carnival as "a social ritual of pure antinomianism" and as the "joyful negation of everything."[26] Bakhtin himself describes it as "the suspension of all hierarchical rank, privileges, norms, and prohibitions," and "of all hierarchic differences, of all ranks and status."[27] In this sense, carnival is a hierarchy-free culture, which creates "a special type of communication ... permitting no distance between those who came in contact with each other."[28]

Ultimately, however, carnival does have an inherent hierarchy: specifically, it has a reverse hierarchy that subverts the official order through the inversion of social roles.[29] A reversal is, of course, not the same thing as a negation. Bakhtin's critics also recognize this, although they rarely mention the contradiction between non-hierarchy and reversal-hierarchy. Clark and Holquist also describe carnival as a "reverse hierarchy" in which there exists "a humbling, debunking, or debasing of whatever is lofty by the lowly."[30] Bakhtin further describes the carnival as a "travesty" that underscores "a reversal of the hierarchic levels: the jester was proclaimed king, a clownish abbot, bishop, or archbishop was elected at the 'feast of fools,' and...a mock pontiff was even chosen."[31] Dentith describes carnival as "the *inversion* and undoing of hierarchical or centripetal discourses."[32] In this description, it is not that social hierarchies do not exist, but rather it is more important to examine the inversion of these traditional hierarchies.

In examining blog fan fiction as a contemporary representation of the carnivalesque, therefore, we see a new form of quasi-hierarchical writing. On the one hand, blog comments lie beneath the post, and, as we have seen, readers generally consider the post more important. On the other hand, blog fan fiction comments often reverse this spatial hierarchy by refocusing the attention of the community onto the comments. The fiction post becomes an object upon which to comment, a reason for writers to post comments and for a community to form. Just like in the carnivalesque, where social hierarchies exist to be overturned, so too do the hierarchies that structure the blog fan fiction overturn traditional hierarchies of criticism and critique through intra-textual writing. In the following analysis I continue this line of thought by illustrating six tenets of intra-textuality to highlight the carnivalesque aspects of the blog. This analysis, of course, can be extended to encompass other forms of communal writing on the web, other types of digital authorship. Ultimately, just as the ARG stands as a metaphor for New Media Studies, the blog here can function as a metaphor for any type of communal writing.

WELCOME TO THE (DIGITAL) CARNIVAL

One of the few scholarly articles to focus on intra-textuality as a theoretical mode of analysis is Tom Brown's analysis of DVD menu features. For Brown, the DVD has heralded a new interactive cinema, where the many extra features on the DVD make it difficult to "extricate the film from the context in which it is presented."[33] Brown compares the modern-day DVD to the "cinema of attractions" in the past, which would often show off the capabilities of the then-novel cinematic medium.[34] Brown mirrors the description of extra-text as described by Brookey and Westerfelhaus: the inter-textual relationship between primary and secondary text on a DVD refocuses into an intra-textual relationship, one in which the intra-text serves the purposes of the producers of the DVD to rhetorically influence the viewer.[35] As Brown describes, the DVD is a New Media text that contains a number of distinctive features, all of which require a new type of analysis. Drawing on his article, I postulate the following six characteristics that scholars can use to analyze a text for its intra-textuality: Self-Reflexivity, Organization, Direct Address, Meta-Knowledge, Ludicity, and Recursive Expansion. I use examples from blog fan fiction written about *Battlestar Galactica* (2003). All of

these blog examples were found on the website LiveJournal. For a complete list of all blog posts, comments and authors, see Appendix A.

Self-Reflexivity

Self-reflexivity defines the specific, textual connection between one element and another in the document.[36] By this, I refer to the way an individual element in a blog can textually reference another: for instance, when a blog comment directly references the post, either by quoting it, referring to it via pronouns or other grammatical means, or identifying it by name or reference to content. By defining and then commenting on key elements in a blog, a comment about a post is, in fact, also a comment about the document as a whole. Posters may often comment on the fact of their posting by writing something like, "Sorry I haven't posted for awhile," self-reflexively creating a blog by describing the creation of that blog. Or, the comments of a blog might refer back to sections of that same blog. For example, a blog commenter might refer to the writing of the comment as content in the comment.

We can see this self-reflexivity in the interaction between cynthia_arrow and lyssie on lyssie's blog fan fiction story based on *Battlestar Galactica*, "Kara/Anders: Uninterrupted Routine."[37] On 28 Dec, cynthia_arrow writes,

> I really like the mood of this [story]. Of course, I'm always a fan of the playful vibe you keep with them [Kara/Anders], but always with this undertone of seriousness, sometimes with something lyrical threatening (just enough) to poke through, like that lovely note you ended on.

Cynthia_arrow begins by directly commenting on a part of the blog post ("...of this"). The "this" grammatically links back to the post, focusing the reader's attention away from the comment and reflecting back to the post itself. At the same time, cynthia_arrow also offers her own version of the events in that post, effectively rewriting the content of the post through a particular prescribed and determined fan-reading of the story. By directly stating how to read the story ("playful vibe"; "undertone of seriousness"; "something lyrical threatening"), or at least how to read particular elements within the story, cynthia_arrow creates a unique view of the post. But, importantly, she is not critical, but rather voices her comments in philosophy of playfulness with a ludic tone. Because the post and the comment are attached to the same document, the intra-textual connection between both coheres

these disparate elements together: it strengthens the fan fiction through self-reference.

Lyssie, author of the fiction post, responds to cynthia_arrow's comment a day later:

> Thank you =) Occasionally, I'm really sad that we didn't get to see Sam and Kara adjusting to married life. I like to think I'm pretty close to accurate in what we've seen—although I'm sure there was a lot more booze involved.

In their own way, both cynthia_arrow and lyssie rewrite lyssie's post, through a conditional fictionality. Conditional fictionality describes an aspect of the blog fan fiction that reflects a possible reading, a potentiality within the document as of yet unattained. This conditional fictionality becomes a rewriting that would take place, were she to change the post: "I'm sure," she says, "there was a lot more booze involved." If the story had been rewritten in practice, rather than in theory, the booze would have flowed more freely, perhaps. This self-reflexivity—both commenting on and contributing to the blog document—conditionally rewrites the post without changing it. The reader must keep two versions in her head at all times: the blog post and the blog post-with-comments. The existence of comments on fiction blogs highlights this sense of all-encompassing collectivity, as blog posts and commenters come together to jointly construct the blog.

We can see a different version of self-reflexivity in a comment on the slash story "Seelix/Cally Lubing the Viper."[38] In this comment, redscribe describes the way the story made her feel: "this is hot fic." By using the term "this," she semantically links her comment to the larger textual corpus: importantly, it's not "that" is a hot fic, but that "this" is. Through her comment, she not only intra-textually links to the same blog to which she contributes, but she is joining her own comment into the community that writes that blog. She is becoming part of the larger fandom involved in this blog.

Bakhtin's notion of the carnivalesque offers a unique insight into this self-reflexivity. The carnivalesque expresses a construction wherein everyone participates: a carnivalesque culture exists only through the relationships *intra* the carnivalesque culture itself.[39] Any personal input into carnival, any participation with carnival, is a construction of that carnival. Self-reflexivity is thus the most basic function of carnival, or of the blog: any contribution of individuals feeds into the collective whole. As Kristeva describes, in carnival

"the actor and the crowd are each in turn simultaneously subject and addressee of the discourse."[40] The blog actualizes this dichotomy.

Organization

A second characteristic of intra-textuality, organization, refers to the writer's proclamation of various components' positioning on a particular document. For example, the authors of a blog can construct the blog using its own organizational structure as content. Organization thus describes both to a reference as to where the document is located, and to a discussion of the location of aspects internal within the document. The blog enacts an intra-textual organizational listing through a discussion of the blog content's placement in a particular genre. In particular, fan fiction has always been organized by fans into particular genres: Bacon-Smith lists a number of them in her analysis of women fan authors.[41] What makes an interesting difference here is that contemporary blog fan fiction not only overtly states the *intended* genre before the post (most posts on LiveJournal are organized by the genre), but also states the genre within the comments of the blog itself, directly citing the genre as part of the content of the blog.

For example, in a comment to runawaynun, author of "Cylons, Shoes and Squirrels," projectjulie writes, "[I'm] "putting this on the masterlist despite its gen-ness."[42] What projectjulie means is that she is going to upload this piece of fiction and save it to a different site, one where it will reach a different community of fans. In this, projectjulie illustrates an *organization* of the fan text: it is worthy of being "on the masterlist," even though it is considered "gen." "Gen" means that the fiction is "general," or not romantic, slash, or in any way dealing with specific elements attributable to other types of fan fiction. In this, projectjulie organizes and classifies the blog while she contributes to it. The classification becomes the content of the blog. Another example from that same story further adds to the organizational content of the blog. In another comment, runawaynun writes a comment on her own story about the genre the story should be considered: "Donna/Tory is my Crossover OTP :D." A Crossover is a type of "alternate universe" story where characters from one show (in this case, *The West Wing*'s Donna) can show up in another show (in this case, *Battlestar Galactica*). OTP means "one true pairing," or a desirable relationship between characters. Runawaynun skillfully establishes how to read her story by including specific organizational elements that add to the blog at the same time.

We can see another example of organization in the story "Hubris, or the Downfall of Helena Cain, part 4 of 4."[43] Wyrdwritere, commenting on her own story, describes how she

> started writing this story for an AU [alternate universe, a genre of fan fic] community that wanted to use Helena Cain on occupied New Caprica. The community folded, but I finished the story anyway.

For wyrdwritere, the choice of where to place her story is important—how she categorizes it determines how the LiveJournal community will read it. She posts a comment not to explain where it "fits" in the canon, but rather where it "fits" in the organization of genres of fan fiction. By classifying the blog, wyrdwritere also builds the blog through an intra-textual connection between the blog content and the blog organization.

Organization is historically related to blogs. As pointed out by Blood in her excellent history of blogs, the original use of a blog was to keep an updated and updatable listing of interesting websites.[44] This list, the blog roll, was often organized thematically, with different genres of websites placed next to each other to create a blog intra-textually through its placement within a particular genre. We can see a similar type of emphasis on organization in Bakhtin's conception of the carnivalesque. As Bakhtin makes clear early in *Rabelais and His World*, the "carnival spirit offers the chance to have a new outlook on the world, to realize the *relative* nature of all that exists, and to enter a completely new *order* of things."[45] The carnival allows the participants to explore their culture from the outside looking in, to construct a new social organization by surveying and leveling the old. Similarly, there is no organization outside of carnival, and people in a carnival are "a whole ... organized in their own way."[46]

In the same way, the collectivity of the blog displaces the traditional hierarchies of the fan author/fan audience dichotomy, by normalizing all authors as blog authors. Although fans have always commented on each others' stories, now these comments can become part of the fan document itself. In terms of organization, this normalization has the effect of providing a neutral space for everyone to contribute. To determine the "space" of the blog post—to organize and classify the post—is also to organize and classify the community of people on LiveJournal that read and write to that post. As in carnival, blogs reverse traditional hierarchies (author/audience/text), and the ways in which a community organizes itself affects the way all are re-

lated. Through the intra-textual joining of the blog post with the blog comment, both fan writers not only rewrite the document, but also in that same act, reread the community to which that text belongs.

Direct Address

A third category of intra-textuality details the "meta-" moments in a document when the author of the work speaks to the viewer via a direct address.[47] Literary scholars have discussed such meta-narrative moments before, most notably in discussions of postmodern narratives. Meta-narratives highlight the constructed quality of a story, the artificiality of the text, by directly addressing the reader, often through the comments of an omniscient and third-person narrator into the action of the story By communicating "the representative nature of narrative," meta-narratives make visible and obvious the means of the narration.[48] By intruding in this way, the narrator makes obvious the narration, and the fact that what the reader is reading is itself a construction. In a blog, direct address is most easily visible through the authorial comments: an author of a fiction post, as we have seen with the examples of lyssie, runawaynun and wyrdwritere, can comment on her own fiction by adding to, commenting on, conditionally rewriting elements of, or even critiquing it.[49]

To see an example of some of these direct addresses, on the blog story "Four Times Lee Adama Almost Died (4/4)," the author of the blog entry helen_c directly addresses each of the comments she receives on the post. For example, she often comments on the comment itself: to suffolkgirl, who writes "The Apollo-Starbuck banter is pitch perfect, even if Kara is a hallucination. Lovely bittersweet tone to this one as well," helen_c writes, "Thank you! Glad you liked the banter." Yet, some of her comments also directly address the story: she finishes her comment, "most of the fic wrote itself."[50] But in directly addressing the audience for whom she writes, helen_c enacts a unique characteristic of New Media technologies—the ability of authors and readers to communicate nearly instantaneously with comments, criticisms or complements. This instantaneity is what makes such a difference from traditional footnoting or annotations: the speed of the response can be phenomenal.

Further, we can see this direct address most evidently in the blog when an author comments on a piece she has written. For example, as we have seen in the comments on "Cylons, Shoes and Squirrels," runawaynun adds

her own personal statement when she writes, "I <3 Tory shopping for a dress for Laura. Of course, there'd be lots of undressing and trying on and...."[51] With this comment, runawaynun provides a direct address to the reader, and through building the text with her own comment, also helps to develop the community of fan readers. Her choice of characterization, explained in this direct address comment, describes not only her interpretation of the source narrative, but also a way for others to read her own *Battlestar Galactica* narrative. Consequently, she intra-textually constructs the story both in her *fiction* text and also in her direct address comments, breaking through the discursive fourth wall to address the fan community.

In terms of Bakhtin, this direct address has antecedents as well in the carnival. The most important moment of carnival is the direct address of the mock king. The metaphorical crowning and decrowning of the mock king expresses for the people the transitory nature of hierarchy and power and represents "the joyful relativity of all structure and order, of all authority and all (hierarchical) position."[52] Through this process, this king becomes a symbol of the meaning of carnival. Importantly, however, the decrowning of the king functions precisely because it is a direct address to the carnival participants. The role of the king survives because he is inseparable from carnival—he is both part of and apart from carnival. By directly addressing the participants in his symbolic crowning/decrowning, the king becomes the focus of the carnival—far from existing "without footlights and without division into performers and spectators," the king *does* become a performer.[53] His very presence, the symbolic gesture of crowning/decrowning, focuses carnival on his role. He performs this gesture, or rather it is performed upon him, and with it, the carnival becomes complete. The king's decrowning is a direct address of the most spectacular kind.

Meta-Knowledge

A fourth characteristic of intra-textuality occurs when an author directly addresses the viewer to comment on and discuss elements in the text that have not yet occurred. To have meta-knowledge about a narrative, to quote sections that have not yet happened, is to reference the work intra-textually. Blog fiction writers enact a similar sense of meta-knowledge when they reference the source canon of the fan's extant media object. We have already seen this commitment to the canon in our discussion of intertextuality in Chapter Two. The canon becomes a universal referent, antecedent to the

piece of fan fiction that all fan readers understand. One cannot understand the blog fan fiction without at least some familiarity, some reference, to the extant media object's canon. The use of the canonical presents an interesting conception of the New Media document. To comment on the canonical authenticity of a blog fan fiction is to describe an intertextual relationship between the extant media object and elements in the blog document; however, to comment about canon in the blog itself is to construct intra-textually the blog document. Referencing canon both works centripetally, referring inward to the constituent understanding of the blog document, and centrifugally, referring outward to the external media object. We can see this reference to canonical authenticity in a comment by pellamerethiel on "Four Times Lee Adama Almost Died (4/4)."[54] Pellamerethiel begins her comment by referencing outward, to aspects of the extant media object:

> ...I'm in the biggest love with Lee and the whole Adamas story—the scenes with Apollo and his father always make me happy, cause they have so great and strong chemistry, cause they're having this true, yet very complicated relationship.

She continues her description and comment by then referencing *inward*, to the blog document itself:

> And all of these I've found in your fic—all these tiny pieces that make me love Adamas even more. I'm speechless, so let me quote my most favourite scenes [from the fiction post].

Pellamerethiel shows how blog fan fiction exists in constant tension between what is *outward*, the extant media object canon, and what is *inward*, the fiction in the document. The implicit dialogue between pellamerethiel and helen_c here points in two directions: it intertextually comments on the relationship between the fan fiction and the extant media object, and also intra-textually comments on the content of the blog document.

Other examples abound in blog fan fiction. For the slash story "Seelix/Cally: Lubing the Viper," fan author lyssie directly addresses her own story to comment on the relationship between the fan fiction and the canon of the "official" *Battlestar Galactica* text.[55] In the story, lyssie posits a lesbian relationship between two minor characters, Seelix and Cally, and describes how that sexual relationship might start. This relationship did not occur in the show (thus, it is not "canon") but lyssie picks up on minor

character traits throughout the series to write a fiction that is authentic to the feeling of the show. Specifically, she uses an implicit, repressed violence in the characters' personalities to represent the burgeoning sexual encounter. In her meta-knowledge comment, she writes, "I'd just rewatched [the episode] Exodus [sic], so Seelix's treatment of Cavil was very fresh on my mind...which meant that the violence was there too." By backing up her characterization in the fiction with assertions about the "official" text, lyssie creates knowledge based on canon, and builds that into the blog text as a whole.

In the same way, participants in carnival cannot act without an inherent understanding of the official culture which is effaced. Bakhtin describes the carnival as "dual-faced"; that is, it has what could be considered the "official" face, which "was turned to the past and sanctioned the existing order," but it also had the "face of the people of the market place [who] looked into the future and laughed." One face lies as part of the "protective, timeless stability," of tradition, while the other face challenges "the unchanging established order and ideology, and stresse[s] the element of change and renewal."[56] In the same way, Jenkins has described the "moral authority" of fans who feel that they know the extant media object just as well—or better—than the media producers. The effect of this is that "the ideology of fandom involves both a commitment to some degree of conformity to the original program materials, as well as a perceived right to evaluate the legitimacy of any use of those materials," including fan use.[57] Fan fiction thus comes from a history of balancing tradition with innovation, and blog fan fiction intra-textually recognizes through comments that reflexively establish canon while simultaneously freeing the fan-created fiction of canonicity.

Ludicity

A fifth element of intra-textuality Brown describes as a ludicity of content repetition.[58] Ludicity describes the playfulness of a text; the many ways that a Barthesian *jouissance* erupts from the text. By interacting and experiencing a text, readers help produce their own meanings within the prescribed structure of the text. Similarly, I have previously discussed the way the *Final Destination III* DVD self-identifies as a game to entice viewers to "play" with the text.[59] Fan fiction is itself a way of "playing" at professional writing, or playfully subverting the copyright of a commercial product for noncommercial fun. There is a playful irony—a wink wink/nudge nudge to the

reader—that blog fan fiction post authors utilize in their work. Blog fan fiction allows its authors to present their own work in a playful and self-deprecating way. Shave notes fan practices as playful: fan fiction

> critiques the performed heroic, stereotypical masculinity. It not only occurs in humorous and parodic pieces of fiction but it is also an intrinsic part of the discussion groups and the story disclaimers. These disclaimers acknowledge that copyright of the characters and universe belong elsewhere. The fans usually admit to ' playing' with the characters.[60]

We can see an example of this form of play in the way rowanjade playfully disclaims her own infringement upon *Battlestar Galactica*'s copyright with her story "They Took My Towel! And Other Furry Tails."[61] She writes:

> This is a Battlestar Galactica/Star Wars cross over. ... Yes, Tails is spelled correctly. Yes, I blatantly stole ideas from both Battlestar Galactica and Return of the Jedi and the Wraith Squadron [a series of *Star Wars* novels], please don't sue me for doing it. This is for amusement and nothing more.

Rowanjade understands copyright here ("I blatantly stole ideas") and the necessity for acknowledgment ("This is for amusement and nothing more"), but playfully skirts the issue of legality/illegality ("please don't sue me"). In another example, stargazercmc writes in response to lyssie's slash story "Seelix/Cally: Lubing the Viper," "Mmmmmm....Cally porn. Tasty." The playfulness with which stargazercmc professes her pleasure of the fan fiction reciprocally feeds back into the fiction itself, and subverts the "official" reading of *Battlestar Galactica.* Reading this comment bolsters the fan community's interest in the fan document itself, and contributes to a strengthening of stargazercmc and lyssie's communal connection. Further, the juxtaposition of the *Battlestar Galactica* and the pornography creates a knowing humor, making the fiction subversive. Sheepfairy echoes this comment about a week late:[62]

> Mmmm...porntastic! Seelix's violence towards the cylons, and how this whole thing is a build-up to her eventually becoming a pilot, is all just delicious icing on the amazingly sexy cake. It is hot and awesome and I kind of love you...

This type of comment demonstrates Carey's ritual communication: the community is built through experiencing and commenting on similar feelings about information and texts.[63] The playfulness of the language and the know-

ing comments function to bond members of the LiveJournal community through the shared experience of writing/reading fan fiction, and the shared, secret subversion of the copyright. Despite the fact these community authors write works for free that deliberately break the law, they feel entitled to do so through both Jenkins's moral economy and the willful look-the-other-way practices of the extant media object producers.

This ludicity mirrors one of the key components of the carnivalesque, the "ancient ritualistic practice of directing laughter."[64] A carnivalesque culture exists in opposition to more serious, traditional modes of hegemony. The laughter of the carnivalesque is a way of cohering a group: laughter attracts and presents the participants of the carnivalesque with a community. Indeed, Dentith shows that Bakhtin uses the carnivalesque as "a more socially unspecific notion of 'play'... [it] become[s] merely 'fun.'"[65] Importantly, this laughter is both subversive and supported. The carnivalesque is subversive by existing "outside of and contrary to all existing forms of the coercive socioeconomic and political organization."[66] At the same time, however, the carnivalesque festival is allowed to occur by this socioeconomic and political organization. The notion of the non-hierarchy simply reinforces the notion of the hierarchical outside of carnival. Eagleton describes carnival as

> so vivaciously celebrated that the necessary political criticism is almost too obvious to make. Carnival, after all, is a licensed affair in every sense, a permissible rupture of hegemony, a contained popular blow-off as disturbing and relatively ineffectual as any revolutionary work of art.[67]

Stallybrass and White follow suit: "Most politically thoughtful commentators wonder, like Eagleton, whether the 'licensed release' of carnival is not simply a form of social control of the low by the high and therefore serves the interests of that very official culture which it apparently opposes."[68] Other scholars describe the hegemonic control over carnival: both Lachmann and Averintsev show that one can only laugh in carnival when one has permission from officially supported culture to do so.[69] In all these views, carnival becomes a force of regeneration for official culture, not the dynamic break with it hypothesized by Bakhtin.

Fan fiction acts similarly: both slash fiction and carnival are subversive acts that are, or can be, supported by the same culture that is being subverted. On the one hand, fan fiction subverts traditional or dominant readings of media product by deliberately breaking copyright. For example, fans may

subvert the friendship between Kirk and Spock in *Star Trek* and reread it as a homosexual bond. Fan fiction authors may use copyrighted materials for their own creative work, deliberately subverting the political power of the established media oligarchy. On the other hand, media producers may also support this behavior, as it encourages fans to buy more products and spread knowledge about the media product by word-of-mouth advertising. As Pesce puts it, "there's a strong sense that [the] act of piracy…was unofficially encouraged," in order that media products get free and effective advertising.[70] As Shave shows, fan fiction ends up supporting hegemony "by providing these fans an outlet, which thereby prevents insurrection at a societal level."[71] Indeed, fan fiction can never truly be a threat to large media conglomerates—few fans read fan fiction *instead* of watching a TV show—and media producers could be said to passively support the minor copyright infringement. Indeed, this passive support of copyright infringement has, in at least two cases, benefited the corporations: with the TV shows *Battlestar Galactica* and *Doctor Who*, according to Pesce, the illegal downloading of the premiere episodes actually increased viewership, as the "piracy made it possible for 'word-of-mouth' to spread."[72]

Fan fiction needs an extant media object just as carnival needs an official culture for self-comparison. The "official culture" is necessary for fan culture: fans, as pointed out by Jenkins, need their fan-created texts to echo with and to support the extant media object.[73] Without that connection, they lose their "moral economy" over the text. This support becomes a part of the fiction, just as it is a part of the carnival.

Recursive Expansion

A final feature of intra-textuality is a particular recursive expansion of the document. By recursive expansion, I refer to the capacity of the digital document to feed back onto itself, in a dynamic reciprocity of information exchange. In this way, the document becomes a self-aggregating experience. For example, an email message can grow longer with each reply, as the text of the previous messages remains below the new text. The email grows through repetition of content, and as such, each email recursively expands. Similarly, on a blog, writers of comments will repeat text from the post as reference in their comment. In this way, elements of the document are repeated to build the document. As a document recursively expands, it creates a feedback loop, a citation system, where the repetition builds upon itself.

This recursive expansion mirrors another aspect of Bakhtin's notion of the carnivalesque: the grotesque, the "very act of becoming and growth, the eternal incomplete unfinished nature of being."[74] Carnival relishes the grotesque, takes pleasure in ever-expanding body that is "unfinished, outgrows itself, transgresses its own limits."[75] Just as a grotesque body continues to grow past its normal limits, to fatten with excess, so too does the carnival expand exponentially. The carnival grows to incorporate all.

Recursive expansion is, by definition, incomplete: it is a cycle with no end, a reference with no antecedent. Every time a document recursively expands, it expands but does not develop new content. There is no forward momentum to the text, but rather a turn inward, a reflexivity of the document back onto itself. As the blog grows and intra-textually connects to itself, it supports itself through its continually expanding comments. Theoretically, there is no limit to how large a blog could grow.

Fan fiction, as well, has a history of expansive growth. For example, Jenkins describes a fan novel by Leslie Fish titled *The Weight*, which runs "for 473 pages of small print and narrow margins."[76] This capacity of the digital document to feed back onto itself is displayed in comments that quote and track back to the original post. For example, in daybreak777's comment on helen_c's story "Four Times Lee Adama Almost Died (4/4)," we can see how the helen_c's story becomes fodder for the comment.[77] She writes, italicizing quotations from the post, *"How the hell would I know? I'm in your head, remember? Besides, you died once, so you should know*. Even in his head, Kara gives it to him straight. And helps him stay alive. Just like always." Further, pellamerethiel comments on "Four Times Lee Adama Almost Died (4/4)" by quoting directly (and liberally) from the blog post. She writes, "let me quote my most favourite scenes," and then uses three separate sections from the post to build her comment, finally concluding from all three that she has "saved it into my memories." Or in a comment on "Cylons, Shoes and Squirrels," runawaynun describes of her own story, "I <3 Tory shopping for a dress for Laura," summarizes exactly what happened in the post.

By rewriting the fan text in the comment, both daybreak777 and pellamerethiel recursively expand the blog by including verbiage and statements remixed from the original. Recursive expansion demonstrates the eternally unfinished nature of the blog: one can never finish a blog that continues to grow and expand inwardly. By including works from the blog fan fiction in

their comments, these fan commenters build the blog as they comment upon it.

INTRA-TEXTUALITY AND THE BLOG DOCUMENT

Fan fiction is a form of rewriting of the extant media object; not a revision, but literally a "writing-around" of different aspects of the cult fiction. Yet, in the process of rewriting, there is more than just a fan's input or work. Instead, it takes a community of fans all contributing communally to one project. By rewriting together, fan communities scribe their fandom into existence. But rewriting is not the end of fans' work. There is a deeper process at work in a New Mediated environment: one that involves not just the creation of new stories, but the rereading of these stories in new contexts and with new insights. For example, in Alternate Reality Games, it is not enough to write a summary of the texts on blogs or wikis: one must then go back and read anew the clues to try and solve the puzzles. Rewriting is not the end result of Digital Fandom, but rather the beginning. As we shall see in the next section, the second step is the group work of this online community, the rereading of New Media documents.

NOTES

[1] Roland Barthes, "From Work to Text," in *Image-Music-Text,* trans. Stephen Heath (New York: Hill and Wang, 1977), 160.

[2] Deborah Kaplan, "Construction of Character through Narrative," in *Fan Fiction and Fan Communities in the Age of the Internet*, ed. Karen Hellekson and Kristina Busse (Jefferson, NC: McFarland and Co., 2006), 136.

[3] For various uses of "intra-text," see Wayne Otto, Sandra White, and Kay Camperell, "Text Comprehension Research to Classroom Application: Developing an Instructional Technique," *Reading Psychology* 1, no. 3 (1980); R. Joseph Schork, "Acoustic Intratexts in *Aeneid* 7.122 and 4.408," *Classical Philology* 91, no. 1 (1996); Dan Shen and Dejin Xu, "Intratextuality, Extratextuality, Intertextuality: Unreliability in Autobiography versus Fiction," *Poetics Today* 28, no. 1 (2007); Raquel Cerdán and Eduardo Vidal-Abarca, "The Effects of Tasks on Integrating Information from Multiple Documents," *Journal of Educational Psychology* 100, no. 1 (2008).

[4] Why Hawaii would have interstates, however, remains a mystery.

[5] Barbara Warnick, *Rhetoric Online: Persuasion and Politics on the World Wide Web* (New York: Peter Lang, 2007), 119.

[6] Jill Walker, "Distributed Narratives: Telling Stories across Networks" (paper presented at AoIR 5.0, Brighton, 21 September 2004), http://huminf.uib.no/~jill/txt/AoIR-distributednarrative.pdf (accessed 01 Aug 2006), ¶1.

[7] Henry Jenkins, *Convergence Culture* (New York: New York University Press, 2006), 130.

[8] See, David Shepherd, ed., *Bakhtin: Carnival and Other Subjects: Selected Papers from the Fifth International Bakhtin Conference University of Manchester, July 1991* (Atlanta, GA: Rodopi, 1993), for uses of carnival in cultural studies.

[9] Rachel Shave, "Slash Fandom on the Internet, or Is the Carnival Over?" *Refractory* 6 http://blogs.arts.unimelb.edu.au/refractory/2004/06/17/slash-fandom-on-the-internet-or-is-the-carnival-over-rachel-shave/ (accessed 07 Oct 2008), ¶3.

[10] Tony Bennett and Janet Woollacott, *Bond and Beyond: The Political Career of a Popular Hero* (London: Macmillan, 1987), 56, 59–60.

[11] Will Brooker, *Batman Unmasked: Analyzing a Cultural Icon* (New York: Continuum, 2001).

[12] John Tulloch and Henry Jenkins, *Science Fiction Audiences* (London: Routledge, 1995), 136.

[13] Ibid., 134, my emphasis: "The discursive negotiation of the text of 'The Monster of Peladon' in this general studies interview occurs then via the ascription of its meaning to the *series of histories*: [specifically] the history of the *Doctor Who* series itself."

[14] Indeed, intertextual references specifically to Doctor Who are problematic in themselves, although Tulloch doesn't mention it: for most of the show, Doctor Who "episodes" were multi-part, broadcast over a period of weeks. Thus, to refer to "The Monster of Peladon" as "an episode" is actually a misnomer—it is rather composed of six episodes, broadcast over the course of a month and a half. See, Andrew Cartmel, *Through Time: An Unauthorized and Unofficial History of Doctor Who* (New York: Continuum, 2005), 208.

[15] Norman Fairclough, *Language and Power* (London: Longman, 1989), 152.

[16] Ferdinand de Saussure, *Course in General Linguistics*, ed. Charles Bally and Albert Sechehaye in collaboration with Albert Riedlinger, trans. Wade Baskin (New York: McGraw-Hill, 1966), 65–7, 119.

[17] Mikhail M. Bakhtin, "The Problem of Speech Genres," in *Speech Genres and Other Late Essays*, trans. Vern W. McGee (Austin: University of Texas Press, 1986), 68.

[18] Mikhail M. Bakhtin, "Discourse in the Novel," in *The Dialogic Imagination: Four Essays,* ed. Michael Holquist, trans. Caryl Emerson and Michael Holquist (Austin: University of Texas Press, 1981), 272. I do not mean to tie intertextuality or intra-textuality centripetal or the centrifugal forces; merely to indicate that a similar relationship exists for both.

[19] Mikhail M. Bakhtin, *Rabelais and His World*, trans. Hélène Iswolsky (Bloomington: Indiana University Press, 1984), 7. Carnival is useful for cultural studies: See, Paul Allen Miller, "The Otherness of History in Rabelais' Carnival and Juvenal's Satire, or Why Bakhtin Got It Right the First Time," in *Bakhtin and the Other*, ed. Peter Barta, Paul Allen Miller, Charles Platter, and David Shepherd (London: Routledge, 2001); Darren Webb, "Bakhtin at the Seaside: Utopia, Modernity and the Carnivalesque," *Theory, Culture & Society* 22, no. 3 (2005); Terry Eagleton, "Bakhtin, Schopenhauer, Kundera," in *Bakhtin and Cultural Theory*, ed. Ken Hirschkop and David Shepherd (Manchester, UK: Manchester University Press, 1989), 178. Eagleton asserts, "Few modern critical concepts have proved more fertile and suggestive, more productively polymorphous, than the Bakhtinian notion of carnival."

[20] This notion of carnival has been debated by critics such as Terry Eagleton, *Walter Benjamin, or Towards a Revolutionary Criticism,* (New York: Schocken Books, 1981), and Peter Stallybrass and Allon White, *The Politics and Poetics of Transgression* (Ithaca, NY: Cornel University Press, 1986). They show that carnival is supported by the powerful in order to offer a "release" to the populous.

[21] Julia Kristeva, "Word, Dialogue, Novel," in *Desire in Language: A Semiotic Approach to Literature and Art*, ed. Leon S. Roudiez, trans. Thomas Gora, Alice Jardine, and Leon S. Roudiez (New York: Columbia University Press, 1980), 78.

[22] Katerina Clark and Michael Holquist, *Mikhail Bakhtin* (Cambridge, MA: The Belknap Press of Harvard University Press, 1984), 302–4.

[23] rowanjade, raincitygirl, comments on "They Took My Towel…" (See, Appendix A).

[24] Clark and Holquist, 300.

[25] Ibid., 310.

[26] Gary Saul Morson and Caryl Emerson, *Mikhail Bakhtin: Creation of a Prosaics* (Stanford, CA: Stanford University Press, 1990), 92, 94.

[27] Bakhtin, *Rabelais*, 246.

[28] Ibid., 10.

[29] Simon Dentith, *Bakhtinian Thought: An Introductory Reader* (London: Routledge, 1995), 73.

[30] Clark and Holquist, 309.

[31] Bakhtin, *Rabelais*, 81.

[32] Dentith, 85.

[33] Tom Brown, "'The DVD of Attractions'?: *The Lion King* and the Digital Theme Park," *Convergence: The International Journal of Research into New Media Technologies* 13, no. 2 (2007), 170. Later, rewritten as a book chapter in James Bennett and Tom Brown, ed. *Film and Television after DVD* (London, UK: Routledge, 2008), 81–100.

[34] See, Tom Gunnning, "The Cinema of Attractions: Early Film, Its Spectator and the Avant-Garde," in *Early Film* ed. Thomas Elsaesser and Adam Barker (London: British Film Institute, 1989).

[35] Robert Brookey and Robert Westerfelhaus, "Hiding Homoeroticism in Plain View: The *Fight Club* DVD as Digital Closet," *Critical Studies in Media Communication* 19, no. 1 (2002), 23–4. See, also, Robert Brookey and Paul Booth, "Restricted Play: Synergy and the Limits of Interactivity in *The Lord of the Rings: Return of the King* Videogame," *Games and Culture* 1, no. 3 (2006) for a similar argument about video games and interactivity, and Paul Booth, "Mediating New Technology: The Realization of a Digital Intellect," *Nebula* 5, no. 1–2 (2008), 32–3.

[36] Brown, "DVD of Attractions," 171, 173.

[37] cynthia_arrow, comment on "Kara/Anders, Uninterrupted Routine"; lyssie, comment on "Kara/Anders, Uninterrupted Routine" (See, Appendix A).

[38] redscribe, comment on "Seelix/Cally, Lubing the Viper" (See, Appendix A).

[39] Bakhtin, *Rabelais*, 246; Kristeva, "Word," 78.

[40] Kristeva, "Bounded," 46.

[41] Camile Bacon-Smith, *Enterprising Women: Television, Fandom and the Creation of Popular Myth* (Philadelphia: University of Pennsylvania Press, 1992), 55. She describes the following types of fan fiction: Mary-Sue, Lay, Hurt-comfort, Relationship, and Slash. There can be many others; for example Henry Jenkins, *Textual Poachers: Television Fans and Participatory Culture* (New York: Routledge, 1992),162–180 describes 10 types of fan narrative extensions.

[42] projectjulie, comment on "blog:fan fiction stories:Cylons, Shoes and Squirrels"; runawaynun, "blog:fan fiction stories:Cylons, Shoes and Squirrels" (See, Appendix A).

[43] wyrdwritere, comment on "Hubris, or the Downfall of Helena Cain, part 4 of 4" (See, Appendix A).

[44] Rebecca Blood, "Weblogs: A History and Perspective," *Rebecca's Pocket,* 07 Sept 2000, http://www.rebeccablood.net/essays/weblog_history.html (accessed 23 Jan 2008).

[45] Bakhtin, *Rabelais*, 34, my emphasis.

[46] Ibid., 255.

[47] Brown, "DVD of Attractions," 175–6.

[48] Paul Cobley, *Narrative* (London: Routledge, 2001), 175.

49 In the blogs analyzed for this book, almost half of the comments (33 out of 70) were written by the author of the post (See, Appendix A).

50 helen_c, comment on "Four Times Lee Adama Almost Died (4/4)" (See, Appendix A).

51 In "netspeak," <3 symbolically represents a heart, which translates as "love," as in "I love the thought of Tory shopping for a dress for Laura."

52 Mikhail M. Bakhtin, *Problems of Dostoevsky's Poetics,* ed. and trans. Caryl Emerson (Minneapolis: University of Minnesota Press, 1984), 124.

53 Ibid., 122.

54 pellamerethiel, comment on "Four Times Lee Adama Almost Died (4/4)" (See, Appendix A).

55 lyssie, comment on "Seelix Cally: Lubing the Viper" (See, Appendix A).

56 Bakhtin, *Rabelais,* 81.

57 Henry Jenkins, "Star Trek Rerun, Reread, Rewritten: Fan Writing as Textual Poaching," in *Fans, Bloggers, and Gamers: Exploring Participatory Culture* (New York: New York University Press, 2006), 55.

58 Brown, "DVD of Attractions," 174.

59 Booth, "Mediating New Technology," 39–43.

60 Shave, ¶18.

61 rowanjade, "They Took My Towel! And Other Furry Tails...." (See, Appendix A).

62 sheepfairy, comment on "Seelix/Cally, Lubing the Viper" (See, Appendix A).

63 James Carey, "A Cultural Approach to Communication," in *Communication and Culture: Essays on Media and Society* (New York: Routledge, 1992), 18–19.

64 Bakhtin, *Problems,* 129.

65 Dentith, 84–5.

66 Bakhtin, *Rabelais,* 255.

67 Eagleton, *Walter Benjamin,* 148.

68 Stallybrass and White, 13.

69 See, Renate Lachmann, "Bakhtin and Carnival: Culture as Counter-Culture," *Critical Critique* 11 (1988); Sergei S. Averintsev, "Bakhtin and the Russian Attitude to Laugher," in *Bakhtin: Carnival and Other Subjects: Selected Papers from the Fifth International Bakhtin Conference University of Manchester, July 1991,* ed. David Shepherd (Atlanta, GA: Rodopi, 1993).

70 Mark Pesce, "Piracy is *Good?* New Models for the Distribution of Television Programming" (paper presented at the Australian Film Television and Radio School, Sydney, 06 May 2005), http://hyperreal.org/~mpesce/piracyisgood.pdf (accessed 04 Jan 2009), 3.

71 Shave, ¶22.

72 Pesce, ¶2–3.

73 Jenkins, "Star Trek," 54–7.

74 Bakhtin, *Rabelais,* 52.

75 Ibid., 26.

76 Jenkins, *Textual,* 177.

77 daybreak777, comment on "Four Times Lee Adama Almost Died (4/4)" (See, Appendix A).

Chapter Four

The Narrative Database and the Web Commons

The serial ... can become a cult both for a naïve audience and for a more sophisticated one.
—*Pérez-Reverte, The Club Dumas, p. 326*

Heroes Wiki is a reference site for NBC (http://www.nbc.com)'s popular sci-fi drama Heroes. Heroes Wiki currently has 2,348 articles. Come here for the latest information on the show and its characters.
—*Heroeswiki Main Page*

As Pérez-Reverte describes, serial narratives—that is, narratives whose plot continues across more than one episode or installment—can develop a cult following. The antique book collectors at the heart of Pérez-Reverte's *The Club Dumas* have, in their own way, become members of a cult that revere the novels of Alexandre Dumas by seeking out and venerating the serialized chapters of, e.g., *The Count of Monte Cristo*. Indeed, serialized narratives have been common in literature for hundreds of years, and even today, some authors make use of the serialized format to publish novels (Stephen King presented his *The Green Mile* in six installments, and other authors have published e-books in serial format).[1] One reason these serialized narratives create "cults" is that cult texts form open-ended narratives that focus on "a singular question or related set of questions."[2] Serial narratives are thus complex and involved: They require the concentration of the reader to piece together narrative events and plot elements inter- and intra-textually separated both by space and by time.

In many ways, the interaction players of an ARG have with the ARG text mirrors the relationship fans have with serialized television. Players of ARGs must watch or view as much of the ARG as possible in order to understand what is happening in the story: similarly, serialized television programs are often confusing for viewers who don't tune in each week. Additionally, ARG plots are often told over a prolonged period of time—often spanning months. For example, the first ARG, *The Beast*, ran for three months, while some games can last half a year or more. The plot of a serialized television show can be equally spread out—if not more so. ARGs, in fact, represent a contemporary serialization writ large, as the interactions with various components of the ARG do, in fact, quite literally serialize the experience of the game.

Other media formats have embraced serial story-telling as well, borrowing the format of the serial from literature. Radio has a well-established tradition of telling stories over many installments, as for example, many of today's serialized television soap operas originally premiered on the radio. Many early films—especially those aimed at children, who would return every week—would tell adventure stories as serials. For example, some of the earlier motion picture examples of the *Batman* franchise started life as serials in the cinema.

Contemporary prime time television is no exception: The narrative arc of a serialized television show does not end at the credits of each episode, but rather continues across and through each subsequent episode, building upon itself and generating a complex storyline.[3] As Mittell points out, contemporary prime-time television has embraced the serial form, in shows as generically diverse as *Lost* (science-fiction/mystery), *Desperate Housewives* (soap opera/mystery), *Arrested Development* (sitcom), *The Sopranos* (drama), *Six Feet Under* (drama/black comedy), *24* (action-adventure), and *Curb Your Enthusiasm* (comedy). Add to these show a batch of shows that premiered after Mittell's article, and we can see that the trend in contemporary narrative television storytelling seems to be moving towards seriality: *Heroes* (2006), *Dexter* (2006), *The Sara Conner Chronicles* (2007), *Fringe* (2008), *Dollhouse* (2009), and *Flashforward* (2009) to name a few. To describe more thoroughly the narrative structure of these complicated shows, Mittell describes a new category to analyze this particular facet of television storytelling, "narrative complexity," and uses it to measure the serialized plot within

an episodic television show: "a true aesthetic innovation unique to its medium."[4]

As a new way of examining television narrative, narrative complexity reconceptualizes television studies. However, contemporary scholars have done little work in determining how issues of television's narrative complexity translates to and manifests in online narratives. Fans of narratively complex television participate in turn in the creation of narratively complex digital documents based on those programs. In an age where "convergence" is the buzzword and television producers put more and more content online in the form of webisodes (mini-episodes that continue or advance a serialized plot[5]), extra-textual content, or special features, it is not enough to examine narrative complexity solely from the standpoint of television. For example, in the second quotation inscribing this chapter, the fan-creators behind the wiki for the cult television show *Heroes* detail the online collection, collation, and categorization of units of narrative information about the program. Fans quote *Heroes* on this wiki as "a completely furnished world," echoing Eco's discussion of cult texts as "part of the beliefs of a sect, a private world of their own."[6] Utilizing the communal authorship and collective intelligence of the fans of the show, the creators of *Heroeswiki* create a narratological compendium of "narratively complex" content. Many cult shows with "narrative complexity" have equally complicated fan-created wikis, replete with narrative information: the aforementioned *Heroeswiki* describes the show *Heroes*; *Lostpedia* examines *Lost*; the *Harry Potter* narrative has *harrypotter.wikia*; the *Doctor Who* narrative is at *tardis.wikia*; and the *Star Wars* narrative has the appropriately named "*Wookieepedia*." For Digital Fandom, these ExtantWikis exist as complex archives of narrative information.[7] For New Media Studies, wikis become an important technology leading to group collaboration, as we see most saliently with ARGs. Players of ARGs use wikis not only to compile information about the game they are playing, but also to work collectively at figuring out the puzzles. ExtantWikis force scholars to rethink traditional ways narrative is conceived online, and ask, how does "narrative complexity" work in on online space? How does the web facilitate this narrative construction? And with what theoretical concepts can we describe the creation of these wikis?

In this chapter, I continue my investigation of New Media Studies through an examination of the fan-created wiki as a narrative database. This narrative database is a reflection of a changed media environment, which

reconceptualizes narrative from a "chrono-logic" mode to an archival one.[8] Instead of representing "plot" through causality, fans represent it spatially, using the inherent hypertextuality of the web to create connections between narrative elements.[9] Each picture and caption on both *Heroeswiki* and *Lost-pedia* represents a link to another wiki-page, each page another index of narratological content of *Heroes*. Fans faithfully transcribe each narrative element from the show to the wiki. Further, the connections between events occur not just in the entry, but through the hyperlinks as well. To discuss this interactive shift in the understanding of narrative, I highlight the role of the audience in this online narrative (re)construction. Jumping off from work on wiki fandom undertaken by Jenkins, Baym, Hellekson, and Mittell, I examine wikis not solely as portals of information, but also as sites of fans' narrative (re)construction of a cult television program.[10]

REREADING THE FAN COMMUNITY: FROM FAN TO FANDOM

Wikis represent a critical shift in our understanding of online interactive texts, authors, and audiences, a change made salient through a reappraisal of our conception of the web. As Paul Levinson shows, the existence of wikis alters even our most traditional assumptions about knowledge and importance, as anyone who encounters Wikipedia while teaching undergraduate research methodologies will attest.[11] Yet, wikis can also engage with a variety of other topics, and is well-suited (and well-used) by fans as well. As fan studies has shown, one important way fans can engage with a cult television program is to rewrite it as fan fiction. As part of this, fan created fan fiction allows other fans to reread the show in a new way. Rereading is a critical aspect of the fan's online interaction with a media object.

Wikis offer a technology that not only challenges our notion of authorship and creativity, but also encourages new conceptions about readership and interpretation as well. Specifically, by rewriting *and* rereading the narrative text, fans playfully interact with the created world. Wikis offer a virtual sandbox within which fans can enact this philosophy of playfulness by playing with the narrative from a safe space, the comfort of the community. In this section, I examine the communal authorship and readership of online fan communities. After an examination of my conception of the "Web Com-

mons" as both an interactive and as a narratological tool, I define the wiki as an exemplar of a narratological change in New Media Studies.

WEB COMMONS

The term *Web Commons* characterizes not a shift in the technological development of the web, but rather a conceptual change in the ways scholars analyze the web. I derive the term "commons" from Lessig's description of the "creative commons."[12] I am not the first to articulate a connection between the web and the commons: Benkler also points out the close connection between the two.[13] However, in contrast to these other descriptions, I also highlight the commons in its relation to a different conception of the web: that of an informational portal.[14]

The Commons as Shared (Information) Resource

By using the term *Web Commons*, I indicate a connection between the web and the feudal commons: "a resource shared by a group of people that is subject to social dilemmas."[15] Hess and Ostrom define the commons as a social situation wherein groups of people work together to establish equitable and reasonable mores in order to participate in a system of communal ownership, governance, speech and/or development. Traditionally, three aspects make up a commons: collective action, meaning no one individual can make unilateral decisions; collective self-governance, in that all members of the commons can contribute to the mores of the group; and social capital, meaning, members of the commons must find value in being part of the commons.[16]

Customarily, we understand the commons metaphor in one of two ways. In "common-pool" commons, anyone can use the resources of the commons independently of external control: for example, air is common-pool, in that anyone can breathe it without paying for it. In a "common-property" commons, an external party (or the community within the commons) sets particular rules in order to establish order and stability within the commons. For example, anyone in an office might use the communal coffeemaker, but everyone must follow the communally-established rules and contribute supplies, funds, or other necessities for this common-property to function. The difference between common-property and common-pool can be summed up as the difference between a brick-and-mortar library and Project Guten-

berg.[17] Project Gutenberg is common-pool. All its "goods" are owner-free, and no one owns the intellectual property contained within the site.[18] A library, conversely, is common-property: while no individual has ownership over the books, and anyone with an address can be a member of the library, anyone who checks books out must subscribe to the prescribed rules of the library.[19]

The web is a unique entity that straddles the commons property/pool divide. On the one hand, the web is open and free. Anyone can use it and there are few rules to follow. The components needed to access the web may be necessary—a computer, a connection—but the actual web itself could be considered commons-pool.[20] My use of the web does not impinge on your use of the web: we cannot "use up" the web. On the other hand, there are a great many socially constructed and culturally supported norms for online communication that make the web seem more like common-property. Internet protocol helps define and delimit the standards by which people write and publish online. WWW inventor Tim Berners-Lee writes that "a consortium could help parties agree on how to work together."[21] His W3C established protocols and formats that are acceptable for online use. Thus, while the actual *use* of the web may be common-pool, the structure of the web can be seen as common-property. Indeed, official rules exist for online communication: as people are litigated for using MySpace to impersonate fictitious people, the standards and norms for legally acceptable online communication become more concrete.[22]

Fans also straddle this commons property/pool -divide. As we saw in the last chapter, fans who write fan fiction do so in a perilous position in-between subversion and support. In many ways, many fan fiction authors see the extant media object as common-pool, while some media producers see it as common-property—or even non-commons and proprietary. This struggle over textual property is what Jenkins describes as "one which has had to be actively fought or at least negotiated between fans and producers in almost every media fandom."[23] For example, while fans are aware of their infringement of copyright, some openly mock the copyright system through ludic comments and playful banter, and others take it more seriously. Yet, there is a contemporary recognition on the part of some media producers that the fans' use of the extant media object as common-pool might benefit the media company. As Anelli has shown in the cases of *Harry Potter* fan fiction, Warner Brothers tends to turn a blind eye to most forms of non-pornographic

fan fiction, as they see fan fiction working as free marketing for *Harry Potter*.[24]

The most salient factor of the Web Commons is the communalization and communal action it stimulates. Like the conception of the commons-as-land metaphor, the salient characteristic of the "Web Commons," is that "no single person has exclusive control over the use and disposition of any particular resource in the commons."[25] However, the key resource of the Web Commons is information, and characteristics of the Web Commons include collaboration over information, communal ownership of information, and the freedom from economic concerns over information.

Thus, two non-mutually exclusive practices exist online, not as different technologies or tools, but rather as different conceptions of the web's usage. For these conceptions, Carey's delineation between the transmission view of communication and the ritual view of communication proves a useful translation to the web.[26] In the Information Web, the web is conceptualized as a vast, hypertextually connected remediation of print and broadcasting.[27] The Information Web is ultimately static and non-interactive: users can read the websites, but cannot interact with them. Users look at web pages and browse through links in order to find information or answer questions. In this transmission view of communication, Carey argues that the goal is the movement of information: the transportation of a message across space. The Information Web is thus a type of research tool. If I want to find out who starred in *Citizen Kane*, for example, I can log on to the Internet Movie Database (imdb) and look it up, just as if I were looking in a reference book in the library. Users can stay logged on for a long time, and can even interact with others to find out information, but the ultimate goal of the user with the Information Web has more to do with retrieval than socialization.

The Web Commons marks an alternate conception of the web, one that Carey might describe as not "the extension of messages in space but ... the maintenance of society in time; not the act of imparting information but the representation of shared beliefs."[28] This "ritual" view of communication represents the sociality of the web, the way in which users of the web log on to chat, to play games with others, or to communicate to other people about what Carey calls "a particular view of the world."[29] For example, if I want not just to look up who played Kane in *Kane*, but also to discuss the intricacies of that portrayal with other *Kane* fans, I can click on the imdb link to the "user comments" and follow the conversations as they occur, contributing

where I may be knowledgeable and learning what I may not know. Communication as a form of dialogue or shared meaning is key here, as the use of the Web Commons informs social practices.

Importantly, people use the web—just as they have used any communication technology—for both transmission and ritual communicative purposes at the same time. The Information Web and the Web Commons work together—they have always worked together. The Information Web and the Web Commons exist in tandem. To conceptualize this, think of the web as a library. On the one hand, if you walk though a library you will see scores of individual cubicles. You can think of these cubicles as static, Information Web portals. Walking past, you can see what the person is doing, but unless you are very rude (a troll?) or want to copy off people's work (a hacker?) you cannot actually change anything. Now walk past the cubicles and see the large table in the center of the library—around the table sit dozens of people all working on one project. Input is communal and interactive. The community may input your opinions into that project as you walk by. This is the Web Commons, and it exists, must exist, with the Information Web. One does not develop from the other; no more than the Bakhtinian centripetal forces develop from centrifugal forces, or intra-textuality develops from intertextuality. It is also entirely possible for someone to enact both types of communication style online at the same time. This difference is *not* technologically dependent, but rather represents two mutually dependent practices on the web.

Web Commons vs. Web 2.0

In contrast, other recent conceptions of web communality have focused on a technological change in the web. The most salient example in popular memory is the term "Web 2.0," a problematic term for some media scholars.[30] For publisher Tim O'Reilly who coined the term, "Web 2.0" defines the way that the web has evolved from a technologically static medium to a dynamic one. In the "Web 1.0" world, he notes, the key to accessing the Internet was the browser—Netscape, Internet Explorer, Safari, Opera, etc.—that was contained on the user's desktop.[31] This browser could access the Internet, but by virtue of the fact it was proprietary software, users were beholden to the design of the product. The browser window, quite literally akin to Burke's terministic screens, "necessarily directs the attention" of the user "into some channels rather than others."[32] What this means is that the way we use tech-

nology colors our interpretation of what we see in that technology. For O'Reilly, when browsers are given "control over standards for displaying content and applications in the browser, they "give Netscape the kind of market power enjoyed by Microsoft in the PC market."[33] His argument concludes that we would eventually only see what Netscape wanted us to see.

For the "Web 2.0" world, however, O'Reilly presents a key piece of software: Google, the online application/web tool that operates as a web portal/search engine to the rest of the web. For O'Reilly, Google is a technological innovation, located "in the space between browser and search engine and destination content server, as an enabler or middleman between the user and his or her online experience."[34] Google, a free, easy-to-use, and constantly updatable application that anyone online can access and use, is, for O'Reilly, the shepherd of a new technological revolution, one in which the key commodity is not a *product* but *access to a product*.

O'Reilly falls prey to a key fallacy here: that is, Google is still viewed in a browser.[35] O'Reilly creates false dichotomy: Google is not really equivalent to Netscape, any more than *The Tempest* is equivalent to The Globe Theatre. One can be a part of the other, but either can exist without the other as well. O'Reilly may have charted a change in the way we use a specific technology, but that it is this technology that we still use. Nevertheless, in the popular lexicon, "Web 2.0" has come to mean a change in the way people use the web, and the way companies create their websites. Central to these changes is the ability of users to control their own data with the introduction of new technology. This technology, Ajax, allows real-time interaction with websites as it functions like a buffer that improves the speed of data transfer.[36]

Ultimately, "Web 2.0," seen through the terministic screens of Google and Ajax, describes a paradigm shift in technology via technology. While useful for describing a change in the way the web works, what the conceptual difference between "Web 1.0" and "Web 2.0" lacks is a description of how we work in the web. For O'Reilly, the shift from "Web 1.0" to "Web 2.0" has been *chronologic* and *technologic*: that is, "Web 2.0" is a technological improvement on "Web 1.0" because it is a new technology, and therefore, the way people use the web is changing. However, elements of "Web 1.0" and "Web 2.0" exist side-by-side, and have always done so. And to describe user-generated content as unique to "Web 2.0" is to ignore a history of user-made websites, many of them fan-based, since the early days of the Internet. Fans,

as we have seen, have embraced the Internet from the start—even the "Web 1.0" days—and have generated content and community since the Internet became public.

Contemporary web usage is no different: fans just use different tools. Wikis represent one form of technology that both impacts and is impacted by society usage. Specifically, fan communities interact in many and varied ways with wikis, most notably through rereading other fans' creative works. Wikis provide fans with a technology to match their creative communalization of cult television shows. As we have seen, Mittell's "narrative complexity" is a heuristic device we can use to guide our discussion of these shows; however, a new conception of complex narrative form emerges in the Web Commons, the narrative database. For an examination of the narrative database, "narrative complexity" is not the end point, but the beginning. Because the story elements of the extant media object transmediate between episodes of television, the sense of narrative complexity that emerges in the extant media object exists intra-textually between the complex episodes, and "demands an active and attentive process of comprehension" on the part of fans.[37] To meet this demand, fans "extend their participation in these rich storyworlds beyond the one-way flow of traditional television viewing, extending the metaverses of complex narrative creations."[38] In other words, fans employ a series of practices to attend to and to develop an understanding and knowledge about the serialized extant media object.

NARRATIVE DATABASE

By forging digital links within the narrative chain of the cult serial, fan wiki writers turn a linear story into a multi-accessed archive of narrative material. In contrast to Manovich, who decries that, in the realm of New Media, the "database and narrative are natural enemies," I argue that the fan-created ExtantWiki actually unites the two.[39] What Manovich calls the database is a collection of unordered information, easily accessible, from which users can pull various entries to assemble a linear narrative. For example, think of an archive of all the shots from a digital film collected in a non-linear editing program like iMovie or Final Cut Pro. Manovich's database is the entire collection of digitized clips. The narrative is the assemblage of the clips into a cohesive order in the timeline. The narrative database, however, differs from this in that the collection of information, created by the community,

orders the narrative through communal interaction. It's not the same as taking units from a random archive, but rather of reassembling units in a new order. However, "order" itself may be an erroneous word in this instance, as it implies a fixture, a set of static coordinates; on a wiki, however, these coordinates are never stable, never fixed, and never completely orderable.

Further, Manovich argues that the database is a technology while a narrative is merely a linear structure. For Manovich, a database is a set of unordered episodes and narrative is causal. In contrast, ExtantWikis are databases with organizational principles which offer a non-traditional view of narrative as a lattice of linked narrative events. The process by which fans enact this form of rereading occurs through a communally-narrated story; that is, through an interaction between themselves and the wiki, fans extract narrative elements from an extant media object, create a separate wiki-page for each one, and then rewrite that narrative in a different form by linking wiki-pages via hyperlinks. Wikis are user-generated archives, which other users can read, add to, change, add pictures or links, revert to an older form, or even delete entirely. Any edits themselves remain online, stored in a document accessible by hyperlinks. Clicking any edit will bring up the history of that change, and what the page was before that edit was enacted. Fans use this wiki technology to archive knowledge about the extant media object and collate it into one online location.

ExtantWikis employ a sense of narrative as separated, but connected, units of knowledge. Wikis as fan-created narratives rely on the rewriting of the extant media story as a form of fan synopsis, and then, crucially, on a rereading of that story as fan-authored discourse. Fans, therefore, redefine the boundaries of "narrative," as they create and re-create the serial cult narrative in a new form.

Narratological Definitions

It would be useful to spend some time discussing precisely what I mean by "narrative." The delineation and study of narrative is termed "narratology," a word coined by Russian formalist Tzvetan Todorov to describe the scientific study of narrative structure.[40] By asking the question "what is narrative composed of?," narratologists attempt to explain the inner workings of the theory of narrative, to detail the attempt to organize events into a cohesive structure. Many theories of narrative and of narratology exist; for, as O'Neill has shown, scholars have discussed the concept of narrative in "something

close to epidemic proportions"—that is, "intellectual control of the field as a whole increasingly exceeds the grasp of any particular practitioner."[41] O'Neill wrote this in 1994, and in the time after his writing, much more has been added to the study of narrative: for example, Ryan has shown that digital technology has lead to a change in the discussion of narrative and narrative theory.[42] Thus, while the study of narrative hinges on a number of technical and obtuse definitions of theoretical concepts, for the sake of clarity I will lay out the narratological terminology I use throughout the rest of this book. Although my analysis centers on these definitions, scholarly literature sees different terminology for many of these terms. I articulate mine here for ease of reading.

I define "narrative" as *a community's sum total of knowledge, about, on and/or of a world.* Key to separating my definition from the scores of other definitions lies in the term "knowledge." I differ my definition from Scholes and Kellogg's classic definition of narrative:

> By narrative we mean all those literary works which are distinguished by two characteristics: the presence of a story and a story-teller. ...For writing to be narrative no more and no less than a teller and a tale are required.[43]

Whereas most traditional definitions of narrative indicate the separation of the telling and the tale, in some variation or another, mine highlights a mash-up of the two. I show that narrative within the Web Commons can be conceived differently: not as a story told through discourse, but as a series of communally described and linked events. To "read" a story online is to recognize and reconstruct it, to create new readings of the narrative elements every time.

"Narrative elements" are those elements within a narrative that can be readily identified. For example, a character is a narrative element, as is a location, an event, a particular conflict, a motif, a theme, a prop or any number of things within that narrative world. Narrative elements become visible through "narrative events," which are actions that occur within a narrative that invoke or involve some change of state, and marks a divide between what came before and what comes after. The "story" is the narrative events as they exist ethereally, as non-narrated. In other words, the story is the tale that is told as it resides in the mind of the reader. Conversely, the "discourse" signifies the way that the story is told, the narration that describes and places an external order on the elements within the tale.[44] The discourse is shaped

by the narrator, who describes the narrative events through the structure of plot.

"Plot" describes the relation between narrative. Chatman further refines this discussion of plot, by delineating two types. "Kernels" are those events that are central to the story: a kernel "advances the plot by raising and satisfying questions." Satellites, conversely, are minor story events "not crucial … [which] can be deleted without disturbing the logic of the plot."[45] Importantly, Chatman does not delineate exactly who outlines this kernel/satellite distinction. Some events may be considered crucial by all—for instance, Hamlet's murder of Polonius is crucial for advancing the plot—but others are more vague. What about Ophelia's drowning? Is that crucial for the plot, and does that not depend on how the audience constructs what the story of *Hamlet* would be? The narrative database, as we will see, escapes this concern by putting the audience squarely in the center of the narrative construction, and the kernels and satellites thus become differentiated from each other by audience involvement, not authorial intent.

NARRATIVE WIKI:
A CRITICAL UNDERSTANDING

The narrative wiki is an interactive text, forged through the Web Commons concepts of cooperation and collaboration, and acts as an archontic text in which fans collect narrative information—kernels and satellites, texts and paratexts[46]—about the extant media object. Much theoretical work on the interactive potential of wikis can be gleaned from the research of Pierre Lévy, for whom the web represents a form of "collective intelligence" and offers fans a community in which to explore information communally.[47] In Lévy's view of collective intelligence, all humans contribute to a collection of humanity's knowledge. On wikis, this is made explicit by variously editing, reworking, changing, or adapting online knowledge spaces. Wikis are collective intelligence writ large, both as examples of mediated sociality on the web and as online repositories of information. From ongoing debates about the Wikipedia's usefulness, to recent forays into wiki's social usage, many fan scholars have begun to examine the function of this *interactive* view of knowledge production in society.[48] However, few have viewed wikis critically as exemplars of a new narrative formation.

Computer programmer Ward Cunningham invented the wiki as a way of digitally consolidating the knowledge of many computer programmers separated by distance and time.[49] The wiki is an ultimately content-less technology, which as we have seen, does not

> even host the content that it enables users to find. Much like a phone call, which happens not just on the phones at either end of the call, but on the network in between, [content-less technology] happens ... between the user and his or her online experience.[50]

Wiki software forms a metaphorical shell around the space for content, and provides the tools necessary for any user, with any level of technical expertise, to input textual and visual content. The wiki functions, as pointed out by digital scholar Eyal Oren, in three ways: the *authoring* potential of the wiki is a way for fast community interaction, the *retrieval* potential means that anything archived on the wiki is likely recoverable, and the *navigation* potential means that the information is stored in a easily accessible, easily navigable encyclopedia format.[51]

Indeed, interactivity and the socialization that comes with it are two of the most salient features of wikis, and important aspects of the Web Commons. Even if a single author starts a wiki, that wiki functions through the interactive potential and actualization of the community that reads and writes on it. The wiki records each member's interaction with the wiki, and files the collaboration with the community that contribute to the wiki. Perhaps the best-known wiki, Wikipedia, houses a massive self-regulated online database on which thousands of people have contributed encyclopedic entries about millions of topics. In fact, as of January 2010, contributors have written over 14 million articles. Each of these articles, accessible to anyone with an Internet connection, can also be *changed* by anyone with an Internet connection.

Each Wikipedia entry exists as a document in temporal flux: at any moment the content of a page can be altered, negated, updated or even removed. As we saw in the previous chapter, this grotesque growth does not limit the ability of the media scholar to analyze the wiki "text," but rather forces a reconceptualization of the manner of that analysis. Benkler describes this communal creation, this "collaborate authorship," as the creation of elaborate structures of mediation online where groups of disparate individuals come together to create representations of their world.[52]

THE NARRATIVE DATABASE IN THEORY

The discussion of how interactive technology changes narrative form is not new. Janet Murray, for example, discusses new digital narrative forms, although she does not describe wikis specifically. Over a decade ago, she argued that digital forms of television would be remediated onto the computer, and that viewers would be able to log online and watch "a complete digital library of a series," which she calls a "hyperserial." [53] To her credit, sites like Hulu or Netflix have realized this hyperserial form, as they allow users to stream television programs directly to the computer. The narrative database combines Murray's concept of hyperseriality with Oren's description of the wiki not to remediate content, but rather to reimagine it in a new space, constructed by a fan-community. Narrative scholar Marie-Laure Ryan describes how digital narrative "can take a variety of shapes."[54] Narrative form, in other words, is mutable.

By archiving the narrative elements from the cult serial, fans both parse apart the television program by separating out the narrative elements, and reconstruct the show's story, through the fan-created discourse of the community of fan writers. Fans tend to take their ExtantWiki seriously: at the top of the *Lostpedia* main page, someone has written (as if from Dante's *Inferno*, warning travelers to Abandon Hope, all ye who enter here) "Information contained within this article must reference its sources. If not, it will be deleted."[55] This attention to detail is further reinforced by the encyclopedic quality of this fan-created wiki for the television show *Lost*.[56] Each narrative element in this index links to a new wiki page, each of which the fan-community has collectively written.

The hypertextual links between each of these items in the index, and within each entry itself, connects narrative elements hypertextually, in the same way the plot connects narrative events causally. For example, on the *Lostpedia* page for the character "Sawyer," fans re-create the narrative of the character named Sawyer by collating information from different episodes of the show, and then rewriting them on the wiki document. Fans can then reread Sawyer's "story" as a new form of narrative.[57] Each element of narrative information in the wiki-page—"James Ford, better known by the alias 'Sawyer',"... "known to the DHARMA Initiative as Jim LaFluer"..."was one of the middle section survivors of Oceanic Flight 815..."—comes from different episodes of the show. But when combined and collated into the

archive, the show's story has been reread as a new discourse by the community of fans on the ExtantWiki.

For fans, the power of the wiki comes not solely from the interactive potential of the text, but also from the narrative potential of the community, made salient and efficient with the Web Commons. Each link in the wiki entry for Sawyer—"DHARMA Initiative," "middle section survivors," "Oceanic Flight 815," etc.—hypertextually connects to another narrative element in the wiki. This intuitive link bridges a connection between these elements, recreating connections made on *Lost* the television show, which may have depicted these connections as plot elements (how is Sawyer connected to the DHARMA Initiative again?) in different ways.

Thus, a narrative database hinges on the interrelated relationship between the audience, the narrative, the story, and the narrator. Traditionally, narratologists define a narrative as the existence of events and the re-telling of those events as ontologically separate components.[58] Often, what these narratologists leave out is the role of the audience in narrative formation. For example, Chatman separates narrative into two timeframes, writing,

> each narrative has two parts: a story (*histoire*), the content or chain of events (actions, happening) … and a discourse (*discours*), that is, the expression, the means by which the content is communicated.[59]

Chatman describes this is a "chrono-logic," that is, a doubly temporal system, where two chronologies (the time it takes to tell the narrative and the timeframe within the narrative itself) integrate to produce the temporal flow of the narrative.[60] Traditionally, therefore, narratology examines narrative boundaries and limitations.[61] The boundaries of traditionally conceived narrative illustrate how the audience constructs the narrative story from aspects of the narrative discourse. Both, in some way, limit the way authors can write narratives and audiences can perceive them. The study of narratives determines the components of narrative in the same way as Saussure determined the components of language: as *parole* is to *langue*, so too is *signifier* to *signified*, and *discourse* is to *story*. The narrative database, however, emerges from a reconceptualization of the way the story and the discourse function as a digital archive, which, as Derrida shows, is "never closed. It opens out of the future."[62] Narratives on wikis are boundless.

Thus, traditionally a "narrative" can be thought of in one of two ways: as narrative events as seemingly already existent, or as narrative events filtered

through the presence of an external narrator. For example, to recount an event to a friend is to narrativize real-world events and to put them in an order. We may tell the events chronologically—i.e., the order in which they occurred—or we may tell them "out of order." To recount a narrative "story" is to summarize actual events, and for the audience to reconstruct them mentally in chronological order. For example, the events that take place in *Citizen Kane* form the story of *Kane*: the diegetic chronology starts with Kane learning he will inherent money and ends with the burning of Rosebud. Although Welles depicts these events in a different order, the audience's active reconstruction of the chronology within the film world becomes the story.

Narrative discourse, alternatively, examines a story presented through a narration, a device of presentation which already determines for the reader the order they audience will experience the narrative events. Discourse evokes the sense of the events passively experienced, mimetically reproduced in a different temporal order, and not as events in and of themselves: "the temporal features of reality *as experienced* are found in the temporalizing activity of human beings ... [as] narrative."[63] To view this aspect of narrative is to view it as a verb, as another's reconstruction of an already extant series of events. To reiterate our *Citizen Kane* example, the discourse of *Kane* represents Welles' scenic order: The film opens with Kane's death, then cuts to a newsreel of Kane's life, which is being watched by those that are investigating his death. The discourse represents the events as told by a narrator (in this case, Welles), and reproduced for an audience, experienced in a particular order.

THEORETICAL SHIFTS

Narrative elements that do not "appear" in the discourse can "appear" in the story: for example, although the character Alvar Hanso does not, as of the fifth season, specifically appear in the television show *Lost*, he has a presence in the diegetic world of the story as the director of the Hanso Foundation. The characters on the show describe his biography, and although his presence has been noted, he does not, as such, exist in the discourse.[64] He does, however, seem to have a presence in the story: as a character in the ExtantWiki narrative database of *Lost*.[65] His profile has as much information

as do many of the other characters who have actually appeared (in person) on the show. Indeed, there's even a picture depicting him.

As Herman describes, there is thus an inherent illogic in this type of story/discourse divide: if Hanso does not appear in the discourse, they would argue, how would viewers know that he is in the story?[66] Something in the discourse cannot by definition be excluded from the story. Indeed, as Richard Walsh states in the conclusion of his argument, "fabula [story] is not independent of any sujet [discourse]—it is entirely dependent upon sujet, is nothing other than the permutation and assimilation of sujet features into an ongoing interpretative version."[67] Thus, the story becomes nothing more than the audience's reconstruction of the events in the discourse: the discourse, however, seemingly depicts this already-reconstructed story. Phenomenologically, this is true: Hanso is in the story and the discourse because he is mentioned in the discourse. Yet, the character's visage never appears onscreen, nor does he interact with other characters in the show. Essentially, his "presence" is an audience's reconstruction of pieces of narrative information that has been scattered within the show *Lost* since episode one. However, the audience's reconstruction of the story elements on the ExtantWiki make Hanso a discursive character, tied to various others. This act of the reconstruction of narrative elements thus lies at the heart of the narrative database.

The Narrative Database

New Media Studies can emphasize this divide between story and discourse not by ignoring the paradox between the two, but by absorbing and creating a new narratological concept that exceeds and disturbs the interaction between the story and the discourse. This also occurs every time players of ARGs reassemble clues, or fans construct knowledge on wikis. If the main thrust of the traditional narratological argument has been the disassociation of the discourse and the story, then contemporary analyses of digital narratives need to examine discourse and story as integral components of a mashed up third form. Digital narrative scholar Carlos Duarte de Sena Caires describes how the creation of an "interactive narrative" will be "essential" for the development of computers, technology and culture.[68] To this extent, ExtantWiki disassociate discourse and story and rely on the serialization of narrative complexity and communalization of fans. Audiences rewrite narratives on ExtantWikis, and reread those narratives as a new, interactive discourse.

The wiki, as the storehouse of a narrative database, becomes one way fans can restructure narrative form to accomplish an active audience-centric reading of the cult serial narrative. In this form of fan writing, fans do not participate in the creation of fiction by rewriting an extant media object, but rather re-create it through rereading the already-written. To envisage narrative as a database is to grant salience to an understanding of narrative not just as an activity or process, but also as a *place*, as an environment upon which meaning can be inlayed. A traditional narrative is temporally connected by plot: the causal association between events. A narrative database, instead, forms from the complex interaction of the audience with the serial narrative, not via an external narrator, but through the connections made by members of the fan community. A narrative database emerges from the sense of cult television narratives as "exotic and ethereal fictional worlds to which the alchemy of textual data and imagination transports the reader, facilitating a pleasurable psychic sense of 'being there' as the action unfolds."[69] The more detail available about the complex cult world, "the denser and more comprehensive it becomes. It assumes the familiar complexity of the material world, sharing its three-dimensional clutter and myriad connective possibilities."[70] This complexity furnishes the fictional world of cult television with the gravitas of authenticity. The rewriting of the cult serial narrative emerges from the rereading of the story by an audience as communal narrator. The rereading of a database is a way of self-narrating, of constructing a discourse for the self.

For this to happen, fan-creators of ExtantWikis take kernels from another's discourse and rewrite or display that story on the wiki page. A cult television serial must balance the episodic nature of the text with seriality: the more serialized television becomes, the more complex the narrative becomes. Each episode of the series does not just contain plot elements for that particular episode, but rather also becomes itself a kernel (or a satellite) for the overarching serial narrative.[71] The ultimate hyperdiegesis of the serial plot emerges through the episodic kernels revealed throughout the series.[72] For a complex narrative like *Lost* or *Heroes*, the "story" is not contained in one episode, but is an on-going practice across the series. Fans watch the show and then rewrite the narrative story, the kernels and satellites of the plot, on the wiki webpage. On *Heroeswiki*, for example, fans have categorized fourteen different units of narrative information: abilities, characters, graphic novels, and episodes. Each of these categories represents a particu-

larly salient kernel of narrative information about the show as a whole: for example, the category "timeline" becomes more important when characters begin travelling in time. By highlighting these particular categories over those not represented on *Heroeswiki,* fans indicate a rereading of the *Heroes* narrative that makes each of these issues important for the cult serial narrative as a whole—as a database.

On the ExtantWiki any fan, through hypertextual connections, can link any two pieces of information. This is particularly salient for the narrative of *Lost*, because the television show itself illustrates the myriad connections between characters. For example, during the extensive flashback and flash-forward sequences, we often see two or three main characters embroiled in situations that diegetically take place before or after the characters "knew" each other on the island: further, fans have illustrated these connections hypertextually, through links between wiki-pages. Each character name is a link to another character, representing a connection between the two. Importantly, the audience creates these links, and can link names even when the extant *Lost* narrative may not make it obvious. For example, *Lostpedia* indicates hypertextual connections between the characters Horace Goodspeed, Benjamin Linus, and Sawyer—all of which the TV viewer can construct from plot connections on the television program, but which are made salient and obvious through the metaphor of the hyperlink on the Extant-Wiki.[73]

Narrative texts, as Miall shows, can be broken into these constituent parts: each character's narrative structure on *Lost* is an "episode" of narrative, or the unfolding of the text at the level of the reader's experience.[74] A reader's own experiences with a particular set of narrative events forms an "episode" of that narrative. If any particular connection does not already exist on screen, or appears for the first time in an episode, fans can rewrite that connection in order to reread that discourse. Thus, there are two processes at work. On the one hand, fans rewrite the story of the extant media narrative by splitting the kernels and satellites into their own wiki pages. This rewrite forms a narrative database, which features all the elements of the narrative restructured by the fan community. On the other hand, and following from this, fans can then reread the extant media narrative as written through and by the fan community, by hypertextually flipping through the kernels likes a hypertext narrative.[75] The database form of narrative estab-

lishes a way for fans to participate in the creation of their own narratives, though communally rewriting and rereading the cult serial narrative.

The Database Needs New Scholarship

What ExtantWiki show is the power of narrative to envelop the audience, to provide a possible world that exists within and between the extant media object's world. The ExtantWiki exists just like a Wikipedia: to provide details and information about a world. The difference is that the world of the ExtantWiki is the cult television world: fictional, but no less "real" to the fan-audience that creates the wiki. Thus, these New Media technologies integrate the audience into the construction of the narrative discourse. In traditional narrative definitions, the audience becomes a passive receptor of the discourse and the active constructor of the story: What a narrator tells the audience becomes a means for the mental reconstruction of story elements. The new technologically mediated forms of narrative in the Web Commons, however, more fully integrate the audience into the construction of that narrative discourse too. Thus, a narrative is constructed through the interaction of members of a community. In the next chapter, I more fully investigate this narractivity as the narrative interaction of the fan community.

NOTES

[1] Interestingly, fans also tend to publish fan fiction in serial format: many works of fan fiction arrive chapter by chapter.

[2] Matt Hills, *Fan Cultures* (London: Routledge, 2002), 134.

[3] See, Kristin Thompson, *Storytelling in Film and Television* (Cambridge, MA: Harvard University Press, 2003), 98–105 for a description of this process; and Steven Johnson, *Everything Bad Is Good for You* (New York: Riverside, 2005), 62–71.

[4] Jason Mittell, "Narrative Complexity in Contemporary American Television," *The Velvet Light Trap* 58 (2006), 30.

[5] See, for a discussion of the narrative complexity of webisodes, Paul Booth, "Frak-tured Postmodern Lives, or How I Found Out I Was a Cylon," in *Battlestar Galactica and Philosophy*, ed. Josef Steiff and Tristan Tamblin (Peru, IL: Open Court Publishing, 2008).

[6] Umberto Eco, "*Casablanca*: Cult Movies and Intertextual Collage," *Substance* 47 (1984): 3.

[7] I use the term "ExtantWiki" to describe wikis created about extant narrative texts.

[8] Seymour Chatman, *Coming to Terms* (Ithaca, NY: Cornell University Press, 1990), 9.

[9] *Heroeswiki* Main Page (See, Appendix B).

[10] Henry Jenkins, *Convergence Culture* (New York: New York University Press, 2006); Nancy Baym, "The Lost Librarians of National Defense," *Online Fandom: News and Perspectives on Fan Communication and Online Life*, 30 Apr 2008, http://www.onlinefandom.com/archives/the-lost-librarians-of-national-defense (accessed 01 May

2008); Karen Hellekson, "SF Fan Wikis: Source, Reference, World," *Res gestae— Documentary and Digital Evidence of the Trace*, 20 July 2008, http://\ khellekson.wordpress.com/2008/07/ (accessed 20 July 2008); and Jason Mittell "Sites of Participation: Wiki Fandom and the Case of Lostpedia," *Transformative Works and Cultures* 3 (2009).

[11] Paul Levinson, *New New Media* (New York: Allyn & Bacon, 2009), 84.

[12] Lawrence Lessig, "The Creative Commons," *Florida Law Review* 55 (1994); Lawrence Lessig, *The Future of Ideas: The Fate of the Commons in a Connected World* (New York: Random House, 2001), 9–20.

[13] Yochai Benkler, "Coase's Penguin, or, Linux and the Nature of the Firm," in *CODE: Collaborative Ownership and the Digital Economy*, ed. Rishab Aiyer Ghosh, (Cambridge, MA: The MIT Press, 2005), 171; see also, Yochai Benkler, *The Wealth of Networks: How Social Production Transforms Markets and Freedom* (New Haven, CT: Yale University Press, 2006).

[14] By "informational portal," I refer to the conception of the web as a "realm of pure information," a vast digital library containing all of human knowledge; see, Michael Benedikt, "Cyberspace: First Steps," in *Cybercultures Reader*, ed. David Bell and Barbara M. Kennedy (London: Routledge, 2000), 20.

[15] Charlotte Hess and Elinor Ostrom, "Introduction: An Overview of the Knowledge Commons," in *Understanding Knowledge as Commons: From Theory to Practice*, ed. Charlotte Hess and Elinor Ostrom (Cambridge, MA: The MIT Press, 2006), 3; see also, Elinor Ostrom, *Governing the Commons: The Evolution of Institutions for Collective Action* (Cambridge, UK: Cambridge University Press, 1990), 1.

[16] Hess and Ostrom, 5–6.

[17] Brick-and-mortar has come to mean areas that exist physically, and are tangible (i.e., Barnes and Noble is a brick-and-mortar store, as opposed to the Amazon.com store, which is not physically housed anywhere). Project Gutenberg is a digital archive of all out-of-copyright literature; it is an attempt to create an open access, free area for access to public domain literature.

[18] "Goods" is a tricky term because nothing is being bought and/or sold on Project Gutenberg. I use the term as in David Bollier, "The Growth of the Commons Paradigm," in *Understanding Knowledge as Commons: From Theory to Practice*, ed. Charlotte Hess and Elinor Ostrom (Cambridge, MA: The MIT Press, 2006), 29–30 in which he redefines them as digital, non-physical entities. Project Gutenberg does require ownership, and this is paid for by volunteer donations from readers.

[19] Garrett Hardin, "The Tragedy of the Commons," *Science* 162, no. 3859 (13 Dec 1968), notes a problem with the idea of the commons. Specifically, the "commons" is not a perfect system of sharing, for "freedom in a commons brings ruin to all" (1247). As a population grows and as resources grow smaller, the self-interest of humans becomes antithetical to the commons project. However, on the wiki, and in the Web Commons, we do not find this problem: digital resources, as we have seen, are boundless and infinite. Space online is unlimited, and there is no cap on the population. Commons can succeed online, as the web is best suited for the community, not just for the individual (see, Ostrom).

[20] With the exception of the fact that one must pay for internet service; although free Wi-Fi and Wi-Max have made "paying" superfluous for many users of the web. Plus, even access to the web can be free, if it is provided by a major metropolitan area, or used at a library or other provider.

[21] Tim Berners-Lee and Mark Fischetti, *Weaving the Web: The Original Design and Ultimate Destiny of the World Wide Web* (London: Orion Business, 1999), 80.

[22] See, Jill Walker Rettberg, *Blogging* (Cambridge, UK: Polity Press, 2008), 121–6.

23 Henry Jenkins, *Textual Poachers: Television Fans and Participatory Culture* (New York: Routledge, 1992), 32.

24 Melissa Anelli, *Harry, a History* (New York: Pocket Books, 2008), 96–100.

25 Benkler, *Wealth*, 61; see also Andrew Currah, "Managing Creativity: The Tensions between Commodities and Gifts in a Digital Networked Environment," *Economy and Society* 36, no. 1 (2007).

26 James Carey, "A Cultural Approach to Communication," in *Communication and Culture: Essays on Media and Society* (New York: Routledge, 1992), 16–20.

27 See, Jay David Bolter, *Writing Space: Computers, Hypertext, and the Remediation of Print*, 2nd ed. (Mahwah, NJ: Lawrence Erlbaum Associates, 2001), 27–46.

28 Carey, 18.

29 Ibid.

30 For instance, the creator of the "The Web Is Us/Ing Us" video about Web 2.0, Michael Wesch, describes the problem as one of strategic non-description, as the term can mean whatever any practioner or scholar wants: see, Michael Wesch, "What Is Web 2.0? What Does It Mean for Anthropology?" *Anthropology News*, May 2007, 30.

31 Tim O'Reilly, "What Is Web 2.0: Design Patterns and Business Models for the Next Generation of Software," *O'Reillynet*, http://www.oreillynet.com/pub/a/oreilly/tim/news/2005/09/30/what-is-web-20.html (accessed 16 Sept 2007), ¶12–15.

32 Kenneth Burke, "Terministic Screens," in *Language as Symbolic Action: Essays on Life, Literature and Method* (Berkeley: University of California Press, 1966), 45.

33 O'Reilly, ¶13.

34 Ibid., ¶1.

35 As of 02 Sept 2008, however, Google had created its own browser, *Chrome*. Ironically, although O'Reilly prophesized that Netscape might one day develop "high-priced server products," it is Google, the free server, that has developed open source browsers (¶15).

36 Jesse James Garrett, "Ajax: A New Approach to Web Applications," *Adaptive Path*, 18 Feb 2005, http://adaptivepath.com/ideas/essays/archives/000385.php (accessed 01 Sept 2007), ¶9.

37 Mittell, "Complexity," 32.

38 Ibid.

39 Lev Manovich, *The Language of New Media* (Cambridge, MA: The MIT Press, 2001), 225.

40 Tzvetan Todorov, *Grammaire du "Décaméron"* (The Hague: Mouton, 1969). Cited by Patrick O'Neill, *Fictions of Discourse: Reading Narrative Theory* (Toronto: University of Toronto Press, 1994), 13: the French original is *narratologie*.

41 O'Neill, 12–13.

42 Marie-Laure Ryan, *Avatars of Story* (Minneapolis: University of Minnesota Press, 2006), xi.

43 Robert Scholes and Robert Kellogg, *The Nature of Narrative* (London: Oxford University Press, 1968), 4.

44 Both my "story" and "discourse" come mainly from Seymour Chatman, *Story and Discourse: Narrative Structure in Fiction and Film* (Ithaca, NY: Cornell University Press, 1978), 19.

45 Chatman, *Story and Discourse*, 53–4.

46 Gérard Genette, *Paratexts: Thresholds of Interpretation*, trans. Jane Lewin (Cambridge, UK: Cambridge University Press, 1997), 1. The term "paratext" means the professionally produced entities within and around a text like the author's name, the title of the work, the introduction, or illustrations that delimit and define the areas of the "text" itself. Genette describes a prescribed boundary: an officially designated border to the narrative. See, also,

Jonathan Gray, *Show Sold Separately: Promos, Spoilers, and Other Media Paratexts* (New York: New York University Press, 2010).

[47] Pierre Lévy, *Collective Intelligence: Mankind's Emerging World in Cyberspace,* trans. Robert Bononno (New York: Perseus, 1997), 61–5.

[48] Hellekson, "SF Fan Wikis," describes the use of wikis for communal knowledge about television shows, and Baym, "Lost Librarians," describes the potential of *Lostpedia* for more scholarly analysis.

[49] Bo Leuf and Ward Cunningham, *The Wiki Way: Quick Collaboration on the Web* (Boston: Addison Wesley, 2001), 3–4.

[50] O'Reilly, ¶17.

[51] Eyal Oren, "SemperWiki: A Semantic Personal Wiki" (Semantic Desktop Workshop 2005 @ ISWC 2005), http://www.eyaloren.org/pubs/semdesk2005.pdf (accessed 25 Sept 2007), Sec 5.

[52] Benkler, *Wealth*, 73.

[53] Janet Murray, *Hamlet on the Holodeck: The Future of Narrative in Cyberspace* (Cambridge, MA: The MIT Press, 1997), 256.

[54] Ryan, *Avatar*, xviii.

[55] *Lostpedia* Season 4 Spoilers (See, Appendix B).

[56] *Lostpedia* Main Page (See, Appendix B).

[57] James (Sawyer) Ford (See, Appendix B).

[58] Gérard Genette, *Narrative Discourse: An Essay in Method*, trans. Jane Lewin (Ithaca, NY: Cornell University Press, 1980), 27–9, in contrast, uses three, including narration, in his list.

[59] Chatman, *Story and Discourse,* 19.

[60] Chatman, *Coming to Terms,* 9.

[61] Mieke Bal, *Narratology: Introduction to the Theory of Narrative*, 2nd ed., trans. Christine Van Boheemen (Toronto: University of Toronto Press, 1997), 3.

[62] Jacques Derrida, *Archive Fever: A Freudian Impression*, trans. Eric Prenowitz (Chicago: University of Chicago Press, 1996), 68.

[63] Donald E. Polkinghorne, *Narrative Knowing and the Human Sciences* (Albany: State University of New York Press, 1988), 127, my emphasis.

[64] The ARG *The Lost Experience* features Hanso, although only in background video and pictures.

[65] Alvar Hanso (See, Appendix B).

[66] David Herman, *Story Logic* (Lincoln: University of Nebraska Press, 2002), 211.

[67] Richard Walsh, "Fabula and Fictionality in Narrative Theory," *Style* 35, no. 4 (2001), 604.

[68] Carlos Duarte de Sena Caires, "Towards the Interactive Filmic Narrative: 'Transparency': An Experimental Approach," *Computers and Graphics* 31 (2007), 801.

[69] Sara Gwenllian-Jones, "Virtual Reality and Cult Television," in *Cult Television*, ed. Sara Gwenllian-Jones and Roberta E. Pearson (Minneapolis: University of Minnesota Press, 2004), 83.

[70] Ibid., 93.

[71] See, Johnson, *Everything Bad*, 65–72.

[72] See, Hills, *Fan Culture,* 137; Gwenllian-Jones, "Virtual Reality," 87.

[73] See, Appendix A.

[74] See, David S. Miall, "Episode Structures in Literary Narratives," *Journal of Literary Semantics* 33 (2004).

[75] See, Marie-Laure Ryan, *Narrative as Virtual Reality* (Baltimore, MD: Johns Hopkins University Press, 2001); George Landow, *Hypertext 3.0* (Baltimore, MD: Johns Hopkins University Press, 2006) for more on hypertext narratives.

Chapter Five:
Narractivity and Spoilers

Each of the closed books was a door, and behind it stirred shadows, voices, sounds, heading toward him from a deep, dark place. He got goose bumps. Just like a vulgar fan.
—Pérez-Reverte, The Club Dumas, p. 246

Powerless may be a reference to an outbreak of the Shanti virus, leading many of the characters to death or stripped of abilities... Matt will die because of Peter exploding again... Sylar will kill Molly or Maya or Bob or Elle....
—Heroeswiki Spoiler:Powerless

In the last chapter I showed how ExtantWiki represent a narrative database of information for fans. Yet the wiki also plays an important role in ARGs as well, as players collate and collect information from across scores of different components of the ARG onto wikis. Perhaps no one understands this better than television scholar Jason Mittell, who worked on the 2006-2007 ARG *The Lost Experience* as both a player and, eventually, as an administrator on *Lostpedia*. According to Mittell, *Lostpedia* (which is completely fan-created) played a key role in the (producer-run) *The Lost Experience,* as key parts of the ARG had to be compiled "to reveal a hidden video offering key information about both the ARG and the in-show DHARMA Initiative."[1] In other words, *Lostpedia,* a fan-run site, became involved with an actual canon-based diegetics of *Lost* the television show. The play of fans eked into the story of *Lost.*

Thus, wikis exemplify an active and dynamic narrative text, of the type encountered in the first quotation from Pérez-Reverte, above. Pérez-Reverte

describes how a "closed book" is an unstudied narrative waiting for the reader to open and discover the worlds hidden within its pages. Yet, a "closed book" is also one that may have been previously read: the plots known, the narrative elements recognized. In these previously read books, there still remains a mystery, the "shadows" of the memory of the reading still lurking in the back of the reader's mind.[2] By rereading the closed book, the readers in—as well as of—Pérez-Reverte's novel set in motion not just the adventures of the unknown, but also the rediscovery of the already-known, the re-appreciation of the loved.

Of course, in this quotation Pérez-Reverte also refers to the "vulgar fan," and reveals a characteristic of the popular definition of fandom: the fan as solitary individual. In the academic study of fans, conversely, scholars often exalt the fan as the epitome of the active audience member, or the productive consumer.[3] In fact, fans are famously communal and group together: fans tend to center their community on the narrative of the extant media object. Fandom itself means being part of a community, and the writing of fan fiction becomes "a social activity for these fans, functioning simultaneously as a form of personal expression and as a source of collective identity (part of what it means to be a 'fan')."[4] Indeed, Baym's phrase "collaborative interpretation" highlights how fans manifest their collective identity through writing fan fiction.[5]

Digital Fandom not only encourages, but also relies on a certain level of community and socialization, as we have seen in regards to the Web Commons. Fan fiction is, in a way, both an appreciation and a reappreciation of the object of that fandom. Appreciation involves reading for meaning, but reappreciation is reading the media object again through the lens of the fan community. We can see this in the second quotation inscribing this chapter, taken from *Heroeswiki*. The fan writers of this wiki have reconceptualized the notion of the *Heroes* story not only to describe the narrative of the show, as we saw in the previous chapter, but also to describe future events. Narrative databases collect the previously read as well as the never-read, as fans assimilate individual units of narrative knowledge and, as a community, reenact and reform them in new ways within the database through the communal interactive action I term "narractivity."

Narractivity arrives in an inchoate stage in media theorist Abigail Derecho's concept of archontic texts. For Derecho, a text is archontic if it "allows, or even invites, writers to enter it, select specific items they find useful, make

new artifacts using those found objects and deposit the newly made work back into the source text's archive."[6] Derecho brings the term "archontic" to fan studies from Jacques Derrida's analysis of the archive as an ever-expanding inventory for both storage and production.[7] As we have seen, narratives on wikis can be boundless. For example, while *The Club Dumas* is a *text* of approximately 70,00 words, it is also an *archive* of material—characters, situations, books—that can be used in other texts, fan made or non-fan made. Archontic texts "always produce more archive, to enlarge itself," and a narratively complex television show like *Heroes* features fan-created elements as part of that archontic text, part of that "tendency toward enlargement and accretion that all archives possess."[8] By collecting units of narrative information, fans construct these archives in much the same way as players of ARGs collate and collect a vast amount of information to facilitate puzzle solving. In order to examine and further refine narractivity, in this chapter I analyze in more detail the wikis for the cult television shows *Lost* and *Heroes*. In both of these sites, we find an exploration of the cult narrative foundation of the show, created through the interaction of members of the fan community.

The results of narractivity manifest in three ways: through the construction of narrative knowledge on the wiki, through the scattering of narrative meaning by spoilers, and through resolution of narrative research. By constructing narrative, fans use narractivity to create knowledge about a text. Combing through the database of narrative information on the wiki, the fan community rereads the narrative of the extant media object, and constructs the story in a narrative database. Further, by scattering narrative meaning on a wiki, fans rewrite the extant media object through the speculative fiction of the spoilers of that object. Finally, fans research narrative through a discursive rereading of the story that mirrors the form of academic or scholarly research into the extant media object. In short, the fan community rereads the extant media object using active narractivity to blend that community's interaction around, about, and with a narrative structure. By examining the way fans construct wikis, we can understand explicitly the way any reader implicitly comprehends and develops ideas in long-form fiction.

WIKI FICTION:
A NEW NARRATIVE COMMUNITY

Wikis exemplify interactivity, or the reciprocal action of participant(s) on/in a medium. By reciprocal action, I reference Baudrillard's examination of communication for its reciprocal communicative practices. In his famous "Requiem for the Media," Baudrillard describes the way models of communication that see communication as the "transmission-reception of a message" are inaccurate. A more precise definition would examine communication, rather, as the interaction between participants: "as a reciprocal space of a speech and a response."[9] Further, this reciprocal interaction occurs not just on a medium, but in one as well. Because of the nature of the wiki, like that of the blog, any dialogue on the text will intra-textually alter that text. The community of wiki-builders self-reflexively creates the wiki as they change it, playfully constructing their community at the same time as they build the text.

Generally, therefore, the more users that contribute to a wiki, the greater the variety of information and the more detailed the entry. The wiki becomes a "knowledge space," or a place where each participant can store the whole of his/her knowledge and allow it to interact with every other participant's knowledge.[10] Wikis externalize a sense of the whole community being more than the sum of its individual parts, and illustrate an interactivity that depends not just on the ability to change something onscreen, but also on the ability of users to communicate with each other. Many fan-created wikis use this interactive, encyclopedic character of wikis to explore the various unexplained narrative possibilities of the extant media object.[11]

On the main page of *Lostpedia,* for example, each picture represents a narrative element of a particular mystery in the show *Lost.* As we saw in the last chapter, the fans of *Lost* that work together on *Lostpedia* have collated and collected all this narrative information in order to both preserve and explore the *Lost* narrative. In order to accomplish this, these fans interactively contribute to this narrative database. However, the interactivity of the participants of the wiki would seem to contrast with the traditional narrative structure of *Lost.* Indeed, as pointed out by journalist John Ness, any narrative told via a wiki would be a mish-mash, an extended series of story arcs that bordered on the unintelligible.[12] Thus, the interactivity inherent in the

wiki "would appear to be antithetical" to narrative "otherwise the plot becomes unclear."[13]

Yet, the interactivity described by Ness, is *technological*, what Janet Murray calls the "mere ability" to move characters on the screen.[14] The dialectic between interactivity and narrative in many of these traditional media studies assumes a particular form of narrative—a traditional definition as "a teller and a tale."[15] Importantly for fans, for Digital Fandom, and for the New Media Studies that examines them, wikis offer a new type of narrative, a type alluded to by Riedl and Young that "can generate stories [and] can adapt narrative to the users' preferences and abilities."[16] As seen in the metaphor of the ARG, this new form of archival narrative also mirrors the interactive attention in which players of ARGs participate. By collecting detailed information into one place, as participants in, e.g., *The Lost Experience* did on *Lostpedia* or players in the game *Perplex City* did to solve the puzzles,[17]ARG communities use the wiki to construct not just the game elements, but the narrative as a whole. Further, we can see the necessity for this new narrative form by Ryan, who argues that "digital narrative should emancipate itself from [traditional] literary models."[18]

THE WIKI AS ARCHIVE

For Derecho, the advent of digital writing has created a new form of fan literature, archontic literature. Her discussion of archontic texts is itself heavily influenced by Derrida's connection between the archive and Freudian psychoanalysis. Derrida delves into the root of "archive" to show an early sense of the word: a space wherein order is achieved.[19] The Greek word *arkheion* signifies a house, an address, or a residence of the *archons*, the superior magistrates who rule and archive public documents. As Derrida shows, the *arkheion* housed information about the citizens of the *polis*:

> The citizens who thus held and signified political power were considered to possess the right to make or to represent the law. On account of their publicly recognized authority, it is at their home, in that place which is their house (private house, family house, or employee's house), that official documents are filed. The archons are first of all the documents' guardians. They do not only ensure the physical security of what is deposited and of the substrate. They are also accorded the hermeneutic right and competence. They have the power to interpret the archives.[20]

Thus, the archive traditionally has roots not just in collecting information, but in interpreting and reassigning it as well. The *arkheion* were not just keepers, but creators of archived knowledge. The study of archives, of the "Archontic principle," must include the theory "both of the law which begins by inscribing itself there and of the right which authorizes it."[21]

Fans accomplish this dual sense of archival through the inscription of the narrative, in all its meanings, onto the wiki. Indeed, the archive is intimately related to this concept of "inscription": Derrida writes, "can one imagine an archive without foundation, without substrate, without substance...? the inscription...leaves a mark right on the substrate."[22] One inscribes on an archive all the knowledge and information of a community, to both collect and collate a community's place in their culture. Yet, the archive is more than just a *record* (or does more than just *record*):

> No, the technical structure of the *archiving* archive also determines the structure of the *archivable* content even in its very coming into existence and in its relationship to the future. The archivization produces as much as it records the event.[23]

In other words, the archive is not just a thing but a process; is not just a device for reproduced information but for production itself.

Derrida describes this capacity for archives to interpret and inscribe knowledge as that of "consignation," or the power of "gathering together signs," of collating knowledge. In many ways, this is similar to what Lévy demonstrates of cyber-knowledge: we do not produce "true knowledge" in a single location, but rather through the interaction between members of a collective intelligence. This interaction occurs in a network of linked community members: Lévy describes "open hyperdocuments accessible on-line, written and read by a community"—in other words, wikis.[24] In his reading of Lévy, Jenkins articulates the promise inherent in these knowledge communities: "what we cannot know or do on our own, we may be able to do collectively."[25]

The cosignatory capabilities of the archive must always be tempered with its archontic properties. Derrida describes the sense of consignation as the coming together of "a single corpus, in a system or a synchrony in which all the elements articulate the unity of an ideal configuration." He goes on to write:

By incorporating the knowledge deployed in reference to it, the archive augments itself, engrosses itself, it gains …. But in the same stroke it loses the absolute and meta-textual authority it might claim to have. One will never be able to objectivize it with no remainder. The archivist produces more archive, and that is why the archive is never closed. It opens out of the future.[26]

The archive constantly grows with the grotesque notion of eternal enlargement, of the type we saw described by Bakhtin in reference to carnival and in terms of blogs and recursive expansion. But there is an inherent paradox at the heart of the archive: by archiving, one must necessarily leave something out. An archive can only record within a culture, within a particular context. Without the place of consignation, "a certain exteriority" there could be no archive: "no archive without outside."[27] At the same time, however, by leaving something out, the archive itself becomes meaningless: what use is an archive that is not total, is not complete? As Derrida further writes, "the archive always works, and *a priori*, against itself."[28] For New Media Studies, the archive thus represents the way communities of fans come together on a narrative database to inscribe the extant media object itself, like wikis represent the coming together of players' knowledge of ARGs. Similarly, fans are rewriting and rereading the narrative parameters of the cult show through this expansive and interactive content creation both to collate all information about the show and also to determine what is and what is not canon.

THE SPOILER AS SPECULATIVE FICTION

Key to this discussion of narractivity on the narrative database is the paradoxical relationship between the archival form of the database and the spoilers on the archive.[29] Archives both record and represent the past; they inscribe, as Derrida would say, "on historiography."[30] Spoilers attempt to reveal key pieces of information for a media object's narrative before the producers of that narrative release that information to the public. The archive is documentation of the previously happened, a record of the contextual has-been. Conversely, a spoiler is a future event: a piece of narrative that hasn't-yet, or might-not. To record a spoiler on an archive like a narrative database is to historicize the future; to chronicle the forthcoming. It is to make the future the past, and to assert the truth of the may be. Each spoiler represents a form of speculative fan fiction, promoting and proposing elements of the narrative that have not happened, but still might.

Spoilers for television narratives are pieces of narrative information that producers reveal or audience members discover before the show airs. As media scholar Rebecca Williams states, they "allow fans to sustain a reading formation based on narrative speculation."[31] They can be as innocuous as the title of an upcoming episode or as narratively important as who will live and who will die. Spoilers exist as communal hypotheses of future events, built through interactivity and centered on narrative exposition. Spoilers are also a way for fans to actively construct meaning in the extant media object, and to refute the dominant interpretation of the media text. Spoilers are therefore a form of what Sconce calls "narrative conjecture" for television shows, elements that audiences imagine could happen in a cult universe.[32] Rather than reading the text "as 'intended' by the producers or interpreted by mainstream critics, fan spoilers can offer unique, alternate, and sometimes quite elaborate new readings of the text."[33]

There are a number of different ways scholars have theorized spoilers in studies of fandom. The most common conception can be seen in literary critic Laura Carroll's observation: spoilers offer clues as to "abrupt and sensational narrative developments."[34] In this view, spoilers are a way for viewers of a show to find out information about the plot before producers reveal it to the general population. Another theorization shows that spoilers become a way of fans to gain cultural capital in issues of power dynamics in their fan communities. Research has shown that fans use them as a way of establishing a hierarchy of knowledge within the subculture of the fan community: "subcultural capital," according to Williams, "can foster fan social capital."[35] Thus, some fans write spoilers and while

> the majority of fans openly express the egalitarianism and equality of spoiled and unspoiled fan factions, there are differences in the forms of capital that each group possesses. The spoiled have greater subcultural and, in particular, fan social capital and therefore occupy the more dominant position in the fandom, dominating the fandom with their fan knowledge, textual interpretations and discursive power.[36]

In short, fans may not just spoil to reveal unreleased narrative moments, but also to dominate the discourse surrounding the extant media object, to demonstrate their knowledge of that text's story, or to gain a powerful tool for social influence in the fan community hierarchy. Foster mirrors this assertion, describing those that spoil *Survivor* on the show's website as "fans [who have] attempted to elevate their status amongst other fans by convinc-

ing them of the accuracy of the reading of their text."[37] The spoiler acts as capital, with which fans assert their supremacy over other fans. The pleasures that come from spoiling in this sense come from the interaction with other fans, just as much as from the text itself.

Another conception of the spoiler is that of extra-textual pleasure. For Jenkins, spoiling is "a giant cat and mouse game that is played between the producers and the audience."[38] This game brings people together in a community of spoiled fans. Gray and Mittell argue that the extra-textual pleasure of the spoiler goes beyond what Jenkins articulates, by "conceptualizing narrative and textuality as entailing much more than plot exposition."[39] The pleasures that fans derive from spoilers come from experiencing the plot as known, with "the emotional pulls of the text" emanating from "that which they know is coming, enjoying the moments leading up to events they have never seen, but feel known."[40] Spoiling is a way of experiencing a narrative differently, not as what will happen, but rather as how something will happen, or why.

However, a further analysis of spoilers presents them not just as a way to build community or to elevate the individual status of fans, but also as a means to create narrative possibilities. First, the spoiler extra-textually builds on the extant media object, as a form of speculative fan fiction. According to Derecho, "in fan fiction, there is an acknowledgement that every text contains infinite potentialities, any of which could be actualized by any writer interested in doing the job."[41] Speculative fan fiction sees these possibilities as future narrative events. Perceptually, to recognize a spoiler as a spoiler is to recognize the narrative possibility that that spoiler offers to the community, which often comes in the guise of communal discussion. For Williams, the spoiler is intimately tied to both the narrative of the extant media object and to the community of fans surrounding the show. Further, Gray and Mittell conclude their argument by implicitly referencing the virtuality of the cult text:

> Most importantly, a well-told tale lives and thrives after its telling, and in the gaps within its telling. Any given reader's path through this story may bring the reader into contact with only a small portion of what it has to offer, and hence textual studies have often been too quick to assume a unitary, unified text, nailing one textual path down as "normal" or even "the text itself," and marginalizing other paths as extra-textual or abnormal. Instead, we might more properly conceive of the text as an active space with a varied terrain and numerous potential pathways.[42]

Thus, the spoiler becomes a way of unifying this text, of fans choosing different pathways to tread across the extant media object's terrain.

A final conception of spoilers is as a form of researched narrative information which mirrors the scholarly work of academics. To research and compile spoilers, fans must engage in an intense academic program, snooping on websites, scouring journals and other sites of arcane knowledge about the show, photographing set locations, even examining Google Earth webpages to see evidence of filming in remote locations.[43] Keith Johnston shows that there is already an academic sensibility in fandom: "Unlike any other time … content analysis [is] now something that [can] be done by the most casual fan with access to a computer." He goes on to show how fans critically analyze film trailers to reveal potential spoilers. Indeed, fan analysis can even be more complicated and intense than academic scholarship: as "film companies …add in more images and increase the pitch of editing to a point where the casual view might miss a piece of information."[44] Fans read and research on narrative elements, just as a scholar might spend a great deal of time textually analyzing a particular literary work. For example, on the spoiler page for *Lostpedia*, a contributor has written:

> This page contains a summary of uncomfirmed season 4 spoilers from **unofficial** sources. The source is mentioned for each spoiler. If spoilers repeat or expand upon earlier information, the more reputable or more complete sources are preferred. For season 4 spoilers confirmed by official sources, see Season 4. [sic][45]

What we find, therefore, is that the community of online fans promotes a narrative text that is multi-faceted and complex. It is not just the text seen on the television, but also the text as experienced through conversation, though extra-textual comments, and through spoilers. Spoilers become part of a narrative constructed through interactivity: a narrative experience, created both by spoiling to create fan fiction, and by spoiling to create fan scholarship. In both these instances, the form of the narrative database influences the content of the spoiled narrative information.

THE ARCHONTIC NARRATIVE: IMPRESSIONS OF NARRACTIVITY

For the *archon*, archives are places a community scribes information, not only to unbind that information, but also to unite and impress that community

into existence. Indeed, Derrida's connection between the notions of the archive, of inscription, and impressions also highlights a connection to the narrative database. The fans that write *Lostpedia* and *Heroeswiki* consolidate, create, and communicate a variety of types of narrative information about these extant media object (see Appendix B). On her blog, Nancy Baym has described ExtantWiki sites like these as "a neglected area of fandom research," and that the popularity of such sites warrants additional scholarship.[46] To demonstrate their popularity, she references an article from *Information Week*, which describes *Lostpedia* as a site that "has grown to nearly 33,000 pages. The site has received 141 million page views. It has 26,000 registered users."[47] Using Derrida's analysis of archives and delineation of three types of archival impressions, we can observe three ways of narractivity occurring in ExtantWikis: first, the interactive narrative of the wikis; second, the scattering of narrative knowledge through the creation, deletion, and explanation of the spoilers; and third, the scholarly research of narrative spoilers.

Narractive Impression: Constructing the Narrative

First, through the compilation of narrative information, viewers of the narrative construct their own story bible, their own conception of the backstory and history of the characters and narrative elements for the media text. A show's bible, written by media producers before or during the shows production, highlights the different elements that make up the show's canon: the characters, technologies, back-stories and other essential components. The term comes from the comic book industry, in which main characters of comics would have detailed back-stories that required background knowledge. Comic books, however, would often have different writers, all of whom would have to work from the same material. Thus, a few key comic designers, in order to ensure continuity and to keep track of details, would write the story bible. The concept of the story bible translated into television usage when televised narratives became expansive and serialized. Writers use the bible to keep track of the expansive back-stories of the characters, and as an extensive reference. In order to construct this version of the bible, fans connect elements of the show's discourse into a cohesive whole by watching the show, or by encountering the elements of the show in various mediated guises.[48] The "collective intelligence" of the fan community becomes the key to this construction as each individual member of the fan

community might have different knowledge bases: for example, perhaps one person knows Jack Shepherd's story on *Lost* and another intimately knows John Locke's. Each fan can contribute his/her own unique information to each component of the narrative database. Importantly, both Jack and Locke are themselves also linked, as seen through the hyperlinks on each other's pages, and each links to other characters, situations, events, and narrative elements from the show.[49]

Derrida's first meaning of inscription provides us with a useful heuristic for examining the creation of the narrative on the narrative database. He writes that the inscription of the archive is "scriptural or typographic"; that is, something "which leaves a mark at the surface or in the thickness of a substrate."[50] To impress is literally to inscribe: to etch or to write upon. Applying this measurement of impression to that of the archive, Derrida marks the *foundation* of the archive: the impression of the material, the writing-down of the substance. The archive impresses information into a location, moving it from an ethereal location of a "knowledge space" to that of a specific site. Inscription is thus the most basic function of the archive, and one of the constituent components of the narrative database.

For the wiki communities on *Heroeswiki*, fans impress their own discourses to the narrative story, in order to construct information about that narrative. They construct this narrative through the addition of paratextual information about the show (titles, credits), secondary textual information (reviews, interviews), extra-textual information (DVD extras and commentaries), intertextual information (novels and tie-ins) and intra-textual information contained in the show and wiki to the narrative rewritten on the wiki.[51] In a basic way, we can see how fans construct and construe this combination of "-textual" informational about the narrative through an examination of paratextual trivia about *Heroes* on the *Heroeswiki* site. This section of *Heroeswiki* demonstrates the most basic interactive impression of the knowledge production of the community, through the evolution of the trivia information. For example, on the page "*Heroeswiki:* Episode Powerless: Spoilers," the first piece of trivia posted on 01 Dec reads: "If the Writers Guild of America strike continues, this episode may be converted into a season finale." This trivia fact references the WGA strike of late 2007 and early 2008, which pushed many shows into hiatus, as producers had to adjust own-going serialized narratives. *Heroes* was one of those shows that producers had to rework. Although not strictly a piece of the *Heroes* narrative itself,

this paratextual information becomes a useful tool for fans to understand the show as a whole. As an entry posted a few days later on *Heroeswiki* reads, "...the ending was changed so that it could function as the season finale....In the online commentary [for the episode], director Allan Arkush says that in the original ending Strain 138 [a virus] is released, infecting Nathan and causing him to collapse during his speech." This original ending is different from what happened onscreen—Strain 138 was *not* released and Nathan was shot instead.[52]

On 04 Dec, as well, the wiki text changed—indicating an interaction with the text by one or more participants in the wiki community. The original quotation in the trivia section about the WGA was changed to read, "Due to the Writers Guild of America strike the full run of the second season was cut short, making this the finale." In this simple act, the act of changing one line of text from the conditional tense to the past tense, the community of the wiki interacts with the text of the wiki itself to exchange and produce information about the narrative, building a database of narratological content.

By 09 Dec, the trivia fact had disappeared entirely from the wiki page. The community's interaction on the page had deleted the articulation of that piece of knowledge. It is not that the knowledge ceased to exist on the wiki (it remains on the edit history pages), but rather that it ceased to have the same importance to the community. The community of wiki knowledge producers and writers felt that that knowledge was no longer necessary, and eliminated it, highlighting the mutability and fluidity of the wiki.

A second method of narrative construction on an ExtantWiki occurs as the community-formed wiki offers fans a non-narrated story in which they can construct their own discourse. By providing narrative elements in a series of hypertextual links, ExtantWiki illustrate how all the parts of a narrative exist *without* an external narrator providing a cohesive order. *Lost*, as we have seen, is the perfect example of an extant media object in which all elements are Kernels, and all Kernels are linked. For example, the stories of Jack and Locke intertwine with those of many other characters, each of whom, as we also saw in the last chapter, intersects with other characters, situations and motifs. On the main *Lostpedia* page, a series of graphically and textually active "portals" hyperlink to narrative elements and underscore their relevance to the *Lost* narrative.[53] Listed at the top of the main page, the different portals include "Survivors Camp, Supporting Characters, The Others, Mysterious Happenings, Locations, Themes" and others. For exam-

ple, clicking on the *The Others* portal leads to a page that details the charac-
ters that populate the camp of "the Others," the particular themes and motifs
that are associated by the community with "the Others," and information
about the history of "the Others." Each portal leads to different narrative
elements ostensibly removed from the process of narration. They seem pure
story, and indicate a shift away narrative discourse.

Because there appears to be no discourse on an ExtantWiki, no order of
events present, it would appear as through a narrator did not exist. Although
this would make an ExtantWiki seem more like a story than a discourse,
there does exist, in fact, an obvious discourse at the heart of an ExtantWiki:
the narrator is the fan community itself. By presenting the narrative in a wiki,
the community of fan writers presents a narrative that makes obvious the
narration, an obviousness that comes from the mutability of the text itself.
Through the interaction with each other by building a wiki narrative data-
base, fans make obvious the narrative and make opaque their narration.
Narrative development of ExtantWiki is clearly visible on *Heroeswiki*, as
fans were quick to inscribe on the "Episode: Powerless" page. This page is
devoted to the season finale, the episode titled "Powerless." On 01 Dec,
before the premiere of the episode, the only wiki page that existed that de-
scribed the episode "Powerless" was a spoiler page.

The expansion of the narrative information by the interaction between
members of the wiki community highlights narractivity. After the premiere
of the episode, on 04 Dec, a minor summary appeared on the page. This
summary detailed major plot developments, including "Peter tries to prevent
the release of the virus" and "Niki and Micah travel to save Monica." Fol-
lowing this, the section "character appearances" details all the characters that
appeared in the episode: "Mohinder, Sylar, Maya," etc. Each name is a portal
that, like on the *Lostpedia* page, would take the reader to a page that summa-
rized the character's place in the narrative and his/her narrative development.
On 09 Dec, however, the interactive writing between the communities of
wiki writers produced a full textual synopsis of the episode, spanning a few
hundred words.[54] The narrative, previously seen in story element form, fans
have here *summarized* as a communal discourse. The first paragraph opens:

> When Mohinder returns to his apartment in Brooklyn, he is greeted by Sylar who
> invites him to have breakfast which Maya made. When Mohinder discovers that Sy-
> lar lost his ability, he attempts to use a knife to defend himself, but Sylar pulls a gun
> on him and questions him about the cure to Shanti virus.

The synopsis continues for another few pages. The wiki community thus writes a discourse for the wiki reader, but at the same time, also rewrites all the textual elements with which the reader can reread the narrative in his/her own discursive fashion. By following any hyperlinks, readers can use the narrative elements enumerated on the wiki in any order and can create his/her own discourse through the story. Although Cobley establishes that "hypertext in written computer narratives makes explicit the degree of choice involved in the ways in which readers construct narratives," ExtantWiki do more.[55] They do not just "make explicit" the reader's choices, they leave open the possibility for any reading at all. As we have seen, fan readers can hypertextually link to any narrative kernels rewritten on the ExtantWiki, and if these links do not exist, they can create them.

Narractive Scattering: *Trace*-ing Narrative Futures

Fans also scatter the narrative by rewriting future elements of the extant media object's story on the narrative database, and then rereading that story as a fan-created "imaginative discourse." Using spoilers as a form of speculative fiction, fans provide details and assertions about the narrative itself. Then, by reading that narrative again, fans re-interpret the way the narrative information moves across the flow of the wiki. On ExtantWikis, spoilers make the future events present, as the narrative database records the interpretation of the events as if they had happened—or, to be more precise, as if they were happening. However, spoilers do not automatically and necessarily delimit the way fans have of looking at a text. Although of the archive, Derrida says that one can "no longer think otherwise," in truth spoilers are representations of fan literally thinking otherwise: of thinking outside the paradigm of the traditional narrative.[56] Spoilers represent a break with narrative unity, as the temporal displacement of future narrative information is spatially united with present narrative elements.

Derrida's second definition of "impression" provides us with a useful heuristic for examining this narrative scattering. This impression is something felt in anticipation, for concerning the archive, "we have no concept, only an impression, a series of impressions associated with a word."[57] This impression is a form of a promise, a deferment of desire, a trace of a thing left forever behind. Fan authors leave spoilers on the page even after producers have revealed the spoilt event on the show. A spoiler is this trace, but with one important difference: it is a trace of a future event. What is a spoiler

once the spoiled event has occurred? Once the spoiler has been "revealed" as either true or false (that is, as either accurate as to what happened in the show, or inaccurate), then what is left of the "spoiler" is a *trace* of that hypothesis of future event.

For example, the first page of spoilers for *Heroeswiki*, indicates a number of possibilities for the finale that had not yet aired.[58] Some of these spoilers include general statements, as in "Sylar will kill Molly or Maya or Bob or Elle." Others are much more specific: "Niki will get trapped in the fire, but D. L [sic] will somehow be alive (possibly by Claire's blood) and save Niki (and possibly die himself)." In total, 24 there are "fan theories" presented on the wiki page, two days before the premiere of the episode. Once the episode aired, we might assume that the spoilers page would be erased, as we saw with the trivia page, or would at least include additional information about which fan theories were "correct" and which were not. What we find, however, is that the spoiler page continues untouched. In other words, these spoilers did not disappear from the page once the episode has aired. Fans did not adjust them, nor did the community of fans change or delete them. Although it is possible that fans merely forgot to change the wiki, or ignored this page once the episode aired, the continued existence of the spoilers indicates that these spoilers also still exist as narrative discourse possibilities. Fans examine the finale of *Heroes*, summarized on its own page, as one possible narrative in a galaxy of other possibilities. Each spoiler, each fan theory, becomes a possible outcome set in "a universe composed of a plurality of distinct … worlds."[59] These distinct worlds, what Ryan references as the "Possible World Theory" of logical semantics, exist as discrete narrative entities in the minds of the audience. For example, in Possible World Theory, two narrative worlds based on *Heroes* can exist simultaneously in the mind of the viewer: in one, D. L. rescues Niki, and in the other, he does not. Perhaps the discourse presented onscreen in the show *Heroes* depicts one of these, but the fact that an audience member can imagine this other world, and impart the knowledge of that narrative world to others, indicates that its presence is one in a vast array of possibilities.

For fans on wikis, this spoiling goes beyond an attempt to "compete" with the producers of a show to uncover narrative knowledge.[60] Spoiling can now be a further step on the path to creating original fiction. The rhetorical awareness of the spoiler as narrative possibility exists in the fan community. In some small way, in a minute and seemingly innocuous manner, one way

fans could use spoilers is to produce paths to other possible narrative outcomes. By *not* erasing the spoilers once the "revelation" of the episode airs, the community appears to voice a collective appreciation for the narrative possibilities that are not, but could be, aired.

Narractive Research: Memory of the Narrative Moment

A third method of narractivity lies in the way fans use spoilers as a form of narrative research. Fans scour websites and news sources to find information with which they can construct a model of what is to come in the show. Narrative research demonstrates the emergence of fan-scholars, fans that use scholarly research methods to "express their love for a text."[61] Fan-scholars use content, textual, and rhetorical analysis, among other methodologies, to examine fragments of paratexts, secondary texts, and transmediated intertexts to assemble a spoiled reading of the extant media object's narrative story. In this way, fans attempt to construct a meaningful articulation of the "facts" of the narrative. By "facts," I refer to spoilers that later turn out to be accurate; that is, spoilers that represent pieces of information that detail events that eventually occur in the extant media object. As O'Neill shows, however, narrative "factuality" can have a different meaning. For O'Neill, a narrative story always appears factual, while a narrative discourse always appears fictitious, because the narrator's "multiple discursive possibilities" preclude a "discursive authority."[62] In other words, any discourse, shaped through a narrator's focalization, appears as though it is a reconstruction of events, and readers cannot trust it to be "true" to the story. Fan-scholars, however, can investigate ExtantWiki, and the database narrative, as if it were "factual," because it displays the story through the community's discourse.

Derrida provides us with another useful reading of the term "impression" which proves fruitful for investigating the fan-scholar. In his analysis, with which he uncovers and analyzes the archontic properties of Sigmund Freud and psychoanalysis, he describes this third reading of the term as "the impression *left* by Sigmund Freud" which is "in memory of the signs" of Freud.[63] In other words, it is an impression of *memory*, of the history of a subject and of a personality, which when described and inscribed leaves a mark in the mind. Spoilers as areas of research activity become these impressions, as they record memories of narrative, marks of research. For fans, the act of spoiling is not just finding out what is yet-unknown, but exploring the possibilities of future memories, or impressions of future events.

Thus, spoiling as research impresses upon the fan community that fan research is a legitimate and worthy activity. In undertaking this research, fans must verify and confirm all the narrative kernels they find, just as if they were researching an academic tome. As Ryan states, "we read fiction as nonfiction when we extract ourselves from its world and, switching reference worlds, assess its viability as a document of real-world events."[64] We can witness this on *Lostpedia* as fans research spoilers about the show. These kernels of narrative information become verified through fan-scholar research: they aren't fan fiction, they're fan fact. These fan-scholars must also face the realization that they might be encountering narrative spoiler kernels that have been falsely planted by the producers of the show, also called "foilers." As Carleton Cuse, one of the executive producers and writers of *Lost,* described in *Variety*: "We always write fake sides for the stuff we send to talent agencies and (casting) breakdowns ... We are casting characters under false pretenses."[65] Fans thus sift through kernels that could be purposefully misleading to find the kernels of story that might be "true"; or, rather, might accurately reflect the fans' view of the show.

In contrast to the *Heroeswiki* spoilers, which enumerate different fan theories without reference to accompanying citation data, the *Lostpedia* spoilers have extensive, referenced organization. The *Lostpedia* spoiler organizational page catalogs the spoilers into different categories: the first are spoilers about the meta-narrative of *Lost*, the second are spoilers for each individual episode of *Lost*, the third are spoilers about main characters, the fourth are spoilers about each recurring guest characters, and the fifth are general spoilers about themes and motifs that run throughout the narrative. Additionally, each category is subdivided into units: the episode spoilers are divided by each separate episode, while the main character spoilers are divided by the name of the character. The actual spoilers themselves are organized within each category, subcategory and unit chronologically by when fans discovered them. Next to the date of the discovery, fans have written the source of the information.

So, for instance, instead of randomly searching for spoilers about the recurring character of "Frank Lapidus," one need only examine the menu at the top of the spoiler page and find that any spoilers about him will be found in section 4, unit 3. The information is meticulously researched and shows that "Frank Lapidus" is to be played by "Jeff Fahey" and was learned on 08-28-07 from an article in *Entertainment Weekly*, found online.[66]

Such organization highlights a great deal of research and collection of data. One source of information, for example, comes from the DVD collection of Season 3 of *Lost*. The fan community acted quickly in adding the extra-textual features of the DVD to the wiki after its 11 Dec 2007 release. The extra-text on the DVD allows the viewer to learn more about the narrative through running commentaries by both those behind and those in front of the camera, as well as other special features like deleted scenes, featurettes, and documentaries about the making of the film. This extra-text represents knowledge *about* the narrative, not *in* it.

We can observe the emergence of the knowledge garnered by fans from the *Season 3* DVD through the spoiler site on *Lostpedia*. By 18 Dec, a mere week after the release of the DVD set, fans had added six new pieces of information to the spoiler site. We learn, for instance, that the character of Annie, seen only once before in the episode "The Man behind the Curtain" in the third season, "is an extremely important part of the island's backstory, and it is a planned chapter to come," and that "what happened to Annie is another chapter of Ben's story that will be seen at some point."[67] As more people watch the *Lost Season 3* DVD, more information is added to the spoiler sites. On 21 Dec, a contributor cites actor M.C. Gainey, who says that "Whoever is coming to this island next, they're gonna wish they had the Others back. We were scientists and humanitarians compared to what kind of animals are coming next." Fans label each of the new spoilers with a citation of where it was found: the 21 Dec contribution, for instance, is labeled "Season 3 DVD." In short, fans uncover and display units of information via an academic method of citation and verification. They spoil to make the show seem more researched, and provide a location for this research in the form of a wiki.

NARRACTIVITY AND THE NARRATIVE DATABASE

By interactively contributing to a growing enunciation of the meaning of a narrative, members of the wiki community integrate their communal/collective knowledge into a narrative framework. The narrative builds the community, just as the community builds the narrative. In the same way as blog authors intra-textually construct blog fan fiction, so too do communities in and on a wiki integrate narrative and interactivity in a narrative process to create wiki fan fiction. This integration also mirrors the way players of ARGs

integrate knowledge about the narrative of the game. This integration of narrative knowledge and interactivity heralds a shift in the way we think about online textuality and authorship; but even more so, it becomes a reflection of a changed media environment, one where individual texts—or individual viewers—become subsumed under a larger corpus.

At the heart of the matter, however, is the way these fans construct individual narrative episodes in their own discursive style. Each wiki page devoted to a particular episode, a synopsis or summary will retell the narrative discourse using, through hyperlinks, the story that has already been constructed. Far from negating the story-telling, however, this discursive practice instead illustrates the narrative possibilities that exist on a wiki. Because of the interactive elements of a wiki, the discourse is always in flux. One fan's construction of the narrative discourse might be different from another fan's construction of the narrative discourse. The narractive elements of the wiki provide the means for this interactive narrative database creation. This narrative creation also highlights the spoilers on the wiki as separate elements of fan fiction. They are not just guesses as to what might happen, but rather indications of what would happen in a different possible narrative. For every possible narrative world that exists, there exists every other narrative possibility as well. Spoilers represent narrative possibilities, indications of a plot that did not happen, but could.

NOTES

1 Jason Mittell, "Sites of Participation: Wiki Fandom and the Case of Lostpedia," *Transformative Works and Cultures*, 3 (2009), ¶2.36.
2 Marie-Laure Ryan, *Narrative as Virtual Reality* (Baltimore, MD: Johns Hopkins University Press, 2001), 147–8.
3 See, Henry Jenkins, *Textual Poachers: Television Fans and Participatory Culture* (New York: Routledge, 1992), 280–3; John Tulloch and Henry Jenkins, *Science Fiction Audiences* (London: Routledge, 1995), 10–15; Matt Hills, *Fan Cultures* (London: Routledge, 2002), 178–81; Cornel Sandvoss, *Fans: The Mirror of Consumption* (Malden, MA: Polity Press, 2005), 164; Jonathan Gray, Cornel Sandvoss, and C. Lee Harrington, "Introduction: Why Study Fans?" in *Fandom: Identities and Communities in a Mediated World*, ed. Jonathan Gray, Cornel Sandvoss, and C. Lee Harrington (New York: New York University Press, 2007), 1–16.
4 Jenkins, *Textual*, 154.
5 Nancy Baym, *Tune In, Log On: Soaps, Fandom, and Online Community* (London: Sage, 2000), 83.

[6] Abigail Derecho, "Archontic Literature: A Definition, a History, and Several Theories of Fan Fiction," in *Fan Fiction and Fan Communities in the Age of the Internet*, ed. Karen Hellekson and Kristina Busse (Jefferson, NC: McFarland & Co., 2006), 65.

[7] Jacques Derrida, *Archive Fever: A Freudian Impression*, trans. Eric Prenowitz (Chicago: University of Chicago Press, 1996), 26.

[8] Ibid., 64.

[9] Jean Baudrillard, *For a Critique of the Political Economy of the Sign*, trans. Charles Levin (New York: Telos Press, 1981), 16; see also, Rob Cover, "Interactivity," *Australian Journal of Communication* 31, no. 1 (2004), who shows how the interactive struggle for meaning in text revolves around the question of author and audience.

[10] Pierre Lévy, *Collective Intelligence: Mankind's Emerging World in Cyberspace*, trans. Robert Bononno (New York: Perseus, 1997), 138.

[11] *Lost* Mysterious Happenings (See, Appendix B).

[12] John Ness, "Mob Narrative," *Newsweek* (Atlantic Edition) 149, no. 10 (05 Mar 2007), ¶2.

[13] Eku Wand, "Interactive Storytelling: The Renaissance of Narration," in *New Screen Media: Cinema/Art/Narrative*, ed. Martin Rieser and Andrea Zapp (London: BFI, 2002), 164–7.

[14] Janet Murray, *Hamlet on the Holodeck: The Future of Narrative in Cyberspace* (Cambridge, MA: The MIT Press, 1997), 128.

[15] Robert Scholes and Robert Kellogg, *The Nature of Narrative* (London: Oxford University Press, 1968), 4.

[16] Mark O. Riedl and R. Michael Young, "From Linear Story Generation to Branching Story Graphs," *IEEE Computer Graphics and Applications* 26, no. 3 (2006), 23.

[17] http://perplexcitywiki.com/wiki/Main_Page.

[18] Marie-Laure Ryan, "Beyond Myth and Metaphor: Narrative in Digital Media," *Poetics Today* 23, no. 4 (2002): 581.

[19] Derrida, *Archive*, 1.

[20] Ibid., 2.

[21] Ibid., 4.

[22] Ibid., 26–7.

[23] Ibid., 16–17.

[24] Pierre Lévy, *Cyberculture*, trans. Robert Bononno (Minneapolis: University of Minnesota Press, 2001), 65.

[25] Henry Jenkins, *Convergence Culture* (New York: New York University Press, 2006), 27.

[26] Derrida, *Archive*, 3, 68.

[27] Ibid., 11.

[28] Ibid., 12.

[29] *Heroeswiki* Spoilers (See, Appendix B).

[30] Derrida, *Archive*, 5.

[31] Rebecca Williams, "'It's about Power': Spoilers and Fan Hierarchy," *Slayage: The International Journal of Buffy Studies* 3, no. 3–4 (2004), http://slayageonline.com/Numbers/slayage11_12.htm (accessed 14 March 2008), ¶6.

[32] Jeffrey Sconce, "What If?: Charting Television's New Textual Boundaries," in *Television after TV*, ed. Lynn Spigel and Jan Olsson (Durham, NC: Duke University Press, 2004), 108.

[33] Charles Soukup, "Hitching a Ride on a Star: Celebrity, Fandom, and Identification on the World Wide Web," *Southern Communication Journal* 71, no. 4 (2006), 327.

[34] Laura Carroll, "Cruel Spoiler, that Embosom'd Foe," *The Verve: A Literary Organ*, 09 Oct 2005, http://www.thevalve.org/go/valve/article/cruel_spoiler_that_embosomd_foe (accessed 25 Sept 2008), ¶3; as quoted in Jonathan Gray and Jason Mittell, "Speculation on

Spoilers: *Lost* Fandom, Narrative Consumption and Rethinking Textuality," *Particip@tions* 4, no. 1, http://www.participations.org/Volume%204/Issue%201/4_01_graymittell.htm (accessed 28 Dec 2007), ¶20.

35 Williams, "Fan Hierarchy," ¶3.

36 Ibid., ¶42.

37 Derek Foster, "'Jump in the Pool': The Competitive Culture of Survivor Fan Networks," in *Understanding Reality Television*, ed. Su Holmes and Deborah Jermyn (London: Routledge, 2004), 286.

38 Jenkins, *Convergence*, 25.

39 Gray and Mittell, ¶22.

40 Ibid., ¶47.

41 Derecho, 76.

42 Gray and Mittell, ¶47.

43 See, Jenkins, *Convergence*, 25.

44 Keith M. Johnston, "'The Coolest Way to Watch Movie Trailers in the World': Trailers in the Digital Age," *Convergence* 14, no. 2 (2008), 148.

45 *Lost* Season 4 Spoilers (See, Appendix B).

46 Nancy Baym, "The Lost Librarians of National Defense," *Online Fandom: News and Perspectives on Fan Communication and Online Life*, 30 Apr 2008, http://www.onlinefandom.com/archives/the-lost-librarians-of-national-defense (accessed 01 May 2008), ¶3.

47 Mitch Wagner, "Lost Fans Find Internet Thrills Via Wikis, Games, Second Life," *InformationWeek*, http://www.informationweek.com/news/personal_tech/virtualworlds/showArticle.jhtml?articleID=207401542 (accessed 02 May 2008), ¶9.

48 We can see the ways, specifically with *Lost*, that narrative kernels and satellites appear transmediated in Jason Mittell, "The Loss of Value (or the Value of *Lost*)," *FlowTV* 2, no. 5 (2005), http://flowtv.org/?p=165 (accessed 08 Sept 2008); Jason Mittell, "The Value of *Lost*, Part Two," *FlowTV* 2, no. 10 (2005), http://flowtv.org/?p=435 (accessed 08 Sept 2008) and Jason Mittell, "Narrative Complexity in Contemporary American Television," *The Velvet Light Trap* 58 (2006).

49 Jack Shephard; John Locke (See, Appendix B).

50 Derrida, *Archive*, 26.

51 See, Jonathan Gray, *Show Sold Separately: Promos, Spoilers, and Other Media Paratexts*, (New York: New York University Press, 2010).

52 *Heroeswiki* Episode: Powerless Trivia (See, Appendix B).

53 *Lostpedia* Main Page (See, Appendix B).

54 *Heroeswiki* Episode: Powerless; *Heroeswiki* Episode: Powerless Summary; *Heroeswiki* Episode: Powerless Characters; *Heroeswiki* Episode: Powerless Full Summary (See, Appendix B).

55 Paul Cobley, *Narrative* (London: Routledge, 2001), 205.

56 Derrida, *Archive,* 10; See, also David Gunkel, *Thinking Otherwise* (West Lafayette, IN: Purdue University Press, 2007).

57 Derrida, *Archive*, 29.

58 *Heroeswiki* Spoiler: Powerless (See, Appendix B).

59 Ryan, *Narrative*, 99.

60 Jenkins, *Convergence*, 25–31.

61 Hills, *Fan Cultures*, 19.

62 Patrick O'Neill, *Fictions of Discourse: Reading Narrative Theory* (Toronto: University of Toronto Press, 1994), 159.

63 Derrida, *Archive,* 30.

64 Ryan, *Narrative,* 105.
65 Quoted in Cynthia Littleton, "'Lost': The Weight of the Wait," *Variety*, 12 Oct 2007, http://www.variety.com/article/VR1117974014.html?categoryid=2641&cs=1 (accessed 13 Mar 2008), ¶27.
66 Jeff Jenson, "'Lost' Adds Fifth New Cast Member," *EW,* 2007, http://www.ew.com/ew/article/0,,20053479,00.html (accessed 01 Dec 2007); *Lostpedia* Season 4 Spoilers (See, Appendix B).
67 *Lostpedia* Season 4 Spoilers (See, Appendix B).

Chapter Six
Interreality and the Digi-Gratis

At this point in the story, the line between fantasy and reality appeared rather tenuous. The flesh-and blood Corso ... was increasingly tempted to see himself as a real character in an imaginary world. But that wasn't good. From there it was only a small step to believing he was an imaginary character who thinks he's real in an imaginary world. Only a small step to going nuts...
—Pérez-Reverte, The Club Dumas, p. 260

Jim's Interests: General: Working out, hanging out at the local bars, expanding my mind, eating Tuna Sandwhiches...or so I'm told and poker... Television:... this show that's on Thursday nights at 8:30pm...I can't place the name of it but it has this crazy interview style thing...[all sic]
—Jim, on MySpace

The Club Dumas, while on the surface a novel about the horrors of occult fanaticism, also delves into discussions about the nature of identity, self, and fictionality. Identity, an intangible and complex topic, emerges as a theme in *The Club Dumas* time and again, as the book collectors base part of their identity on the characters they read about in Dumas' oeuvre. Indeed, fans of any media text—be it book, opera, film or television show, base part of their identity on that text: as Sandvoss explains, we constantly use media to define us, for a text "is intrinsically interwoven with our sense of self, with who we are, would like to be, and think we are."[1] Fans can use media texts as a metaphoric "call-sign," identifying themselves as a fan through the clothes they wear (fans of music and of sports often do this), the ancillary products they purchase, or the discussions they have with other fans.

One important aspect of this definition of the self can take place online, in virtual worlds like Facebook and MySpace. As online environments grow

more and more populous—as of December 2009, the population of Facebook profiles outnumbers the population of the United States[2]—it becomes crucial to understand the relationship between our virtual lives and our physical lives. As an illustration of this, ARGs are largely played online, in virtual environments like wikis, blogs and websites. But importantly, many ARGs cross over into the physical world as well: players are often asked to travel to physical locations and participate in "real world" activities. What, then, is this relationship between the real and the virtual? How does one intersect into another, and does it even matter?[3] In terms of our everyday lives, how do our virtual identities and our physical identities intersect?

For viewers of media objects, the Web Commons offers a variety of inter-, intra- and extra-textual ways of constructing and construing an external identity. For example, many media producers have created fictional websites for television show characters which appear "real" (that is, they appear as though they were made by the character in the diegetic universe of the show). Fans can thus seemingly interact more directly with the extant media object by clicking on fictional webpages that purport to depict the personal webpages of the characters.[4] As Jenkins and others have shown, extant media objects no longer encompass just the movie, TV show, or video game: instead, through the spread of narratives across different media, the audience's understanding of that narrative comes through a reconstruction of the fluid nature of this mediation.[5] In fact, by distributing narrative across media boundaries we find that fans encounter *more* ways to construct their "senses of self" than in the past.

In particular, Social Network Sites (SNS) like MySpace present virtual spaces in which fans can construct profiles of television characters, and then interact with those characters as if they were "real" people.[6] For example, the second quotation that inscribes this chapter comes from the profile of the character Jim from the television show *The Office*.[7] Although some of the narrative information in the quotation comes directly from *The Office* (for example, there is a running joke about one character's obsession with Jim eating a tuna sandwich), other information comes from the fan's rewriting of the character (for example, Jim's musical taste). Other narrative information is itself non-diegetic, as when the fan writes that Jim's favorite television show airs "Thursday [sic] nights at 8:30pm"—the night and time that *The Office* was on. The construction of these fan/character personas on MySpace represents a playful way for fans to interact with a character from the televi-

sion show: instead of identifying with the character as an external narrative object, the fan can literally roleplay the character as the fan sees him/her. This new form of interaction with a digital document takes place in a dynamic interreality of physical and virtual identities. The interreal concept of the "mash-up," represents a created object itself poised between subversion and support of a commercial economy. A mash-up here is not mere hybrid or convergence, in which the separate components lose their individual distinctiveness as they are subsumed in/by the converged culture, but rather each maintains its distinctiveness while, at the same time, creating something new.

For example, audio mash-up artists made use of the concept of music piracy as "a source of distinction," as John Shiga puts it, in which participants distinguish themselves "by invoking the threat of legal sanctions such as cease-and-desist orders … [and] acquire recognition and prestige." As he goes on to point out, mash-up artists use the most popular, commercial "Top 40" music as source texts, and then tout that very illegality as a marker of value.[8] The flouting of market economics leads to a higher social and subcultural capital for the artists. Many mash-up artists, for example, "Girl Talk," then release their albums online for free, or for a user-defined fee. The *mash-up* becomes less of a money-making scheme than it does an experience in subverting the system for value not in a monetary sense, but in a socially constructed one. Value, in a mash-up culture becomes a concept thus steeped in both finance and in relationships.[9] In terms of fandom and New Media Studies, the mash-up of the virtual and the physical identity of fans and users of New Media exemplify an interreal examination of online self.

REPRODUCING THE FAN COMMUNITY

So far, we have seen how fans enact a complex process of rewriting the extant media object as fan fiction and then rereading that fiction through the lens of the fan community. In this chapter, I explore a third part of this system of fan appropriation, the reproduction of the fan community. Through the process of rereading within a community, fans identify with the media object as a part of that community's own self-identification, and reproduce that fan community by applying the mores and socialization of fandom via other contexts.

MySpace represents an obvious example of this reproduction, as fans congregate on MySpace and create visible links between members of the fan

community. They literally scribe the community into existence, and write that community into the extant media object. Furthermore, by creating personas of media characters, the fan infuses the character with new characteristics, and the fan/character amalgam becomes a mash-up of both the fictional identity of the character and the virtual identity of the fan—a mash-up of the digital world and the offline world "persona-fied" in the concept of the interreal. This type of roleplay offers fans another way of enacting a philosophy of playfulness, with both the media text and the community of fans: roleplay allows fans to perform a new meaning of the text in a visible way, and playing with the character necessarily involves playing within a community of other fans.

DIGI-GRATIS

The metaphor of the mash-up offers another opportunity for New Media Studies: the presence of fandom in the Web Commons exists as a mash-up of two different economic forces which, while always having been present in contemporary culture, are reaching a climatic and dramatic juncture. These economic forces—the market economy of industrial production and the gift economy of shared exchange—mark two separate, but unified, areas of economic research. As economist Alan Schrift shows, "where commodity exchange is focused on a transfer in which objects of equivalent exchange value are reciprocally transacted, gift exchange seeks to establish a relationship between subjects in which the actual objects transferred are incidental to the value of the relationship established."[10] In other words, while the market economy describes the buying and selling of goods, the gift economy articulates the establishment of relationships among its participants, the formation of a community.

However, contemporary digital economies represent more than just this either/or scenario of market or gift. The way fans buy, sell, trade, relate, and exchange on the Internet retains individual characteristics of both the market and the gift, but, importantly, also diverges from these economic systems to form something new. The creation of fan communities and content all exist in this mash-up economy, as cult fans make use of products that have been designed in a market economy, but use them in order to promote social construction in a manner reminiscent of a gift economy. MySpace is an exemplar space in the mashed up Digi-Gratis economic structure.

I offer the term "mash-up" to linguistically differentiate my conception of the Digi-Gratis from Lawrence Lessig's conception of the hybrid economy. The main difference between Lessig's hybrid economy and the Digi-Gratis economy lies in the way the two requisite economies interact within the new economic system. Initially, Lessig argues that both requisite economies have to work *with* each other: "no distinction between [the] 'sharing' and 'commercial' economies can be assumed to survive forever, or even for long."[11] In other words, the hybrid economy converges the two distinct economies into a single, unified economic structure. He later states, however, that the link between the two, "simpler" economies "is sustained, however, only if the *distinction* between the two economies is preserved."[12] In other words, Lessig's contradictory stance shows the hybrid economy as both a *convergence* of economies and in an irreconcilable *tension*. Lessig's solution to this contradiction is to assume that one economy alternatively dominates the other, depending on the situational transaction. For example, the video hosting site YouTube offers a space for users to upload their own videos for free; however, it also provides the mechanics for video creators to link to online stores as an overlay on the videos. Both economies are working, but the overlay offers a visual confirmation that one always dominates the other.

In contrast, the Digi-Gratis economy assumes that both economies are crucial for the functioning of a complete economic system, and work together, always. Fans create "gifts" out of the products they purchase in the market economy, and the market caters to the fan culture by offering free services that fans can interpret as gifts. Recently, this can be seen in networks streaming videos online. The Digi-Gratis economy is not *new*, in as much as both economies, the market and the gift, have been working in tandem for hundreds of years. Digital technology simply highlights this economic interaction.

The coexistence of fan texts as both commodities and gifts forms through the way fans view the inherent worth or value of a television text. An audience can inscribe this value into the television, or producers can design a cult show with the intention of audiences inscribing value to it. For example, Gwenllian-Jones describes of some textual devices put into *Xena: Warrior Princess* by media producers to attract a cult fan audience: "intertextuality, metatextuality, self-referentiality, story-arc and stand-alone episodes within the same series, an exaggerated play of fracture and textual excess and generic interconnections with wider subcultures."[13] Additionally, genre spe-

cialty channels like the Sci-Fi Channel both create and target cult audiences by designing media products like *Battlestar Galactica* as long-running serial narratives.[14] This dual inscription assumes that cult fandom cannot be associated with *just* the market economy or the gift economy. In other words, value comes not just from market production, or from fan consumption, but through a complex interaction of both. To describe more fully this Digi-Gratis economy, we must understand that first, while market economies underscore the *production/consumption* dichotomy relationship, digital technologies alter this relationship; and second, that the nature of the media text itself as multi-modal process (and not static object) results in an Lacanian-esque pursuit of desire, one which cultivates fans as both consumers and as gift-givers.

Consumption Does Not Imply Destruction

Traditional media studies concentrate on the fan as part of an economic binary between *producer* of media content and *consumer* of media content in a market economy. The "media text" itself is seen as an object received and consumed by the fan. The fan may poach the text, may reinterpret it, or may tactically respond to it; but importantly, will first consume the text, and only then will interpret it. The gastronomic metaphor of fandom has provided a sense of the media text as a concrete "whole" upon which the fan devours. The metaphor only becomes complete when we realize that profit in a market only comes about because *consumption also implies destruction*—the destruction of possession, and the destruction of demand. (Taken to its logical conclusion, of course, this metaphor also leads one to see of what caliber most people consider fan fiction: the product of extreme gastronomic excess.)

In contrast, however, the *modus operandi* of the Web Commons is not the production of material goods, but rather the production of knowledge, of the production of information.[15] As information becomes the commodity traded online, digital technology, the Web Commons, and the activity of fandom has questioned this gastronomic assertion of the market economy.[16] Unlike physical goods, there is no "loss" from the production of information.[17] Indeed, there can be no true "ownership" of information, as Ghosh points out: to keep information to yourself is to make sure that no one knows that you have it to begin with.[18]

This form of information ownership helps make visible a new economic model online, a gift economy that deals less with monetary exchanges and more with the socialization of information. Specifically, as Jenkins et al. show, aspects of the gift economy have been tied into the web from its inception: "values were built into the infrastructure of the web which was designed to facilitate the collaboration of scientists and researchers rather than to enable the metered access expected within a commodity culture."[19] From early researchers like Howard Rheingold to more recent like social media expert danah boyd, the metaphor of the gift economy has been central to the web.[20] This is one reason why major media corporations, whose economic foundation has roots in the market economies of the late nineteenth and early twentieth centuries, are having trouble containing the illegal downloading of consumers in the early twenty-first century. Piracy appeals to fans not just because it is free, but also because it becomes a form of subcultural capital, a practice that takes advantage of the gift mentality fostered by the web.

As opposed to the market economy, gift giving does not depend on monetary value: gift exchange is defined by the absence of financial calculation. Gifts also differ from commodities in that they depend on some sort of interpersonal dependence: "the giver of a gift remains an element of the good or service and does not alienate himself from it."[21] Ritualized gifting—the structured and ordered exchange of items of significant symbolic value—depends more on the community in which the giving occur than it does on the actual items given.[22] Giving creates social life, as William Merrin shows in his description of gift-giving cultures:

> Giving [brings] **social rank**, with the capacity and willingness to give bringing honor and respect; it [creates] **strong social relations**, as a positive act of communication forming affective ties and alliances between families or tribes; and it [brings] **social power**, creating a power relation of indebtedness, obligation and loss of face, with honor only being regained through a counter-gift.[23]

Although we are more familiar with our contemporary market economy, relatives of gift-giving economies still exist today: an example would be the giving of rings as a ceremonial gesture in marriage, one that symbolizes, as Baudrillard cites, a "social logic" of consumption.[24] We give rings to symbolize union, companionship, and completeness.[25] Further, to bring a bottle of wine or an appetizer to a social gathering is not just to provide libation or sustenance, but to bring camaraderie and friendship as well.

Giving gifts, as described by Mauss, is a three part system of ritualized exchange: the giving of the gift leads to an obligation to reciprocate, that is, to give a gift back at a later date, which in turn leads to the obligation to receive the gift.[26] In fact, to reciprocate a gift means not just that one *should* return a similar gift, but also that one *must*, by all rights, give a gift of equal or greater value back. Once a gift is given, one is obligated to receive it—we cannot refuse an appetizer brought to a dinner party (no matter how slimy) without risking insulting our guests, damaging our social reputation, and complicating our relationships within the community. Once received, we are then obligated to reciprocate that gift—to bring our own (less slimy) appetizer when we are invited over for dinner.[27] If we do not reciprocate, we have committed a social faux pas. These three obligations—to give, to receive, and to reciprocate at a later date—describe a social situation in which the actual gifts given matter less than the fact that they were given and received.

Ultimately, the relation between gift and market both emerge from a central concept. Both economies rely on the notion that there is or will be a limited supply of goods: once they are sold or gone, there are no more. In a market economy, this becomes apparent because, at some point, the consumer will not have something he/she needs or wants, and will be forced to buy it from a supplier. The consumption of the goods implies the destruction of the goods, as the term "consumption" implies the utilization of perishable goods. A market economy, further, survives by convincing people they need more objects, thus creating a demand. Similarly, a gift economy also relies on the notion that there are no more objects, but conversely: a gift is meaningless unless the giver no longer has it. Indeed, having an object represents the possession of power. Giving a gift implies loss and sacrifice. The gifting of an item implies the destruction of the possession of that item: by giving it, I destroy my possession of it but create my own loss.[28]

Thus, if digital technology no longer requires the destruction of the original, and key to gift-giving was the sense of obligation created from the loss of the gift, how can we call the sharing of information "gift-giving"? If, as Derrida shows, we can only give knowing that we will no longer have it—but we still retain what we have given, digitally—does what we transfer over the network constitute a gift?[29] In fact, it does, but with a caveat: the new gift, the digital gift, is a gift without an obligation to reciprocate. Instead of reciprocity, what the gift in the digital age requires for "membership" into the fan community, is merely an obligation to reply.

The difference between reciprocity and reply lies in the status of the object given. To reciprocate, one must give back or return mutually, in kind. There must be an equal amount given as taken. However, by "reply" one simply needs to respond, that is, to give an answer in receipt. "Reply" does not imply a quantitative degree of response, but rather an acknowledgment. To obligate a reciprocation of a digital gift is to necessitate a measurement either in bits or in length. To obligate a reply to a digital gift, however, is only to ask for a moment for communion. To institute a communicative reply is to draw "persons together in fellowship and community," as Carey writes, and is thus to strengthen the communal ties amongst members of a group.[30] The more communication undertaken, the stronger the group becomes. Thus, while giving a digital gift might differ from the terms set out in traditional gift economies, it is similar in its social bonding experiences.

What we find in the Web Commons, therefore, is the remnants of both the market and the gift economics exist side by side. The commercial aspect of the web—the buying and selling of goods—exists in full force (as the popularity of amazon.com and other e-sellers continues to eclipse traditional brick-and-mortar stores), but adjacent to it is the sense of the web as a vast repository of digital gifts (free downloads, free streaming video, free offers abound). It's not that one dominates, or will dominate depending on the situation, but that both exist *simultaneously*. In both the market and the gift economies, the sense of consumption/destruction is strong; but the existence of the *other* economy reverses that sense for the first. The consumptive attitude in the market economy is negated by the digital reproducibility of the gift; the sense of loss in gift-giving is annulled by the sense of possession which emerges from the market economy.

Hau and Fetish: Desiring the Process

A second factor in the emergence of the Digi-Gratis is the transmediation and serialization of contemporary media products, as contemporary cult texts defer narrative closure, creating desire through unfulfillment.[31] Early in his germinal book *The Gift*, Mauss asks the question that plagues him throughout his investigation: "What power resides in the object given that causes its recipient to pay it back?"[32] This power he eventually describes using the Maori word *hau*: the power of the object, the inherent individual essence, or the spirit of the object.[33] Mauss found that the *hau* was, for many participants in a gift economy, an innate quality that necessitated its exchange. Indeed,

we can see this *hau* for the participants in a gift economy as the supernatural elements of the gift itself. Following Durkheim's description of the sacred as society's unexplainable events, Mauss investigated the way this socio-religious power contributed to the social significance of gifts.[34] Thus, those that participate in a gift economy find that "things given have a soul that compels them to return to their original owner."[35] Indeed, this feeling reso-nates for some fans, as the "power" of the media object can seem to come from that object.

Like Mauss, Marx too finds power in things, although his value comes from the social significance of the object itself. This he calls "commodity fetishism," or the process by which a product, "as soon as it emerges as a commodity, it changes into a thing which transcends sensuousness"—in other words, the value-added of the commodity shifts contains inherent worth.[36] For Marx, fetishism surrounds commodities because of the nature of the commodity itself.[37] The "commodity fetishism," however, perverts the notion of an exchange. While gifts have a quality—a *hau*—that makes them worth owning, this quality—the fetish—also causes them to be more than mere constructed objects: they become socio-cultural products.[38] Participants in the market economy embrace this fetishized version of the commodity, taking it into the "misty realm of religion," where commodities become worshiped, sought after, and revered, as if sacred.[39] Baudrillard extends Marx's argument, showing that this religious fetishism is deliberately de-ployed in society in order to turn the commodities into signals of status that center around the hierarchical, power-based society created around the object. When objects are exchanged, the object loses its "objectness" and becomes part of the relations of exchange, or "the transferential pact that it seals between two persons."[40]

In modern cultures, according to Baudrillard, this notion of community-through-exchange has disappeared and been replaced by the sense of a "se-miotic exchange." *Hau* has become fetishized. Semiotic exchange sees objects not as integral in *representing* social arrangements, as in our example of the wedding ring, but rather sees objects as *replacing* social dynamics. In other words, to consume a product is not to enter into a social arrangement with another, but rather the exact opposite, to engage in a form of outclassing one another. In other words, objects have more significance, more cultural worth, and more inherent value than do the people that use them. Apple's iPhone serves as a good contemporary example of this symbolic meaning:

although other phones may be more powerful or better designed than this Apple product, ownership of this product is important because of the symbolic status it bestows upon the owner.

In his famous critique of Mauss, however, Lévi-Strauss argues that the *hau* "is not the ultimate explanation for exchange; it is the conscious form whereby men ... apprehended an unconscious necessity whose explanation lies elsewhere."[41] In this, the *hau* represents not a mystical force, but rather, like Marx's assessment of fetishism, a feeling inscribed by the community to that object. Whereas Mauss sees the *hau* as emanating from some inherent, mystical value in the object itself, Lévi-Strauss argues that it comes from the value others place upon that object.

Consequently, the concepts of *hau* and fetishism both deal with the Lacanian concept of displaced desire. On the one hand, the fetishized object is never enough: the desire to own contributes to the feeling of lack which can never truly be fulfilled. On the other hand, the desire for a *hau* appears to emerge, as Mauss would indicate, from the object itself. Trading objects back and forth promotes social relationships, but leads to a lack during the expected exchange. In the gift economy, it is the lack caused by the giving of the gift (a gift kept is a gift ungiven); in the market economy, it is the lack caused by the desire to own, to become part of the commodity culture prescribed by the media producers themselves. But as we've seen, cult narratives emphasis this lack: they promote it as a way of garnering and keeping viewers. Ironically, the market economy thus values the community formed via the fetishized product while the gift economy values the object itself as a commodity. Our economy, in this way, has always been hybridized.

Thus, to construct a cult text, a media producer need only focus on a few key elements to give the text a sense of lack. A cult text focuses on a serial plot, an extended narrative structure, and on far-reaching ideas and imagination.[42] Through the development of these characteristics, media producers hope to raise questions about the narrative: questions that fans will have to tune in to answer. As we have seen, Hills extends this analysis, arguing that the cult text "focuses its endlessly deferred narrative around a singular question or related set of questions."[43] Answering these questions is the fan community, a culture of fans that exists around the cult text to fill in these deferred narrative elements.[44]

To define a text as a cult, as an "endlessly deferred narrative," is to assert an active negation: a show is what it constantly defers, what it constantly

does not show. A cult show's meaning exists not in any one place, but rather in the ethereal location in-between answer and question, in-between desire and the fulfillment of desire.[45] From the psychoanalytic perspective, this eternal displacement of "lack" represents nothing more and nothing less than reality itself. For Žižek, reading Lacan, "the realization of desire does not consist in its being 'fulfilled,' 'fully satisfied,' it coincides rather with the reproduction of desire as such, with its circular movement."[46] Desire always occurs through a postponement of the realization of that desire: we always must desire, for what we desire is desire itself. For the cult narrative, the fan realizes a desire to see a full rendering of that cult world, "the creation of a vast and detailed narrative space, only a fraction of which is ever directly seen or encountered within the text."[47] This expansiveness of desire was crucial to Mauss's argument about the gift as well: The cycle of gift giving perpetuates because we desire the desire for giving, for receiving, and for reciprocating. The cult text is the literary equivalent of that desire, brought to the fan by the media producer as a *product*, but experienced by the media fan in the same way she might experience a gift.

Cult fans thus encounter their lack and their desire in two ways: first, in the deference of the narrative; second, in the deference of having watched the show and feeling the need to "give" back. In the market economy, we would emphasis the monetary contribution: buying the DVDs, the shirts, the episodes on iTunes. In the gift economy, we would emphasis the fan fiction, the gossip, the conversations. But in the Digi-Gratis economy, other factors become apparent: none, perhaps, more visible than the creation of fan/character profiles on MySpace, which mashes up the very notions of monetary exchange and fan fiction.

INTERREALITY

A visible representation of this Digi-Gratis economy can be seen through the creation of character profiles on MySpace. I call this representation an "inter-reality," by which I mean a digital space that blurs distinctions between the virtual and the "real." By mashing up the identities of the television character and the fan, the profiles function both as fan gifting (giving a form of fan-created fiction to the fan community reproduced on MySpace) and of fan marketing (as the profiles themselves become forms of advertising for the media product). For example, Gwen Cooper, character from the BBC televi-

sion show *Torchwood*, has a number of profiles created for her on MySpace. One of these profiles in particular demonstrates clear-cut interreality: on the one hand, this profile is a not-for-profit expression of a devotion to a media text; a love for the show *Torchwood*.[48] The creator doesn't just make the profile in order to talk to her friends, but rather there is a deliberate use of the profile to demonstrate an identity of the creator as a "fan" of the show *Torchwood*. The profile becomes a way of "putting on" *Torchwood*—and Gwen Cooper especially—so that the fan identifies not just as *fan* but as *fan-of-Gwen* (and thus identifies *as* Gwen). On the other hand, however, the profile also works as free advertising for *Torchwood* itself, as anyone who stumbles across it, or any of the creator's friends who are also on MySpace, may discover the show through this profile. Thus, because the profile was made by a fan, it allows other friends of the fan to experience *Torchwood* not just as a television show, but as a narrative dispersed across different mediations.

The creator of this profile posts information about the character ("I'm part of a top secret 'Special Ops' team") in the About Me section, describing attributes of the fictional character. Thus, the profile does purport to be a persona of Gwen Cooper from the show—as if she had written it herself (or, perhaps, if the BBC had created one for her, as we will see in the next chapter). This writing becomes the character identity. Further down the profile, however, the fan then breaks the "fourth wall" and reveals to her readers that she is "not, and do[es] not claim to be, either Eve Miles [the actress] or Gwen Cooper [the character]."[49] This disclaimer is obviously a product not of the character's profile, but of the fan herself: with it, she directly addresses the reader of the MySpace profile. This is the fan identity, and with this disclaimer, the MySpace fan/character persona is complete: The persona becomes neither just a profile of the character, nor of just the fan, but of a mash-up of the two. That is, the identity of the MySpace profile itself is neither the fan's nor the characters, but is rather a unique entity in and of itself. Profiles as representations of this identity exist neither wholly online, nor entirely in the "real world," but rather in the interreal spaces between the online and the offline world. Through the creation of these fan/character amalgams, fans redefine the boundaries of identity online as they both create and contribute to the development of extant media characters.

Identity Definitions

Although it is beyond the scope of this book to explore all the intricacies of identity theory (especially in terms of the post-structuralist vein of this book's methodology), it is useful here to pause to lay out some important ways that I am using the terms "identity" and "virtual identity," and how they relate to the larger concepts of interreality, Digital Fandom, and especially how both these function in New Media Studies.[50] As represented by the ARG, one tension that repeatedly comes to a head is that between the physical world and the virtual, or the way in which virtual activities can play out in real-world situations. For ARGs, it's not that there is no difference taking place online and those that take place offline; it's that that difference doesn't really matter to the players. For example, players of *The Art of the Heist* had no problems translating their online search for information to an offline car dealership. Also, players of *ilovebees* sought out GPS coordinates in the "real world" when the online component of the game provide them. Similarly, when experiencing obviously faked or made-up character profiles, the differences between a virtual and a "real" identity hardly seem to matter.

By the term "identity," I refer to Stuart Hall's description of the concept as a doubled referent, a "point of *suture*," between "the discourse and practices which attempt to 'interpellate,' speak to us or hail us into place as the social subjects of particular discourse," and "the processes which produce subjectivities, which construct us as subjects which can be 'spoken.'"[51] In other words, Hall sees identity as already existent in between a prescribed identity built from external forces and a self-realized, internal identity, a "sense of self." Further, as Hall points out, identities are always in flux, as "identity" itself is a complex and multifaceted concept that uses "the resources of history, language and culture in the process of *becoming* rather than being."[52] One never is, but always is in process.

The term "virtual identity," on the other hand, comes from Dutch legal scholar Jacob van Kokswijk, who has defined the virtual identity as a "representation of an identity in a virtual environment, [that] can exist independently from human control and can (inter)act autonomously in an electronic system."[53] Van Kokswijk's definition of "virtual identity" is, in turn, made up of two other definitions: the "online identity," a perceived view of who you are when online," and the "digital identity," which he defines as the "representation of identity in terms of digital information."[54] We can think of the online identity as akin to the mental construction of the voice at the other

end of a telephone call: the body on the other side of the AIM conversation. The online identity is who we think others are while they are online. The digital identity is literally the visual representation of the code that differentiates each separate identity online; the HTML that stands in for that person's identity. For van Kokswijk, the virtual identity is a construction of the online and the digital, with characteristics that exist online even when the user is offline.

Van Kokswijk's definition of "virtual identity" is useful because it mirrors, in many ways, the construction of a MySpace persona: When other people post comments on a MySpace persona, that persona becomes a continually updatable identity, which exists independently of the person who created it. Importantly, van Kokswijk's definition implies a *mechanical* alternation of the virtual identity, although I use the term more generally to refer to any change of a persona not enacted by the creator of that persona. Like identity itself, a virtual identity is not necessarily a stable construction, however, for "when a user creates an identity, it can be a conscious construction, it can evolve subconsciously over a period of time, or it could simply be a reflection of the user in real life."[55]

Finally, the term "interreal" comes from electronic/interactive artist Roy Ascott, who describes our digital culture as "post-biological age" where each computer or digital terminal becomes part of a "complex and often widely distributed system, in which both human and artificial cognition and perception play their part."[56] All human knowledge is connected and accessed through a series of interconnected, interactive discussions. All human inquiry—be it the disciplinary knowledge of the academy or the experiential knowledge of the individual—are attempts to understand a greater truth. Knowledge is a metaphor for comprehending this truth. For Ascott, all knowledge can thus be broken into a "discontinuous, multi-layered set of events."[57] Indeed,

> we have abandoned the model of a continuous reality whose essence is revealed to us in greater or lesser profundity according to some mental skills or tricks we have picked up in the schoolroom or the laboratory. These layers are so stacked that there is no hierarchy of layers, no top or bottom, no first or last. Insight then is derived from access to these layers, seeing all hypotheses as transient, looking only for usefulness in the metaphors they variously present, rather than abiding truths.[58]

This space of stacked layers of knowledge, he claims, is an "inter reality set between the virtual and the 'real.'"[59] Ascott's "inter reality" is a theoretical concept suited for examining the connections between different concepts in the sciences, arts, and technologies.

My use of the term "interreality," however, differs in important ways from Ascott's. While I embrace Ascott's use of the term "inter real" as a concept between the virtual and the "real," I extend the term to describe not only a particular knowledge space, but also the creation of a particular set of virtual constructs. As van Kokswijk shows, a virtual identity exists also in a form of the interreal that mixes "the virtual and physical realities [of people online] into a hybrid total experience."[60] Thus, I put van Kokswijk's virtual "face" on Ascott's conceptual inter reality to show the "interreal" as a conceptual arena where virtual identities can commingle and create a new "space," and its application to Social Network Sites.

SOCIAL NETWORK SITES:
A CRITICAL UNDERSTANDING

MySpace is one in a growing number of online Social Network Sites (SNS) on which users create profiles, as well as view the profiles of others. Each profile becomes a representation of the creator by describing the creator's physical characteristics (height, hair color, eye color), situational characteristics (place of residence, job, relationship status), opinioned characteristics (favorite movies, favorite books), relational characteristics (lists of friends, lists of offline social networks), and pictorial characteristics (photographs). SNSs are places where, as Jenny Sundén writes, one can "type oneself into being."[61] Social network sites make explicit the identity work we all do every day: we are always constructing our façade, our identity on a daily basis. Fans, as well, use MySpace to define their sense of self. For van Kokswijk, an individual's "identity" can be broken into two constituent parts: the "I," or the unique self-awareness and self-reflection of the individual, and the "me," or the aspects of the core accessible by external observers.[62] Like Hall's sutured identity, these parts of the conception of the self work in tandem. The "I" part of an identity—the "self"—is, for van Kokswijk, the part that can never fully be digitized, never fully be written online. The crux of this "I" is that it can never be stable, and reflects the subject's experiences as an ever-changing array of alternatives. The "I" is unique, personal, and not fully

writable: Whereas the "me" is performed, and represents characteristics the "I" wants others to observe, in order to control the impression of those who *do* observe.[63] For van Kokswijk, therefore, MySpace offers a space where individuals can display their "me" characteristics without fully representing (or even being aware of) their mutable "I" characteristics.

Importantly, therefore, if all personas on MySpace are made up of "me" characteristics—that is, characteristics that are deliberately made observable—then any one persona's characteristics occupy the same ontological space as another persona's. Personas cannot be "true" or "false," only more or less performed.[64] The dialectical composition of identity on MySpace has enormous consequences for New Media Studies. Take, for example, the case of Lonelygirl15. Hundreds of thousands of viewers watched the video-blog of this teen on YouTube and friended her on MySpace in 2005 and 2006. In 2006, however, Lonelygirl15 was revealed to be a fabrication. Two men had created the persona "Lonelygirl15," hired a 19-year-old actress named Jessica Rose to play her, created her MySpace page, and filmed her in a impression of video-blog style. Fans of Lonelygirl15, however, did not care: instead, they "seemed to take the revelation [of her "fictionality"] in stride" and "to many, it did not seem to matter whether she was real or not."[65] It did not matter because her "me" characteristics, those in her *persona*, were what mattered to these fans, not her ontological status as fabricated or not. What matters in this type of online interaction is *not* the authenticity of the offline identity, the "I," but rather the multitudes of virtual identities that the user depicts, the many "me's." Other similar confusions have arisen in recent years: blog scholar Jill Walker Rettberg describes the case of MySpace user "Kaycee Nicole," who "died" on MySpace before she was revealed as a complete fabrication perpetrated by a Kansas woman.[66] Further, in 2007 Lori Drew, a mother who pretended to be a 16-year-old boy on MySpace, used this virtual identity to entice a 13-year-old girl to commit suicide.[67] The cases of Lori Drew, Kaycee Nicole and Lonelygirl15 all center on the confusion between what is real and what is virtual online: even a "fake" persona can have "real-world" consequences. If, in a virtual environment, our personas become constructions that represent our sense of self—although self itself can never fully be representable—then, as van Kokswijk has shown, it becomes increasingly important for users to understand the way that the community functions in MySpace to aid in the interpretation of personas.[68] Some users want to display as truthful a set of characteristics as they can; others

deliberately distort or misrepresent characteristics. There are three elements of MySpace that affect fan studies and the myriad ways fans are using the Social Network Site for fan/character amalgamation: persona creation, persona mutability, and virtual community formation. Importantly, each of these concepts feeds into the larger structure of MySpace: one cannot exist without any of the others. Each of these conceptions thus functions as a component of the interreal space created for, and by, MySpace, and an element in the design and existence of the Digi-Gratis.

First, MySpace offers its users an interreal space in which they create virtual identities of themselves ("personas") that pictorially and textually represent their senses of self. A persona is a digital representation of the person ontologically dependent on the computer, the creator, and the community for its existence. Being aware of one's own identity is an important part of MySpace persona creation, as the writer must understand the public visibility of the profile.

While the creator of a profile may include information he/she feels is relevant to the digital world, there are other aspects of the persona that the person creating it may not have control over. For example, the playful comments that other personas post on the profile become aspects of that virtual identity that influence how others will see it. In the aforementioned profile of Jim from *The Office,* two of the comments demonstrate this playfulness and this virtual identity affect.[69] As readers, we can interpret the profile of "Jim" using these comments: the first, from L., reads "hey do you know john krasinskis real myspace? [sic]."[70] Through this comment, we understand that Jim is a character (we may already know that he is portrayed by John Krasinski) and that therefore, this profile must not be ontologically based on a "real" person. L. wants to know his "real" MySpace page (as though this one were "fake"?), not the "real" MySpace page for the *fictional* character of Jim. Real, here, is a problematic term for L.: does she mean the "real" page or the "real" person? Which is "real," anyway, when, as we see, all personas are virtual? However, this real/virtual description is again confused by the playfulness of the next comment, from Knoxy!, who writes "Hey Jim when is season 5 on DVD? :)." This comment also creates a juxtaposition between what we (as savvy viewers of *The Office*'s documentary-style filmmaking[71]) know of Jim and what we (as MySpace denizens) know of the profile of Jim. We know that the profile is of a fictional character, and the comment seems to take a tongue-in-cheek tone with that knowledge.

Although these are relatively obvious observations to make, the point is that the profile creator of Jim did not have influence over these comments: although Jim can include information in his profile that hints at his identity as a character on *The Office*, the comments can confuse or even directly contradict that assertion. The playful mix of the comments also references the twin concerns of the Digi-Gratis economy. L.'s request for information about John Krasinski's MySpace page is a non-monetary assertion, a search for a digital gift in the form of information (it will also, she hopes, lead her to the non-monetary profile of John Krasinski). In this way, she strives to explore *The Office* not as a product, but as a multi-modal process which is transmediated across television and MySpace. Knoxy!'s comment, however, directly ties into a market economy, as she wants to know where to purchase Season 5 of *The Office* on DVD. This MySpace persona in general, in fact, represents a mash-up of the gift and market economies, as it seems to be created to generate a sense of community around Jim's character, but that character is based in a media product marketed, and sold, to the public.

However, if we examine MySpace for its persona creation abilities, then we must also examine it for the way these personas can be changed online, for the persona mutability. In the past, any public display of identity would have been intimately tied to the physical body, and therefore difficult, if not impossible, to change. The body provides a visual sense of who we are, as throughout humankind's history, we have been identified by physical, observable bodily factors: our race, our sex, our facial features, et al. Online, however, there is "no body" upon which to base identity. No longer linked to the body, an online identity can be constructed in a variety of ways. Sherry Turkle has shown us the multiplicity of identity construction in her description of online textual gaming, and describes how we use different identities for different effects: online, I can have a powerful avatar, even if I am a weak person offline.[72] Alluquere Rosanne Stone echoes this, arguing further that online, we present *multiple* identities and personalities.[73] Psychologist Wolfgang Kraus illustrates this multiplicity when he writes, "belonging [to an identity] becomes—generally speaking—a question of choice, which must be answered by the individual."[74] Our online identity "is not grounded in history and politics, but is a pastiche, a mosaic, made up of ephemeral fragments," all of which coalesce around a sense of the mutability emerging from our offline sense of self.[75]

One way this identity pastiche forms on MySpace is through the visible representation of a social community. A MySpace persona is constructed not just with textual details about the person that made it, but also as a node on that persona's social network.[76] Users of MySpace can "friend" other users of MySpace, and this friendship then becomes visibly represented by a hyperlink between each persona. The more "friends" one has on MySpace, the larger the social network, and the more connected the persona becomes in their network. Each hyperlink establishes not only a connection to another persona, but also an interreal shared space *between* the two personas. As more personas connect, a larger social network forms. This visible community illustrates what Bruns terms "equipotentiality," or the sense that all participants can make unique contributions to a group project. If we think of MySpace as an infinite group project—a community intra-textually built by the users of MySpace, then this equipotentiality operates "through shared discursive, communicative spaces."[77] Each connection a persona establishes not only joins it with another persona, but also helps to establish a shared space between the two personas. Jim may be the profile owner, but his visible connection to both L. and Knoxy! makes his community—those who share and contribute information—part of this identity. MySpace visibly represents community *as* identity.

For users of MySpace, creating a profile of a character is more than fan fiction, and more than textual poaching: it is a space where identities mingle. This examination of the interreal identity illustrates a re-conceptualization of the theoretical binary between the fan-as-consumer and the fan-as-producer. Through the structure of the Digi-Gratis economy, these fans articulate a notion of digital gift-giving: The persona roleplay enacted between two interreal personas indicates a gift of *time* and *attention* to another fan. Only in an economy that had characteristics both of the commodity market and of the gift economy could MySpace fan/character roleplay happen. Fans use these profiles as "gifts" to give both to other fans and to the media producers themselves: these profiles are a way to articulate notions of appreciation, thankfulness, and gratitude for the characters. At the same time, however, they function also as free advertising for the media producer, and serve to promote the product as much as they do the fan.

THEORETICAL SHIFTS

Fans on MySpace present an interreal display of two types of virtual identity: fan persona and character persona. These virtual identities change the ontological status of the fictional characters into what Espen Aarseth describes "simulations": personas that exist "somewhere in between reality and fiction."[78] This alteration occurs because fans on MySpace see the Social Network Site as a space apart from that of the de Certeauan strategic space of the producer. In a video podcast, Jenkins argues that online spaces are seen, specifically by youth culture, as separate from other spaces: "they often present themselves as a utopian space that is totally removed from the world of school and the world of home. They're described as a place where people can have their own identities…."[79] The dialectical nature of "consumption" and "production," previously conceptualized as the "strategies and tactics" of reading by de Certeau, changes with the advent on online Social Network Sites. MySpace interacts with, complements, and even sometimes overrides "real" space, and forces the dichotomy between de Certeau's twined conceptions of strategies and tactics to break down. Fans create interreal personas online to swap narratives, to create communities, and to show their devotion to an extant media object. This rewriting leads other fans on MySpace to reread this creative content as examples of virtual identity in a digital environment. As Poster argues, "electronic media are supporting a … profound transformation of cultural identity."[80] By using the terms "strategies" and "tactics," de Certeau makes his metaphor obvious: Producers and consumers are seemingly at war with one another over meaning. Producers encode meaning through strategies of power while consumers tactically decode their own meaning through "movements that change the organization of a space."[81] As we will see in the next chapter, MySpace personas, however, do not just change the relationship between strategies and tactics—they change the field of battle entirely.

NOTES

[1] Cornel Sandvoss, *Fans: The Mirror of Consumption* (Malden, MA: Polity Press, 2005), 96.

[2] In an open letter to all subscribers, Facebook founder Mark Zuckerberg says that Facebook has over 350,000,000 subscribers (Mark Zuckerberg, "Open Letter," 01 Dec 2009, http://blog.facebook.com/blog.php?post=190423927130 (accessed 01 Dec 2009). That

same month, the US Census reported the US population at just over 308,000,000 (www.uscensus.com).

3 Sue Thomas, "The End of Cyberspace and Other Surprises," *Convergence: The International Journal of Research into New Media Technologies*, 12, no. 4 (2006), 390.

4 John Caldwell, "Convergence Television: Aggregating Form and Repurposing Content in the Culture of Conglomeration," in *Television after TV*, ed. Lynn Spigel and Jan Olsson (Durham, NC: Duke University Press, 2004), 51.

5 Henry Jenkins, *Convergence Culture* (New York: New York University Press, 2006), 97; see, also, Jill Walker, "Distributed Narratives: Telling Stories Across Networks" (paper presented at AoIR 5.0, Brighton, 21 Sept 2004), http://huminf.uib.no/~jill/txt/AoIR-distributednarrative.pdf (accessed 01 Aug 2006), ¶1.

6 In this chapter and the next, I will be specifically examining MySpace as the Social Network Site where such character creations occur. There are, however, other Social Network Sites which feature interactive fan-created content: Facebook, for example, allows users to become "fans" of particular media objects, and then notice of this fandom is inserted into the profile of the fan—imbuing the fan's Facebook page with salient identifying markers. MySpace is still a popular site, and as pointed out by Paul Levinson, *New New Media* (New York: Allyn and Bacon, 2009), 122, has the capacity for more fictionalization than does Facebook. I use the term "Social Network Site," instead of the more common "Social Networking Site," in terms referenced by danah boyd and Nicole Ellison, "Social Network Sites: Definition, History, and Scholarship," http://jcmc.indiana.edu/|vol13/issue1/boyd.ellison.html (accessed 07 Oct 2008), ¶5–6.

7 Jim (See, Appendix C).

8 John Shiga, "Copy-and-Persist: The Logic of Mash-Up Culture," *Critical Studies in Media Communication* 24, no. 2 (2007): 107–8.

9 See, Mark Andrejevic, "Watching Television without Pity: The Productivity of Online Fans," *Television and New Media* 9, no. 1 (2008), 32.

10 Alan D. Schrift, "Introduction: Why Gift?" in *The Logic of the Gift: Toward an Ethic of Generosity*, ed. Alan D. Schrift (New York: Routledge, 1997), 2.

11 Lawrence Lessig, *Remix: Making Art and Commerce Thrive in the Hybrid Economy* (New York: Penguin, 2008), 150.

12 Ibid., 177, my emphasis.

13 Sara Gwenllian-Jones, "Web Wars: Resistance, Online Fandom and Studio Censorship," in *Quality Popular Television*, ed. Mark Jancovich and James Lyons (London: BFI Publishing, 2003) 166.

14 Sara Gwenllian-Jones and Roberta E. Pearson, Introduction to *Cult Television* (Minneapolis: University of Minnesota Press, 2004), xii.

15 Yochai Benkler, *The Wealth of Networks: How Social Production Transforms Markets and Freedom* (New Haven, CT: Yale University Press, 2006), 41: "The widely held intuition that markets are more or less the best way to produce goods, that property rights and contract are efficient ways of organizing production decisions, and that subsidies distort production decisions, is only very ambiguously applicable to information."

16 See, the essays in Rishab Aiyer Ghosh, ed., *CODE: Collaborative Ownership in the Digital Economy* (Cambridge, MA: The MIT Press, 2005); also, Axel Bruns, *Blogs, Wikipedia, Second Life, and Beyond* (New York: Peter Lang, 2008), 9–36. For an early view of gift economy in cyberspace, see Peter Kollock, "The Economics of Online Cooperation: Gifts and Public Goods in Cyberspace," in *Communities in Cyberspace*, ed. Marc A. Smith and Peter Kollock (London: Routledge, 1999), 221–2.

17 This is not a new idea: Thomas Jefferson (1813) once wrote: "If nature has made any one thing less susceptible than all others of exclusive property, it is the action of the thinking

power called an idea ... [I]ts peculiar character, too, is that no one possesses the less, because every other possesses the whole of it" (quoted in Lessig, *Remix*, 290).

[18] Rishab Aiyer Ghosh, "Why Collaboration Is Important (Again)," in *CODE: Collaborative Ownership and the Digital Economy,* ed. Rishab Aiyer Ghosh (Cambridge, MA: The MIT Press, 2005), 2.

[19] Henry Jenkins, Xiaochang Li, Ana Domb Krauskopf, with Joshua Green, "If It Doesn't Spread, It's Dead (Part Three): The Gift Economy and Commodity Culture," *Confessions of an Aca-Fen,* 16 Feb 2009, http://henryjenkins.org/2009/02/if_it_doesnt_spread_ its_dead_p_2.html (accessed 16 Feb 2009), ¶17.

[20] Howard Rheingold, *The Virtual Community: Homesteading on the Electronic Frontier* (Reading, MA.: Addison-Wesley, 1993), 49; danah boyd, "Facebook's Little Gifts," *Apophenia,* 13 Feb 2007, http://www.zephoria.org/thoughts/archives/2007/02/13/ facebooks_littl.html (accessed 10 Mar 2009), ¶8–9.

[21] Duran Bell, "Modes of Exchange: Gift and Economy," *Journal of Socio-Economics* 20, no. 2 (1991): 156.

[22] Marshall Sahlins, "The Spirit of the Gift," in *The Logic of the Gift: Toward an Ethic of Generosity,* ed. Alan D. Schrift (New York: Routledge, 1997), 84.

[23] William Merrin, *Baudrillard and the Media* (Cambridge, UK: Polity Press, 2005), 13, emphasis his.

[24] Jean Baudrillard, *The Consumer Society,*" trans. Chris Turner (London: Sage, 1998), 60–1.

[25] And, perhaps in a holdover from less enlightened days, possession and ownership.

[26] Marcel Mauss, *The Gift: The Form and Reason for Exchange in Archaic Societies,* trans. W. D. Halls (New York: Norton, 1990), 39–43.

[27] The dinner situation itself is based in gift-giving—we "gift" our company, our food, and our shelter, which in turn requires a reciprocal invitation to share in the guests food, company and shelter at a later date.

[28] See, particularly, Jacques Derrida, *Given Time: I. Counterfeit Money,* trans. Peggy Kamuf (Chicago: University of Chicago Press, 1992), 12; Mauss, 15–18.

[29] Derrida, *Given Time,* 12.

[30] James Carey, "A Cultural Approach to Communication," in *Communication and Culture: Essays on Media and Society* (New York: Routledge, 1992), 18.

[31] Matt Hills, *Fan Cultures* (London: Routledge, 2002), 134.

[32] Mauss, 3.

[33] Ibid., 11–12.

[34] Emile Durkheim, *The Elementary Forms of Religious Life,* trans. Karen Fields (New York: Free Press, 1995).

[35] Maurice Godelier, *The Enigma of the Gift,* trans. Nora Scott (Chicago: University of Chicago Press, 1999), 15.

[36] Karl Marx, *Capital: A Critique of Political Economy,* trans. Ben Fowkes (London: Penguin Classics, 1990), 163.

[37] Ibid., 164–5: "the mysterious character of the commodity-form consists therefore simply in the fact that the commodity reflects the social characteristics of men's own labor as objective characteristics of the products of labor themselves, as the socio-natural properties of those things."

[38] Godelier, 20.

[39] Ibid., 165; see also Pérez-Reverte.

[40] Jean Baudrillard, *For a Critique of the Political Economy of the Sign,* trans. Charles Levin (New York: Telos Press, 1981), 64.

41 Claude Lévi-Strauss, "Selections from Introduction to the Work of Marcel Mauss," in *The Logic of the Gift: Toward an Ethic of Generosity,* ed. Alan D. Schrift, trans. Felicity Baker (New York: Routledge, 1997), 55–6.

42 Sara Gwenllian-Jones, "Virtual Reality and Cult Television," in *Cult Television*, ed. Sara Gwenllian-Jones and Roberta Pearson (Minneapolis: University of Minnesota Press, 2004), 83.

43 Hills, *Fan Cultures,* 134.

44 See, Philippe Le Guern, "Toward a Constructivist Approach to Media Cults," trans. Richard Crangle, in *Cult Television*, ed. Sara Gwenllian-Jones and Roberta E. Pearson (Minneapolis: University of Minnesota Press, 2004), 19.

45 See, Jacques Derrida, *Positions*, trans. Alan Bass (Chicago: University of Chicago Press, 1981).

46 Slavoj Žižek, *Looking Awry: An Introduction to Jacques Lacan through Popular Culture* (Cambridge, MA: The MIT Press, 1991), 7.

47 Hills, *Fan Cultures*, 137.

48 Gwen Cooper (See, Appendix C).

49 Ibid. Also, Gwen Cooper wouldn't advertise that she worked for a "secret agency" on MySpace. Not exactly secret anymore.

50 The savvy reader is invited to explore this topic in more depth in: Sherry Turkle, *Life on the Screen: Identity in the Age of the Internet* (New York: Simon and Schuster, 1995); Jonathan Rutherford, *Identity: Community, Culture, Difference* (London: Lawrence & Wishart, 1998); the essays in Paul du Gay, Jessica Evans, and Peter Redman, ed., *Identity: A Reader* (London: Sage, 2000); David Gauntlett, *Media, Gender and Identity: An Introduction* (London: Routledge, 2002).

51 Stuart Hall, "Introduction: Who Needs 'Identity'?" in *Questions of Cultural Identity*, ed. Stuart Hall and Paul Du Gay (London: Sage Publications, 1996), 5–6.

52 Ibid., 4, my emphasis.

53 Jacob van Kokswijk, *Digital Ego: Social and Legal Aspects of Virtual Identity*, rev. ed. (Delft, the Netherlands: Eburon Academic Publishers, 2008), 13.

54 Ibid., 53.

55 Ibid., 63.

56 Roy Ascott, "Homo Telematicus in the Garden of A-Life—Editorial," *TightRope 1/95* http://www.phil.unisb.de/projekte/HBKS/TightRope/issue.1/texte/royascott_eng.html (accessed 06 Oct 2008), ¶2.

57 Ibid., ¶7.

58 Ibid.

59 Ibid.

60 van Kokswijk, 27.

61 Jenny Sundén, *Material Virtualities* (New York: Peter Lang, 2003), 3.

62 Of course, this presupposes that there is a stable "core" identity at the heart of any individual—a problematic assertion, as any particular identity is necessarily only viewable through its contrast with other identities, which are themselves equally mutable (see Kenneth Burke, *A Rhetoric of Motives* (Berkeley: University of California Press, 1969), 21–2).

63 See, Erving Goffman, *The Presentation of Self in Everyday Life* (New York: Doubleday, 1959).

64 Barring any accidental postings, or any hackings.

65 Joshua Davis, "The Secret World of Lonelygirl15," *Wired* 14, no. 12 (2006), 239.

66 Jill Walker Rettberg, *Blogging* (Cambridge, UK: Polity Press, 2008), 122.

67 AP News, "Mom: Girl Killed Herself over Online Hoax," *MSNBC*, 19 Nov 2007, http://www.msnbc.msn.com/id/21844203/ (accessed 08 Mar 2009).

[68] van Kokswijk, 88–9.

[69] Jim (See, Appendix C).

[70] For the sake of anonymity, I use an abbreviation here instead of the name on the MySpace page.

[71] See, Paul Booth and Brian Ekdale, "Translating the Hyperreal (or How *The Office* Came to America, Made Us Laugh, and Tricked Us into Accepting Hegemonic Bureaucracy," in *Transformations and Mistranslations: American Remakes of British Television*, ed., Carlen Lavigne and Heather Marcovitch, (Lanham, MD: Lexington Books, In Press).

[72] Turkle, 188.

[73] Alluquere Rosanne Stone, *The War of Desire and Technology at the Close of the Mechanical Age* (Cambridge, MA: The MIT Press, 1996), 18.

[74] Wolfgang Kraus, "The Narrative Negotiation of Identity and Belonging," *Narrative Inquiry* 16, no. 1 (2006), 108.

[75] Ben Agger, *The Virtual Self* (London: Blackwell, 2007), 110.

[76] This public display of connections is a crucial component of SNSs, as the Friends list "contains links to each Friend's profile, enabling viewers to traverse the network graph" (boyd and Ellison, ¶10).

[77] Bruns, 47.

[78] Espen Aarseth, "Nonlinearity and Literary Theory," in *Hyper/Text/Theory*, ed. George Landow (Baltimore, MD: Johns Hopkins University Press, 1994), 78–9.

[79] Henry Jenkins, "Lecture 06: Media Literacy as a Strategy for Combatting Moral Panic [sic]," MIT OCW: CMS.930 / 21F.034 Media, Education, and the Marketplace, fall 2001, Video Podcast on iTunes University.

[80] Mark Poster, *The Information Subject* (London: Taylor and Francis, 2001), 72.

[81] Michel de Certeau, *The Practice of Everyday Life*, trans. Steven Randall (Berkeley: University of California Press, 1984), 38.

Identity Roleplay on MySpace

[Corso] wondered whether someone, some twisted novelist or drunken writer of cheap screenplays, at that very moment saw him as an imaginary character in an imaginary world who thought he wasn't real. That really would be too much.

— *Pérez-Reverte, The Club Dumas, p, 260*

My name is Luke Danes... [and] the best thing to walk into my life [is]Lorelai Gilmore. We were married and we were having a kid. Then some things happened and she left. [...]Then Kiwi Lorelai came in the picture. I thought we broke up so I went on the market again. Well I hurt her. So we got back together and she was raped. She is about to have a baby so she freaked out and broke up with me and I am not sure on where it is going if it is going anywhere at all. [all sic]

— *Luke, on MySpace*

Having previously reassessed the ontological state of his surrounding and his own identity as a "real" person, Pérez-Reverte's Corso reasons, if he isn't real, then perhaps he is a character in another's work, a fictional being imagined by an author. The fact that he is fictional and is the product of an author becomes a moment of reflexivity for the readers of the novel, as Pérez-Reverte reinscribes the character as character in order insert his authorial presence in the imaginative universe of *The Club Dumas*. Pérez-Reverte, by describing Corso the fictional character *as* a fictional character, scribes himself into the book ("some twisted novelist" indeed!)

As we saw in the last chapter, fans enact a similar process with characters they see in fictional cult television shows. By creating MySpace profiles of these characters, fans build a space wherein the virtual identity of the fan and the virtual identity of the character mash up into an ontologically new

entity. As we can see in the second inscription to this chapter, this notion of identity roleplay is complicated. The author of this "About Me" section of the MySpace profile of Luke Danes has not summarized his own life, but rather the life of the character "Luke Danes" from the television show *Gilmore Girls*.[1] The "About Me" section is a space on a persona's profile through which the writer of the persona can describe him or herself. Indeed, Luke has even detailed characters ("Kiwi Lorelai") and events ("she was raped") that did not occur or appear onscreen. The writer behind "Luke" has interleaved his own commentary and textual elements within the extant narrative of *Gilmore Girls*. As Angela Thomas shows, contemporary fan fiction authors participate in character interaction by infusing "aspects of their real identities into [the] characters" they create.[2] By rewriting the character, the creator of the Luke profile has participated in the active reconstruction of that character's meaning in a mediated, interreal space through identity roleplay.

By the phrase "identity roleplay," I refer to the sense that fans both act as if they were the character, and "play" with the characteristics that define that character. They can be two or more personas at once. Similarly, Dena writes about the ARG that players can alternate between types of players, sometimes working intensely at solving difficult puzzles or summarizing aspects of the game on wikis, or other times passively encountering what others have done.[3] To enact this identity roleplay, fans insert aspects of their own personality into the character to rewrite the narrative around this fan/character amalgam. In doing so, they construct a space for a community's rereading of extant narratives and the reproduction of the fan community represented viscerally through the social nature of fans' creative content. Recent examples depict this form of identity roleplay in other mediated guises: for example, in Sept 2008, the *New York Times* ran a story about fans of the television show *Mad Men* who use the social messaging site Twitter to pose as characters from the show and post updates in the characters' voices. Columnist Stelter, however, indicates that it is possible that the fans who Tweet do, in fact, work for AMC, the television channel on which *Mad Men* is shown.[4] To be sure, even if these Twitter accounts are a marketing scheme, it demonstrates the pervasiveness of fan practices in contemporary culture. If not marketing, these fans then may be acting as characters in order to more fully integrate themselves into the extant media object.

This form of identity roleplay augments parasocial research into the relationship between fans and extant media characters, in which audiences are seen to form social bonds with both fictional and nonfictional television personalities by identifying with the character as if they were real.[5] In other words, fans' interaction with characters is seen as if it were an interpersonal relationship. This form of parasocial interaction is complicated on MySpace, however, as fans enact this identity roleplay not by seeing characters as if they were real, but by inhabiting them; by becoming and roleplaying them.

Through an analysis of a number of MySpace texts for the cult television shows *Veronica Mars*, *Gilmore Girls*, *Doctor Who*, and *Torchwood*, I illustrate three ways identity roleplay functions in online profiles: (1) narrative affects the crafting of an identity; (2) profiles not only build on the narrative of the show, but branch from it as well; and (3) blog fan fiction on MySpace enacts an intra-textual form of fan/character roleplay. With this intertwining of narrative and identity, MySpace creates an interreal space where profiles of offline "real people" and profiles of online "simulated characters" can mingle, interact, and create digital fan fiction, and, in the process, problematizes the de Certeauan dichotomy of strategic and tactical readings.

MYSPACE ROLEPLAY AND PARASOCIAL THEORY

Following Jenkins's lead, many traditional fan studies have used implicit examples of de Certeau's notion of "textual poaching" as the basis for analyzing fan practices. In these types of analyses, the fan identifies with characters through an active reading of the text, and operates within and from the space of the producer.[6] To interact with characters from this extant media object in traditional fan studies, therefore, is to see them as inhabiting a different space, a separate space from that of the fan. Fans identify with these characters, in the sense that they see similar traits in the character as they see in themselves, and the character becomes a vehicle, a means of (re)presenting their own selves in fan fiction. In other words, the fan and the character are distinct.

Although traditional media studies assume this divide between the fan and the character, the amalgamation of fan and character in online spaces challenges that assumption. MySpace denizens force a revised reading of de Certeau's textual poaching as they make MySpace their own space, a space where the strategies of the producers, the "elaborate theoretical places (sys-

tems and totalizing discourses),” are rewritten as libratory creative content.[7] Thus, instead of tactically reading the source text to “appropriate popular texts and reread them in a fashion that serves different interests,” these fans rewrite the space of the producers itself, and transgress the boundary between de Certeau’s strategies and tactics of reading. Specifically, de Certeau conceptualizes the production of a text spatially, using the metaphor of the city: created with certain routes laid out, the city allows pedestrians to walk their own path, to define their own “rhetoric of walking.”[8] In this way, producers can intend a path, but pedestrians can tactically traverse another. Pedestrians cannot create a new path, but can reappropriate a city path for their own use. Unlike de Certeau’s text-as-city, however, the creation of character profiles does not just allow pedestrians to walk, it encourages them to rebuild the roads and repave the sidewalks as they go. It is in the working together, in the community of a social network, that the narrative dimensions of a text can become fleshed out and expansive.

For example, an interreal persona of Captain Jack Harkness from the BBC shows *Doctor Who* and *Torchwood* communicates with different fans of these shows on MySpace through the spaces he has created on his profile for two personas.[9] In other words, the owner of the account interacts with other fan/player amalgams and re-enacts (or rewrites), fan fiction about the show. He deliberately separates out two types of fans of the character Jack Harkness on MySpace. One type of fan interacts with “Jack Harkness™,” who creates roleplaying fan fiction in this interreal space: “this is a Role Play account,” he vehemently writes, “and I ONLY ADD ROLE PLAYERS!” His other persona, however, is also listed: “If you don’t r/p [roleplay], please check out the following MySpace: captain_jack_harkness.” Thus, despite his clear roleplay-only statement, he does, in fact, write this character with elements of his own personality, made visible through the choice of which character to roleplay (the Jack Harness™ one, or the non-roleplayed profile captain_jack_harkness). The use of either will determine the way this fan/character amalgam is interpreted by the fan community. This fan is asserting not only control over the character, but an inhabitance of it as well.

Fans on MySpace, interacting within the interreal, answer Hills, who asserts, “the difficulty with de Certeau’s model is that it seems too rigid to deal helpfully with any blurring of consumer and consumer-as-producer identities.”[10] The fan community reproduces their interpretation of the extant media narrative by reasserting their influence in a digital space. This influ-

ence creates a unique digital confusion: since it is impossible to know who the creator is behind any one profile, every profile itself becomes a distinctive identity. Without knowledge of the extant media object's canon, or direct textual markers on the persona itself, readers of MySpace could not distinguish a profile of a fictional character from a profile of a person existent offline. In other words, there is nothing inherent to MySpace that indicates fictionality or factuality in persona presentation.

To differentiate between fan and character on MySpace is to rely on parasocial interaction theory, Horton and Wohl's influential statement that stresses that the social bond formed between viewers and characters is "analogous to and in many ways resembles social interaction in ordinary primary groups."[11] In other words, we might say that viewers often form bonds with the characters they witness onscreen, and these bonds mirror the social bonds formed between people that meet in the "real world." This mediated character could be "actual," that is, a non-fictional person (such as a news anchor or a weatherman), or the character could be "made-up," that is, a fictional entity (such as a character in a television series). Either way, the mediated personality becomes a figure with whom a fan identifies. This use of parasocial interaction theory has been used to examine a fan's level of involvement with online, digital characters with virtual identities, as the interaction between the person sitting at her computer screen and the persona at which she looks mirrors the relationship between the viewers of television and the emotional attachment those viewers feel towards the characters.[12]

There are two main limitations to parasocial interaction theory when using it to examine fans, however. First, Horton and Wohl's use of the theory, which works because the mediated character "uses the mode of direct address, [and] talks as if he [sic] were conversing personally and privately" with the audience, focuses more on the individual watching and interpreting the program than on the media text.[13] Parasocial "interaction" is therefore a misnomer, for the characters within the text can affect the viewer, but the viewer has little recourse in affecting the characters. One of the reasons the Internet so dramatically influences parasocial theory is because of its inherent interactive characteristics, as Thorston and Rodgers have demonstrated.[14] They refer to what Rafaeli calls the "ortho-social," or an extra-textual participation with a media text wherein fans can write a letter to the editor of a newspaper, call a talk show, or use, in some way, a "traditional unidirectional mass media in a new, reactive, or interactive manner."[15] Although fans have

interacted with media texts in this ortho-social manner for decades the inherent interactive capabilities of the Internet have increased dramatically both the means and the ability for fans to directly influence the media texts.[16]

Second, additional research on parasocial theory has found that it needs to "distinguish between media figures who are direct representations of real people (such as newscasters), and [those who are] fictional creations."[17] Parasocial theory exists to identify a relationship between the viewer and any persona on television. In the digital, however, such individualized relationships are problematized, for as we have seen, *any* persona on MySpace, be it character or fan, fictional or authentic, is in itself a complete construction. The interreality of the Internet, especially on MySpace, means that, by definition, one cannot inherently *know* whether a virtual identity is of a "real" person or of a character: in other words, external knowledge (about the media object, about the source canon, or about the show itself) is necessary for viewers to grasp the ontological distinction. This knowledge is created by the fan community on MySpace, not through parasocial interaction, but through identity roleplay.

MySpace offers fans the ability to reread their own identities through another's narrative. In this sense, narrative and self become inseparable. For Ochs and Capps, our sense of self develops through narrativized incidents, while at the same time our sense of narrative evolves as our sense of self deepens.[18] In terms of MySpace, a persona provides not only a snapshot of who it represents, but also a constantly updated—and updatable—narrative of his or her life. Following the narrative implied by comments posted and replied back and forth between personas, as well as through stories posted by users of MySpace on their personas, viewers of MySpace can read this narrative within the lives of those virtual identities. As fans add to this mix by creating profiles of fictional characters and then insert their own identities into them, they forge a new relationship between virtual identity and narrative. Importantly, this fan/character amalgam is unique for each fan, and contributes not to the extant media object itself, but rather to each fan's individual rereading of that object.

A LINK BETWEEN STRATEGY AND TACTIC

This shift in the sense of fan identity calls into question traditional fan studies' use of textual poaching. By "textual poaching," de Certeau argues that

The reader takes neither the position of the author nor an author's position. He invents in the text something different from what they [the authors] "intended." He detaches them from their (lost or accessory) origin. He combines their fragments and creates something un-known in *the space organized by their capacity for allowing an indefinite plurality of meanings.*[19]

As indicated, this "poaching" of meaning necessarily occurs in the space of the producer any time one reads. As de Certeau makes clear, any particular reading follows a different trajectory than any other: "readers are travelers; they move across lands belonging to someone else, like nomads poaching their way across fields they did not write."[20] For Jenkins, reading de Certeau, textual poaching offers "an alternate conception of fans as readers who appropriate popular texts and reread them in a fashion that serves different interests."[21] Fandom is a form of continual poaching on others' works. Further, this poaching, this movement, can only take place in a space of power prescribed by the producer, who strategically makes and inserts intended meanings into a text, but from which readers can tactically make their own interpretations.

De Certeau argues that these tactics show that readers poach meaning from producers and make "reading thus ... an 'art' which is anything but passive."[22] In short, the act of reading does not mean passively consuming another's text, but rather "making it one's own, appropriating or reappropriating it."[23] Jenkins extends this argument by showing how fans appropriate the works of producers into their own creativity, poaching on the works of others.[24] According to Harrington and Bielby's meta-analysis of fan studies, Jenkins's conception of this tactical reading makes up the basis of most traditional studies of fan practices.[25] For example, Jenkins demonstrates that fans create amateur music videos from footage "poached" from television shows, in order to interact with the characters parasocially: "fan viewers are often totally disinterested in the identity of the original singer(s) but are prepared to see the musical performances as an expression of the thoughts, feelings, desires, and fantasies of the fictional character(s)."[26] By "poaching" the meaning of the song, the fan music video creator reappropriates and reinscribes that meaning to the character by poaching content from two different sources. In effect, without directly referencing Horton and Wohl, Jenkins has described how parasocial theory functions within a fan's reception of a media text: like in parasocial interaction, fans create a connection to a character or a media text.

In this view of fandom, fans and characters are immediately divided from each other. Fans identify with the character. The fan externalizes her own feelings, her own sense of self, and inscribes these feelings into an external source, the extant media character. We can see this fan separation from an idealized version of a character in a quote from one of Jenkins's students, interviewed for *Science Fiction Audiences*. John, the student, writes:

> "I always wanted to be like Spock. I suppose I was like him—an outsider. He was an alien in the ship and I was an outsider in my town. I grew up there but I didn't belong. He was in science and things like that. He would go to investigate things. He would solve all the problems. He was someone I looked up to at the time I think that being in internal conflict with yourself about being outwardly emotional is something that is common to many people in science and technology and especially something I have experienced."[27]

For Jenkins's student, the character of Mr. Spock, the emotionless science officer on the *Enterprise* in *Star Trek,* represents an ideal model, someone he always wanted to be like. Even in this connection, however, the fan establishes a distance between himself and Spock: it is not that he wants to *be* Spock, but rather he wants to be *like* Spock. This is not mere semantics, for part of any investigation of fandom hinges on the intimate connection the fan feels with the extant media object. For John, as for many fans, the closest they could hope to get to a text was, as Tulloch and Jenkins state, to "have particularly strong feelings ... towards characters which allow them to explore conflicts they face in their own lives."[28] Gwenllian-Jones also describes a similar form of identification for fans of Xena, the titular character in the eponymous cult television show, who takes on a life of her own for fans: cult characters like Xena "seem to assume 'lives' and 'identities' of their own, about which the audience knows far more than it does about the actors who play them."[29] As Gwenllian-Jones shows, Xena's character, for the fans, becomes a combination of what is in the text and what fans construe from the text. The fans examined in Gwenllian-Jones's study enact a form of a parasocial relationship with Xena, treating the character as if she were real, and thus different from themselves.

What some fans practice on MySpace, however, is not the identification *with* the fictional character, but rather identification *as* that character. Xena may exist for offline fans of the show as a character within that universe, but on MySpace, some fans can actually inhabit that character. As fans use the

Web Commons for exploring extra-dimensions of characters, a reconceptualization of fan studies must take into account this form of performativity. Fans have always identified closely with a narrative text, but online the "relationship between fans and objects of fandom goes beyond forming a symbolic basis for fan communities" and the "perception of the external object as a part of the self is in turn based on the recognition, consciously or unconsciously, of aspects of the self in the external object."[30] The generative possibilities—the ways that fans can generate their own content, their own media objects—offers not only a way to appropriate cultural material into a relevant fan practice, but also a way that cultural material can be tied to the fan's own "sense of self."

SOCIAL NETWORK SITE FICTION: ROLEPLAY

By "putting on" the persona of the extant media character, fans participate in a form of identity roleplay that goes beyond the "impersonation" described by Hills as the act of "becoming" a fan; or the "performativity" described by Sandvoss as self-reflection.[31] When fans create MySpace character personas, they intimately, and necessarily, become entangled in an identity conflict. Offline, we can tell the difference between a TV character and a physical person because of the screen; one is mediated, the other is not. When a character becomes the object of affection of a cult television fan, he/she becomes mediated through a technology that clearly delineates a separation from the spectator and the character. On MySpace, however, the personas of users exist in the same space as those of the personas of the characters. All these characters are equally mediated. As we have seen with the cases of Lonelygirl15, Kaycee Nicole and Lori Drew, virtual identities matter online. When two personas interact, we find that fans not only connect their virtual identity with aspects of the extant media object, but also that they incorporate "their-selves" into that extant media object's narrative text.

Within this connection, however, fans not only place themselves within the media product, but also roleplay as the character seemingly in order to invest themselves with aspects of that media character. Because Social Network Sites are online spaces which

allow individuals to (1) construct a public or semi-public profile within a bounded system, (2) articulate a list of other users with whom they share a connection, and (3) view and traverse their list of connections and those made by others within the system,

they facilitate this fan (re)construction of extant narratives in a way unlike that which we have seen in blog fan fiction or ExtantWikis.[32] Interreality, and the virtual identity that exists within it, are publicly created through fan interaction in the Web Commons. MySpace allows fans to explore this public identity formation in a conceptual space of their own creation.

Fans can incorporate themselves into an extant media object on MySpace in three ways: through a fragmentation of virtual identities, through a reconstruction of narrative texts, and through character acting with reconstructed characters, which is integral to fandom on MySpace. These three methods center around the issue of the transmediated narrative text: the more dispersed a text is in time and space, the more a fan can find places to insert herself into the text.[33] As Gwenllian-Jones shows, "the appeal of ... vast, transmedia fictions lies precisely in their invitations to immersion and interactivity; they are constructed, marketed, and used by fans not as 'texts' to be 'read' but as cosmologies to be entered, experienced and imaginatively interacted with."[34] In the Web Commons, fans intuitively understand that these cult texts can be reproduced on MySpace as vast, interreal worlds.

As one of the ways fans can "enter" a text, MySpace offers a virtual identity factory.[35] With hundreds of millions of subscribers, MySpace has thousands of profiles of characters. By tying together identity formation, narrative construction, and character acting, all these personas relay specific identity information not just about fans or characters, but also about MySpace personas; not only about virtual identities, but also about identities that mash-up traditional notions of character, fan, and identification.

Fragmented Identity

The first method scholars can use to examine the virtual identity of the fan in an interreal space is to view the fan's integration of their persona with the extant media character's persona. Since there is no limit to the number of personas allotted to an individual, a fan can also create myriad personas, each one corresponding to a different set of identity markers they want to highlight. Each persona, therefore, becomes an "embellished ...personality"

within a realm of other embellished persona-alities.[36] By extricating different aspects of their own senses of self, and then portraying those aspects in different persona online, fans learn not only how to mark their virtual identity as a unique form from other virtual identities online, but also how to represent their own conceptual sense of self—their "me" identity—as it applies in the "real world." Through this representation, the fan identifies the aspects of a virtual identity that can be related to that of an extant media character.

This form of virtual identity writing becomes a way to digitally self-identify. The space of this post says a lot about what that fan wants known about his/her persona. For example, as we saw in the last chapter with Jim, L., and Knoxy!, one of the most valuable places to find information about a profile is through the comments posted to the persona. In the last chapter we saw how L. and Knoxy!'s comments affected the reader's interpretation of the profile of Jim. However, in terms of virtual identity construction, comments can also be a way for the commenter to forge a virtual identity, though the interaction with the profile on which one comments. Posting a comment to another fan's persona can indicate similarities and differences upon which to build identity.[37] For example, in the comments section of a character persona from *Gilmore Girls*, the poster Gilmoregirls3 writes "DUDE i love gg its my fav show ever!!!!!! I love ur space its so kute!!!! [all sic]."[38] Gilmoregirls3 here establishes her identity as fan of *Gilmore Girls* ("gg" is a common fan abbreviation for *Gilmore Girls*), and helps to establish characteristics of this identity on the "[My]space" site that she visits—"its so kute" expresses her opinion about the site, confirming her distinctive traits. As Judith Donath has shown, the choice of where to post is a vital one for online communication, as personas gain credibility through the location of their posts.[39]

The fan author of a MySpace character persona then actively rewrites his/her virtual identity by posting comments that respond to, and elicit a response from, the other members of the community: This presents a difference from other personas. As literary scholar Kenneth Burke has written, identity is negotiated by examining what one is not. To form an identification with another, one needs to entice the other to dialogue, and within this dialogue, find both places of commonality and places of difference.[40] Through differences we can learn both what we are and, importantly, what we are not. We can see how the posting of a particular statement can be contrasted to the other statements made on and by the persona. A rereading of that persona's

comment might reveal a difference between the two interlocutors, or might reveal a similarity—but either way, it would reveal an aspect of the virtual identity for both personas.[41] Importantly, as pointed out by Mark Poster, this formation of identity hinges on the interactive response of others, on the back-and-forth responses of the community.[42]

This communal interactivity between fan participants functions to tie narrative to virtual identity. We can see this on the official *Veronica Mars* MySpace site, created for the CW, in which a number of salient identity issues become apparent (the CW was the network on which *Veronica Mars* aired).[43] This official CW site depicts a form of parasocial attachment to these characters, but the actual use of the site by fans indicates rather that the fans are creating virtual identities in the interreal through identity fragmentation. In terms of parasocial interaction, the site appears to be created by the CW with the intent of giving MySpace users and fans of *Veronica Mars* the ability to communicate with the character. The more authentic they can make them seem—that is, the more they can make the persona "Veronica Mars" appear to represent an offline person—presumably the more attachment audience members will feel. The reality comes across firstly in the professionalism of the page: the sleek black background and the foregrounding of important information about Veronica highlights the "reality" of the character. It also comes through the information itself: Veronica's profile displays her virtual characteristics including her sex, age and location. However, the large "Catch *Veronica Mars* Tuesday 9PM CW" in the "About Me" section seems to negate this "reality." Here is another aspect of the Digi-Gratis economy: the digital mash-up of the character identity as both fictional—catch her on TV—and "real"—"female, 19 years old, Neptune High"—becomes an interreal aspect of the profile.

The first nine "friends" in Veronica's social network come from the show *Veronica Mars*.[44] Each link demonstrates how the CW makes personas out of these characters. The social network of the characters creates a further identity for "Veronica Mars," because it situates her within a complex series of relationships that mirror the relationships the personas of non-character, non-mediated users and fans on MySpace. As boyd and Ellison show, connecting with friends on MySpace is an "aspect of self-presentation" that "forms through the articulation of friendship links, which serve as identity markers for the profile owner."[45]

Further down the page, however, fans appear to subvert this parasocial persona in an interreal manner: a more scattered list of non-character friends becomes apparent.[46] A mixture of personas of characters and personas of fans, these friends confuse the issue of "Veronica Mars's" personality. Of note, one "friend" is the CW itself, while another friend is the show that immediately preceded *Veronica Mars* on the CW network, *Gilmore Girls*. This normalizes the television world into an interreal juxtaposition of identities: suddenly, everything that exists on the CW seems to exist in the *same virtual world*. Importantly, this virtual world seems to mix easily with our own world. To become friends with fan personas, or any persona of a non-fictional, non-mediated person, is to make the Veronica Mars CW persona a nexus of interreal identities, each a fragmented form of an individual interreal persona connected by a virtual community.

A second indication of this identity roleplay comes through the interaction of the posted comments with the profile itself, which helps build the identity credibility of the character of Veronica Mars.[47] Other personas on MySpace can write comments and post them on the website for others to read, and the MySpace profile continuously updates these comments as readers post them. Each comment is displayed in reverse order, like blog comments. For example, a comment on the *Veronica Mars* MySpace page from Aneeda burrita? reads, "so about the new pic...LoVe iT!!!" Although the comment may seem banal, it is anything but: it begs the question, why does Aneeda burrita? comment to a character she realizes is fictional? Whom does she think it going to respond? While the communication that occurred here is obvious (that one persona changed his/her persona picture and a second persona responded), the complicated meaning behind the posting of the comment—the "why," not the "what" of the comment—begs further analysis.

To change a persona picture is not necessarily just a cosmetic change, but also a way of "throwing on" a new identity, as one might wear a different style of clothing to school. Aneeda burrita? here identifies with "Veronica Mars" and tries to build her own virtual identity through the interreal combination of the space of "Veronica Mars" and the content of her own posted comments. In this way, Aneeda burrita? navigates her identity through another's profile, perhaps hoping that when others see her comment, they will click over to view her profile. In this way, the persona of "Veronica Mars" seemingly acts as a surrogate persona for the identity construction of other

personas, through the relationship between the sites. By creating a new space, an interreality, in which to construct her own identity, Aneeda burrita? has forged the relationship between character persona and the fan personas. Additionally, she has contributed a digital "gift"—of attention, of comment, of time—to the profile, further establishing the commercial popularity of *Veronica Mars* for other viewers of the profile, and bolstering a Digi-Gratis economy.

We can see a similar fragmentation of identity formation on profiles of The Doctor from the television show *Doctor Who*. On one particular persona, the creator has rewritten the character as a 45 years old, has posted a picture of himself, and has a list of friends, some of which are other character personas from *Doctor Who*, and some of which are fan personas. The interactions on the comments section mirror much of what occurs on the "Veronica Mars" persona: most commenters reread the "Doctor Who" site to construct aspects of their own interreal persona. For example, a user named "G." writes, "We are really glad you won't be travelling alone. Looking forward to the new season."[48] Although G. appears to be aware that *Doctor Who* is a television show ("new season") he also communicates on the "Doctor Who" MySpace profile as if the Doctor were a "real" person. I don't mean to insinuate that G. doesn't think *Doctor Who* is fictional, but merely that G. is here linking his own profile with that of The Doctor's. While adding to the persona of "G.," the comment from G. also contributes to his/her own persona, as users interested in what "Doctor Who" might say to G. might hyperlink there. The connection between "G." and "Doctor Who" occurs through an interreal association between the two personas, as fragments of one virtual identity bleed into other virtual identities, and create an interreal relationship.

Thus, by conversing on these sites, not only do Aneeda burrita? and G. create identities centered around *Veronica Mars* and *Doctor Who,* but they also rewrite their presence within the worlds of the shows. Aneeda burrita? could be Veronica's friend—just as the nine "character" personas are on "Veronica's" persona. G. could know The Doctor, and could really want to be a part of that show. Given that SNSs enable individuals to connect with one another, it is not surprising that they have become deeply embedded in user's lives, as boyd has demonstrated.[49] The conversation between two personas is more than a form of parasocial desire: it is identification and roleplay in an interreal space. By placing themselves in those particular spaces, Aneeda burrita? and G. create unique spaces between the producer's

space of *Veronica Mars* and *Doctor Who* and their own virtual identities, their own interrealities.

Reconstruction through Branched Narratives

A second way scholars can use an interreal analysis is by examining the reconstruction of extant media objects on MySpace. Fans identify more readily with characters through interacting with extant media objects, as Ng shows: actually creating or interacting with the extant media object through fan fiction or fan videos creates an "experience that cannot be derived from watching the show."[50] MySpace offers fans a space in which they can reproduce characters and situations from the extant media object, and then use those characters to reproduce fan culture. Through imaginative dialogue, the rewriting of characteristics seen on the television show, or reliving the narrative events that have been most dramatic, the fan encounters the extant media object's narrative as a mutable text. This mutability is what fan fiction scholars like Jenkins call the "silly-putty" of the story: fans end up "stretching [the extant media object's] boundaries to incorporate their concerns, remolding its characters to better suit their desires."[51] Each fan-created character persona becomes a way of both reliving and altering the extant media object's narrative text, opening up new possibilities by recreating those that have already occurred onscreen.

This method of identity roleplay on MySpace occurs through the interaction between narrative elements on the page. One's persona fits within the social framework produced by the fan community on MySpace. As van Kokswijk shows, virtual identity is not just defined as the place, but also the "*plot* you are in."[52] Plot, here, can mean two things: either a plot of land (i.e., the space you construct online) or a "plot" of a narrative (i.e., the narrative you create for yourself online). Thus, an extant media character's persona provides both a space and a narrative framework around which fan personas can extend narrative possibilities.

We can see this narrative dimension in the way the character persona of gwencooper, another profile of the character Gwen Cooper from the television show *Torchwood*, describes herself in the "About Me" section on her MySpace persona.[53] Gwencooper first uses this space to define her persona, (re)writing "My story starts off with me as a police officer in Cardiff but then i get involved in the Torchwood team [all sic]." In this statement, the writer of gwencooper has described the extant media character as media producers

and the actress have made her on the show—this is, therefore, a diegetic description, or one that repeats narrative/character information we already know from the canon of the extant media object. This is an aspect of the character's persona.

The "About Me" goes on, however, to rewrite *Torchwood*: "I'm a very down-to-earth girl, kind and generous, but extremely ambitious, feisty, intelligent and witty, if i do say so myself. But im really the girl next door [all sic]." These characteristics do not all diegetically describe the character of Gwen Cooper from *Torchwood*. Instead, these characteristics point to an amalgam identity, one created in an interreality by *adding* aspects to the diegesis of the narrative. The insertion of alternative narrative elements into a fan's rewritten version of an extant media object alters the interpretation of that narrative, and creates what Jenkins calls "I Wonder Ifs": narratives that "explore 'possibilities' that are hinted at but not developed within the [texts]."[54] By adopting a different narrative from what is considered canonical by the viewers, fan persona creators can tie their own virtual identities more directly with a set of values that may or may not differ from other fans. They become identified through their differences. In the gwencooper example, the fan aspects of the persona are inserted into the character aspects of the persona elements, creating a virtual identity that is not necessarily supported by the show (or, least, are opinions about the character that may not be shared by all viewers). This subjectivity creates a form of branching narrative, in which a rereading of the additions by fan writers creates an alternative view of the diegetic narrative text, another possible outcome from the one observed on the television.

In another example, the creator of the *Gilmore Girls* fan/character persona "zachandstaceforever" has hypothesized a text in which protagonist Rory did not break up with lover Dean during her college years, and instead stayed with him throughout the rest of the series.[55] This contradicts the continuity of the series, which saw Rory falling for different men, including rebel Jessie and heartthrob Logan. On the zachandstaceforever page, the character of Dean, portrayed through the MySpace character persona, enacts a dialogue with another persona through the comments section that articulates this separate narrative.[56] Through this dialogue, the Rory/Dean narrative continues as a separate branch from the show. For example, "BadAssRory" writes on zachandstaceforever's wall that "they [Rory and Dean] order their food and wait for their food to come. rory [sic] sips her coffee."

In this way, the fans behind the BadAssRory and zachandstaceforever personas build their own virtual identities by dialoguing and rewriting a characterization of the show. It is not just that they distance themselves from the (diegetically correct) character of Logan, but also that they ally themselves with the (diegetically incorrect) character of Dean. By deliberately altering the narrative, and displaying this alteration in a public profile, both zachandstaceforever and BadAssRory describe their identities through the division of a diegetic narrative: they do not so much build on the narrative as *branch* from it. The contrast could not be more explicit: Logan is the son of a rich newspaper magnate (think, ironically, of MySpace's owner, Rupert Murdoch), and is portrayed as a rogue and a playboy who settles down with Rory despite his womanizing tendencies. Dean, on the other hand, was a working-class but honest boyfriend who proclaimed his love for Rory early in the series. By "siding" with Dean over Logan zachandstaceforever and BadAssRory establish a number of traits that they feel strongly about: loyalty, hard work, and puppy love.

By re-focusing the narrative around Dean, who personifies these traits, zachandstaceforever and BadAssRory rewrite the virtual identity of the persona through a separate narrative thread, which exists in an interreal narrative space. This new identity, built from pieces of *Gilmore Girls*, from pieces of the textual elements zachandstaceforever and BadAssRory have posted elsewhere online, and from the elements of their own lives that they may have included in these personas, bypasses the mechanics of the media producer. Zachandstaceforever and BadAssRory remove themselves from the *Gilmore Girls* narrative not by writing fan fiction directly, but by rewriting the space of the text itself: the space that zachandstaceforever and BadAssRory know as "*Gilmore Girls*" is different from the one that others watch on television. Their "*Gilmore Girls*" is one of their own creation, to be reread as such by other fans.

Roleplay through Fan-Created Dialogue

However, just as there is a tension between the experience of *Gilmore Girls* on the CW and *Gilmore Girls* on zachandstaceforever's profile, there is a tension between identity formations within the persona writer him-/herself. The desire for an individual identity is shaped and structured by a tension between communal expectations and individual desires. This tension is made most salient on MySpace, as the tension between the fan and the character in

one interreal persona creates a difficult tangle of identity formations. As Bolter suggest in digital writing one needs to "construct her identity," yet any persona creation becomes "a cooperative effort."[57] In order to have an effective post, a poster must necessarily construct an identity that is different from others, but similar enough to warrant being in/on the same page.

Scholars can thus use a third method of interreal analysis: By observing the identity roleplay of the fan's fragmented, virtual identities, the scholar can observe these reconstructed characters as representation of the fan herself. Soukup identifies a similar process at work in fan-created celebrity websites:

> via photograph galleries, the designer of the fansite has, to an extent, the means to control the physical representation of the celebrity via the inclusion or exclusion of specific photographs. These fans are not merely interpreting the celebrity via existing media texts, they are also creating a new text.[58]

As fans integrate into their fan-created MySpace character personas, they insert identity characteristics to deepen the character, and flesh out additional aspects of the extant media object. Through connections made with other personas on MySpace—some character, some fan, some neither—the fan-creator incorporates the virtual community as an additional aspect of the virtual identity of the character. This incorporation indicates the formation of an interreal space, for the fan to post not only characteristics of the character, but characteristics of the fan as well. Through the posting of comments back and forth between two different personas, written in the characters' voice, fans act with their character persona creations. For instance, if John, from Tulloch and Jenkins's example, had created a Mr. Spock character persona on MySpace, not only would he have been able to be "like" Spock, but he also would have been able to post comments *as* Spock, interact with characters who are friends *with* Spock, and write blogs in the voice *of* Spock.[59]

For example, in the *Gilmore Girls* profile titled coffeeluvr4life, the user has posted a picture of the *actor* Lauren Graham, role-played as the *character* Lorelai Gilmore (writing, "Don't I look stunning?" reads the caption), and reread that comment as the *fan*, coffeeluvr4life ("*laughs* yeah right...").[60] She appears to use the picture of the actor to situate this character/fan persona outside the mediated world of *Gilmore Girls*, as a persona that mashes up the line between fan and character identity.

Thus, the social identity formed by coffeeluvr4life demonstrates not just the mash-up of identities on MySpace, but also the playful acting and role-play that fans enact with characters through their personas. Coffeeluvr4life does not just identify with Lorelai Gilmore as a character that exists else-where in the space created by the producers, but also roleplays *as* Lorelai Gilmore as an aspect of her own identity in an interreal space of her own creation. Roleplay involves a definition of the self as something "other," or what Torvill Mortensen calls "another you."[61] We are always performing, as Goffman describes, but the roleplay on MySpace takes a decidedly different turn: for when we deliberately perform another already-extant identity on MySpace, we highlight and underscore the different identity characteristics that we feel are important, and put on a presentation of a different self. MySpace virtual personas exist neither in the space of the other, nor in the space of the reader, but rather in a different, interreal space. These personas foster fan/character roleplay as MySpace provides surrogate experiences for fans to experience the narrative text.

This third form of virtual identity construction on MySpace can also be seen in a fan-constructed site for persona "Veronica Marz." Fans not only refer to this character as one who exists in a non-mediated, physical reality, but also live vicariously through this character on MySpace. Instead of simply *thinking* that characters can exist external from their own mediation, fan personas roleplay and *create* an interreal space where they interact to write a narrative, utilizing a form of narractivity. The "Veronica Marz" profile uses additional fan/character personas to rewrite a more individual-ized identity.[62] The layout of the profile represents a more personal approach to the website. In the case of "Veronica Marz," the site is designed as if it represented the personality of Veronica Mars. Using the idea of a distributed narrative of the *Veronica Mars* text allows the creator to imagine that the narrative of the show continues online, transmediated with MySpace.

Further, the roleplay of the fan/character amalgam creates a new form of interactive fan fiction: dialogue between "Veronica Marz" and other charac-ter personas.[63] The construction of fan fiction on MySpace differs from the way it is constructed on the blog. On MySpace, the fans write fan fiction through interreal dialogue posted as comments between personas. In this way, the fiction appears as an interaction, written through the narrative dialogue between two interreal personas. For example, the persona of "Dick"

interacts on the profile of "Veronica Marz" to rewrite the narrative of *Veronica Mars* as a new story. "Dick" narrates, in the third person:

> Dick rolled his eyes. God, she was pathetic. And Logan was pathetic, too. He couldn't believe that something so 'wonderful' (as Logan had previously described it) as love could turn two people into completely different people than they'd been before.

Interestingly, the two people that "Dick" refers to had broken up in the show before this post had been made; therefore, the events referred to are unique to the MySpace fiction.

In order to function as fan fiction, however, the fan community must necessarily separate this dialogue from the show that exists diegetically as text of *Veronica Mars*. In writing this new text, "Veronica Marz" creates a digital environment outside the reach of the television show, the CW network, or the other fan-readers. Although the characters are shared between the network and the fan, they are rewritten with a new virtual identity that neither asserts the strategic input of the media producer, nor demonstrates the tactical response of the fan to others in the fan community. Instead, the fan/character amalgam straddles this divide, existent in a new, interreal realm. Although aspects of the market economy, in the guise of the media producer, may "own" the character, the fan also controls the fan/character persona and provides the profile as a type of gift to the other fans of *Veronica Mars*.

We can see a further refinement of this virtual persona roleplay in the MySpace character persona of captain_j_harkness. Captain_j_harkness represents a fan/character identity, one in which the fan roleplays as a character from *Torchwood* by interacting with other fans' personas. The comments section of captain_j_harkness displays one half of two dialogues between this fan and two others, named A. and ~Barty~[Shadow]~.[64] Instead of branching the narrative, or indicating a change in the narrative structure of the extant media object, as we saw with Veronica Marz, the narrative described by captain_j_harkness takes place in an interreal, non-diegetic space outside that prescribed by the extant media object. In fact, the interlocutors engage in a spirited debate about the character, but do so in the first person. Whereas in Veronica Marz the character personas roleplayed with other character personas (i.e., Dick talked with Logan through MySpace), through cap-

tain_j_harkness the fan rewrites the character (Captain Jack Harkness) out of the diegetic universe and rereads him in a fan-created interreal space.

For example, A. writes on the comments for captain_j_harkness that "she laughed slightly when he mentioned partyer 'Yeah I'm not a big party animal I enjoy spending time just me and a glass of vodka' [all sic]." With this quotation, she indicates not a sense of the storyline, serial plot arc, or episodic narratives of *Torchwood*, but rather introduces a new thread of the narrative story. A. is creating her own persona on MySpace through an interaction with the virtual identity of captain_j_harkness. While the character of "Captain Jack" might enjoy going out to parties in *Torchwood*, the type of interaction suggested by A. is incongruent with the personality of the *Torchwood* character. What A. rereads here is a sense of her identity as a fan interacting with a virtual identity of "Captain Jack."

Captain_j_harkness, for A., is not the character "Captain Jack" from *Torchwood*, nor is he the fan/creator of the MySpace page: instead, he is a mash-up of the two. Through their dialogue, A. and captain_j_harkness are not textually poaching material from *Torchwood*, but making their own material, created both from the remnants of an extant media object, and from their own rereading, their own sense of community. Their interaction on MySpace allows an ever-evolving space for the creation of meaning from extant narratives. Whereas traditional fan studies would use de Certeau's conception of textual poaching and tactical reading to indicate a form of character interaction and identification, MySpace, the communalization of the Web Commons, and the mashed up economic structure of the Digi-Gratis, denotes a need for new scholarship into Digital Fandom, as a characteristic analysis of New Media Studies.

IDENTITY ROLEPLAY

By eliding the role of the consumer from a tactical one to one that mashes up strategies and tactics in a new space, MySpace dramatically represents the Digi-Gratis economy. By melding virtual identity production and narrative completion, MySpace personas merge two worlds, fan identities that exist offline and character identities that exist in a mediated relationship to the fan, into the interreal. The producer's "power" over the characters, intuitively assumed in a market economy, is negated by the fan's own determinism over

the media object. Yet, the fan's work—given freely and in order to build a community—participates within the realm of the gift.

The fan's participation in the creation process, facilitated by the creation of the interreal, results in a new form of media text, that itself could become the object of fandom from others. Fans use MySpace as a constructive arena of media creation: they change the object of their fandom into something *new*. By combining elements of characters and fan personas into one interreal text, fans not only circumvent the products they have grown to love, but also create new products that others can love. In this way, they articulate a fandom in which they are willing to alter their favorite texts in new spaces of fandom. In these new spaces—fan spaces—the virtual identity becomes part of the fan's interpretation of the extant media object.

Finally, because MySpace depicts not just the ability to create new profiles, but also the capacity for visually representing whole communities, it represents a new way of conceptualizing fandom. Through the active rewriting and the interactive rereading of extant media objects, fans reproduce their fandom in new contexts. The communities of fans that form and roleplay together on MySpace are not just meeting to discuss the object of their fandom, but are also creating a whole new way to interact. Taken to its logical extreme, these reproductions become new ways of experiencing not just fandom, but media studies as well.

NOTES

[1] Due to the anonymity offered on MySpace, there is no way to tell the sex of the creator of "Luke." In this case, as in the rest of this chapter, I will use the pronoun that would be appropriate for the *subject* of the persona (i.e., "Luke" will take the masculine pronoun while "Rory Gilmore" will take the feminine).

[2] Angela Thomas, "Fan Fiction Online: Engagement, Critical Response and Affective Play through Writing," *Australian Journal of Language and Literacy* 29, no. 3 (2006): 236–7.

[3] See, Christy Dena, "Emerging Participatory Culture Practices: Player-Created Tiers in Alternate Reality Games," *Convergence: The International Journal of Research into New Media Technologies* 14, no. 1 (2008), 43.

[4] Brian Stelter, "A Marketing Move the 'Mad Men' Would Love," *New York Times*, 01 Sept 2008, http://www.nytimes.com/2008/09/01/business/media/01twitter.html?scp=2&sq=twitter&st=cse (accessed 02 Sept 2008), ¶2.

[5] David Horton and Richard Wohl, "Mass Communication and Parasocial Interaction," *Psychiatry* 19 (1956), 229.

[6] John Fiske, "The Cultural Economy of Fandom," in *The Adoring Audience: Fan Culture and Popular Media*, ed. Lisa A. Lewis (London: Routledge, 1992), 30–3.

7 Michel de Certeau, *The Practice of Everyday Life*, trans. Steven Randall (Berkeley: University of California Press, 1984), 38.
8 Ibid., 100.
9 Jack Harkness™ (See, Appendix C).
10 Matt Hills, *Fan Cultures* (London: Routledge, 2002), 39; see also Matt Hills, "Strategies, Tactics and the Question of *Un Lieu Propre*: What/Where Is 'Media Theory'?" *Social Semiotics* 14, no. 2 (2004).
11 Horton and Wohl, 299.
12 See, Kjerstin S. Thorston and Shelly Rodgers, "Relationships between Blogs and eWOM and Interactivity, Perceived Interactivity, and Parasocial Interaction," *Journal of Interactive Advertising* 6, no. 2 (2006), 42–3 for an excellent literature review of parasocial theory.
13 Horton and Wohl, 215.
14 Thorson and Rodgers, 46.
15 Sheizof Rafaeli, "Interactivity: From New Media to Communication," in *Sage Annual Review of Communication Research: Advancing Communication Science: Merging Mass and Interpersonal Processes, 16*, ed. R. P. Hawkins, J. M. Wiemann, and S. Pingree (Beverly Hills: Sage, 1988), 124.
16 Which we can perhaps best see this in the interactions of *Star Trek* fans who famously saved the original television show from cancellation by organizing letter-writing campaigns, a practice which has recently been used for newer cult television shows like *Roswell* and *Firefly*.
17 David C. Giles, "Parasocial Interaction: A Review of the Literature and a Model for Future Research," *MediaPsychology* 4 (2002), 286.
18 Elinor Ochs and Lisa Capps, "Narrating the Self," *Annual Review of Anthropology* 25, no. 1 (1996), 20–1. Ochs and Capps define the "self" much as I have described the sense of "I"—"an unfolding reflective awareness of being-in-the-world, including a sense of one's past and future" and they define "narrative" much as I define "discourse"—"narratives are versions of reality. They are embodiments of one or more points of view rather than objective, omniscient accounts," which would be aligned with my definition of "story."
19 de Certeau, 169, my emphasis.
20 Ibid., 174.
21 Henry Jenkins, *Textual Poachers*: *Television Fans and Participatory Culture* (New York: Routledge, 1992), 23.
22 de Certeau, xxii.
23 Ibid., 166.
24 Jenkins, *Textual*, 24–7.
25 C. Lee Harrington and Denise D. Bielby, "Global Fandom/Global Fan Studies," in *Fandom: Identities and Communities in a Mediated World*, ed. Jonathan Gray, Cornel Sandvoss, and C. Lee Harrington (New York: New York University Press, 2007), 188.
26 Jenkins, *Textual*, 235.
27 John Tulloch and Henry Jenkins, *Science Fiction Audiences* (London: Routledge, 1995), 233.
28 Ibid.
29 Sara Gwenllian-Jones, "Starring Lucy Lawless?" *Continuum: Journal of Media and Cultural Studies* 14, no. 1 (2000): 11–12.
30 Cornel Sandvoss, *Fans: The Mirror of Consumption*, (Malden, MA: Polity Press, 2005), 96–7.
31 Hills, *Fan Cultures*, 171; Sandvoss, *Fans*, 97. For Hills, impersonation can also entail the "constant management of fluid boundaries between self (cult impersonator) and other

(icon)" (167). Hills uses the example of Elvis impersonators, who have to negotiate their identity as a fan of Elvis and their identity as Elvis. By impersonating Elvis, the fan inhabits the role of the musician, subsuming his/her own identity in order to complete the transformation.

[32]　danah boyd and Nicole Ellison, "Social Network Sites: Definition, History, and Scholarship," http://jcmc.indiana.edu/vol13/issue1/boyd.ellison.html (accessed 07 Oct 2008), ¶4.

[33]　Christy Dena, "Patterns in Cross-Media Interaction Design: It's Much More than a URL... (Part 1)," *Crossmediaentertainment,* http://www.cross-mediaentertainment.com/DropBox/ DENA_MoreThan_Part1.pdf (accessed 25 Sept 2), ¶1; see, also, Jill Walker, "Distributed Narratives: Telling Stories Across Networks" (paper presented at AoIR 5.0, Brighton, 21 Sept 2004), http://huminf.uib.no/~jill/txt/AoIR-distributednarrative.pdf (accessed 01 Aug 2006); Dena, "Player-Created Tiers."

[34]　Sara Gwenllian-Jones, "The Sex Lives of Cult Television Characters," *Screen* 43, no. 1 (2002), 84.

[35]　Meaning both a place where virtual identity can be made and also a virtual space of identity construction.

[36]　Jacob van Kokswijk, *Digital Ego: Social and Legal Aspects of Virtual Identity,* rev. ed. (Delft, the Netherlands: Eburon Academic Publishers, 2008), 56.

[37]　As Hills, *Fan Cultures,* 159–60 shows, fans often perform the identity of "fan" for other fans.

[38]　Gilmoregirls3 (See, Appendix C).

[39]　Judith Donath, "Identity and Deception in the Virtual Community," in *Communities in Cyberspace,* ed. Marc Smith and Peter Kollock (New York: Routledge, 1999), 34; also, Judith Donath and danah boyd, "Public Displays of Connection," *BT Technology Journal* 22, no. 4 (2004), 77.

[40]　Kenneth Burke, *A Rhetoric of Motives,* (Berkeley: University of California Press, 1969), 21–2; also, Timothy W. Crusius, "A Case for Kenneth Burke's Dialectic and Rhetoric," *Philosophy and Rhetoric* 19, no. 1 (1986).

[41]　As it happens, when checked, Gilmoregirl3's MySpace page had no reply to this comment, but the possibility of a reply still existed.

[42]　Mark Poster, *The Information Subject* (London: Taylor and Francis, 2001), 78.

[43]　*Veronica Mars* CW (See, Appendix C).

[44]　Ibid.

[45]　boyd and Ellison, ¶41.

[46]　*Veronica Mars* CW (See, Appendix C).

[47]　Ibid.

[48]　*Doctor Who* (See, Appendix C).

[49]　danah boyd, "Why Youth (Heart) Social Network Sites: The Role of Networked Publics in Teenage Social Life," in *MacArthur Foundation Series on Digital Learning—Youth, Identity, and Digital Media Volume,* ed. David Buckingham (Cambridge, MA: The MIT Press, 2007), http://www.danah.org/papers/WhyYouthHeart.pdf (accessed 10 Jan 2008), ¶14–15.

[50]　Eve Ng, "Reading the Romance of Fan Cultural Production: Music Videos of a Television Lesbian Couple," *Popular Communication* 6, no. 2 (2008), 110.

[51]　Jenkins, *Textual Poachers,* 156.

[52]　van Kokswijk, 74, emphasis mine.

[53]　Gwencooper (See, Appendix C).

[54]　Henry Jenkins, *Convergence Culture* (New York: New York University Press, 2006), 181.

[55]　The name "zachandstaceforever" already implies a mashed up relationship: this one persona, at least in name, is the creation of two people. However, given the pseudonony-

mous capacity of MySpace, it is impossible to tell with any certainty if this persona has been created by one or by two persons.

[56] zachandstaceforever (See, Appendix C).

[57] Jay David Bolter, *Writing Space: Computers, Hypertext, and the Remediation of Print*, 2nd ed. (Mahwah, NJ: Lawrence Erlbaum Associates, 2001), 116, writes before the popularity of Social Network Sites, but his description of the dialogic nature of online communication applies to MySpace and other SNSs as well.

[58] Charles Soukup, "Hitching a Ride on a Star: Celebrity, Fandom, and Identification on the World Wide Web," *Southern Communication Journal* 71, no. 4 (2006): 329.

[59] Tulloch and Jenkins, 233. There are Spock personas on MySpace: see closefriend-ofjamestkirk as an example (See, Appendix C).

[60] coffeeluvr4life (See, Appendix C).

[61] Torvill Elvira Mortensen, "Me, the Other," in *Second Person: Role-Playing and Story in Games and Playable Media*, ed. Pat Harrigan and Noah Wardrip-Fruin (Cambridge, MA: The MIT Press, 2007), 297–8.

[62] Veronica Marz (See, Appendix C).

[63] Ibid.

[64] captain_j_harkness (See, Appendix C). The dialogue between A. and captain_jack_harkness is two-way. However, one must be "friends" with captain_jack_harkness to read his end of the conversation. My friend request, sadly, has been ignored.

Conclusion

Digital Fandom, Alternate Reality Games, and Demediation

In essence, games are the only universally serious activity. They leave no room for skepticism, wouldn't you agree?
—*Pérez-Reverte, The Club Dumas, p, 314*

These are the [books] I love best. They shine above the rest for their beauty, for the love they have inspired. These are the ones I walk hand in hand with to the brink of the abyss. ...Life may strip me of all I have. But it won't turn me into a miserable wretch.
—*Pérez-Reverte, The Club Dumas, p, 152*

As Pérez-Reverte's protagonist Corso progresses through *The Club Dumas,* the events that he encounters seem constructed to confound him, as if he were a player unwittingly led into an artificially constructed game. Corso believes that what he could consider "reality" and what he sees as the "ludicity," or game-like characteristics of the plot machinations of the collectors, have mashed up and have become inseparable from one another. The circumstances surrounding the search for and rescue of an occult manuscript make him question the ontological "reality" of his existence, as he wonders not just what to do next, but also whether anything he does will have any effect on his life whatsoever. He wonders if the events in which he's found himself embroiled might be elaborate ruses, aspects of a game to which he does not understand the rules, or even if he is in control of his own actions. He races from one trap to another, encountering people along the way that seem caricatures and stereotypes of fictional characters in a story, rather than "real" people in "real" life. Perhaps, he reasons, these characters, this group

of maniacal antique book collectors, are playing a game with him as pawn, creating events in order to fulfill a particular goal. Corso's confusion of his reality for a game represents an ontological break, a tension between the ludic and the non-ludic that we can see represented in the first quotation that inscribes this chapter: games are serious, and leave no room for skepticism. For the book aficionados, this game is serious business, not ludic escapism.

Throughout this book we have investigated contemporary media objects that enact tensions similar to the ludic/serious one proposed by Pérez-Reverte. For example, the blog mashes the tension between whole work and distributed text; the wiki mashes the tension between a narrative story and a narrative discourse as well as between narrative structure and interactivity; MySpace mashes the tension between ontologically "factual" and ontologically "fictional" personas, as well as between issues of reality and virtuality. In turn, we have also seen how these mash-ups relate to the concept of the fan within the community of the Web Commons and the economic structure of the Digi-Gratis economy. This process presented by Digital Fandom has important consequences for contemporary fan studies specifically, and for larger issues of textuality, narrative and identity in media studies in general.

Alternate Reality Games are New Media productions—perhaps the ultimate expression of New Media—and represent exemplars of New Media Studies theories. Digital Fandom and ARGs are related by the transgression of boundaries that both the fan and the ARG enact. ARGs, as we will see, transgress a number of boundaries, the most salient of which is that between the mediated and the non-mediated. Fans, similarly, transgress the line between production and consumption, and importantly, alter our interpretation of that boundary. The transgressive nature of both fans and ARGs highlights a connective thread between them. And just as we have spent the past few chapters describing how New Media Studies can refocus its scholarship onto new digital text through the metaphor of the ARG, so too should we reexamine the ARG through the same lens. In this conclusion, I want to examine how the ubiquitous mediation of ARGs functions within an already saturated media society, through a paradoxical demediation of media technology. Further, I want to show that the philosophy of playfulness encountered within fandom has larger complications across the media environment.

MEDIA/TECHNOLOGY

As Schneider and Kortuem describe, the apparent tension between technology and mediation has been conceptualized as highlighting the tension within the ARG (they refer to it as a persuasive game):

> technology is not the focus of the game but rather the technology supports the game. Although technology is ubiquitous in a Pervasive Game, its role is a supporting one and thus the technology is kept as unobtrusive as possible.[1]

As I detail in this conclusion, this dichotomy between the ubiquity and the unobtrusiveness of media and technology forces a reconceptualization of our understanding of contemporary mediation and technology. Specifically, the ARG problematizes Bolter and Grusin's examination of remediation as an outgrowth of traditional media studies. They claim that every media technology depends on previous media technology for its content. However, despite their statement to the contrary,[2] I show how their argument actually hinges on a form of technological determinism, as they ignore key components of New Media, including interactivity, dialogue, and community.[3] Bolter and Grusin neglect to investigate how the user's experiences of mediation—so crucial for an ARG—can change with the use of different online media technologies. Specifically, an ARG highlights a reality for players as the mediation of the game disappears in what I'm calling a demediation of digital culture. Demediation is a state where the ubiquity of mediation hides that selfsame mediation. This concept lies in contrast to Baudrillard's simulacra, for demediation does not, in fact, itself hide the real.[4] Instead, despite the appearance that they blur the boundaries between the ludic and the non-ludic, ARGs actually reinforce that boundary; and in doing so, they reinforce the constituent elements of the ludic/non-ludic binary, and provide a reassurance and strengthening of what contemporary media studies might call the unmediated reality of physical existence.

REMEDIATION/DEMEDIATION

ARGs exist in a "demediated" reality, a Derridean "undecidable" position that mashes up the hypermediate and immediate conceptions of mediation.[5] For Derrida, an undecidable concept cannot exist at either end of a binary or a dialectic. For example, in *Specters of Marx,* Derrida describes the concept

of the ghost as existent in an undecidable state between living and dead, two normally mutually exclusive polarities.[6] The undecidability of demediation lies in opposition to Bolter and Grusin's decidable definition of remediation, which in contrast underscores the dialectic of hypermediacy and immediacy. Mediation, as Bolter and Grusin write, is contradictory and impossibly alternative: "our culture wants both to multiply its media and to erase all traces of mediation: ideally, it wants to erase its media in the very act of multiplying them."[7]

At the heart of their argument lies the paradoxical notion that media both represent and replace human communication. This argument echoes in Klaus Jensen's three degrees of mediation.[8] The first degree forms from the bio-logical, socially-based resources of communication. In this view of media-tion, oral communication is key, as the interlocutors that communicate must be in contact with each other: it "depend[s] on the presence of the human body in local time-space."[9]

Jensen's media of the second degree involve "communication across time and space, irrespective of the presence and number of participants."[10] The characteristic modes of communication in this second degree include print, television, video technology and radio. Common features of second degree media include "one-to-one reproduction, storage, and presentation of a particular content and...radically extended possibilities for dissemination across time and space."[11] Second degree media separate the interlocutors by time and space, but ultimately remain based in an analogue culture. Media of the second degree, further, externalize the human mind, and not only present, but also create, a sense of the author or designer: as Foucault has pointed out, they become "a matter of constituting oneself as a subject of rational action through the appropriation, the unification, and the subjectivation of a frag-mentary and selected already-said."[12]

Finally, Jensen's media of the third degree are "digitally processed forms of representation and interaction.[13] Computers are central to this conception, as they can combine all media of the first and second degree onto one plat-form. In this way, computers become a form of metamedia that makes infor-mation more accessible and interaction more applicable to communication.[14] Media of the third degree simulate face-to-face interaction, in that the tempo-ral situation of communication is near-instantaneous, but the method of communication may be spatially divided. Just as it portends a return to first degree media, third degree media becomes, as Ong would say, "a more

deliberate and self-conscious" mediation one fostered by a reliance on technological means for communication.[15]

The degrees of media are, in large part, based on the technology of mediation. We assume that media exist in a constant tension, and we must always negotiate between our looking at media (hypermediacy) and looking through media (immediacy). The ARG exists in a position inside this tension, between hypermediacy and immediacy. This position, the demediate, represents a change in our conception of reality as both mediated by and detached from technology.[16] As such, the demediacy of ARG becomes a potent metaphor for New Media Studies as well, as the complete integration of all media technologies into one media environment heralds an inescapable connection between media and technology in contemporary society.

Immediacy is the logic of erasure, as Murray describes.[17] We expect our media to disappear; we want to become enveloped in the moment presented by the media. "Immediacy is supposed to make [the] computer interface 'natural' rather than arbitrary" and will "erase itself, so that the user would no longer be aware of confronting a medium."[18] In this, the nature of immediacy provides an interface through which the viewer is supposed to have an unhindered view of the "real" world. For example, when a film viewer momentarily forgets they are in the theatre and becomes "lost" in the screen, enveloped and absorbed by the mediation to the point that the mediation replaces reality for that viewer, that viewer is immersed in an immediate environment.

Conversely, hypermediacy is the logic of overt mediation. According to Bolter and Grusin, "hypermediacy offers a heterogeneous space, in which representation is conceived of not as a window on the world, but rather as 'windowed' itself—with windows that open on to other representations or other media."[19] An appreciation of the cinematography of a film, or the acknowledgement of the composition of chiaroscuro in a photograph, are moments of hypermediacy, where the representation of the media itself becomes more visible than the "reality" that media attempts to portray. Hypermediacy is the state of the obviousness, of extreme mediation. When we admire the special effects in a film—effectively losing our immersion and appreciative of the craft—we become enamored with hypermediacy.

Bolter and Grusin argue that the resolution of this tension between immediacy and hypermediacy is remediation, a "double logic" which both erases and makes visible the act of mediation.[20] Remediation is the reflection

of one type of media content in another medium, the re-presentation of a medium. Key to Bolter and Grusin's argument lies in their citation of Marshall McLuhan's assertion that "the content of any medium is always another medium."[21] Rather than the obvious denotative meaning of his statement, that a medium literally displays another and repurposes it, Bolter and Grusin show that McLuhan was thinking of "a more complex kind of borrowing."[22] Specifically, they argue that digital technologies are today's quintessential remediated devices, which constantly reflect the media of the television, film, photography and painting. This reflection has two consequences. First, "the digital medium wants to erase itself, so that the viewer stands in the same relationship to the content as she would if she were confronting the original medium."[23] Digital technology, therefore, tries to "disappear," to become immediate. Conversely, "the very act of remediation ... ensures that the older medium cannot be entirely effaced; the new medium remains dependent on the older one."[24] In this way, digital technology represents both the immersive experience of mediation and the obvious of the act of that mediation as the overt "repurposing" of one medium in another: "every medium includes its predecessors within itself even as it appears new and improved."[25]

The process of contemporary (re)mediation, however, evolves from more than just the dichotomy between hypermediacy and immediacy: it actually centers on three distinct tensions, each of which emerges from the combination of three apparatuses: a medium, media content, and technology. As media become more complex, complications occur in the way these three apparatuses overlap as an audience's participation both with the tools and with the presentation of media content complicates mediation. For example, a tension becomes apparent in the intersection of the medium and the media content, as we can recognize media and media content either as objects themselves or as representations of real objects in the world. A photograph, for example, is both a tangible artifact and a representation of a real object. In this way, media always present an absence: the object in a photograph is not that object, but rather a representation of the absence of that object. Such tension is noted by W. J. T. Mitchell, who summarizes Barthes' description of photography by stating, "Everyone knows a picture of their mother is not alive, but they will still be reluctant to deface or destroy it."[26] Even though the photograph itself is an object, it is marked with additional symbolic meaning from object it represents.

A second tension occurs when a form of technology physically intersects with a medium used to present it. We can see this tension most saliently in print, as the medium must be both present and absent in order for the technology to create the media content. If a medium, in this case the paper (or papyrus, or other flat surface), is marked by a technology—pen and ink, pencil and graphite, quill and ink, etc.—then etchings on the surface of the medium leave content in the form of letters, symbols, pictograms or other forms of symbolic communication. In order to interpret these symbols, however, a reader must construct meaning from the tension between the presence of the ink and the absence of ink—or, the visibility of the technology and the disappearance of the technology. It is equally important where one does not write, as is where one does. The markings on a paper are noticeable because they are not uniform, and because they illustrate an absence of blank space. In the digital, too, we can see this presence/absence most literally in the code used to program: one of the constituent aspects of digital writing lies in its binary base of 1/0 and the constituent metaphors this binary represents: yes/ no, on/off, presence/absence.

A third tension, between the media content and the technology, occurs when technology develops as both a tool for producing media content and also a means for displaying media content. For example the computer is both the technology and also the medium through which one views the media content.[27] As Jenkins writes, the computer has ushered in a culture of media convergence where users can both consume and produce media on the same device and "participation is understood as part of the normal ways that media operate."[28]

The tensions between the medium, the content, and the technology illustrate one particularly salient absence in Bolter and Grusin's *Remediation*: the effect of the social/cultural on mediation. Although they discuss in brief how the social and cultural logic of mediation, what they call the "authenticity of experience," can affect our interpretation of media, they spend little of their book articulating these authenticities.[29] Indeed, at times, Bolter and Grusin's discussion of "remediation" is hindered by their determinism. As they discuss it, technological determinism is simply the flipside of determined technology: they propose to "explore digital technologies ... as hybrids of technical, material, social and economic factors."[30] Yet, their basic thesis remains deterministic: As they demonstrate, media are always based on other media as "each act of mediation depends on other acts of mediation.

Media need each other in order to function as media at all."[31] This determinism limits the scope of their analysis by eliminating the user from the process of mediation, the unique element of each medium that forms a user's experiences. As Jensen states, "the theory of remediation tends to choose sides, inviting an analytical gaze at the surface of the interface, *bracketing technologies, users and social contexts.*"[32] For example, a unique property of the televisual medium comes not from any individual element onscreen, but from the "flow" of programming, the progression of television programming, commercials and station identifications that creates a new type of text. Flow is not just "hypermediated television, but also the result of the viewer's *experience* of the medium."[33]

In contrast, and pertinent to contemporary digital media, ARGs exist solely as user experiences and not entirely as remediations. To take part in an ARG is to experience an intangible, untenable, ethereal media event. As we have seen, there is no "text" of an ARG; Barthes' definition of "text" is apropos here. Barthes defines the "text" as existent between works, creating an intertextual web of meaning.[34] Because elements of the ARG are spread out across different spatial environments and temporal locations, they literally exist in many locations at different times. Only through the immediate as well as the hypermediate experiences of the users/players of ARGs can the ARG "text" itself be known, encountered, and played.

THE DEMEDIATION OF THE ARG

As a perceptible example of this inherent fallacy of remediation's double logic, Alternate Reality Games challenge and overturn the binary division between hypermediacy and immediacy. The media used in ARGs represent breaks in the logic of remediation, as the poles of immediacy and hypermediacy have been flipped and the binary between the two has been elided. In fact, reality-blurring games, as Sherry Turkle points out (although her analysis pre-dates the ARG), "stand betwixt and between the unreal and the real; they are a game and something more."[35] She calls this a form of "blurred genre," which underscores the way ARGs overturn enact two contradictory tenets: they do not so much remediate as they do demediate, effacing the media as they conversely rely on them.

On the one hand, as McGonigal describes, ARGs are "digitally distributed" across different media technologies, and are only visible through the

obviousness of their mediation.[36] They are hypermediated because they do happen entirely because of mediation. By existing solely through mediated technology, ARGs make that mediation the basis of their ontological state of being. On the other hand, and at the same time, ARGs attempt to hide through mediation, to use "natural settings as the immersive framework."[37] To experience the mediation of an ARG is to become aware of its contextual use in real life. If clues come in a mediated form, they mirror real-life communication. ARGs are immediate because they thus seem to happen outside of mediation. Players of ARGs use everyday technology to interact with the game: this technology becomes part of the game—part of the immersion.

By attempting to perform both sides of this dichotomy, ARGs participate in a particular sense of hyper-immersion, as the complete ubiquity of media technology envelops the players as it becomes invisible. The mediation of the ARG cannot be mediation because there is no "game" to mediate outside of the ARG. ARGs exist because they reverse and exceed immediacy and hypermediacy: they demediate both the non-ludic and the ludic.

The ARG thus uses media to hide its mediation; as such, the ARG seems immersive, but effaces the mediation it necessarily presents. ARGs are not just dependent on media, they are media. The only way we could experience mediation as mediation is if there is something outside of that mediation. As philosopher Slavoj Žižek shows, "what is crucial for us here is ... the very borderline separating the outside from the inside."[38] The total effacement of one end of a dialectical polarity serves only to sever the knowledge of that polarity itself from humankind. For example, Žižek later notes that if humankind were to be completely mechanized, we would lose the ability to be able to tell machine from flesh: The complete effacement of one pole (the "flesh" of humankind) standardizes identity and "the human being will gradually lose its grounding in the concrete life-world—that is to say, the basic set of coordinates which determine its (self-) experience."[39] To become completely engulfed in a mediated world, to extrapolate, is to lose the ability to tell mediation from reality.

ARGs take place at the level of mediation: there is no ARG outside of that which is mediated. Thus, media encompass the ARG. If there is no ARG outside of media, then there can be no perception of the ARG without media, and media anneal our understanding of what the ARG actually is, or can be. Further, once puzzles in ARGs are solved, they are mediated again on wikis, which house all the information collected about the game.[40] Even so-called

"real" world events, non-ludic stagings that take place in the "real" world, become mediatized as they are re-broadcast to the rest of the players on these encyclopedic wikis. This hyper-immersion of ARG content hides the "event" of the ARG, which becomes a compilation of mediations collected elsewhere.[41]

ARGs, because of this blend of immediacy and hypermediacy, inhabit an interreal space that has characteristics that can be described as both immersive and as obvious. In an ARG, the awareness of the media serves only to reinforce the immediacy of the experience. In real life, one is constantly surrounded by media. E-mail routinely interrupts a workspace. A phone call will disrupt a face-to-face conversation. Although there is still mediation, it has become so common that to not have mediation would be bizarre: the ARG highlights the hypermediacy as an immediate experience. It is important to note this elision, for as Žižek demonstrates, "the simple direct reference to external reality ... as well as the opposite attitude of 'there is no external reality'," are both totalizing and limiting determinations. What is necessary for Žižek is a space in which external reality and the mediation of that reality can co-exist "without lack and obstacles."[42]

The ARG and demediation indicate a shift to the reestablishment of a non-mediated reality. By playing games, and externalizing the mechanisms by which we recognize the game as game, the ARG, in fact, reveals the underlying non-ludicity of the situation. Players of ARGs experience the completely mediated, and in doing so, reestablish the phenomenological experience of the "real world" "outside" the ARG. By uncovering the ludic, we can recognize the non-ludic, and demonstrate the re-establishment of reality itself. Because the ARG reinforces the boundary between the constituent binaries, they must be both ludic and non-ludic at the same time. Thus, by reinforcing the boundary, the ARG also reinforces each side of that boundary: as Žižek might say, because we have a window, we know there is both an inside and an outside. Players of ARGs cause the "game world" to seem to disappear into the non-ludic realm of the "real world," and the experiences of the players playing the game become nothing more—or less—than participation in a form of real life. Because the ARG reinforces the boundary, it also reinforces a divide between the ludic and the non-ludic, and the existence of both the media and the absolutely unmediated.

ARGs, therefore, represent an exemplar of a New Media Studies paradigm: instead of focusing on "media" as separated from the reality of daily

life, New Media Studies assumes media as integral. The further we advance the less important the boundary between the two becomes. To return to Merrin, we can see that a

> disciplinary paradigm shift is what we are dealing with today. Developments in digital media aren't a cumulative 'add-on' to media studies that can be adequately explained through its existing classifications, concepts and categories. They take us beyond both the broadcast-era and the broadcast media studies that developed to reflect and study it. Today, only a post-broadcasting, digital paradigm can explain our contemporary media experience.[43]

New Media Studies, as represented through and by the ARG, represents this new paradigm. By demediating reality through the ARG, the Puppetmasters and other ARG creators construct an experience for players in which they have a greater ability to control their use of media. When a mediated message is used in an ARG, the confusion over its "ludism" (is this e-mail part of the game or not?) both detracts and enhances the player's power over the media. The use of media in an ARG is so ubiquitous, it both mirrors and exaggerates the use of media in non-ludic life. This ubiquity makes the mediation immersive, to reinforce the fact that the ARG is not a game. Yet in doing so, the hypermediacy of the media effaces its very use. Just as we do not think about the ubiquity of the "real world," so too do ARGs cause us to forget their own mediation. Although McGonigal argues that one reason users play ARGs is for the passivity of the game to overtake their decision-making in the non-ludic world, the opposite may also be true: when a mediated message is used in an ARG, the confusion over its "realism" enhances a player's power over the media.[44] Players choose whether to accept the e-mail, even whether or not to play the game at all. In effect, ARGs assuage the passivity of postmodern simulation.

The unique power of the ARG to exist solely through the player's experiences of the media separates it from Bolter and Grusin's concept of remediation. By engaging with the player's activities, the ARG enacts a mash-up of the ludic and the non-ludic, which then demediates the experience of the player. Further, demediation also closes another gap left open by Bolter and Grusin. For Bolter and Grusin, immediacy and hypermediacy are two absolute poles: one cannot know both at the same time. By displaying its media, the ARG becomes more opaque: the more the media we use to play become obvious, the more we cannot know if we are playing. This hypermediate

immediacy is countered by an immediate hypermediacy. The more obvious the mediation in an ARG, the more immediate the experience. Paradoxically, to make the media more obvious is to make the game less so.

DEMEDIATION AND DIGITAL FANDOM

I conclude this book with reference to the final quotation from Pérez-Reverte inscribing this chapter. In it, he reflects for the book collectors in *The Club Dumas* the same type of passion that fans hold for the extant media object of their affection: "These are the ones I walk hand in hand with to the brink of the abyss…" Despite all the travails, all the horrors and pain he experiences throughout the novel, Pérez-Reverte's hero concludes his journey by reasserting his deep affection for the antique books he collects and trades: he takes them to his grave for eternal contemplation.

In much the same way, we have experienced the way players of Alternate Reality Games embrace the mediation, remediation, and demediation of contemporary media culture. Similarly, by exploring new concepts in media studies, Digital Fandom does not examine a new type of fan, but rather defines a new way of looking at fans. As Christy Dena writes, some media content created by an audience's reaction to an extant media object has actually become

> the main product of consumption for mass audiences. Although observable in many forms of cultural production, this phenomenon is interrogated specifically through the genre of alternate reality games.[45]

ARGs present cult worlds *as* the real world: Not just cult worlds fans can watch and integrate into their lives, but also cult worlds fans can actually inhabit and populate. ARGs exist between and betwixt the ludic and the non-ludic: and, as pointed out by Gosney, this divide between the ludic and the non-ludic is already eroding.[46]

ARGs are creeping into our everyday lives in ways both familiar and unique, as ARGs are gaining widespread popularity. For instance, a recent National Public Radio newscast described how some museums, in order to draw in visitors, are constructing Alternate Reality Games around works of art, culture or history in the museum.[47] The curators construct a narrative around many of the objects and artworks within a collection, and when visitors come to the museum, they can try and "solve" this real-world puzzle

in the space of the exhibit. For example, a project at the Albany Institute of History and Art, in Albany, New York, encourages children to follow an interactive web game to explore the museum's collection of historical arti- facts from the early days of Albany.[48] Further, entire genres of ARGs exist that are based neither on extant media objects, nor are viral marketing schemes. Instead, these new games, called "games for social change," or "serious games," articulate experiments in socially-active and civically- minded participants. For instance, the game *A World without Oil* detailed a fictitious 32 weeks of a global oil crisis.[49] Participants were asked to spend each of 32 weeks acting as if the world was running out of petroleum. During the first week, the game asked participants to pretend as if gasoline had risen above $4.00 a gallon.[50] By week 16, the in-game gas prices had risen to over $7.00 a gallon and participants were told that riots were taking place. By demonstrating a possible future, these games become a way of exploring contemporary issues with a more ludic sensibility. A more recent serious game, *Superstruct*, used the idea of *A World without Oil* but forecasted a more general future of the world as a whole.[51] The game asked participants to imagine what would happen in the year 2019 if many of the nascent social ills of today had been magnified and expounded upon. The game asks, to what degree can we change our present by investigating our future? By using Web Commons technologies like blogs, wikis, Social Network Sites, and videos, the Puppetmasters of *Superstruct* made the game—and our reality itself—hyper-immersive.

As ARGs make their way into the mainstream, more participants will start to play. Whether they be serious games, narrative add-ons like *Why So Serious*, viral advertisements like *ilovebees*, or interactive narrative elements like *The Lost Experience*, these Alternate Reality Games will provide players with active and powerful communities: this form of communal creation, as we have seen, is paramount to fans in general and Digital Fandom more specifically. We can see this change illustrated persuasively in Jane McGoni- gal's description of the Cloudmakers. This group of online fans, who met online to try and solve the Alternate Reality Game *The Beast*, were puzzling over the game on 11 September 2001, when terrorists piloted planes into the World Trade Center buildings. McGonigal describes how the Cloudmakers' conversations at first mirrored many others at that time: they exchanged words of hope and inspiration. However, the online interaction between the people on the listserv quickly evolved into something else: Wanting to parlay

their expertise at solving online Alternate Reality Games, the Cloudmakers decided to "solve the puzzle of who the terrorists are."[52] As one participant wrote, "Let's become a resource. Utilize your computer & analytical talents."[53] The online group formed an online collective using the communal capabilities of the Web Commons to solve a real-world issue. The Web Commons fostered the interactions between the group members, and became a way for the group to parlay their specific talents in a real-world situation.[54] What ARGs offer, therefore, is not just a way of examining reality, or a way of playing a game, but also a means through which we can see how communities form and populate the Web Commons.

It is with a philosophy of playfulness that participants in New Media enact the mediated communities they join. The examples in this book—ludic comments on blog posts; playful narrative progressions on wikis; roleplay on Social Network Sites—are just those: examples that represent a larger trend. Many more are out there, and I'm sure in the time since I write this more will have developed. Twitter has developed a strong digital identity of its own, and there have been Google Wave mash-up video/text/audio amalgams as well. The technology we use in digital life are developing far faster than academic and scholarly publication can keep pace. It is imperative that we begin new methods of analysis that take into account these changes, just as it is equally imperative that our publication rate matches technological change.

ARGs represent a demediate arena of culture, where mediation becomes a way of life. Fans embraced this notion: through entering the hyperdiegesis of the cult worlds to which they attach their fandom, fans accept this dualism. ARGs represent a new branch of media, and we should examine them not with old, limiting conceptions, but with an eye to the future.

NOTES

[1] Jay Schneider and Gerd Kortuem, "How to Host a Pervasive Game: Supporting Face-to-Face Interactions in Live-Action Roleplaying," (UbiComp workshop on Designing Ubiquitous Computing Games, 2000), http://www.cs.uoregon.edu/research/wearables/ Papers/how2host.ps (accessed 10 Oct 2008), 2.

[2] Jay David Bolter and Richard Grusin, *Remediation* (Cambridge, MA: The MIT Press, 1999), 69–78.

[3] Bolter and Grusin, 28, 45–48; Janet Murray, *Hamlet on the Holodeck: The Future of Narrative in Cyberspace* (Cambridge, MA: The MIT Press, 1997), 71, shows how interactivity is a key aspect of New Media; Henry Jenkins, *Convergence Culture* (New York: New York University Press, 2006), 18–19 describes the dialogic quality of New Media;

Marc A. Smith and Peter Kollock, ed., *Communities in Cyberspace* (London: Routledge, 1999), look at online community.

4 Jean Baudrillard, *Simulacra and Simulation*, trans. Sheila Faria Glaser (Ann Arbor: University of Michigan Press, 1994): For Baudrillard "simulation threatens the difference between the 'true' and the 'false,' the 'real' and the 'imaginary.'" Hyperreality, the "liquidation of all referentials," emerges when the simulation of reality overtakes the experience of reality, when we start "substituting the signs of the real for the real" (2). In other wrods, our mediated culture is in transition: whereas mediation once represented a reality that was external to that first-order reality, now mediation represents a false reality, a hyperreality that does not exist outside of that mediation. For Baudrillard, reality has been mediated, through the image, "into an immediate catalytic operation of the real by the screen" (Jean Baudrillard, "Aesthetic Illusion and Virtual Reality," in *Reading Images*, ed. Julia Thomas (Houndsmills, UK: Palgrave, 2000), 199). The immediate cause of this is the inundation of images in our culture: "We don't need digital gloves or a digital suit" to live in a virtual world, for "we are moving around in the world as in a synthetic image" (198). Baudrillard, *Simulacra*, 27, argues that "we are no longer in a logic of the passage from virtual to actual, but in a hyperrealist logic of the deterrence of the real by the virtual." Whereas, for Baudrillard, our simulations and mediations are completely replacing our reality, demediation highlights reality by foregrounding mediation.

5 See, Jacques Derrida, "Afterward: Toward an Ethic of Discussion," in *Limited Inc.*, trans. Samuel Webber (Evanston, IL: Northwestern University Press, 1988), 116.

6 Jacques Derrida, *Specters of Marx: The State of the Debt, the Work of Mourning, and the New International*, trans. Peggy Kamuf (London: Routledge, 1994), 5.

7 Bolter and Grusin, 5.

8 Klaus Jensen, "Mixed Media: From Digital Aesthetics towards General Communication Theory," *Northern Lights* 5 (2007): 18–20. Jensen's three degrees of mediation mirror Walter Ong, *Orality and Literacy*, (London: Routledge, 2002) who describes the technological development of culture, from an oral, to a literate, and then into a secondary orality brought about by electronic communication.

9 Jensen, "Mixed Media," 18.

10 Ibid.

11 Ibid., 19.

12 Michel Foucault, "Self-Writing," in *Ethics: Subjectivity and Truth Vol 1*, ed. Paul Rabinow and trans. Robert Hurley and Others (New York: The New Press, 1997), 221.

13 Jensen, "Mixed Media," 19.

14 Alan Kay and Adele Goldberg, "Personal Dynamic Media," in *Computer Media and Communication: A Reader*, ed. Paul A. Mayer (Oxford: Oxford University Press, 1999), 20. Kay and Goldberg first posed the term "metamedia" to describe computers.

15 Ong, 134, here writes before digital technology's cultural saturation, but his description of the electronic revolution mirrors contemporary discussion of digital technology and media of the third degree.

16 See, Bolter and Grusin, 28; also David Gunkel, *Thinking Otherwise* (West Lafayette, IN: Purdue University Press, 2007), 27–9.

17 Murray, 98–9.

18 Bolter and Grusin, 23–4.

19 Ibid., 34.

20 Ibid., 5, 45.

21 Marshall McLuhan, *The Medium Is the Message* (New York: Random House, 1994), 23–4.

22 Bolter and Grusin, 45–50.

23 Ibid., 45.

24 Ibid., 47.
25 Nancy Allen, "Telling Our Stories in New Ways," Review of *Remediation* by Jay David Bolter and Richard Grusin, and *The Language of New Media* by Lev Manovich, *Computers and Composition* 18 (2001), 192.
26 W. J. T. Mitchell, *What Do Pictures Want?: The Lives and Loves of Images* (Chicago: University of Chicago Press, 2006), 31.
27 See, Lev Manovich, *The Language of New Media* (Cambridge, MA: The MIT Press), 64–5.
28 Jenkins, *Convergence*, 246.
29 Bolter and Grusin, 71.
30 Ibid., 77.
31 Ibid., 55.
32 Jensen, "Mixed Media," 11, my emphasis.
33 Raymond Williams, *Television: Technology and Cultural Form* (London: Routledge, 1990), 93. Kristin Thompson, *Storytelling in Film and Television* (Cambridge, MA: Harvard University Press, 2003), 8, disagrees with the importance placed on "flow."
34 Roland Barthes, "From Work to Text," in *Image-Music-Text*, trans. Stephen Heath (New York: Hill and Wang, 1977), 156–8.
35 Sherry Turkle, *Life on the Screen: Identity in the Age of the Internet* (New York: Simon and Schuster, 1995), 188.
36 Jane McGonigal, "'This Is Not a Game': Immersive Aesthetics and Collective Play," Digital Arts & Culture Conference Proceedings, 2003, http://www.seanstewart.org/beast/mcgonigal/notagame/paper.pdf (accessed 01 Sept 2007), 2.
37 Ibid.
38 Slavoj Žižek, *Looking Awry: An Introduction to Jacques Lacan through Popular Culture* (Cambridge, MA: The MIT Press, 1991), 15.
39 Slavoj Žižek, "Cyberspace, or the Unbearable Closure of Being," in *The Plague of Fantasies* (London: Verso, 1997), 135.
40 Dena, "Player-Created Tiers."
41 What Daniel Boorstin, *The Image* (New York: Random House, 1961), 9–44, might call "pseudo-events."
42 Žižek, "Cyberspace," 132–3.
43 William Merrin, "Media Studies 2.0: Upgrading and Open-Sourcing the Discipline," *Interactions: Studies in Communication and Culture* 1, no. 1 (2009): 32.
44 Jane McGonigal, "The Puppetmaster Problem: Design for Real-World, Mission-Based Gaming," in *Second Person: Role-Playing and Story in Games and Playable Media*, ed. Pat Harrigan and Noah Wardrip-Fruin (Cambridge, MA: The MIT Press), 262.
45 Dena, "Player-Created Tiers," 42.
46 John Gosney, *Beyond Reality: A Guide to Alternate Reality Gaming* (Boston, MA: Thompson, 2005), xii.
47 Elizabeth Blair, "Interactive Games Make Museums a Place to Play," *NPR*, 12 Jan 2009, http://www.npr.org/templates/story/story.php?storyId=99244253 (accessed 13 Jan 2009).
48 http://www.albanyinstitute.org/kids/v3final/index.html.
49 http://worldwithoutoil.org/.
50 Ironically, the next year it did.
51 http://superstructgame.org.
52 McGonigal, "'This Is Not a Game,'" 1.
53 Quoted in Ibid., 1.
54 The Cloudmakers stopped after two days, however, for fear of appearing as if they were not taking the tragedy seriously.

Downloaded Blog Fan Fiction

Because blogs are always updated, it is difficult to get an exact date of completion. Thus, I cite the date I downloaded a blog entry, or the date when a blog comment was made. If a commenter left more than one comment in between the dates I downloaded, I acknowledge that in bold. By the last day of downloads (30 Dec 2007), I had downloaded 10 separate blog fan fiction texts (Table A.1). Total list of comments and titles is featured in Table A.2

Table A.1. Full Titles of Blog Fan Fiction and Web Address:

"Hubris, or the Downfall of Helena Cain, 3 of 4."	http://community.livejournal.com/ so_say_we_all/12310.html
"Cylons, Shoes and Squirrels"	http://community.livejournal.com/bsg2003fics/560052.html
"Seelix/Cally, Lubing the Viper."	http://lyssie.livejournal.com/1176623.html
"Hubris, or the Downfall of Helena Cain, 4 of 4."	http://community.livejournal.com/bsg2003fics/564526.html
"Four Times Adama Almost Died (4/4)."	http://helen-c.livejournal.com/108938.htm
"They Took My Towel! And Other Furry Tails."	http://community.livejournal.com/bsg2003fics/567327.html
"Gaius Pulls It Off"	http://community.livejournal.com/bsg2003fics/567738.html
"Reconnaissance"	http://community.livejournal.com/bsg2003fics/568890.html
"The Woods."	http://community.livejournal.com/sprnova_fixxx/17311.html
"Kara/Anders, Uninterrupted Routine."	http://lyssie.livejournal.com/1187196.html
"Missing Year Update!"	http://chilipip.wordpress.com/welcome-2/kin/

Table A.2. Blogs, Blog Authors, Commenters

Date: 2007	Blog post author and title	Commenters
01 Dec	wyrdwritere, "Downfall 3"	No comments posted
01 Dec	wyrdwritere, "Downfall 4"	millari
04 Dec	runawaynun, "Cylons, Shoes"	freifraufischer, **runawaynun (x2)**, projectjulie
04 Dec	wyrdwritere, "Downfall 4"	millari, **wyrdwritere (x4)**, elzed, pellamere-thiel, artemis_90
09 Dec	runawaynun, "Cylons, Shoes"	freifraufischer, **runawaynun (x2)**, projectjulie
09 Dec	wyrdwritere, "Downfall 4"	millari, **wyrdwritere (x4)**, elzed, pellamere-thiel, artemis_90
09 Dec	helen_c, "Four Times (4/4)"	siljamus, **helen_c (x7)**, fredsmith518 (x2), suffolkgirl, daybreak777, marenfic, pellamere-thiel, rose_griffes
12 Dec	runawaynun, "Cylons, Shoes"	freifraufischer, **runawaynun (x2)**, projectjulie
12 Dec	wyrdwritere, "Downfall 4"	millari, **wyrdwritere (x4)**, elzed, pellamere-thiel, artemis_90
12 Dec	helen_c, "Four Times (4/4)"	siljamus, **helen_c (x7)**, fredsmith518 (x2), suffolkgirl, daybreak777, marenfic, pellamere-thiel, rose_griffes
12 Dec	lyssie, "Seelix and Cally"	life_on_queen (x2), **lyssie (x6)**, stargazercmc, timjr, runawaynun, falconsoko
15 Dec	runawaynun, "Cylons, Shoes"	freifraufischer, **runawaynun (x2)**, projectjulie
15 Dec	wyrdwritere, "Downfall 4"	millari, **wyrdwritere (x4)**, elzed, pellamere-thiel, artemis_90
15 Dec	helen_c, "Four Times (4/4)"	siljamus, **helen_c (x7)**, fredsmith518 (x2), suffolkgirl, daybreak777, marenfic, pellamere-thiel, rose_griffes
15 Dec	lyssie, "Seelix and Cally"	life_on_queen (x2), **lyssie (x8),** stargazercmc, timjr, runawaynun, falconsoko, redscribe (x2), sheepfairy
15 Dec	rowanjade, "Towel"	life_on_queen
18 Dec	runawaynun, "Cylons, Shoes"	freifraufischer, **runawaynun (x2)**, projectjulie
18 Dec	wyrdwritere, "Downfall 4"	millari, **wyrdwritere (x4)**, elzed, pellamere-thiel, artemis_90

18 Dec	helen_c, "Four Times (4/4)"	siljamus, **helen_c (x7)**, fredsmith518 (x2), suffolkgirl, daybreak777, marenfic, pellamere-thiel, rose_griffes
18 Dec	lyssie, "Seelix and Cally"	life_on_queen (x2), **lyssie (x8)**, stargazercmc, timjr, runawaynun, falconsoko, redscribe (x2), sheepfairy, projectjulie
18 Dec	rowanjade, "Towel"	life_on_queen, **rowanjade**, raincitygirl, rebelliousrose
18 Dec	jeeshee, "Gaius"	No comments posted
21 Dec	runawaynun, "Cylons, Shoes"	freifraufischer, **runawaynun (x2)**, projectjulie
21 Dec	wyrdwritere, "Downfall 4"	millari, **wyrdwritere (x4)**, elzed, pellamere-thiel, artemis_90
21 Dec	helen_c, "Four Times (4/4)"	siljamus, **helen_c (x7)**, fredsmith518 (x2), suffolkgirl, daybreak777, marenfic, pellamere-thiel, rose_griffes, sheepfairy
21 Dec	lyssie, "Seelix and Cally"	life_on_queen (x2), **lyssie (x10)**, stargazercmc, timjr, runawaynun, falconsoko, redscribe (x2), en_hattifnatt, sheepfairy, projectjulie
21 Dec	rowanjade, "Towel"	life_on_queen (x2), **rowanjade (x3)**, raincity-girl (x2), rebelliousrose
21 Dec	jeeshee, "Gaius"	No comments posted
21 Dec	jeeshee, "Reconnaissance"	lyssie, **jeeshee**
24 Dec	runawaynun, "Cylons, Shoes"	freifraufischer, **runawaynun (x2)**, projectjulie
24 Dec	wyrdwritere, "Downfall 4"	millari, **wyrdwritere (x4)**, elzed, pellamere-thiel, artemis_90
24 Dec	helen_c, "Four Times (4/4)"	siljamus, **helen_c (x7)**, fredsmith518 (x2), suffolkgirl, daybreak777, marenfic, pellamere-thiel, rose_griffes
24 Dec	lyssie, "Seelix and Cally"	life_on_queen (x2), **lyssie (x10)**, stargazercmc, timjr, runawaynun, falconsoko, redscribe (x2), en_hattifnatt, sheepfairy, projectjulie
24 Dec	rowanjade, "Towel"	life_on_queen (x2), **rowanjade (x3)**, raincity-girl (x2), rebelliousrose
24 Dec	jeeshee, "Gaius"	No comments posted
24 Dec	jeeshee, "Reconnaissance"	lyssie, **jeeshee**
24 Dec	danniisupernova, "Woods"	rap541 (x2), **danniisupernova (x2)**
27 Dec	runawaynun, "Cylons, Shoes"	freifraufischer, **runawaynun (x2)**, projectjulie
27 Dec	wyrdwritere, "Downfall 4"	millari, **wyrdwritere (x4)**, elzed, pellamere-thiel, artemis_90

27 Dec	helen_c, "Four Times (4/4)"	siljamus, **helen_c (x7)**, fredsmith518 (x2), suffolkgirl, daybreak777, marenfic, pellamere-thiel, rose_griffes
27 Dec	lyssie, "Seelix and Cally"	life_on_queen (x2), **lyssie (x10),** stargazercmc, timjr, runawaynun, falconsoko, redscribe (x2), en_hattifnatt, sheepfairy, projectjulie
27 Dec	rowanjade, "Towel"	life_on_queen (x2), **rowanjade (x3)**, raincity-girl (x2), rebelliousrose
27 Dec	jeeshee, "Gaius"	No comments posted
27 Dec	jeeshee, "Reconnaissance"	lyssie, **jeeshee**
27 Dec	danniisupernova, "Woods"	rap541 (x2), **danniisupernova (x2)**
27 Dec	lyssie, "Kara/Anders"	No comments posted
30 Dec	runawaynun, "Cylons, Shoes"	freifraufischer, **runawaynun (x2)**, projectjulie
30 Dec	wyrdwritere, "Downfall 4"	millari, **wyrdwritere (x4)**, elzed, pellamere-thiel, artemis_90
30 Dec	helen_c, "Four Times (4/4)"	siljamus, **helen_c (x7)**, fredsmith518 (x2), suffolkgirl, daybreak777, marenfic, pellamere-thiel, rose_griffes
30 Dec	lyssie, "Seelix and Cally"	life_on_queen (x2), **lyssie (x11),** stargazercmc, timjr, runawaynun, falconsoko, redscribe (x2), en_hattifnatt, auroramama, sheepfairy, projectjulie
30 Dec	rowanjade, "Towel"	life_on_queen (x2), **rowanjade (x3)**, raincity-girl (x2), rebelliousrose
30 Dec	jeeshee, "Gaius"	No comments posted
30 Dec	jeeshee "Reconnaissance"	lyssie, **jeeshee**
30 Dec	danniisupernova, "Woods"	rap541 (x2), **danniisupernova (x2)**
30 Dec	lyssie, "Kara/Anders"	**lyssie (x3)**, cynthia_arrow, prolix_allie, latteaddict
30 Dec	Chilipip & Asso, "Year"	No comments posted

Appendix B

Downloaded ExtantWikis

Table B.1. Downloaded ExtantWiki

Heroeswiki "Main Page"	http://Heroeswiki.com/Main_Page
"Spoiler: Powerless"	http://Hereoeswiki.com/Spoiler:Powerless
"Episode: Powerless"	http://Hereoeswiki.com/Episode:Powerless
"Index"	http://heroeswiki.com/Index
"Create Your Own Hero"	http://heroeswiki.com/Create_Your_Hero
Lostpedia "Main Page"	http://www.Lostpedia.com/wiki/Main_Page
"Season 4/Spoilers"	http://www.Lostpedia.com/wiki/Season_4/spoilers
"Jack Shephard"	http://www.Lostpedia.com/wiki/Jack
"John Locke"	http://www.Lostpedia.com/wiki/John_Locke
"James (Sawyer) Ford"	http://www.Lostpedia.com/wiki/Sawyer
"Lost: Mysterious Happenings"	http://www.Lostpedia.com/wiki/Portal:Mysterious

Appendix C

MySpace Character Profiles

Table C.1. MySpace Character Profiles

captain_j_harkness	*Myspace.com/captain_j_harkness*. (2008). http://profile.myspace.com/index.cfm?fuseaction==user. viewprofile&friendid=119494970 (accessed 07 Oct 2008).
closefriendofjamestkirk	*MySpace.com/closefriendofjameskirk*. (2008). http://profile.myspace.com/index.cfm?fuseaction==user. viewprofile&friendID=310509123 (accessed 08 Oct 2008).
coffeeluvr4life	*Myspace.com/coffeeluvrlife*. (2007). http://profile.myspace.com/index.cfm?fuseaction==user. viewprofile&friendid=110833970 (accessed 01 Aug 2007).
Doctor Who	*Myspace.com/leerainford*. (2009). http://www.myspace.com/leerainford (accessed 06 Apr 2009).
gilmoregirls3	*Myspace.com/gilmoregirls3*. (2007). http://profile.myspace.com/index.cfm?fuseaction==user. viewprofile&friendid=193528050 (accessed 01 Aug 2007).
Gwen Cooper	*Myspace.com/Gwen*. (2009). http://profile.myspace.com/index.cfm?fuseaction==user. viewProfile&friendID=122033336 (accessed 24 Mar 2009).
gwencooper	*Myspace.com/gwencooper*. (2008). http://profile.myspace.com/index.cfm?fuseaction==user. viewprofile&friendid=90956481 (accessed 07 Oct 2008).
Jack Harkness™	*Myspace.com/122039243* (2009). http://profile.myspace.com/index.cfm?fuseaction==user. viewProfile&friendID=122039243 (accessed 24 Mar 2009).

Jim	*Myspace/45053624* (2009). http://profile.myspace.com/index.cfm?fuseaction=user. viewProfile&friendID=45053624 (accessed 24 Mar 2009).
Luke	*Myspace.com/luke_danes8.* (2007). http://profile.myspace.com/index.cfm?fuseaction=user. viewprofile&friendid=103471865 (accessed 10 Oct 2007).
Veronica Marz	*Myspace.com/mizzmarzx.* (2006). http://profile.myspace.com/index.cfm?fuseaction=user. viewprofile&friendid=130922322 (accessed 10 Dec 2006).
Veronica Mars CW	*Myspace.com/veronicamarscw.* (2006). http://profile.myspace.com/index.cfm?fuseaction=user. viewprofile&friendID=92251231 (accessed 10 Dec 2006).
Veronica_Mars	*Myspace.com/veronica_mars.* (2006). http://profile.myspace.com/index.cfm?fuseaction=user. viewprofile&friendid=14789920 (accessed 10 Dec 2006).
zachandstaceforever	*Myspace.com/zachandstaceforever.* (2007). http://profile.myspace.com/index.cfm?fuseaction=user. viewprofile&friendid=72513851 (accessed 01 Aug 2007).

Works Cited

Aarseth, Espen. "Nonlinearity and Literary Theory." In *Hyper/Text/Theory*, edited by George Landow, 51–86. Baltimore, MD: Johns Hopkins University Press, 1994.

Abercrombie, Nicholas, and Brian Longhurst. *Audiences: A Sociological Theory of Performance and Imagination*. London: Sage Publications, 1997.

Agger, Ben. *The Virtual Self*. London: Blackwell, 2007.

Allen, Graham. *Intertextuality*. London: Routledge, 2000.

Allen, Nancy. "Telling Our Stories in New Ways." Review of *Remediation*, by Jay David Bolter and Richard Grusin, and *The Language of New Media*, by Lev Manovich. *Computers and Composition* 18 (2001): 187–94.

"Alternate Reality Game." *Wikipedia*. http://en.wikipedia.org/wiki/Alternate_reality_game (accessed 01 Oct 2008).

Amesley, Cassandra. "How to Watch *Star Trek*." *Cultural Studies* 3, no. 3 (1989): 323–39.

Andrejevic, Mark. "Watching Television without Pity: The Productivity of Online Fans." *Television and New Media* 9, no. 1 (2008): 24–46.

Anelli, Melissa. *Harry, a History*. New York: Pocket Books, 2008.

AP News. "Mom: Girl Killed Herself over Online Hoax." *MSNBC*. 19 Nov 2007. http://www.msnbc.msn.com/id/21844203/ (accessed 08 Mar 2009).

Arnold, Thomas K. "'Lost 2' Finds Way to Top of DVD Sales." *Hollywood Reporter*. 14 Sept 2006. http://www.hollywoodreporter.com/hr/search/article_display.jsp?vnu_content_id=1003121876 (accessed 01 Nov 2008).

Ascott, Roy. "Homo Telematicus in the Garden of A-Life–Editorial." *TightRope 1/95* 1994. http://www.phil.unisb.de/projekte/HBKS/TightRope/issue.1/texte/royascott_eng.html (accessed 06 Oct 2008).

Averintsev, Sergei S. "Bakhtin and the Russian Attitude to Laugher." In *Bakhtin: Carnival and Other Subjects: Selected Papers from the Fifth International Bakhtin Conference University of Manchester, July 1991*, edited by David Shepherd, 13–19. Atlanta, GA: Rodopi, 1993.

Bacon-Smith, Camile. *Enterprising Women: Television, Fandom and the Creation of Popular Myth*. Philadelphia: University of Pennsylvania Press, 1992.

Bakhtin, Mikhail, M. "Discourse in the Novel." In *The Dialogic Imagination: Four Essays*, edited by Michael Holquist, translated by Caryl Emerson and Michael Holquist, 259–422. Austin: University of Texas Press, 1981.

—. "The Problem of Speech Genres." In *Speech Genres and Other Late Essays*, translated by Vern W. McGee, 60–102. Austin: University of Texas Press, 1986.

—. *Problems of Dostoevsky's Poetics*, edited and translated by Caryl Emerson. Minneapolis: University of Minnesota Press, 1984.

—. *Rabelais and His World*, translated by Hélène Iswolsky. Bloomington: Indiana University Press, 1984.

Bal, Mieke. *Narratology: Introduction to the Theory of Narrative,* 2nd ed., translated by Christine Van Boheemen. Toronto: University of Toronto Press, 1997.

Barthes, Roland. "The Death of the Author." In *Image-Music-Text,* translated by Stephen Heath, 142–8. New York: Hill and Wang, 1977.

—. "From Work to Text." In *Image-Music-Text,* translated by Stephen Heath, 155–64. New York: Hill and Wang, 1977.

—. *S/Z: An Essay,* translated by Richard Miller. New York: Hill and Wang, 1974.

—. "Theory of the Text." 1973. In *Untying the Text: A Post-Structuralist Reader,* edited by Robert Young, translated by Ian McLeod, 31–47. London: Routledge, 1981.

Baudrillard, Jean. "Aesthetic Illusion and Virtual Reality." In *Reading Images,* edited by Julia Thomas, 198–206. Houndsmills, UK: Palgrave, 2000.

—. *The Consumer Society,* translated by Chris Turner. London: Sage, 1998.

—. *For a Critique of the Political Economy of the Sign,* translated by Charles Levin. New York: Telos Press, 1981.

—. *Simulacra and Simulation,* translated by Sheila Faria Glaser. Ann Arbor: University of Michigan Press, 1994.

Baym, Nancy. "The Lost Librarians of National Defense." *Online Fandom: News and Perspectives on Fan Communication and Online Life.* 30 Apr 2008. http://www.onlinefandom.com/archives/the-lost-librarians-of-national-defense (accessed 01 May 2008).

—. *Tune In, Log On: Soaps, Fandom, and Online Community.* London: Sage, 2000.

Bell, Duran. "Modes of Exchange: Gift and Economy." *Journal of Socio-Economics* 20, no. 2 (1991): 155–67.

Benedikt, Michael. "Cyberspace: First Steps." In *Cybercultures Reader,* edited by David Bell and Barbara M. Kennedy, 19–33. London: Routledge, 2000.

Benkler, Yochai. "Coase's Penguin, or, Linux and the Nature of the Firm." In *CODE: Collaborative Ownership and the Digital Economy,* edited by Rishab Aiyer Ghosh, 169–206. Cambridge, MA: The MIT Press, 2005.

—. *The Wealth of Networks: How Social Production Transforms Markets and Freedom.* New Haven, CT: Yale University Press, 2006.

Bennett, James, and Tom Brown, ed. *Film and Television after DVD.* London: Routledge, 2008.

Bennett, Tony, and Janet Woollacott. *Bond and Beyond: The Political Career of a Popular Hero.* London: Macmillan, 1987.

Berners-Lee, Tim, and Mark Fischetti. *Weaving the Web: The Original Design and Ultimate Destiny of the World Wide Web.* Britain: London Business, 1999.

Birdsall, W. "Web 2.0 as Social Movement." *Webology* 4, no. 2 (2007). http://www.webology.ir/2007/v4n2/a40.html (accessed 24 Mar 2008).

Blair, Elizabeth. "Interactive Games Make Museums a Place to Play." *NPR.* 12 Jan 2009. http://www.npr.org/templates/story/story.php?storyId=99244253 (accessed 13 Jan 2009).

Blood, Rebecca. "Weblogs: A History and Perspective." *Rebecca's Pocket.* 07 Sept 2000. http://www.rebeccablood.net/essays/weblog_history.html (accessed 23 Jan 2008).

Boese, Christine. "The Ballad of an Internet Nutball: Chaining Rhetorical Visions from the Margins of the Margins to the Mainstream in the Xenaverse." PhD diss., Rensselaer Polytechnic Institute, 1997. http://www.nutball.com/dissertation/ (accessed 28 Aug 2008).

Bollier, David. "The Growth of the Commons Paradigm." In *Understanding Knowledge as Commons: From Theory to Practice*, edited by Charlotte Hess and Elinor Ostrom, 27–40. Cambridge, MA: The MIT Press, 2006.

Bolter, Jay David. *Writing Space: Computers, Hypertext, and the Remediation of Print*, 2nd ed. Mahwah, NJ: Lawrence Erlbaum Associates, 2001.

Bolter, Jay David, and Richard Grusin. *Remediation*. Cambridge, MA: The MIT Press, 1999.

Boorstin, Daniel. *The Image*. New York: Random House, 1961.

Booth, Paul. "Frak-tured Postmodern Lives, or How I Found Out I Was a Cylon." In *Battlestar Galactica and Philosophy*, edited by Josef Steiff and Tristan Tamblin,17–27. Peru, IL: Open Court Publishing, 2008.

—. "Intermediality in Film and Internet: *Donnie Darko* and Issues of Narrative Substantiality." *Journal of Narrative Theory* 38, no. 3 (2008): 398–415.

—. "Mediating New Technology: The Realization of a Digital Intellect." *Nebula* 5, no. 1–2 (2008): 28–43.

Booth, Paul, and Brian Ekdale. "Translating the Hyperreal (or How *The Office* Came to America, Made Us Laugh, and Tricked Us into Accepting Hegemonic Bureaucracy." In *Transformations and Mistranslations: American Remakes of British Television*, edited by Carlen Lavigne and Heather Marcovitch. Lanham, MD: Lexington Books, In Press.

Bourdieu, Pierre. *Distinction: A Social Critique of the Judgment of Taste*, translated by Richard Nice. Cambridge, MA: Harvard University Press, 1984.

boyd, danah. "Facebook's Little Gifts." *Apophenia*. 13 Feb 2007. http://www.zephoria.org/thoughts/archives/2007/02/13/facebooks_littl.html (accessed 10 Mar 2009).

—. "Why Youth (Heart) Social Network Sites: The Role of Networked Publics in Teenage Social Life." In *MacArthur Foundation Series on Digital Learning—Youth, Identity, and Digital Media Volume*, edited by David Buckingham. Cambridge, MA: The MIT Press, 2007. http://www.danah.org/papers/WhyYouthHeart.pdf (accessed 10 Jan 2008).

boyd, danah, and Nicole Ellison. "Social Network Sites: Definition, History, and Scholarship." 2007. http://jcmc.indiana.edu/vol13/issue1/boyd.ellison.html (accessed 07 Oct 2008).

Brockman, John. *Digerati: Encounters with the Cyber Elite*. San Francisco: Hardwired, 1996.

Brooker, Will. *Batman Unmasked: Analyzing a Cultural Icon*. New York: Continuum, 2001.

Brookey, Robert, and Paul Booth. "Restricted Play: Synergy and the Limits of Interactivity in *The Lord of the Rings: The Return of the King* Video Game." *Games and Culture* 1, no. 3 (2006): 214–30.

Brookey, Robert, and Robert Westerfelhaus. "Hiding Homoeroticism in Plain View: The *Fight Club* DVD as Digital Closet." *Critical Studies in Media Communication* 19, no. 1 (2002): 21–43.

Brown, Tom. "The DVD of Attractions'?: *The Lion King* and the Digital Theme Park." *Convergence: The International Journal of Research into New Media Technologies* 13, no. 2 (2007): 169–83.

Bruns, Axel. *Blogs, Wikipedia, Second Life, and Beyond*. New York: Peter Lang, 2008.

Burke, Kenneth. *A Rhetoric of Motives*. Berkeley: University of California Press, 1969.

—. "Terministic Screens." In *Language as Symbolic Action: Essays on Life, Literature and Method*, 44–62. Berkeley: University of California Press, 1966.

Bury, Rhiannon. *Cyberspaces of Their Own: Female Fandoms Online*. New York: Peter Lang, 2005.

Busse, Kristina, and Karen Hellekson. "Introduction: Work in Progress." In *Fan Fiction and Fan Communities in the Age of the Internet*, edited by Karen Hellekson and Kristina Busse, 5–32. Jefferson, NC: McFarland and Co., 2006.

Caldwell, John. "Convergence Television: Aggregating Form and Repurposing Content in the Culture of Conglomeration." In *Television after TV*, edited by Lynn Spigel and Jan Olsson, 41–74. Durham, NC: Duke University Press, 2004.

Carey, James. "A Cultural Approach to Communication." In *Communication and Culture: Essays on Media and Society*, 13–36. New York: Routledge, 1992.

Carroll, Laura. "Cruel Spoiler, that Embosom'd Foe." *The Verve: A Literary Organ*. 09 Oct 2005. http://www.thevalve.org/go/valve/article/cruel_spoiler_that_embosomd_foe (accessed 25 Sept 2008).

Cartmel, Andrew. *Through Time: An Unauthorized and Unofficial History of Doctor Who*. New York: Continuum, 2005.

Cerdán, Raquel, and Eduardo Vidal-Abarca. "The Effects of Tasks on Integrating Information from Multiple Documents." *Journal of Educational Psychology* 100, no. 1 (2008): 209–22.

Chatman, Seymour. *Coming to Terms*. Ithaca, NY: Cornell University Press, 1990.

—. *Story and Discourse: Narrative Structure in Fiction and Film*. Ithaca, NY: Cornell University Press, 1978.

Clark, Katerina, and Michael Holquist. *Mikhail Bakhtin*. Cambridge, MA: The Belknap Press of Harvard University Press, 1984.

Cobley, Paul. *Narrative*. London: Routledge, 2001.

Cooper, Dennis. "This Is Not an Isolated Incident: An Introduction." In *Userlands: New Fiction from the Blogging Underground*, edited by Dennis Cooper, 11–13. New York: Akashic Books, 2007.

Coppa, Francesca. "A Brief History of Media Fandom." In *Fan Fiction and Fan Communities in the Age of the Internet*, edited by Karen Hellekson and Kristina Busse, 41–59. Jefferson, NC: McFarland & Co., 2006.

Cover, Rob. "Interactivity." *Australian Journal of Communication* 31, no. 1 (2004): 107–20.

Crusius, Timothy, W. "A Case for Kenneth Burke's Dialectic and Rhetoric." *Philosophy and Rhetoric* 19, no. 1 (1986): 23–37.

Currah, Andrew. "Managing Creativity: The Tensions between Commodities and Gifts in a Digital Networked Environment." *Economy and Society* 36, no. 1 (2007): 467–94.

Davis, Joshua. "The Secret World of Lonelygirl15." *Wired* 14, no. 12 (Dec. 2006): 232–9.

de Certeau, Michel. *The Practice of Everyday Life*, translated by Steven Randall. Berkeley: University of California Press, 1984.

de Sena Caires, Carlos Duarte. "Towards the Interactive Filmic Narrative: 'Transparency': An Experimental Approach." *Computers and Graphics* 31 (2007): 800–08.

Deery, June. "TV.com: Participatory Viewing on the Web." *The Journal of Popular Culture* 37, no. 2 (2003): 161–83.

Dena, Christy. "ARG Stats." *Universe Creation 101*. 08 Dec 2008. http://www.christydena.com/online-essays/arg-stats/ (accessed 10 Dec 2008).

—. "Emerging Participatory Culture Practices: Player-Created Tiers in Alternate Reality Games." *Convergence: The International Journal of Research into New Media Technologies* 14, no. 1 (2008): 41–57.

—. "Patterns in Cross-Media Interaction Design: It's Much More than a URL... (Part 1)." *Crossmediaentertainment.* 2007. http://www.cross-mediaentertainment.com/DropBox/ DENA_MoreThan_Part1.pdf (accessed 25 Sept 2008).

Dentith, Simon. *Bakhtinian Thought: An Introductory Reader.* London: Routledge, 1995.

Derecho, Abigail. "Archontic Literature: A Definition, a History, and Several Theories of Fan Fiction." In *Fan Fiction and Fan Communities in the Age of the Internet*, edited by Karen Hellekson and Kristina Busse, 61–78. Jefferson, NC: McFarland & Co., 2006.

Derrida, Jacques. "Afterward: Toward an Ethic of Discussion." In *Limited Inc.*, translated by Samuel Webber, 111–54. Evanston, IL: Northwestern University Press, 1988.

—. *Archive Fever: A Freudian Impression,* translated by Eric Prenowitz. Chicago: University of Chicago Press, 1996.

—. *Given Time: I. Counterfeit Money*, translated by Peggy Kamuf. Chicago: University of Chicago Press, 1992.

—. *Positions*, translated by Alan Bass. Chicago: University of Chicago Press, 1981.

—. *Specters of Marx: The State of the Debt, the Work of Mourning, and the New International*, translated by Peggy Kamuf. London: Routledge, 1994.

Donath, Judith. "Identity and Deception in the Virtual Community." In *Communities in Cyberspace*, edited by Marc A. Smith and Peter Kollock, 29–59. London: Routledge, 1999.

Donath, Judith, and danah boyd. "Public Displays of Connection." *BT Technology Journal* 22, no. 4 (2004): 71–82.

du Gay, Paul, Jessica Evans and Peter Redman, ed. *Identity: A Reader.* London: Sage, 2000.

Durkheim, Emile. *The Elementary Forms of Religious Life*, translated by Karen Fields. New York: Free Press, 1995.

Eagleton, Terry. "Bakhtin, Schopenhauer, Kundera." In *Bakhtin and Cultural Theory*, edited by Ken Hirschkop and David Shepherd, 178–88. Manchester, UK: Manchester University Press, 1989.

—. *Walter Benjamin, or Towards a Revolutionary Criticism.* New York: Schocken Books, 1981.

Eco, Umberto. "*Casablanca:* Cult Movies and Intertextual Collage." *SubStance* 47 (1984): 3-12.

Ekdale, Brian. "The Small Screen Getting Smaller: Network Television on the Web." Paper presented at the annual meeting of the Midwest Popular Culture Association. Indianapolis, IN (2006).

Erickson, Thomas. "Social Interaction on the Net: Virtual Community as Participatory Genre." Proceedings of The Thirtieth Annual Hawaii International Conference on System Sciences, IEEE (1997).

Eskelinen, Markku. "The Gaming Situation." *Game Studies 0101* 1 no. 1 (2001) http://gamestudies.org/0101/eskelinen/ (accessed 15 Oct. 2008).

Fairclough, Norman. *Language and Power.* London: Longman, 1989.

Firewolfe, "Battlestar Galactica 1980/1985 Finding Earth," *Fanfiction.net.* 20 Nov 2007. http://www.fanfiction.net/s/3777645/1/Battle_Star_Galactica_1980_1985 Finding Earth (accessed 30 Dec 2007).

Fiske, John. "The Cultural Economy of Fandom." In *The Adoring Audience: Fan Culture and Popular Media*, edited by Lisa A. Lewis, 30–49. London: Routledge, 1992.

—. *Reading the Popular.* New York: Routledge, 1989.

—. *Understanding Popular Culture.* New York: Routledge, 1989.

Foster, Derek. "'Jump In the Pool': The Competitive Culture of *Survivor* Fan Networks." In *Understanding Reality Television*, edited by Su Holmes and Deborah Jermyn, 270–89. London: Routledge, 2004.

Foucault, Michel. "Self-Writing." In *Ethics: Subjectivity and Truth Vol 1*, edited by Paul Rabinow, translated by Robert Hurley and Others, 207–22. New York: The New Press, 1997.

—. "What Is an Author?" In *Language, Counter-memory, Practice*, edited and translated by Donald Boucahrd and Sherry Simon, 113–138. Ithaca, NY: Cornell University Press, 1977.

Garrett, Jesse James. "Ajax: A New Approach to Web Applications." *Adaptive Path*. 18 Feb 2005. http://adaptivepath.com/ideas/essays/archives/000385.php (accessed 01 Sept 2007).

Gauntlett, David. *Media, Gender and Identity: An Introduction*. London: Routledge, 2002.

Genette, Gérard. *Narrative Discourse: An Essay in Method*, translated by Jane Lewin. Ithaca, NY: Cornell University Press, 1980.

—. *Paratexts: Thresholds of Interpretation,* translated by Jane Lewin. Cambridge, UK: Cambridge University Press, 1997.

Ghosh, Rishab Aiyer, ed. *CODE: Collaborative Ownership in the Digital Economy*. Cambridge, MA: The MIT Press, 2005.

—. "Why Collaboration Is Important (Again)." In *CODE: Collaborative Ownership and the Digital Economy,* edited by Rishab Aiyer Ghosh, 1–6. Cambridge, MA: The MIT Press, 2005.

Giles, David C. "Parasocial Interaction: A Review of the Literature and a Model for Future Research." *MediaPsychology* 4 (2002): 279–305.

Gindin, Sergei I. "Contributions to Textlinguistics in the Soviet Union." In *Current Trends in Textlinguistics*, edited by Wolfgan U. Dressler, 261-274. Berlin: de Gruyter, 1978.

Godelier, Maurice. *The Enigma of the Gift,* translated by Nora Scott. Chicago: University of Chicago Press, 1999.

Goffman, Erving. *The Presentation of Self in Everyday Life*. New York: Doubleday, 1959.

Gosney, John W. *Beyond Reality: A Guide to Alternate Reality Gaming*. Boston: Thompson, 2005.

Goss, James, and Rob Francis (producers). *Love Off-Air*. Documentary feature on *Doctor Who: The Invasion,* DVD. London: British Broadcasting Corporation, 2006.

Grafton, Anthony. *The Footnote: A Curious History*. Cambridge, MA: Harvard University Press, 1999.

Gray, Jonathan, and Jason Mittell. "Speculation on Spoilers: *Lost* Fandom, Narrative Consumption and Rethinking Textuality." *Particip@tions* 4, no. 1 (2007). http://www.participations.org/Volume%204/Issue%201/4_01_graymittell.htm (accessed 28 Dec 2007).

Gray, Jonathan, Cornel Sandvoss, and C. Lee Harrington, eds. *Fandom: Identities and Communities in a Mediated World*. New York: New York University Press, 2007.

—. "Introduction: Why Study Fans?" In *Fandom: Identities and Communities in a Mediated World*, edited by Jonathan Gray, Cornel Sandvoss, and C. Lee Harrington, 1–16. New York: New York University Press, 2007.

Gray, Jonathan. *Show Sold Separately: Promos, Spoilers, and Other Media Paratexts*. New York: New York University Press, 2010.

—. *Television Entertainment*. New York: Routledge, 2008.

—. *Watching with The Simpsons: Television, Parody, and Intertextuality.* New York: Routledge, 2006.

Gunkel, David. *Hacking Cyberspace.* Boulder, CO: Westview Press, 2001.

—. "Rethinking the Digital Remix: Mash-ups and the Metaphysics of Sound Recording." *Popular Music and Society* 31, no. 4 (2008): 489–510.

—. *Thinking Otherwise.* West Lafayette, IN: Purdue University Press, 2007.

Gunnning, Tom. "The Cinema of Attractions: Early Film, Its Spectator and the Avant-Garde." In *Early Film,* edited by Thomas Elsaesser and Adam Barker. London: British Film Institute, 1989.

Gwenllian-Jones, Sara. "The Sex Lives of Cult Television Characters." *Screen* 43, no. 1 (2002): 79–90.

—. "Starring Lucy Lawless?" *Continuum: Journal of Media and Cultural Studies* 14, no. 1 (2000): 9–22.

—. "Virtual Reality and Cult Television." In *Cult Television,* edited by Sara Gwenllian-Jones and Roberta E. Pearson, 83–98. Minneapolis: University of Minnesota Press, 2004.

—. "Web Wars: Resistance, Online Fandom and Studio Censorship." In *Quality Popular Television,* edited by Mark Jancovich and James Lyons, 163–77. London: BFI Publishing, 2003.

Gwenllian-Jones, Sara, and Roberta E. Pearson, Introduction to *Cult Television,* ix–xx. Minneapolis: University of Minnesota Press, 2004.

—. eds. *Cult Television.* Minneapolis: University of Minnesota Press, 2004.

Hall, Stuart. "Introduction: Who Needs 'Identity'?" In *Questions of Cultural Identity,* edited by Stuart Hall and Paul Du Gay, 1–17. London: Sage Publications, 1996.

Hardin, Garrett. "The Tragedy of the Commons." *Science* 162, no. 3859 (13 Dec 1968): 1243–8.

Harrington, C. Lee, and Denise D. Bielby. "Global Fandom/Global Fan Studies." In *Fandom: Identities and Communities in a Mediated World,* edited by Jonathan Gray, Cornel Sandvoss, and C. Lee Harrington, 179–97. New York: New York University Press, 2007.

Harty, E. R. "Text, Context, Intertext." *Journal of Literary Studies* 1, no. 2 (1985): 1–14.

Hellekson, Karen. "SF Fan Wikis: Source, Reference, World." *Res gestae—Documentary and Digital Evidence of the Trace.* 20 July 2008. http://khellekson.wordpress.com/2008/07/20/sf-fan-wikis/ (accessed 20 July 2008).

Hellekson, Karen, and Kristina Busse, eds. *Fan Fiction and Fan Communities in the Age of the Internet.* Jefferson, NC: McFarland and Co., 2006.

Herman, David. *Story Logic.* Lincoln: University of Nebraska Press, 2002.

Hess, Charlotte, and Elinor Ostrom. "Introduction: An Overview of the Knowledge Commons." In *Understanding Knowledge as Commons: From Theory to Practice,* edited by Charlotte Hess and Elinor Ostrom, 3–26. Cambridge, MA: The MIT Press, 2006.

Hevern, Vincent W. "Threaded Identity in Cyberspace: Weblogs & Positioning in the Dialogical Self." *Identity: An International Journal of Theory and Research* 4, no. 4 (2004): 321–35.

Hills, Matt. "Defining Cult TV: Texts, Inter-texts, and Fan Audiences." In *The Television Studies Reader,* edited by Robert C. Allen and Annette Hill, 509–23. London: Routledge, 2004.

—. *Fan Cultures.* London: Routledge, 2002.

—. "Strategies, Tactics and the Question of *Un Lieu Propre*: What/Where Is 'Media Theory'?" *Social Semiotics* 14, no. 2 (2004): 133–49.

Horton, David, and Richard Wohl. "Mass Communication and Parasocial Interaction." *Psychiatry 19* (1956): 215–29.

Huffaker, David. "Teen Blogs Exposed: The Private Lives of Teens Made Public." *American Association for Advancement of Science*. St. Louis, MO, 2006. http://www.soc.northwestern.edu/gradstudents/huffaker/papers/Huffaker-2006-AAAS-Teen_Blogs.pdf (accessed 20 June 2007).

Huffaker, David A., and Sandra L. Calvert. "Gender, Identity, and Language Use in Teenage Blogs." *Journal of Computer-Mediated Communication* 10, no. 2 (2005). http://jcmc.indiana.edu/vol10/issue2/huffaker.html (accessed 12 Dec 2007).

Huizinga, Johan. *Homo Ludens: A Study of Play Element in Culture*. Boston: Beacon Press, 1955.

Jenkins, Henry. "Afterward: The Future of Fandom." In *Fandom: Identities and Communities in a Mediated World*, edited by Jonathan Gray, Cornel Sandvoss, and C. Lee Harrington, 357–64. New York: New York University Press, 2007.

—. *Convergence Culture: Where Old and New Media Collide*. New York: New York University Press, 2006.

—. "Lecture 06: Media Literacy as a Strategy for Combatting Moral Panic [sic]." *MIT OCW: CMS.930 / 21F.034 Media, Education, and the Marketplace, Fall 2001*. Video Podcast on iTunes University (accessed Jan 2008).

—. "Star Trek Rerun, Reread, Rewritten: Fan Writing as Textual Poaching." In *Fans, Bloggers, and Gamers: Exploring Participatory Culture*, 37–60. New York: New York University Press, 2006.

—. *Textual Poachers: Television Fans and Participatory Culture*. New York: Routledge, 1992.

Jenkins, Henry, Xiaochang Li, Ana Domb Krauskopf, with Joshua Green. "If It Doesn't Spread, It's Dead." *Confessions of an Aca-Fen*. 11 Feb 2009. http://henryjenkins.org/2009/02/if_it_doesnt_spread_its_dead_p.html (accessed 16 Feb 2009).

—. "If It Doesn't Spread, It's Dead (Part Three): The Gift Economy and Commodity Culture." *Confessions of an Aca-Fen*. 16 Feb 2009. http://henryjenkins.org/2009/02/if_it_doesnt_spread_its_dead_p_2.html (accessed 16 Feb 2009).

Jensen, Jeff. "'Lost' Adds Fifth New Cast Member." *EW*. 29 Aug 2007. http://www.ew.com/ew/article/0,,20053479,00.html (accessed 01 Dec 2007).

Jensen, Klaus Bruhn. "Mixed Media: From Digital Aesthetics towards General Communication Theory." *Northern Lights* 5 (2007): 7–24.

Jenson, Joli. "Fandom as Pathology: The Consequences of Characterization." In *The Adoring Audience*, edited by Lisa Lewis, 9–30. London: Routledge, 1992.

Johnson, Keith M. "'The Coolest Way to Watch Movie Trailers in the World': Trailers in the Digital Age." *Convergence* 14, no. 2 (2008): 145–60.

Johnson, Steven. *Everything Bad Is Good For You*. New York: Riverside, 2005.

Kaplan, Deborah. "Construction of Character through Narrative." In *Fan Fiction and Fan Communities in the Age of the Internet*, edited by Karen Hellekson and Kristina Busse, 134–52. Jefferson, NC: McFarland and Co., 2006.

Kay, Alan, and Adele Goldberg. "Personal Dynamic Media." In *Computer Media and Communication: A Reader*, edited by Paul A. Mayer, 111–9. Oxford: Oxford University Press, 1999.

Keen, Andrew. *The Cult of the Amateur*. New York: Random House, 2007.

Kendall, Kenneth E., and Allen Schmidt. "Mash-ups: The Art of Creating New Applications by Combining Two or More Web Sites." *Decision Line*, 15–16. Mar 2007. http://

www.decisionsciences.org/DecisionLine/Vol38/38_2/dsi-dl38_2ecom.pdf (accessed 02 Dec 2008).

Killoran, John B. "Homepages, Blogs, and the Chronotopic Dimensions of Personal Civic (Dis)Engagement," in *Rhetorical Democracy: Discursive Practices of Civic Engagement*, edited by Gerard A. Hauser, Amy Grim, and the Rhetoric Society of America Conference, 213–20. Mahwah, NJ: Lawrence Erlbaum Associates, 2003.

Kollock, Peter. "The Economics of Online Cooperation: Gifts and Public Goods in Cyberspace." In *Communities in Cyberspace*, edited by Marc A. Smith and Peter Kollock, 220–39. London: Routledge, 1999.

Kollock, Peter, and Marc A. Smith. Introduction to *Communities in Cyberspace*, edited by Marc A. Smith and Peter Kollock, 3–27. London: Routledge, 1999.

Kraus, Wolfgang. "The Narrative Negotiation of Identity and Belonging." *Narrative Inquiry* 16, no. 1 (2006): 103–11.

Kristeva, Julia. "The Bounded Text." In *Desire in Language: A Semiotic Approach to Literature and Art*, edited by Leon S. Roudiez, translated by Thomas Gora, Alice Jardine, and Leon S. Roudiez, 36–63. New York: Columbia University Press, 1980.

—. "Word, Dialogue, Novel." In *Desire in Language: A Semiotic Approach to Literature and Art*, edited by Leon S. Roudiez, translated by Thomas Gora, Alice Jardine, and Leon S. Roudiez, 64–91. New York: Columbia University Press, 1980.

Lachmann, Renate. "Bakhtin and Carnival: Culture as Counter-Culture." *Critical Critique* 11 (1988): 115–52.

Lancaster, Kurt. *Interacting with Babylon 5*. Austin: University of Texas Press, 2001.

Landow, George. *Hypertext 3.0: Critical Theory and New Media in an Era of Globalization*, rev. ed. Baltimore, MD: Johns Hopkins University Press, 2006.

Le Guern, Philippe. "Toward a Constructivist Approach to Media Cults," translated by Richard Crangle. In *Cult Television*, edited by Sara Gwenllian-Jones and Roberta E. Pearson, 3–26. Minneapolis: University of Minnesota Press, 2004.

Lessig, Lawrence. *Code: Version 2.0*. New York: Basic Books, 2006.

—. "The Creative Commons." *Florida Law Review* 55 (1994): 763–77.

—. *Free Culture: The Nature and Future of Creativity*. New York: Penguin, 2004.

—. *The Future of Ideas: The Fate of the Commons in a Connected World*. New York: Random House, 2001.

—. *Remix: Making Art and Commerce Thrive in the Hybrid Economy*. New York: Penguin, 2008.

Leuf, Bo, and Ward Cunningham. *The Wiki Way: Quick Collaboration on the Web*. Boston: Addison Wesley, 2001.

Levinson, Paul. *New New Media*. Boston: Allyn & Bacon, 2009.

Lévi-Strauss, Claude. "Selections from *Introduction to the Work of Marcel Mauss*," translated by Felicity Baker. In *The Logic of the Gift: Toward an Ethic of Generosity*, edited by Alan D. Schrift, 45–69. New York: Routledge, 1997.

Lévy, Pierre. *Collective Intelligence: Mankind's Emerging World in Cyberspace,* translated by Robert Bononno. New York: Perseus, 1997.

—. *Cyberculture*, translated by Robert Bononno. Minneapolis: University of Minnesota Press, 2001.

Littleton, Cynthia. "'Lost': The Weight of the Wait." *Variety.com*. 12 Oct 2007. http://www.variety.com/article/VR1117974014.html?categoryid=2641&cs=1 (accessed 13 Mar 2008).

Lovink, Geert. *Zero Comments: Blogging and Critical Internet Culture*. New York: Rout-
ledge, 2008.

Manovich, Lev. *The Language of New Media*. Cambridge, MA: The MIT Press, 2001.

—. "What Comes after Remix?" 2007. http://www.manovich.net/DOCS/remix_2007_2.doc
(accessed 03 Jan 2008).

McLuhan, Marshall. *The Medium Is the Message*. New York: Random House, 1994.

Marx, Karl. *Capital: A Critique of Political Economy*, translated by Ben Fowkes. London:
Penguin Classics, 1990.

Mauss, Marcel. *The Gift: The Form and Reason for Exchange in Archaic Societies,* translated
by W. D. Halls. New York: Norton, 1990.

McGonigal, Jane. "I Love Bees: A Buzz Story." Paper presented at AD:TECH, San Francisco,
25–27 April 2005. http://avantgame.com/McGonigal_42%20Entertainment_|ADTECH_
April%202005.pdf (accessed 01 Sept 2007).

—. "The Puppetmaster Problem: Design for Real-World, Mission-Based Gaming." In *Second
Person: Role-Playing and Story in Games and Playable Media*, edited by Pat Harrigan
and Noah Wardrip-Fruin, 251–63. Cambridge, MA: The MIT Press, 2007.

—. "A Real Little Game: The Performance of Belief in Pervasive Play." Level Up. Proceedings
of DiGRA conference, Utrecht, the Netherlands, Nov 2003.

—. "'This Is Not a Game': Immersive Aesthetics and Collective Play." Digital Arts & Culture
Conference Proceedings, 2003. http://www.seanstewart.org/beast/mcgonigal/notagame/
paper.pdf (accessed 01 Sept 2007).

Meadows, Mark Stephen. *Pause and Effect*. Indianapolis, IN: New Riders, 2003.

Merrin, William. *Baudrillard and the Media*. Cambridge, UK: Polity Press, 2005.

—. "Media Studies 2.0: Upgrading and Open-Sourcing the Discipline." *Interactions: Studies in
Communication and Culture* 1, no. 1 (2009): 17-34.

Miall, David S. "Episode Structures in Literary Narratives." *Journal of Literary Semantics* 33
(2004): 111–29.

Miller, Carolyn R., and Dawn Shepherd. "Blogging as Social Action: A Genre Analysis of the
Weblog." In *Into the Blogosphere: Rhetoric, Community, and Culture of Weblogs*, edited
by Laura Gurak, Smiljana Antonijevic, Laurie Johnson, Clancy Ratliff, and Jessica Rey-
man. Minneapolis: University of Minnesota Press, 2004. http://blog.lib.umn.edu/ blo-
gosphere/ (accessed 20 Jan 2008).

Miller, Paul Allen. "The Otherness of History in Rabelais' Carnival and Juvenal's Satire, or
Why Bakhtin Got It Right the First Time." In *Bakhtin and the Other*, edited by Peter
Barta, Paul Allen Miller, Charles Platter, and David Shepherd, 141–64. London: Rout-
ledge, 2001.

Mitchell, W. J. T. *What Do Pictures Want?: The Lives and Loves of Images*. Chicago: Univer-
sity of Chicago Press, 2006.

Mittell, Jason. "The Loss of Value (or the Value of Lost)." *FlowTV* 2, no. 5 (2005).
http://flowtv.org/?p=165 (accessed 08 Sept 2008).

—. "Narrative Complexity in Contemporary American Television." *The Velvet Light Trap* 58
(2006): 29–40.

—. "Sites of Participation: Wiki Fandom and the Case of Lostpedia," *Transformative Works
and Cultures*, 3 (2009).

—. "The Value of Lost, Part Two." *FlowTV* 2, no. 10 (2005). http://flowtv.org/?p=435
(accessed 08 Sept 2008).

Molesworth, Richard. "BBC Archive Holdings." *Doctor Who Restoration Team*. 1997. http://www.purpleville.pwp.blueyonder.co.uk/rtwebsite/archive.htm (accessed 15 Oct 2008).

Montola, Marcus. "Exploring the Edge of the Magic Circle: Defining Pervasive Games." Proceedings of DAC, Copenhagen, Denmark, 2005. http://www.iki.fi/montola/ exploringtheedge.pdf (accessed 01 Aug 2007).

Moores, Shaun. *Media/Theory*. London: Routledge, 2005.

Morgan, Thaïs. "Is There an Intertext in this Text?: Literary and Interdisciplinary Approaches to Intertextuality." *American Journal of Semiotics* 3, no. 1 (1985): 1–40.

Morson, Gary Saul, and Caryl Emerson. *Mikhail Bakhtin: Creation of a Prosaics*. Stanford, CA: Stanford University Press, 1990.

Mortensen, Torvill Elvira. "Me, the Other." In *Second Person: Role-Playing and Story in Games and Playable Media*, edited by Pat Harrigan and Noah Wardrip-Fruin, 297–306. Cambridge, MA: The MIT Press, 2007.

Murray, Janet. *Hamlet on the Holodeck: The Future of Narrative in Cyberspace*. Cambridge, MA: The MIT Press, 1997.

Ness, John. "Mob Narrative." *Newsweek (Atlantic Edition)* 149, no. 10 (05 Mar 2007): 8.

Ng, Eve. "Reading the Romance of Fan Cultural Production: Music Videos of a Television Lesbian Couple." *Popular Communication* 6, no. 2 (2008): 103–21.

O'Neill, Patrick. *Fictions of Discourse: Reading Narrative Theory*. Toronto: University of Toronto Press, 1994.

O'Reilly, Tim. "What Is Web 2.0: Design Patterns and Business Models for the Next Generation of Software." *O'Reilly*. 2005. http://www.oreillynet.com/pub/a/oreilly/tim/news/2005/09/30/what-is-web-20.html (accessed 16 Sept 2007).

Ochs, Elinor, and Lisa Capps. "Narrating the Self." *Annual Review of Anthropology* 25, no. 1 (1996): 19–43.

Ong, Walter. *Orality and Literacy*. London: Routledge, 2002.

Oren, Eyal. "SemperWiki: A Semantic Personal Wiki." Semantic Desktop Workshop 2005 @ ISWC. 2005. http://www.eyaloren.org/pubs/semdesk2005.pdf (accessed 25 Sept 2007).

Örnebring, Henrik. "Alternate Reality Gaming and Convergence Culture: The Case of *Alias*." *International Journal of Cultural Studies* 10, no. 4 (2007): 445–62.

Orr, Mary. *Intertextuality*. London: Polity, 2003.

Ostrom, Elinor. *Governing the Commons: The Evolution of Institutions for Collective Action*. Cambridge, UK: Cambridge University Press, 1990.

Ott, Brian. L., and Cameron Walter. "Intertextuality: Interpretive Practice and Textual Strategy." *Critical Studies in Media Communication* 17, no. 4 (2000): 429–46.

Otto, Wayne, Sandra White, and Kay Camperell. "Text Comprehension Research to Classroom Application: Developing an Instructional Technique." *Reading Psychology* 1, no. 3 (1980): 184–91.

Penley, Constance. *Nasa/Trek: Popular Science and Sex in America*. London: Verso, 1997.

Pérez-Reverte, Arturo. *The Club Dumas*, translated by Sonia Soto. New York: Vintage, 1997.

Pesce, Mark. "Piracy Is *Good*? New Models for the Distribution of Television Programming." Paper presented at the Australian Film Television and Radio School, Sydney, 6 May 2005. http://hyperreal.org/~mpesce/piracyisgood.pdf (accessed 04 Jan 2009).

Polkinghorne, Donald E. *Narrative Knowing and the Human Sciences*. Albany: State University of New York Press, 1988.

Poster, Mark. *The Information Subject*. London: Taylor and Francis, 2001.

Postigo, Hector. "Video Game Appropriation through Modifications." *Convergence: The International Journal of Research into New Media Technologies* 14, no. 1 (2008): 59–74.

Potts, John. "Who's Afraid of Technological Determinism?: Another Look at Medium Theory." *Fibreculture* 12 (2008). http://journal.fibreculture.org/issue12/ (accessed 01 Sept 2008).

Rafaeli, Sheizof. "Interactivity: From New Media to Communication." In *Sage Annual Review of Communication Research: Advancing Communication Science: Merging Mass and Interpersonal Processes, 16*, edited by R. P. Hawkins, J. M. Wiemann, and S. Pingree, 110–34. Beverly Hills: Sage, 1988.

Rettberg, Jill Walker. *Blogging.* Cambridge, UK: Polity Press, 2008.

Rheingold, Howard. *The Virtual Community: Homesteading on the Electronic Frontier.* Reading, MA.: Addison-Wesley, 1993.

Riedl, Mark O., and R. Michael Young. "From Linear Story Generation to Branching Story Graphs." *IEEE Computer Graphics and Applications* 26, no. 3 (2006): 23–31.

Rutherford, Jonathan. *Identity: Community, Culture, Difference.* London: Lawrence & Wishart, 1998.

Ryan, Marie-Laure. *Avatars of Story.* Minneapolis: University of Minnesota Press, 2006.

—. "Beyond Myth and Metaphor: Narrative in Digital Media." *Poetics Today* 23, no. 4 (2002): 581–609.

—. *Narrative as Virtual Reality.* Baltimore, MD: Johns Hopkins University Press, 2001.

Sahlins, Marshall. "The Spirit of the Gift." In *The Logic of the Gift: Toward an Ethic of Generosity*, edited by Alan D. Schrift, 70–99. New York: Routledge, 1997.

Sandvoss, Cornel. *Fans: The Mirror of Consumption.* Malden, MA: Polity Press, 2005.

Saussure, Ferdinand de. *Course in General Linguistics*, edited by Charles Bally and Albert Sechehaye in collaboration with Albert Riedlinger, translated by Wade Baskin. New York: McGraw-Hill, 1966.

Schneider, Jay, and Gerd Kortuem. "How to Host a Pervasive Game: Supporting Face-to-Face Interactions in Live-Action Roleplaying." UbiComp Workshop on Designing Ubiquitous Computing Games, 2000. http://www.cs.uoregon.edu/research/wearables/Papers/ how2host.ps (accessed 10 Oct 2008).

Scholes, Robert, and Robert Kellogg. *The Nature of Narrative.* London: Oxford University Press, 1968.

Schork, R. Joseph, "Acoustic Intratexts in *Aeneid* 7.122 and 4.408." *Classical Philology* 91, no. 1 (1996): 61–3.

Schrift, Alan D. "Introduction: Why Gift?" In *The Logic of the Gift: Toward an Ethic of Generosity*, edited by Alan D. Schrift, 1–22. New York: Routledge, 1997.

"Sci Fi Channel Partners with Trion for Interwoven TV Show and Virtual World." *Virtual Worlds News.* 02 June 2008. http://www.virtualworldsnews.com/2008/06/sci-fi-channel.html (accessed 10 Mar 2009).

Sconce, Jeffrey. "What If?: Charting Television's New Textual Boundaries." In *Television after TV*, edited by Lynn Spigel and Jan Olsson, 93–112. Durham, NC: Duke University Press, 2004.

Serfaty, Viviane. *The Mirror and the Veil: An Overview of American Online Diaries and Blogs.* Amsterdam: Rodopi, 2004.

Shave, Rachel. "Slash Fandom on the Internet, or Is the Carnival Over?" *Refractory* 6 (2004). http://blogs.arts.unimelb.edu.au/refractory/2004/06/17/slash-fandom-on-the-internet-or-is-the-carnival-over-rachel-shave/ (accessed 07 Oct 2008).

Shefrin, Elana. "*Lord of the Rings, Star Wars*, and Participatory Fandom: Mapping New Congruencies between the Internet and Media Entertainment Culture." *Critical Studies in Media Communication* 21, no. 3 (2004): 261–81.

Shen, Dan, and Dejin Xu. "Intratextuality, Extratextuality, Intertextuality: Unreliability in Autobiography versus Fiction." *Poetics Today* 28, no. 1 (2007): 43–87.

Shepherd, David, ed. *Bakhtin: Carnival and Other Subjects: Selected Papers from the Fifth International Bakhtin Conference University of Manchester, July 1991*, Atlanta, GA: Rodopi, 1993.

Shiga, John. "Copy-and-Persist: The Logic of Mash-Up Culture." *Critical Studies in Media Communication* 24, no. 2 (2007): 93–114.

Smith, Marc A., and Peter Kollock, eds. *Communities in Cyberspace*. London: Routledge, 1999.

Soukup, Charles. "Hitching a Ride on a Star: Celebrity, Fandom, and Identification on The World Wide Web." *Southern Communication Journal* 71, no. 4 (2006): 319–37.

Stallybrass, Peter, and Allon White. *The Politics and Poetics of Transgression*. Ithaca, NY: Cornell University Press, 1986.

Stelter, Brian. "A Marketing Move the 'Mad Men' Would Love." *New York Times*. 01 Sept 2008. http://www.nytimes.com/2008/09/01/business/media/01twitter.html?scp=2&sq=twitter&st=cse (accessed 02 Sept 2008).

Stone, Alluquere Rosanne. *The War of Desire and Technology at the Close of the Mechanical Age*. Cambridge, MA: The MIT Press, 1996.

Sullivan, Andrew. "Comments." *The Daily Dish*. 03 Mar 2008. http://andrewsullivan. theatlantic.com/the_daily_dish/2008/03/comments.html (accessed 05 Mar 2008).

Sundén, Jenny. *Material Virtualities*. New York: Peter Lang, 2003.

Szulborski, Dave. *This Is Not A Game: A Guide to Alternate Reality Gaming*. New York: New Fiction Publishing, 2005.

Tapscott, Don, and Anthony Williams. *Wikinomics: How Mass Collaboration Changes Everything*. New York: Penguin, 2006.

Thomas, Angela. "Fan Fiction Online: Engagement, Critical Response and Affective Play through Writing." *Australian Journal of Language and Literacy* 29, no. 3 (2006): 226–39.

—. "Fictional Blogs." In *Use of Blogs (Digital Formations)*, edited by Axel Bruns and Joanne Jacobs, 199–209. New York: Peter Lang, 2006.

Thomas, Sue. "The End of Cyberspace and Other Surprises," *Convergence: The International Journal of Research into New Media Technologies*, 12, no. 4 (2006): 383–391.

Thompson, Kristin. *Storytelling in Film and Television*. Cambridge, MA: Harvard University Press, 2003.

Thorston, Kjerstin S., and Shelly Rodgers. "Relationships between Blogs and eWOM and Interactivity, Perceived Interactivity, and Parasocial Interaction." *Journal of Interactive Advertising* 6, no. 2 (2006): 39–50. http://www.jiad.org/article79 (accessed 01 Oct 2008).

Todorov, Tzvetan. *Grammaire du "Décaméron"*. The Hague: Mouton, 1969.

Toffler, Alvin. *The Third Wave*. New York: Bantam Books, 1980.

Tulloch, John, and Henry Jenkins. *Science Fiction Audiences: Watching 'Doctor Who' and 'Star Trek.'* London: Routledge, 1995.

Turkle, Sherry. *Life on the Screen: Identity in the Age of the Internet*. New York: Simon and Schuster, 1995.

Tushnet, Rebecca. "Copyright Law, Fan Practices, and the Rights of the Author." In *Fandom: Identities and Communities in a Mediated World*, edited by Jonathan Gray, Cornel Sandvoss, and C. Lee Harrington, 60–74. New York: New York University Press, 2007.

van Kokswijk, Jacob. *Digital Ego: Social and Legal Aspects of Virtual Identity*, rev ed. Delft, the Netherlands: Eburon Academic Publishers, 2008.

Wagner, Mitch. "Lost Fans Find Internet Thrills Via Wikis, Games, Second Life." *InformationWeek*. 26 Apr 2008. http://www.informationweek.com/news/personal_tech/ virtualworlds/showArticle.jhtml?articleID=207401542 (accessed 02 May 2008).

Walker, Jill. "Distributed Narratives: Telling Stories Across Networks." Paper presented at AoIR 5.0, Brighton, 21 Sept 2004. http://huminf.uib.no/~jill/txt/AoIR-distributednarrative.pdf (accessed 01 Aug 2006).

Walker, Rob. "Enterprising: Her *Star Trek* Conventions Harnessed the Power of Media Fandom Long before the Barons of Content Did." *New York Times Magazine*. 23 Dec 2008.

Walsh, Richard. "Fabula and Fictionality in Narrative Theory." *Style* 35, no. 4 (2001): 592–606.

Wand, Eku. "Interactive Storytelling: The Renaissance of Narration." In *New Screen Media: Cinema/Art/Narrative*, edited by Martin Rieser and Andrea Zapp, 163–78. London: BFI, 2002.

Warnick, Barbara. *Rhetoric Online: Persuasion and Politics on the World Wide Web*. New York: Peter Lang, 2007.

Webb, Darren. "Bakhtin at the Seaside: Utopia, Modernity and the Carnivalesque." *Theory, Culture & Society* 22, no. 3 (2005): 121–38.

Wesch, Michael. "What Is Web 2.0? What Does It Mean for Anthropology?" *Anthropology News* (May 2007): 30–31.

"What Effect Have Fans Had?"*The Lurkers Guide to Babylon 5*. 19 Mar 2006. http://www.midwinter.com/lurk/resources/fans.html#effect (accessed 10 March 2009).

WHCnelson. Review of "Battlestar Galactica 1980/1985 Finding Earth." *Fanfiction.net*. 20 Nov 2007. http://www.fanfiction.net/r/3777645/ (accessed 30 Dec 2007).

Williams, Raymond. *Culture and Materialism*. London: Verso, 1980.

—. *Keywords: A Vocabulary of Culture and Society*. Oxford: Oxford University Press, 1976.

—. *Television: Technology and Cultural Form*. London: Routledge, 1990.

Williams, Rebecca. "'It's About Power': Spoilers and Fan Hierarchy." *Slayage: The International Journal of Buffy Studies* 3, no. 3–4 (2004). http://slayageonline.com/ Numbers/slayage11_12.htm (accessed 14 March 2008).

Williams, Robin, and David Edge. "The Social Shaping of Technology." http://www.comunicazione.uniroma1.it/materiali/16.47.15_WilliamsEdge_1996_TheSoci alShapingOfTechnology.pdf (accessed 25 Aug 2008).

Žižek, Slavoj. "Cyberspace, or the Unbearable Closure of Being." In *The Plague of Fantasies*, 127-158. London: Verso, 1997.

—. *Looking Awry: An Introduction to Jacques Lacan through Popular Culture*. Cambridge, MA: The MIT Press, 1991.

Zuckerberg, Mark. "Open Letter." 01 Dec 2009. http://blog.facebook.com/blog.php?post=190423927130 (accessed 01 Dec 2009).

Index

N

Perplex City. See Alternate Reality
 Games
perruque, 40, 41
persona, 144, 158, 163, 165
 "me" identity, 141, 143
 change, 165
 character, 7, 130, 139, 146, 153, 156,
 161–172
 community, 145
 definition of, 144
 fan, 146, 153, 165, 166, 168, 169, 172
 fan/character, 128, 139, 162–174
 identification with, 163
 identity, as, 144, 166, 169
 mash-up, as, 145, 180
 mutability, 143, 145
 roleplay, 146, 161, 171, 172
persona-fied, 130
persuasive game. *See* Alternate Reality
 Game
Pesce, Mark, 73
philosophy of playfulness, 2, 12, 38, 63,
 82, 130, 180, 192
piracy, 73, 129, 133
Plot. *See also* narrative:plot
plot, land or narrative, 167
podcast, 147
polarity, 7, 187
popular culture, 18, 36
Possible World Theory, 118
post-biological age, 141
Poster, Mark, 147, 164
Postigo, Hector, 20
postmodern, 14, 67, 189
post-structuralist, 49, 139
Potts, John, 21
producerly texts, 36
production, 22, 41, 103, 132, 137–138,
 146, 155–159, 166, 169, 172–173
production/consumption dialectic, 22, 43
productive consumption, 18
produser, 22, 40, 41
Project Gutenberg, 84
prosumer, 22

psychoanalysis, 107, 119
Pugh, Casey, 38
Puppetmasters. *See* Alternate Reality
 Game: Puppetmasters

R

radio, 18, 80, 182
Rafaeli, Sheizof, 157
readership, 82
reading
 tactical, 36, 159, 173
reciprocity, 24, 73, 134
religion, 11, 60, 136
remediation, 85, 181–190
remix culture, 36
reply
 email, 73
 vs. reciprocity, 134
reproduction
 fan community, of, 129, 154, 167
 fan community, of the, 7
 fandom, of, 174
 texts, of, 36, 38
rereading, 7, 72, 82, 147, 169–170, 174
 community, 67, 89, 98, 173
 fan-created fan fiction, 82, 88, 168
 identity, 158
 narrative, 98, 117, 129, 154
 process of, 39
 story as discourse, 89, 93–98, 117
 television, 109
Rettberg, Jill Walker, 143
rewriting, 7, 42, 82, 117, 147, 174
 blog, 43, 48
 character, 128, 154
 communal reimagining, as, 34
 conditional, 67
 fan fiction, as, 75, 82
 identity, 169, 171
 media studies, 39, 49
 narrative, 89, 93, 96, 97, 98, 129, 154,
 172
 producer, the space of the, 156

General Editor: *Steve Jones*

Digital Formations is an essential source for critical, high-quality books on digital technologies and modern life. Volumes in the series break new ground by emphasizing multiple methodological and theoretical approaches to deeply probe the formation and reformation of lived experience as it is refracted through digital interaction. **Digital Formations** pushes forward our understanding of the intersections—and corresponding implications—between the digital technologies and everyday life. The series emphasizes critical studies in the context of emergent and existing digital technologies.

Other recent titles include:

Felicia Wu Song
 Virtual Communities: Bowling Alone, Online Together

Edited by Sharon Kleinman
 The Culture of Efficiency: Technology in Everyday Life

Edward Lee Lamoureux, Steven L. Baron, & Claire Stewart
 Intellectual Property Law and Interactive Media: Free for a Fee

Edited by Adrienne Russell & Nabil Echchaibi
 International Blogging: Identity, Politics and Networked Publics

Edited by Don Heider
 Living Virtually: Researching New Worlds

Edited by Judith Burnett, Peter Senker & Kathy Walker
 The Myths of Technology: Innovation and Inequality

Edited by Knut Lundby
 Digital Storytelling, Mediatized Stories: Self-representations in New Media

Theresa M. Senft
 Camgirls: Celebrity and Community in the Age of Social Networks

Edited by Chris Paterson & David Domingo
 Making Online News: The Ethnography of New Media Production

To order other books in this series please contact our Customer Service Department:
(800) 770-LANG (within the US)
(212) 647-7706 (outside the US)
(212) 647-7707 FAX

To find out more about the series or browse a full list of titles, please visit our website:
WWW.PETERLANG.COM